A POPULAR HISTORY OF THE ARTS

Golden Hands Books

Marshall Cavendish
London and New York

Picture Credits

Published by Marshall Cavendish Publications Limited
58, Old Compton Street
London, W1V 5PA.

© Marshall Cavendish Limited, 1968/69/70/75
58, Old Compton Street,
London, W1V 5PA.

This material was first published by
Marshall Cavendish Limited in *Mind Alive*

This volume first printed 1975

Printed in Great Britain by Severn Valley Press Limited

ISBN 0 85685 129 9

Introduction

Art is man's most complete and creative means of self-expression. Throughout the world, various cultures have emerged each representing a different life-style, and from these sources we have evolved a colourful and fascinating picture of human experience. *A Popular History of the Arts* is one of the most comprehensive accounts of this evolution, ranging from the primitive to the highly sophisticated representations of life through art. Focusing on seven major areas of artistic expression, including painting, sculpture, drama, music and literature, this authoritative text combines the scope of a broad discussion of popular artistic expression with a selective concentration on major points of development.

Most people would consider painting as the primary art form, and both the history and the development of painting techniques is fully represented here. Starting from the earliest use of symbols in religious painting, this section also includes an excellent series of discussions of Renaissance and classical painting, through the French Impressionists, right up to the modern movement. It also contains studies of particular categories, such as the nude, still life, and portraiture. Painting is only one of the major art forms however, for art represents man in all his variety. He has made his mark in many other ways, and through many great men. Some of the greatest names in history are encountered here – from Shakespeare to T. S. Eliot, Beethoven to the Beatles, Leonardo da Vinci to Picasso. As well as these household names, some of our most precious art has been bequeathed by thousands of unknown people, in the form of beautifully made objects, often designed for everyday use, but perfect in design and execution. We have also included an extensive section on one of the most recently evolved art forms, that of the cinema, which has its own place in artistic discussion.

An absorbing account indeed, and the text is fully illustrated with hundreds of pictures, many in colour. *A Popular History of the Arts* is attractive and informative and will provide the reader with hours of pleasure.

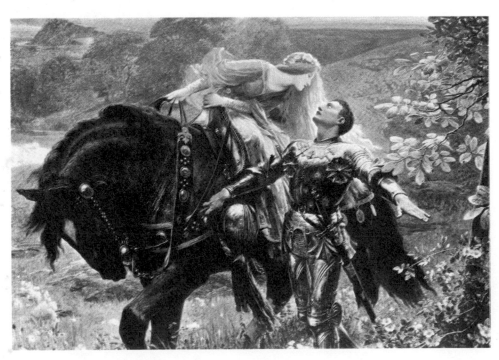

Contents

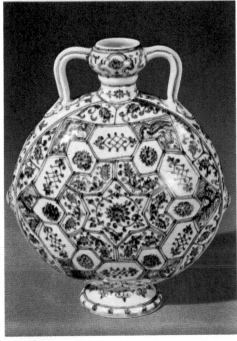

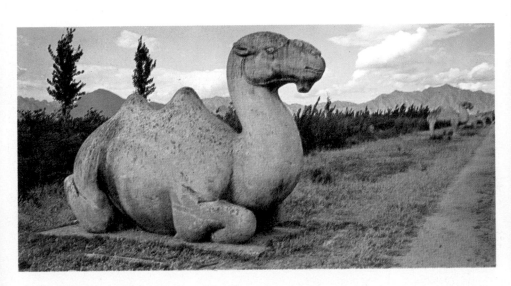

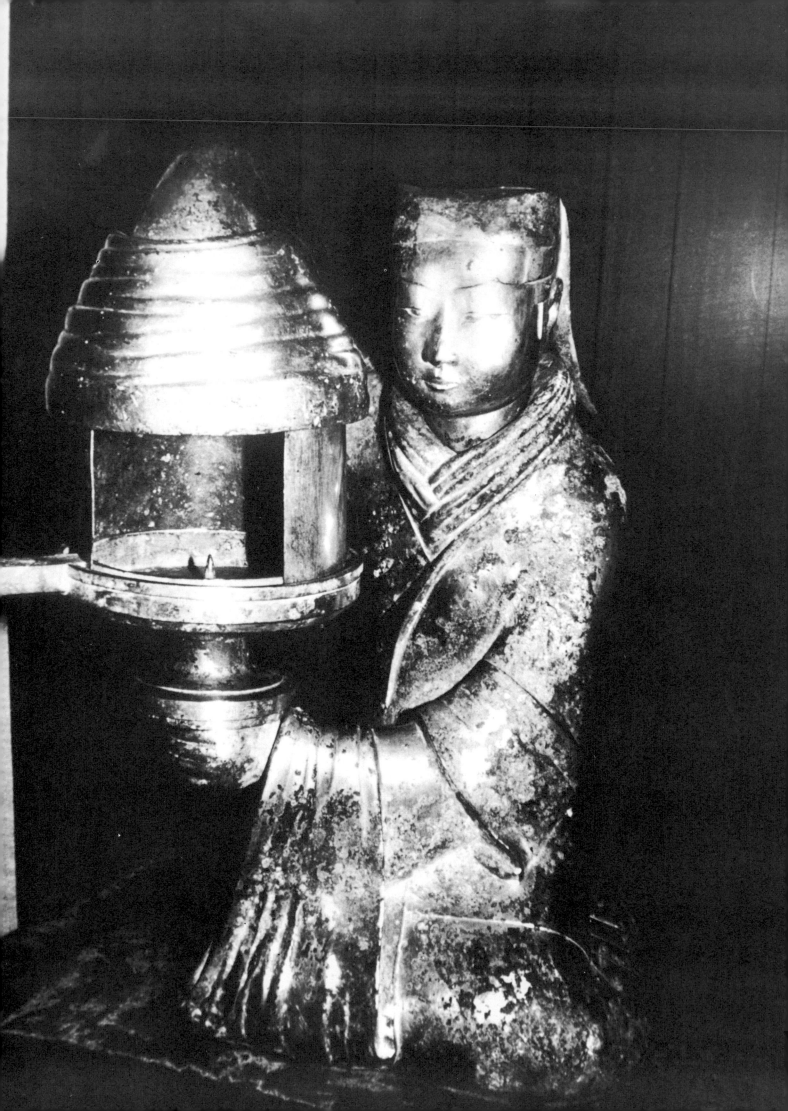

Quiet artists of a stormy land

Delicate, crackled glaze on a fragile vase; remote, pale landscapes of mountain and sea — a sense of eternity has lingered in the art of China for 3,500 years of turbulent history.

CHINA HAS a continuous artistic tradition extending over 3,500 years. Generally, her art is quiet and conservative rather than exotic, reflecting the continuity of Chinese culture and the influence of Confucianism. On the other hand Taoist influences run like a thread through almost the whole of Chinese art, making for simplicity and the striving for mystic union with nature.

While much Chinese painting and sculpture is Buddhist, the Indian philosophy-religion of Buddhism has never quite penetrated the soul of Chinese culture to the same depth as Confucianism and Taoism. Nevertheless, Buddhism caught the imagination of many Chinese artists because it provided a vehicle for the expression of popular religious feeling beyond the scope of Taoism and Confucianism. Other foreign influences, especially ideas from western and central Asia, were also assimilated into Chinese culture. In principle, the aim of Chinese artists has always been to project ideas and feelings in addition to aesthetically pleasing visual representations.

Traditional Chinese architecture is picturesque, and the serene statues of the Buddha impressive, but neither architecture nor sculpture represents the best in Chinese art. Chinese ivory and lacquer work is of outstanding beauty. The Chinese have always prized jade, which for them symbolized charity, integrity, wisdom, courage and similar virtues. Exquisite silks were produced in China 2,000 years before any other country understood the technique of silk production. Traders carried the silks across Asia to the Mediterranean for sale to wealthy purchasers in ancient Rome. In China, rich courtiers wore brilliantly dyed silk cos-

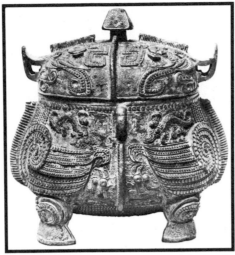

This highly elaborate bronze vessel is in the shape of an owl and is mounted on three legs. It was produced during the Shang-Yin dynasty.

Chinese Dynasties

Shang-Yin	1523–1027	B C
Chou	1027–221	
Warring States	480–221	
Ch'in	221–206	
Han	B C 206–220	A D
Three Kingdoms	220–265	
Six Dynasties	265–588	
Sui	589–618	
T'ang	618–906	
Five Dynasties	906–959	
Sung	960–1279	
Yüan	1280–1368	
Ming	1368–1644	
Ch'ing	1644–1912	
Republic	1912–	

tumes decorated with swastikas and dragons, birds, insects, flowers, and many more intricate designs.

Until the thirteenth century, Chinese artists painted their pictures on silk because this was the most durable and suitable material available. After this time, most painters began to use paper, although some still preferred to paint on silk.

Except for small paintings in books, almost all Chinese paintings are in the form of scrolls, with wooden rods at the ends. Some hang vertically, some horizontally. Many painters have used long, horizontal scrolls to paint riverside scenery. When the scroll is unrolled it is as though the viewer is in a moving boat watching the shore: scene follows scene, with calligraphic explanation in between. Calligraphy and painting are closely related in Chinese art, and the same kind of brushwork is used for both. A Chinese artist is necessarily a calligrapher before he is a painter.

Gifts for the gods

Many bronze containers, mounted on three supporting legs, were produced by unknown craftsmen between the beginning of the Shang-Yin dynasty and the end of the Han dynasty (c. 1500 B C to A D 220). These vessels usually held food and wine offered to the gods in ancestor-worship ceremonies, but some rich families used them as domestic utensils. The vessels also had ceremonial significance and conferred status upon those who possessed them. The vessels vary in height from a few inches to about four feet, and in weight from a few ounces to about 1,500 pounds. Some are plain, some have symbolic,

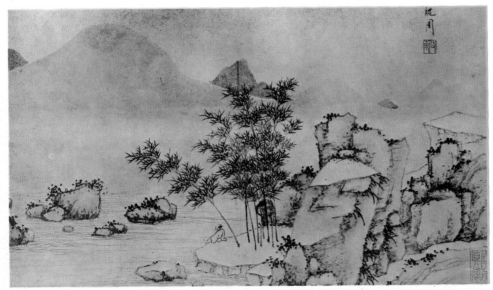

Left, A Chinese figure of a kneeling girl, designed to allow smoke to be chanelled through the hollow arm into the cast.

Above, Landscape by Shen Chou — an influential artist of the Wu School. The individual brushwork is one characteristic of his style.

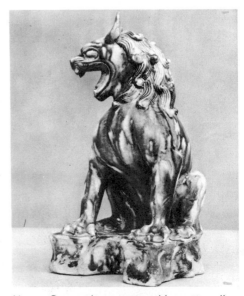

Above, Green glaze covers this pottery lion, made during the T'ang dynasty, a period notable for the advance in the art of ceramics.

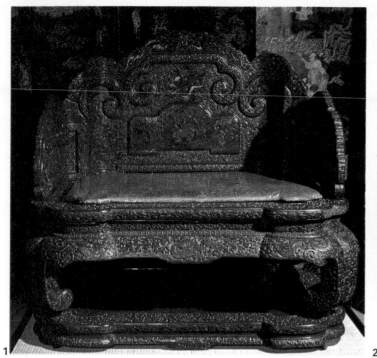

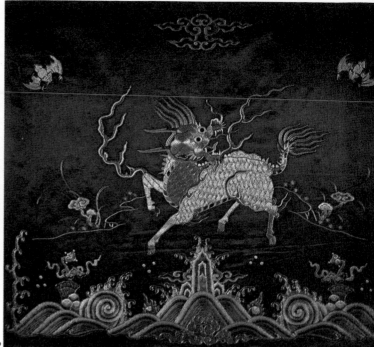

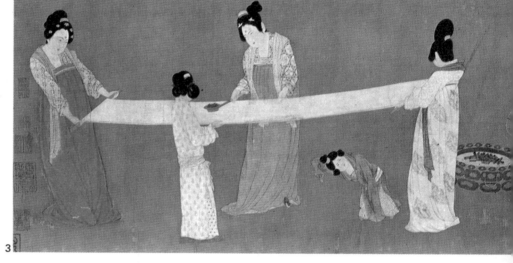

highly stylized, geometrical patterns. Others are highly decorated with human figures or animals, birds, reptiles and insect motifs. Some depict scenes of sacrifice, hunting, war or happenings in daily life. About 1,000 of these superb pieces have been found, and together they give a great insight into the life of ancient China.

Early Chinese buildings were made of wood and packed earth, with stone bases for pillars. Recent excavations have unearthed the remains of several large buildings, one of them more than 90 feet long. The early houses had gables and overhanging roofs. Written records reveal that ancient China had well-planned cities, with temples and royal palaces. Ballads tell of elaborate porches, gates and courtyards. Nearly 2,500 years ago, Confucius complained that buildings had already become too decorative. Most traditional buildings extended horizontally rather than vertically. When tall buildings were constructed, they were so designed that they swayed with the wind; they were topped with sloping roofs which reduced the impact of the wind.

Apart from the written records, much of present knowledge about ancient Chinese architecture comes from clay models of buildings, and reliefs on tiles and stone slabs. Archaeologists found these objects, together with delightful models of ox carts, wells, stables and granaries, buried in tombs dating from the period of the Han dynasty (206 B C–A D 220).

By about the first century A D, motifs from southwestern Asia and the eastern Mediterranean made their way into China. Sculptors began to produce fabulous winged lions and winged and fierce horned dragon-headed creatures to guard the tombs of Chinese emperors. Tomb wall-paintings from about the same period show lively scenes of guests arriving on horseback or by chariot at friendly gatherings, to be entertained by musicians.

From the fourth century A D onwards, Chinese Buddhists cut cave temples and giant images of the Buddha from the rock

Good-luck symbols carved in red lacquer decorate this wooden throne of the Ch'ing dynasty, **1**, which stood before the gate of Ch'ien-lung's hunting palace in Peking. Of the same period is

face in Indian fashion. At the 'Caves of the Thousand Buddhas', at Tun-huang in Kansu, more than 400 grottoes were carved out from the cliff. Chinese Buddhists also developed a style of sculpture that took inspiration from the *Mathura* and *Gandhara* styles of India. But their art, like their religion, became less and less Indian with the passing of time.

Buddhas in elaborate shrines

The rhythmical movement of Indian figures disappeared. The body became less important, the face more so. The Buddha's image became less aesthetically exciting, more impressive and serene. Chinese sculptors designed their Buddhas to be viewed from the front only; the back of most of their figures has little interest.

Early Buddhist images were set up in shrines which gradually became more and more elaborate. Wooden temples and monasteries became as grand as palaces, with galleries, pavilions, courtyards and gardens. *Stupas* (domed monuments built

this tapestry, **2**, showing one of the mythical monsters of China. **3** a detail from a silk scroll painted by Hui-tsung, a gifted emperor of the Sung dynasty, shows court ladies ironing silk.

in India to house sacred Buddhist relics) caught the imagination of Chinese Buddhists returning from pilgrimages to India. The Chinese already possessed multi-storey wooden buildings and these gradually evolved into the Chinese counterpart of the stupa, the *pagoda*. The earliest surviving Chinese pagoda, a 12-sided stone tower built in A D 520 in Honan, shows Indian influence. But later, pagodas became more traditionally Chinese in style. Most Chinese pagodas have between five and 12 storeys.

One of the earliest known Chinese artists was Ku K'ai-Chih, a calligrapher-painter and poet who lived in the fourth century A D. Wild, unconventional and witty, he was a favourite at court. He painted portraits of courtiers, using Taoist-inspired landscapes as incidental background. It is said that he captured not only the likeness of his sitters, but also the essence of their spirit. Between c. A D 300 and 600, many Buddhist paintings appeared.

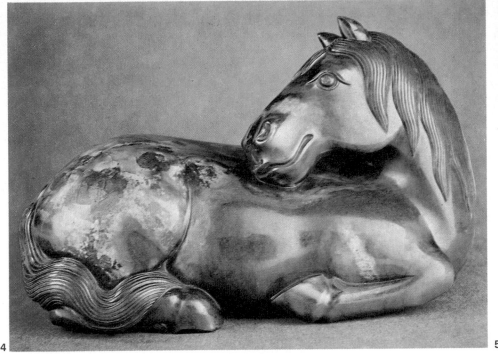

4

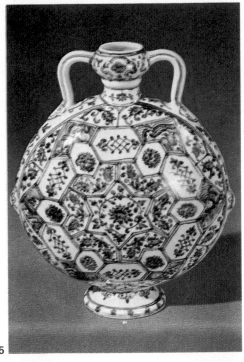

5

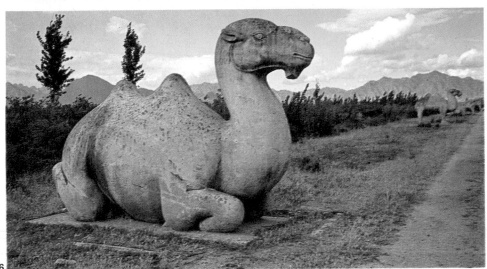

6

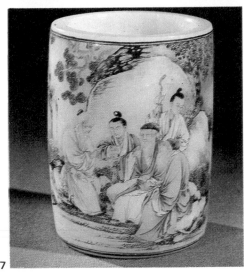

7

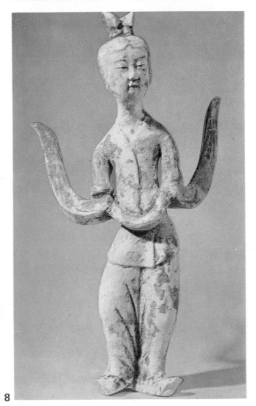

8

Since ancient times, jade has been prized by the Chinese. For its qualities of strength, purity and colour, the Han scholar Hsü Shen endowed it with five virtues: charity, rectitude, wisdom, courage and equity. The little horse, **4,** was probably carved during the T'ang dynasty. Love of colour and luxury characterized the Ming dynasty: blue and white ware produced during it, like the beautifully decorated flask, **5,** has been admired and imitated in many different countries.

In *c.* AD 500, Hsieh Ho, a portrait painter of Nanking, set forth six principles of painting which gave technical and aesthetic guidance to painters and art critics. Hsieh Ho laid down that the painter should cause the breath of vitality to flow through a painting, make firm bone-like strokes and give form and shape to his work. He should use colours in harmony with the subject matter, carefully plan space and composition, and imitate early paintings of high quality. These six principles have guided Chinese painters since Hsieh Ho's time. They are not dissimilar from guidelines laid down for judging paintings by a secretary of the French Academy in 1680.

During the T'ang dynasty (618–906) China came into increasingly close trading

6 a camel carved in limestone, one of 12 animals which line the Sacred Way leading to the tomb of Ming Emperor Yung-lo. During the next dynasty, the Ch'ing, the production of porcelain in the Imperial factories attained new heights of perfection; this vase, **7,** depicts a scene from everyday life. **8** a lady of the T'ang period, made of fired terracotta, of the type which often accompanied the dead to their tombs as companions in the after life.

contact with the outside world. Mosques and even Christian churches were built in Ch'ang-an, the T'ang capital. Foreign cultural influences were assimilated and these enriched Chinese art. T'ang craftsmanship ranged from imaginative filigree work to ornate sarcophagi, from finely carved ivories to masterpieces of metalwork in gold, silver and bronze. Chinese painters caught the spirit of affluence and optimism which surrounded them. They painted plump, stately women of the T'ang court grouped together to pursue respectable domestic activities such as silkmaking or, perhaps, more frivolously, to while away their time playing games.

In the eighth century, a dynamic school of Buddhist painting emerged under the leadership of Wu Tao-Tzu. His temple

9

murals revealed ecstatic visions of gods and goddesses in paradise, with a touch of Indian sensuality and rhythm. No bigot, Wu Tao-Tzu also painted portraits of Confucius and Lao Tzu (the traditional founder of Taoism). All his paintings were later destroyed in a great purge of the Buddhists in 843, but other artists imitated his work.

Between the end of the T'ang dynasty and the end of the Sung (960–1279), artists developed 'mountain and water' landscapes on Buddhist-Taoist themes. They painted saints, sages and immortals meditating in remote hermitages on inaccessible mountains. Colour, shape and space were meticulously arranged. A mood of peaceful simplicity pervades their works, which have a deep mystical significance.

Chinese porcelain led the world in its beauty of shape and colour during the Sung dynasty and many varieties were produced. *Celadon* ware, much prized outside China, was the colour of leaf or bluish green. Nervous Arab rulers liked to possess it because they believed that it cracked, or changed colour, if brought into contact with poison. *Lung-Ch'üan* ware was light grey, but burnt yellowish when fired in the kiln. *Crackle* (cracking which occurs in firing because the glaze shrinks more than the body) came to be prized for its decorative effect, and was often deliberately induced. A finer, secondary crackle was developed too.

Disaster came to China in 1279 when the Mongols swept down from the north and established the Yüan dynasty in Peking. Many Chinese scholars fled the court and retired into seclusion to devote their days to painting and literature. In iso-

lation, the painters tended to develop individual styles – a new development in China's conservative art. Their broad aesthetic interests led to a closer relationship between poetry, calligraphy and painting. Some scholar-artists, using delicate brush strokes, incorporated their poems into their paintings.

Gentlemen-artists continued to paint during the time of the Ming dynasty, which replaced Mongol rule in 1368. Their artistic interest spread to architecture, garden design and art collecting. Professional painters at the Ming court, however, were forced to observe academic rules that inhibited the creativeness of their works. They sought to compensate for this by using brilliant colours and creating decorative forms.

Porcelain and jade

During the Ming dynasty porcelain became much more colourful. The Ming 'blue and white' (glazed porcelain with blue decoration), imitated in Japan, Persia and southeastern Asia, inspired the porcelain of Delf. The Chinese produced vast quantities of Ming porcelain, much of which they exported. In 1643, nearly 130,000 pieces of porcelain, mostly from one manufacturing centre, were shipped to the Netherlands alone. Jade lost its ritual significance, but was increasingly valued for its pleasing appearance, and jade work reached a high peak of craftsmanship.

In 1644, the Chinese Ming dynasty fell, to be replaced by the Ch'ing (Manchurian) dynasty, which lasted until 1912. Again, artists fled from the foreign court; some retired, some became monks. The Ch'ing

emperors valued Chinese culture and pursued conservative policies in order to preserve it. Some of the emperors themselves became artists. The dilettante emperor Ch'ien-lung (reigned 1736–96) built up a vast art collection. Eight thousand of his paintings survive in the Palace Museum of Formosa. He invited an Italian Jesuit, Joseph Castiglione (an accomplished artist) to his court, who took the title and name Privy Councillor Lang Shih-ning. Through Castiglione, characteristics of European painting, such as perspective and shading, came into Chinese art. But the artist-emperor ruled that these characteristics were interesting as craftsmanship rather than true art, and Castiglione's influence did not last. Most painters in Ch'ing times took inspiration from the past and tried to interpret and re-create the styles of old masters. They cared little for their subject matter, but placed great emphasis on techniques.

The Ch'ing emperors patronized the ceramics industry, and their officials took a hand in its management. Vast quantities of Ch'ing porcelain were produced in brilliant colours. Simple designs, often of flowers and birds, decorated early Ch'ing porcelain. Later, these were replaced by landscapes, scenes from everyday life, or illustrations to stories. Ch'ing lacquer work was also produced in factories controlled by the emperors. Lacquered wood chests and cupboards, often inlaid with jade, mother-of-pearl, or semiprecious stones, became highly popular among wealthy Europeans.

Painting in present-day China is either in traditional style, full of vitality and originality, or is Western-inspired.

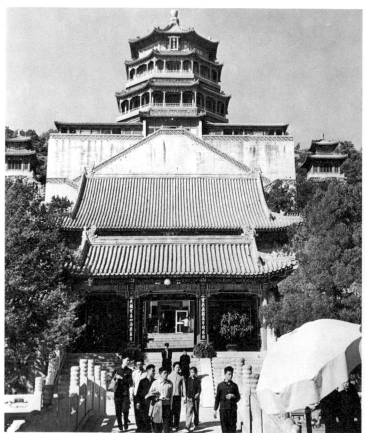

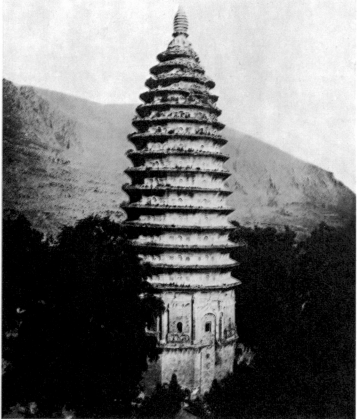

Left, the Summer Palace Pai Yun Tien was built outside Peking by the Dowager Empress Tzu-hsi of the Ch'ing dynasty. She used the money raised for the purpose of forming a navy, and was much condemned for her extravagance. *Right,* the earliest surviving Chinese pagoda, a 12-sided stone tower in Honan, dates back to A D 520. This form of architecture developed from the Indian *stupa,* which housed sacred Buddhist relics.

The art of Japan

Expert borrowers, the artists and craftsmen of Japan transformed China's art forms into a distinctive style of their own. Silk, swords and ceramics were among the media they worked with skill.

Key Periods in Japanese Art

Prehistoricuntil A D	552
(Jomon and Yayoi)	
AsukaA D	552–646
Nara	710–794
Heian	794–1185
Kamakura	1185–1392
Muromachi	1378–1573
Moyama	1573–1615
Edo or Tokugawa	1615–1867

ALL JAPANESE arts and crafts are related to each other, and all are intricately bound up with the national religion of Shinto, or with Buddhism, which entered Japan from China in about the sixth century A D. Japan's artists have always stressed the importance of design and had a lively appreciation of colour and an eye for dramatic aspects of the passing scene.

Practically the whole of Japanese art derives at least partly from Chinese or Korean culture. The exceptions to the general rule are the earliest Japanese sculpture, which may be national in inspiration, and the later art, much of which incorporates Western ideas and techniques. But although so much of Japan's culture was borrowed, Japanese artists revitalized what they took, transmuting it into new, essentially Japanese forms. An intense feeling for nature – the essence of Shinto – permeates all Japan's art.

The characteristic expression of Japanese art is through painting and prints, executed almost exclusively in water-colours or ink. Other important forms of art include architecture, sculpture, ceramics, textiles, lacquer-work and metalwork. Swords, kimonos, theatre and temple masks, dress fasteners and tomb posts have all been developed into highly complex art forms by the Japanese.

The oldest surviving Japanese works of art are crude but impressive clay figures sculpted in the middle or late *Jomon* (rope-pattern) period, between c. 3000 B C and 100 B C. These bizarre, barely human figures were probably first made as fertility symbols. Many represent pregnant women, and it is likely that men in ancient Japan prayed to them, begging that their wives might have many sons. The figures vary between about two and 12 inches in height. The earliest of them were crudely decorated, perhaps by pressing straw or matting against the wet clay. Most of these figures were probably the private property of hunters and fisher-folk of Stone-Age Japan. It is likely that their owners hung them from the tent-like roofs of their houses, which were no more than holes dug in the ground.

A new pattern of sculpture, *Haniwa* (circle of clay) figures, flourished during

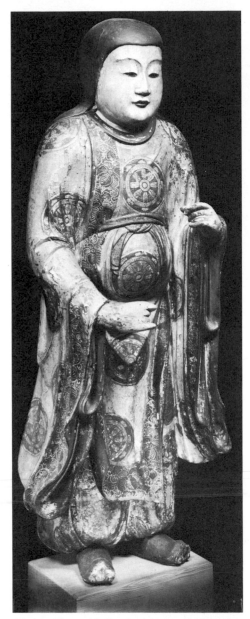
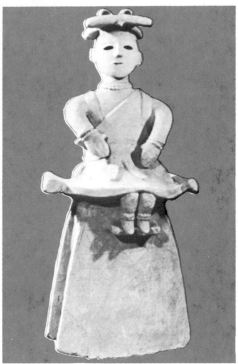
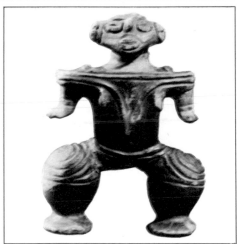
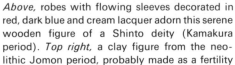

Above, robes with flowing sleeves decorated in red, dark blue and cream lacquer adorn this serene wooden figure of a Shinto deity (Kamakura period). *Top right*, a clay figure from the neolithic Jomon period, probably made as a fertility

the third and fourth centuries A D. The more interesting Haniwa figures represent people, animals, houses, furniture and personal possessions. These clay figures are so named because they were set in concentric circles in burial mounds. Craftsmen made them hastily on the death of important people. The figures are hollow and stand between 20 and 40 inches high. They have holes and slits for mouth and eyes, which give them a piercing, ghost-like intensity. The Haniwa figures are essentially Japanese, but the funerary purpose for which they were used suggests that even at this early stage Japan was influenced by the culture of China,

symbol. A crude attempt at decoration was made by pressing straw against the wet clay. *Above right*, this ghost-like *Haniwa* sculpture was one of the many human and animal figures erected in circles round burial mounds in the Yayoi period.

which dominated Japanese art until very recent times. There is a Japanese legend, however, that Haniwa figures were originally made as life-saving substitutes for royal servants, and were used in a modification of the custom that when an emperor or empress died the servants were buried alive with their royal master or mistress, to wait on them for ever.

When Buddhism came to Japan from China in the sixth century A D, it complemented the native religion of Shinto, rather than replaced it. Along with Buddhist missionaries came Chinese and Korean craftsmen who taught the Japanese new forms and techniques.

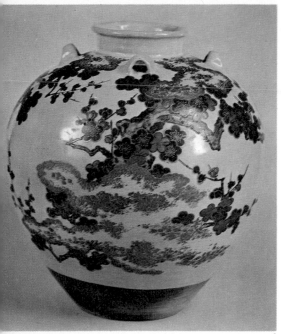

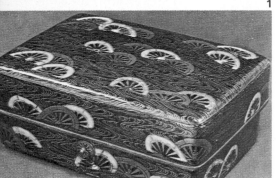

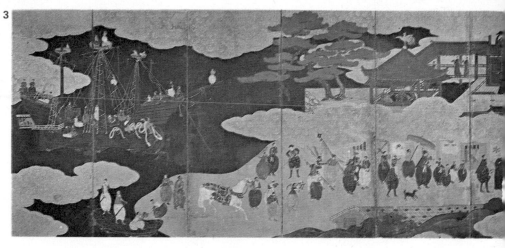

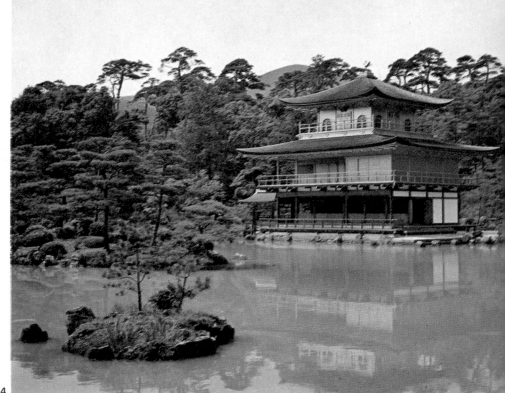

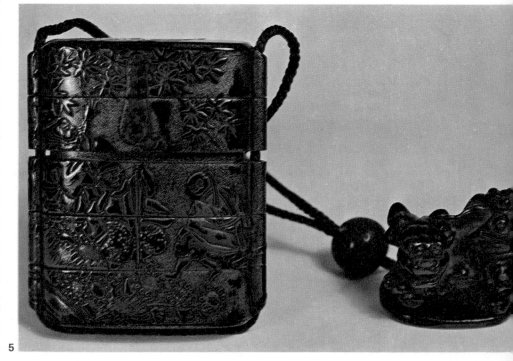

Japanese sculptors began to work in wood, clay lacquer, dry lacquer and bronze, producing mostly statues of the Buddha or his disciples. Always quick to learn new techniques, the Japanese produced some of the best Buddhist sculpture.

While the Chinese usually regarded sculptors as merely craftsmen, the Japanese honoured them as artists. *Ateliers* (artists' studios) grew up, where outstanding sculptors supervised their students. Images were made in separate parts, and assembled by the students for completion by the master.

Although most Japanese sculpture is Buddhist, a powerful portrait sculpture, based on the Shinto religion, flourished during the period of the Kamakura *shoguns,* or military commanders (1185–1333). Generally, however, Japanese sculpture began to decline from the twelfth century.

In architecture, the coming of Chinese culture into Japan brought a fairly advanced style of temple construction. Horyuji Temple, near Nara, is the best preserved example. It was built on the beam and pillar principle, and has screening walls that are non-structural. Like all traditional Japanese building it was constructed mainly of wood. Horyuji was first built in about AD 607 and reconstructed in about 700, by which time more than 500 Buddhist shrines, monasteries and temples had been built. Horyuji Temple is believed to be the world's oldest existing wooden building. Although temples built after Horyuji were bigger and more elaborate, they were constructed

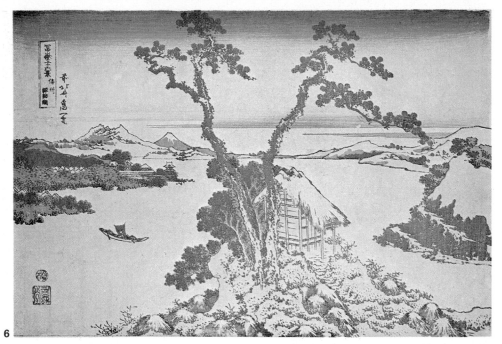

6

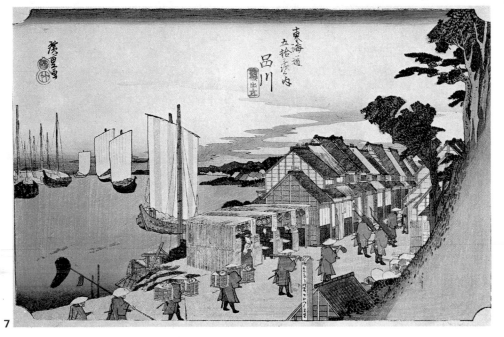

7

tea ceremony – an art in itself – became popular and also influenced the design of house interiors. Other characteristics of Japanese architecture introduced about this time were *tokonoma* (alcoves) and *shoji* (sliding paper doors).

During the Kamakura period, Japanese craftsmen developed ceramic ware, following the superb example of China under the Sung dynasty (ended 1279). Japanese porcelain has never equalled that of China in quality, but it has infinitely more variety. In the seventeenth century, Japanese potters produced many beautiful works of porcelain, their special achievement being coloured, treacly glazes. Much of this porcelain was produced for the tea ceremony.

The oldest existing Japanese paintings, dating from the sixth century, are Buddhist wall-paintings and scrolls in the Chinese style. Zen Buddhist black and white ink sketches, simply but skilfully drawn, were also based on Chinese forms, and these became very popular. In time, however, the themes that painters chose became more and more secular.

Painting reached a high peak during the Kamakura period when, having absorbed Chinese tradition, artists struck new, essentially Japanese styles. At this time there were close links between the visual arts and literature. Rich, varied and colourful scroll-paintings on silk, called *e-makimono,* gave visual representations of literary themes. Most of these scrolls were painted between 898 and 1333.

Strip cartoons

At first illustrations were provided to accompany the text, or the artist displayed his calligraphic skill with delicately written captions to the pictures. Later the full flowering of scroll technique led to the total elimination of the written word. As the scroll was unrolled, so was the story, vivid scenes succeeding one another so that the viewer could 'read' them as clearly as a book. This was probably the most sophisticated and charming form of what we know today as the strip-cartoon technique. But while the modern cartoon artist bases his technique on simple drawing and the elimination of detail, the scroll artists of the Kamakura period revelled in exquisite little pictures, rich in colour and imagery, with the whole range of emotions – humour, violence, sympathy and at times a cruel caricature – entrancing and absorbing the viewer.

In Japan, art has always tended to impinge on the more mundane areas of life. Objects which in other countries have been manufactured merely for their utility, have given Japanese craftsmen scope to develop their artistry. In particular they have excelled in *tsuba* (sword-guards) and *inro* and *netsuke* (men's dress accoutrements). Exquisite craftwork in a variety of forms was produced during the Tokugawa period (1603–1867).

Japanese craftsmen took a delight in swords and sword furniture generally, particularly tsuba, some of which were as delicately made as jewellery. Aristocrats often exchanged tsuba as gifts, and many were never actually fitted to sword blades.

1 A delicate tracery of branches and flowers in gold enamel decorates this vase of the early Edo period, which is purely Japanese in style. Free from Chinese influence, too, is this fine lacquer cosmetic box of the Heian period, **2**, inlaid with mother-of-pearl on a gold, silver and black background. **3** Travellers from the West inspired tremendous interest after the arrival of the Jesuits in 1542. This early Edo screen of the type known as *Namban Byobu* ('screens of the southern barbarians') depicts Portuguese merchants disembarking bearing strange wares from overseas. **4** A golden pavilion built to gratify the taste of Yoshimitsu, a shogun

(military commander) of the Muromachi period, graces a delightful garden in Kyoto. Later it was converted into a Zen Buddhist temple. The Japanese were superb craftsmen and lavished their artistry on the most prosaic objects. **5** A man carried this *inro* (seal container), *left,* attached to his sash by an intricately carved *netsuke, right,* in the shape of a lion. Art reached the ordinary people with the adoption of the colour print from China in the eighteenth century. **6** One of the *Thirty-six Views of Fuji,* by Hokusai Katsushika, who influenced Gauguin and Van Gogh. **7** One of the *Fifty-three Stations of the Tokaido Road* by Hiroshige Ando.

on the same basic principles.

In ancient Japan, the capital city changed whenever an emperor died, because it was thought that his death polluted the area of the court. One such change occurred in 710 when the new city of Nara, built in the Chinese style, became the capital. This occurred at about the time Horyuji Temple was rebuilt. It was followed by a great burst of architectural activity. As part of the general Chinese cultural influence of the time, the

most typical shape of pagoda was introduced into Japan.

From 794, religious architecture ceased to dominate, and *Shindenzukuri* (the architectural style of the nobility) came into being. After about 1185, architecture became less Chinese in style. Simpler houses were built for the warrior class. Shelves and niches were added to the normally plain interiors of houses, so that paintings and other works of art could be conveniently displayed. The elaborate

Above, not only the oldest temple in Japan, but the oldest wooden building in the world, Horyuji Temple was built in the Asuka period by Prince Shotoku. *Right,* sword guards like these, complete with fierce warriors and animals, were often exchanged as gifts by rich aristocrats.

Inro were small ornamental flat lacquer-work cases, which men hung from the sashes of their kimonos by silken cords. The word *inro* means seal-containers, and they were originally worn to contain the personal seals of the wearer, ready for use. Later, inro made with several compart-ments were used to contain things which a Western-clad man might carry in his pockets – medicines, sweets and tobacco, for example. (Both men and women took to smoking when the Portuguese introduced the habit in the sixteenth century.) Inro were attached to the sash by *netsuke* – miniature works of art intricately carved in wood, bamboo, ivory, bone or horn, or wrought in metal. Netsuke took a variety of forms; rats, wrestlers, gods, demons, lucky charms, masks – all these served as subjects for the craftsman's art. Painters, swordmakers, woodcarvers and other artist-craftsmen found the making of netsuke figures a profitable sideline. Some craftsmen achieved marvellous results, carving, for example, 24 Chinese stories inside a two-inch-high netsuke in the shape of a bamboo shoot.

'Unsurpassed under heaven'

Each form of Japanese art tends to impinge upon other forms, giving the arts a co-hesive quality. As literature provided themes for the scroll-paintings, so the theatre provided scope for the develop-ment of mask-making into a form of art. Several stylized masks were worn by performers in each Nō play (a highly con-ventionalized combination of dancing, chanting and music). Nō plays reached their peak in the fifteenth century. The masks expressed various emotions: kind-ness, cruelty, love, fury, passion, idiocy

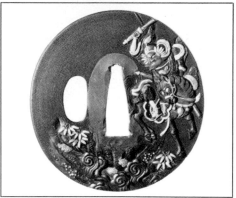

and so on. Mask-making became the specialized craft of a number of families, who passed the profession on from father to son, claiming that their work was 'un-surpassed under heaven'. Masks were also used in other forms of theatre such as *kyogen* (comic interludes in Kabuki drama) and *kagura* (Shinto shrine and temple dances).

The idea of the colour print also came from China, but Japanese artists gave it an entirely new form. Between 1740 and 1890 they developed it into a vigorous and popular art that portrayed everyday life, the theatre, geishas and courtesans, and also the make-believe world of monsters and ghosts. Vast numbers of prints were stamped from blocks and sold cheaply; for the first time art was identified with the common people rather than with the court and the privileged classes. The sedate, respectable works of the scroll painters gave way to the energetic, intensely alive art of the masses. Despised by the tradi-tional patrons of art, the colour prints were at first produced to illustrate the new popular literature read by the rising commercial classes. Later, they were eagerly bought to decorate the walls of even the humblest houses. Many of the prints were of the kind called *ukiyo-ye* (pictures of the passing scene).

The early prints were stamped in black

from heavy wood blocks, which were cut away so that the lines stood out in relief. In time, colour was added. The black and white proofs were hand-painted, and later several blocks were used to give multi-coloured prints.

Hishikawa Moronobu (1625–1694) largely began the new art, producing lively woodcuts for book illustrations. Many of his prints show stockily built women, often in compromising situations. Hishikawa Moronobu's pupil, Torii Kiyonobu (1664–1729) and his son Torii Kiyomasu (1706–63), developed the public's craze for dramatic prints of actors, and produced posters for the Kabuki theatre. These prints and posters remained popular until the end of the nineteenth century.

Okumura Masanobu (1685–1764) por-trayed pretty but rather chubby girls in long kimonos, adding pink and green to the black of earlier prints. Suzuki Harunobu (1725–70), however, was pro-bably the originator of the polychrome print, which had as many as ten colours. His female figures were slimmer, more delicate than those of earlier print artists. He grouped them in the interesting settings of the world they lived in.

The print artist who really painted women to the greatest degree of elegance was Kitagawa Utamaro (1753–1806). He drew inspiration for his work by living in the *Yoshiwara* – the courtesans' sector of Edo (present-day Tokyo). Kitagawa Utamaro tended to idealize his women, but he also set them against realistic backgrounds, portraying them surrounded by admiring customers.

A prolific eccentric

During the year 1794–5 Toshusai Sharuku, who may once have been an actor himself, produced prints caricaturing actors, show-ing them often masked, playing women's parts in plays. The starkness of his prints offended the public, who resented having their favourite actors parodied, and in his lifetime Toshusai Sharuku's works re-mained unsold.

One of the most prolific, dedicated and eccentric artists of all time, Hokusai Katsushika (1760–1849) is believed to have produced more than 30,000 prints, before his frenzied and unhappy life came to an end at the age of nearly 90. His prints, which influenced Paul Gauguin, Vincent van Gogh, and other European painters, concentrated on nature and superb land-scapes. His works include *Thirty-six Views of Fuji, A Hundred Views of Fuji* and *Famous Bridges and Waterfalls.* Hiroshige Ando (1797–1858) was a master of land-scapes, whose prints influenced James McNeill Whistler. They include *Fifty-three Stations of the Tokaido Road,* and *A Hundred Views of Edo.*

Western influences, which first pene-trated Japan in the late sixteenth century, were almost entirely excluded by the government in the mid-seventeenth. Western ideas again entered Japan after 1868, with unhappy effects on the arts. The Japanese are currently developing new styles, achieving a more harmonious blending of eastern and western inspiration.

Art reflects a faith

Many countries contributed to the splendour of the art of Islam. Intimately bound up with a religious faith shared by millions, its supreme expression is in the architecture of the mosques of the Arab world.

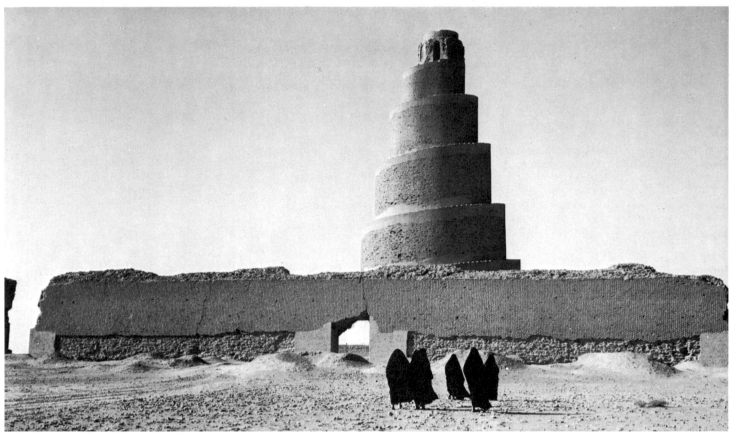

ISLAMIC ART is intimately bound up with the spirit of the Islamic religion and it largely centres on the Moslem place of worship, the mosque. It follows that the main form of Islamic art is architecture. The Moslems have hardly any sculpture – a result of the discouragement of image-making by strict Moslems. The Arab tradition of painting came almost to an end early in the eighth century when religious principles began to be more strictly applied. East of the Arab countries, Moslems observed the ban on image-making in religious, but not in secular, art. The Persians perfected a style of miniature-painting, outstanding in beauty of colour and form, which inspired the Mughal and Rajput painters of India.

The art of Islam is a combined product of many countries. Apart from architecture and painting, Moslem artists and craftsmen have applied their talents to carpet- and rug-making, textiles, metalworking, glassware, wood-carving, plasterwork, bookbinding and illustration, and ceramics – particularly tile-making. To a large extent even these arts and crafts have centred round the mosque and its adornment.

Islam came into being when Mohammed fled from Mecca to Medina and was accepted by the Medinans as their leader, This incident, called the *Hegira,* marked the beginning of the Moslem era and coincided with the Christian year A D 622.

Mohammed at first prayed to Allah (God) by prostrating himself in the direction of Jerusalem. Later, he turned to face the Kaaba, a pre-Moslem, simply built shrine in Mecca. From that time onwards Moslems have always turned towards Mecca to pray. These happenings had great significance in the development of Islamic architecture.

Churches into mosques

The early Moslems were in spirit tent-dwelling desert nomads, and they had no architecture worthy of the name. When they expanded outside Arabia they took over not only the architectural styles of the peoples they conquered, but also some of their religious buildings. In Syria, for example, which was seized from the Byzantine Empire shortly after Mohammed's death, the Moslems usually converted into mosques one or more of the Christian churches in each captured town. They had no ambition to establish great temples to the glory of God, rather they wanted simple houses of prayer for the faithful.

The conversion of a church into a mosque posed problems. For example, when the Great Church at Hama, in Syria, was converted in 636–7, the Christian congregation, as was normal in churches, looked eastwards to face the altar. But the Moslems had to face south, and to do this they simply converted the western entrances into windows and cut new

Modelled like a Babylonian temple tower, this spiralling minaret is part of the Great Mosque of al-Mutawakkil. Founded in 836 in ancient Samarra, Iraq, it is the largest mosque ever built.

entrances into the northern wall. Thus they prayed *across* the aisles, facing Mecca. In Persia too, conquered shortly after Syria, the Moslems converted existing buildings into mosques, using impartially Zoroastrian fire temples, or *apadanas* (halls of royal palaces). But in Iraq, where they established new towns, such as Baghdad, they found no suitable buildings and had to construct their own. Their early mosques were extremely simple. At Kufa, for example, they marked out a square, enclosed it by a ditch and built a *zulla* (covered colonnade) along the side nearest to Mecca, using marble from near-by buildings. This, like oasis palms, shielded worshippers from the burning sun.

For a thousand years after Mohammed's time Islam continued to expand. Wherever they went, the Moslems set up mosques, either converting existing buildings or constructing new buildings in a variety of borrowed styles. Yet all their buildings had an architectural unity. A mosque could never be mistaken for any other kind of building. Similarly, when the Moslems came to build *madrasahs* (religious colleges), domed tombs, palaces and other buildings, these bore the characteristic

and unmistakable stamp of Islam.

The typical mosque that emerged was basically a rectangular courtyard, called a *haram,* with a fountain or water-basin in the centre, where worshippers could ritually purify themselves before prayer. A colonnade roofed with cupolas often surrounded this courtyard. On the side nearest to Mecca was the house of prayer, almost devoid of furniture, but often richly carpeted. Viewed from the outside, the most distinctive feature of a mosque is its *minarets* (high towers) and it is normally from the top of one of these minarets that the *muezzin* (crier) calls the faithful to prayer five times each day, following the original tradition of Medina. Yet minarets are not essential to the mosque. Many small mosques have no minarets, but most have one or more, four being the most common. Many minarets have a balcony near the top, built to allow the muezzin to cry his message in all directions.

The house of prayer almost always has a domed roof, often onion shaped. This is supported either by solid walls or, more typically, by arcades. Large mosques have interior arcades, part functional, part decorative. Moslem architects used traditional, semicircular arches to carry heavy loads, but evolved new styles of arch for decorative effect, principally horseshoe, four-centred and pointed arches. They created *stalactite* vaulting in which a number of arch-shaped vaulting cells cover the inner linings of the arches. The decorated arches and stalactite vaulting quickly became typical features of Islamic architecture.

Decorated tiles

The Moslems early developed the craft of glazed tile-making, and many mosque interiors are surfaced with tiles or mosaics of outstanding beauty. Functionally, the tiles have a cooling effect, a useful property, because most mosques are situated in warm or hot climates. The general ban on representations of human or animal figures led Arab artists to experiment with geometrical designs, or to create stylized forms of decoration based on leaves, shoots and tendrils of plants. The cursive Arabic script, intrinsically beautiful, offered another field for experiment. Large plaques often decorate mosque walls and the pillars of internal arcades. These plaques are beautifully inscribed with either the names of Allah, Mohammed, or the first four caliphs, or with quotations from the Koran. The older, rectilinear, form of the Arabic script called *Kufic,* after the city of Kufa in Iraq, was frequently used, and this harmonized particularly well with the simplicity of spirit of early Islam. The geometrical and plant forms and the Kufic or cursive script provided the basic motifs for the ornamental tiles.

In the wall of the mosque nearest to Mecca (the *qibla*) is the *mihrab,* a niche in the wall, which is of great religious significance. From the mihrab an *imam* leads the congregation in prayer, which for Moslems involves a number of ritually set physical movements of the body. Hence the carpeted floor is more appropriate than

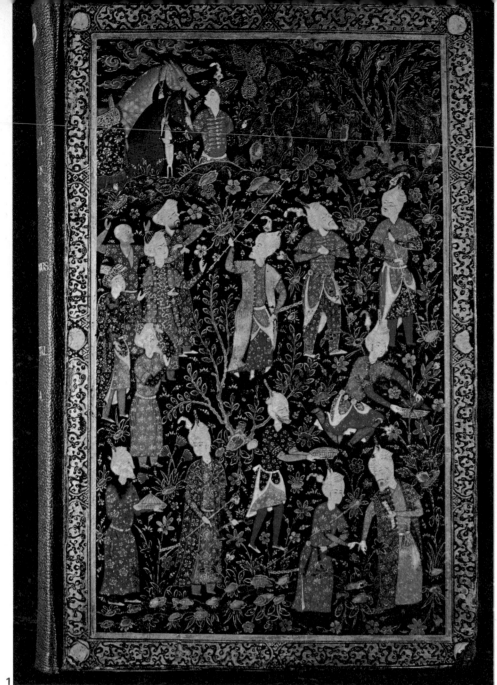

1

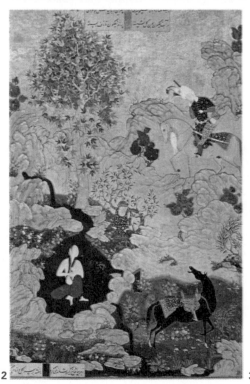

2

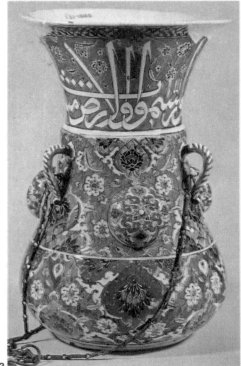

3

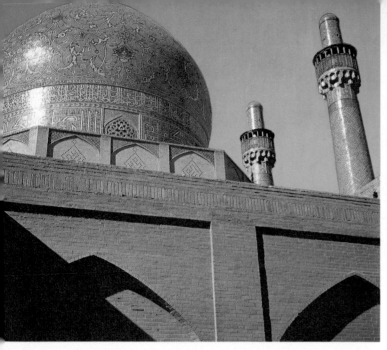

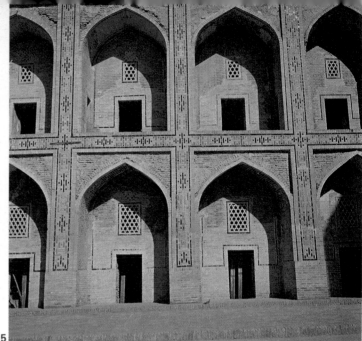
5

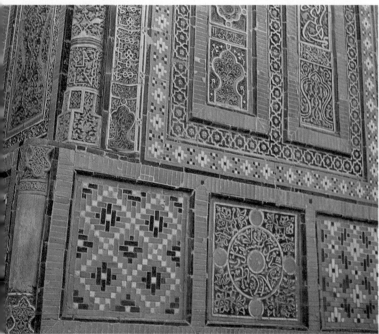

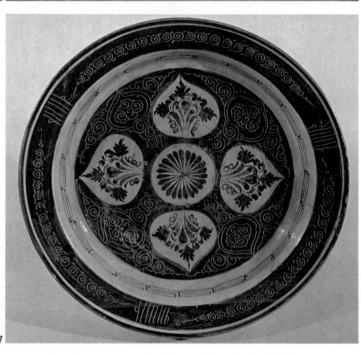
7

1 Clear, jewel-like colours dazzle the eyes with their radiance in this lacquer-painted book-binding of the sixteenth century from Tabriz, Iran. In that country, depiction of the human form, forbidden by strict Moslem code, was allowed in secular art. Persian miniature-painters of the sixteenth century excelled in delicate depictions of themes from Persian literature. **2** The hero Khusraw spies the princess Shirin bathing, in an illustration from the *Khamsa,* or Five Poems, of Nizami. **3** Boldly designed and coloured, this sixteenth-century ceramic lamp was made for the most important mosque of Istanbul – the Sulaymaniyeh Çami. Dome and minarets of the Chaharbagh Mosque in Isfahan, Iran, gleam in the sun, **4.** Decorated in magnificent blue mosaic patterns traditional in Islamic architecture, such houses of prayer are to be seen all over the Moslem world. **5** In Bukhara in the USSR the courtyard of a *madrasah* (religious college) exhibits many characteristics of mosque architecture. Among the arts perfected by the Moslems was that of tile-making. Flowing arabesque, abstract and floral designs adorn the façades of Shakh-i-Zinda **6** (detail), a complex of tombs near Samarkand. Abstract design elements figure too in fifteenth-century ceramic ware from Iran, **7.**

chairs or benches would be. To the right of the mihrab is the *minbar* (pulpit) from which the sermon is preached on Fridays, the holy day.

Left of the mihrab is a railed platform, the *dikka,* supporting the *maksara* – traditionally the seat of honour for the caliph. The original purpose of the dikka was to separate the caliph from would-be attackers who might mingle with the congregation, because three of the first caliphs were assassinated, two actually in a mosque. Mosques were normally lit by lamps or candelabra which enhanced the beauty of the arcaded interiors but otherwise had no special religious significance.

The oldest existing mosque, the Dome of the Rock, in Jerusalem, built 687–91,

resembles Byzantine buildings such as the church of San Vitale in Ravenna or St Sergius in Constantinople (now Istanbul). It was built on a rock that protrudes through the floor and is believed to be the spot from which Mohammed ascended to heaven. The richly gilded dome of this mosque rests on a drum having 16 windows. This structure is supported by 4 piers and 12 columns arranged in a circle to surround the rock. A comparatively low octagonal structure forms the external wall of the mosque, reaching to rather less than half the height of the dome. At Samarra, in Iraq, where the Moslems founded a great city in the mid ninth century, they built the largest mosque ever constructed. This was patterned on

the Dome of the Rock, but its minaret was a massive tapered spiral structure, recognizably copied from the Babylonian ziggurats.

The Great Mosque at Damascus, completed in 715, is in some respects even more Byzantine. Its interior walls are covered with beautiful mosaics in the stylized plant and geometrical patterns that became usual. Damascus, capital of the Syrian Umayyad dynasty, was soon rivalled by Cordoba, which became the capital of another branch of the Umayyads, based in Spain. In 785 the Umayyads founded a mosque at Cordoba that is to this day one of the most beautiful religious buildings in the world. The Cordoba mosque was further embellished during later centuries.

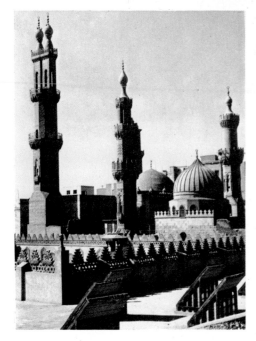

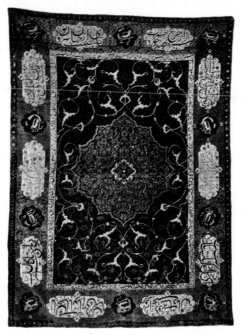

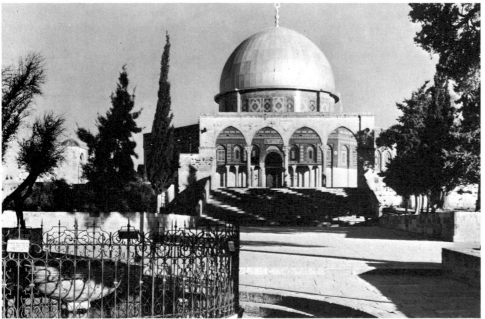

ready shrunken Abbasid caliphate it was by no means the end of the Islamic culture. Like the Turks, who had been moving into Anatolia from the eleventh century onwards, the Mongols adopted the Moslem religion with the result that Islam expanded rather than contracted. The Abbasid caliphate had hardly disappeared from Baghdad before Moslem traders took the faith eastwards to Sumatra, and during the next four centuries mosques began to appear throughout Indonesia. Within a century the Mongol rulers of Persia and Iraq had become patrons of the arts. They built stately mosques and their artists established the tradition of Persian miniature-painting, produced to illustrate the works of the poets. Tabriz, and later Shiraz and Herat (now in Afghanistan) became the chief centres of their beautiful miniatures, delightfully painted in startling colours often against a background of gold. The miniature-painters took a variety of themes, including courtly banquets and wine parties, hunting scenes, worship in the mosque, love episodes, activities of demons and Islamic legends.

The height of Islamic culture

In the second half of the fourteenth century yet another conqueror came from the east, Timur the Lame (Tamerlane), a Tartar, or Mongol Turk. His ruthless armies quickly overran India, Afghanistan, Persia and Syria. Yet even this apparent disaster proved to be a blessing for Islam, for Timur was not only a well-educated man who loved the arts, but also a devout Moslem. The Timurid period of Islamic culture that then began is symbolized by Timur's mausoleum at Samarkand. This beautiful mausoleum, called the *Gur Emir,* is reminiscent of the *ger* or portable felt tent of the Mongol nomads. It is basically a bulbous fluted dome with a ribbon tent-like decoration, supported by a tiled drum decorated in the Kufic script, resting on an octagonal surround. A marvellous age of Islamic culture reached its full flowering c. 1600 in Persia under the rule of Shah Abbas. His capital, Isfahan, became a city of unparalleled architectural beauty, so that travellers said 'Isfahan is half the world.' In Isfahan's Masjid-i-Shah (Shah Mosque), with its magnificent blue tile-work and faience mosaic, the art of the mosque reached near-perfection.

Baber, a later relative of Timur's, who seized India in 1526, set up the Mughal dynasty which gave its name to another great branch of art. Timurid-Persian art fused with native Indian art to produce the distinct Mughal style of painting and architecture – the supreme example being the Taj Mahal, the domed tomb built for Shah Jahan's wife. But Mughal art is more properly Indian than Islamic.

Although the Moslem faith continued to expand after 1600, Islam's great period in art was over. Moslem craftsmen still carry on the minor arts, producing fine metalwork, carpets, textiles and other objects in the traditional styles, but the truly remarkable achievements of Islamic art, especially in architecture and painting, lie in the past.

Above, the Dome of the Rock of Jerusalem, the earliest mosque ever built (687–91), was constructed on a rock believed to be the spot where Mohammed ascended into heaven. Another early mosque, *top left,* al-Azhar in Cairo, is a fine example of the Egyptian style of Islamic architecture. *Top right,* it must have taken much time and patience to weave the intricate design on this Persian carpet from Tabriz. The flowing Arabic script forms part of the pattern on the margins.

Its special feature is its elaborately decorated, double-storeyed mihrab, added two centuries after the mosque was built.

A remarkable aspect of Islamic art was its tendency to flourish in one area while declining in another. While Moslem culture shone in Spain it declined in Egypt. Then, in 969, the Fatimids, an Arab dynasty, established an independent caliphate based on Cairo. Their dynasty, which lasted for two centuries, took the lead in Islamic culture west of Syria. In 970 they began to build al-Azhar. This mosque, which followed the standard Arab pattern, was of massive stone construction as were most of the many other Fatimid buildings. Book-painting, in the style of Baghdad, seems to have flourished under the Fatimids, but the only surviving Fatimid paintings are on ceramic ware.

Even before the Umayyads had built their mosque in Cordoba, the Umayyad dynasty in Damascus had disappeared to be replaced by the Abbasid dynasty (750–1258), based on the new capital of Baghdad. East of Egypt and Arabia, Arab influence waned and Persian culture came increasingly to influence Islamic art. Islamic art and literature then entered its 'golden age' and Baghdad became the legendary city of the Thousand and One Nights. A slight decline set in from 1055, when the Seljuk Turks from Turkestan took the city, but a 'silver age' lasted for another two centuries until the Mongols captured Baghdad in 1258. During the whole of the Abbasid period the decorative arts flourished. Persia became the centre for crafts, including carpet-making, unsurpassed in their quality. Although human and animal motifs never appeared in mosque decoration, they became common elsewhere.

When the Mongols destroyed the al-

Sensual and holy, the art of India

Temples hewn from rock, rhythmic and vital figure studies — the inventive and joyous art of India is a 4,000-year story in which human beauty and religious faith achieve a unique harmony.

DEEP SYMBOLIC MEANING permeates the whole of Indian art, fusing the twin themes of sex and religion in harmonious combination. India (including both present-day India and Pakistan) has been one of the most fertile sources of artistic inspiration for an unbroken period of more than 2,000 years, but its earliest art treasures are at least 4,000 years old. The sub-continent has produced an amazing variety of styles in painting, sculpture and architecture, reflecting the taste of immigrant settlers whose art has been blended into the mixed culture of the country.

Rhythm and vitality

Between about 2500 BC and 1500 BC, a pre-Aryan civilization flourished at Harrapa, Mohenjo-Daro, and other cities of the Indus valley. Seals, statues, jewellery and pottery excavated from the Indus cities resemble remains from Sumerian cities, suggesting that an interchange of artistic ideas existed in earliest-known times. The bronze figurine of an impish dancing girl has the rhythm and vitality which characterized the whole of Indian sculpture for the following 3,000 years.

Little is known about art, or indeed history, in India between the disappearance of the Indus civilization and the rise of Buddhism, which flourished during the reign of King Asoka (272–232 BC). The Buddhists built huge brick *stupas* (domed monuments capped by wooden or stone umbrellas) as shrines to contain sacred relics of the Buddha and Buddhist saints. The stupas were surrounded by railed passageways round which Buddhists ceremonially trudged in devotion to the Buddha. The first stupas were probably modelled on the pattern of earlier burial mounds erected over the remains of dead chiefs and kings. The balustrade posts of an early stupa (second century BC), at Bharhut (near Allahabad), are lavishly decorated with *Yakshas* and *Yakshis* (male and female imps) and with worshippers adoring symbols of the Buddha.

But perhaps the most interesting stupa is at Sanchi, near Bhopal. The Sanchi balustrade has four finely carved gateways which illustrate stories of the Buddha from the *Jataka Tales* (a collection of about 500 popular stories of the Buddha's lives on Earth). The Sanchi sculptors had a remarkable insight into plant and animal forms. Early Buddhist sculptors never showed the Buddha in human form. They represented him instead by symbols that included wheels, alms bowls, empty thrones, footprints and sandals. But in the ornate stupa at Amaravati (completed about AD 200) sculptors caught the intensity of religious passion in some of the first carvings of the Buddha in human form.

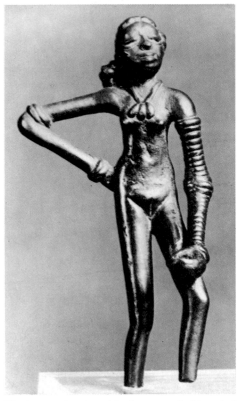

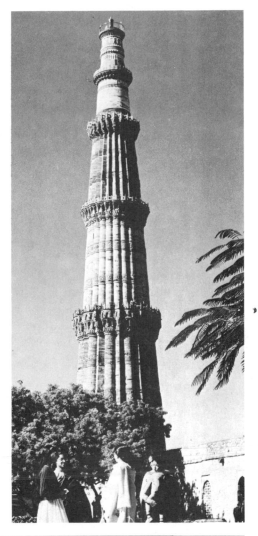

The bronze dancing girl, *above,* was fashioned at Mohenjo-Daro nearly 4,500 years ago, but her character and vitality make her appeal timeless. The Kutub Minar, *right,* in memory of a thirteenth-century Moslem conqueror's victory is built of marble and sandstone and is 238 feet high. *Below,* completed in 1654, the Taj Mahal, described as coming 'within more measurable distance of perfection than any other work of man'.

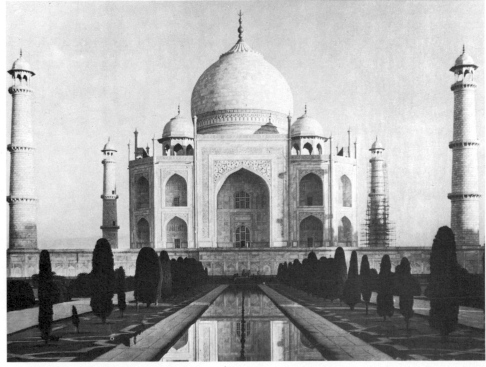

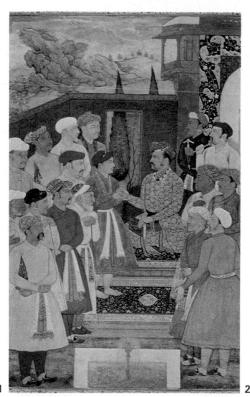

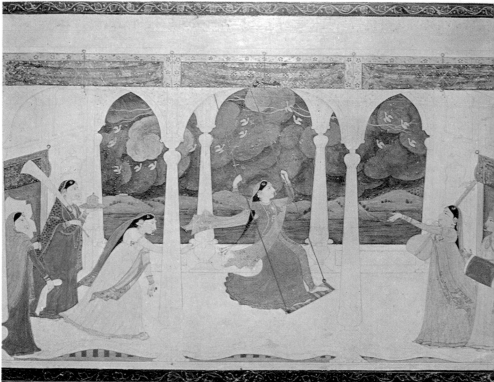

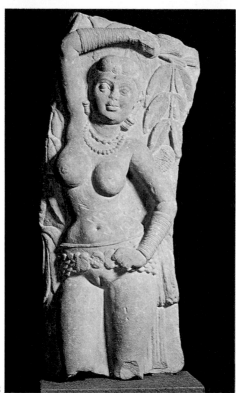

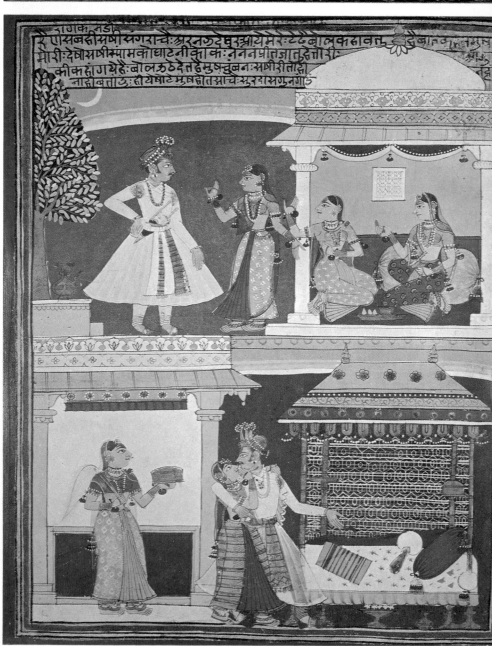

1 A Mughal miniature, *c.* 1610–14, of Emperor Jahengir receiving his son, Prince Parvis, in *durbar* gives a vivid picture of court ceremonial. 2 The young woman in *The Swing, c.* 1810, is typical of the Kangra school. The swing, an old Indian theme, symbolizes love menaced by threatening clouds. 3 The slim waist, wide hips and full bust of a *Yakshini,* or tree-goddess, exemplify the ideal of female beauty held in the second century A D. 4 *Krishna and Radha* by the Meware school, *c.* 1645, shows the god's love for his favourite. At top, they meet; below, he draws her to his couch. 5 *Torso of a Bodhisattva,* fifth century. Subtle modelling and perfect blending of stylistic figures shows the mastery of Gupta sculptors. 6 At Ellora, the great temple of Kailasanatha was hewn from vast masses of solid rock. It is a splendid example of 'rock-cut' architecture.

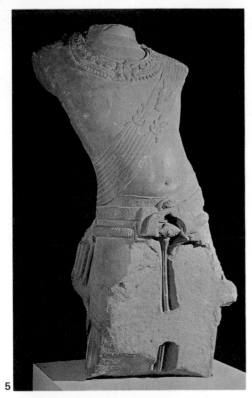

5

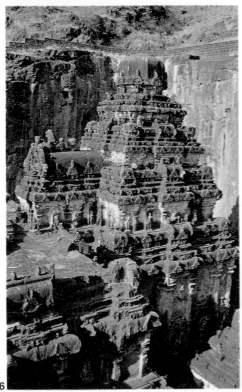

6

The Buddhists developed 'rock-cut architecture' by cutting caves into the rock face and sculpting them into monasteries complete with assembly chambers, cells and stupas. Karli and Ajanta, in Maharashtra state, are good examples of these cave-monasteries. Karli, which dates from the second century BC, is carved 124 feet into the rock. Its doorway is flanked by sensual pairs of lovers, representative of the whole of Indian temple sculpture. At Ajanta, Buddhist monks cut 28 cave-monasteries during the first seven centuries AD, and developed a flourishing school of Buddhist painting.

Simultaneously with the development of stupa architecture, new styles of sculpture emerged at Mathura and at Gandhara

in northern India. It was at one or other of these centres that sculptors produced the first images of the Buddha in conventional postures, showing him protecting, meditating, praying, preaching, warning, blessing, and so on, according to the position of his right hand. The Mathura style, which began possibly as early as the end of the first century BC, was wholly Indian, and both Jainism and Buddhism influenced its development. The Mathura sculptors produced many plaques of meditating Jain saints, but their themes were sometimes less austere. They blended the pious harmoniously with the sensual. Their Yakshis have the same seductive appeal as the Mohenjo-Dara dancing girl created more than 2,000 years before. Gandhara art was Greco-Buddhist in style and began about the first century BC as a by-product of trading links between the Roman empire and northwestern India. The Gandhara craftsmen portrayed the Buddha, bodhisattvas and various Indian deities almost in the image of Greco-Roman deities.

The earliest existing Indian paintings are at Ajanta, painted in the first seven centuries AD by Buddhist artists who worked on the interior walls of the cave-monasteries by sunlight reflected from metal mirrors. The painters took both sacred and secular subjects for their themes. Along with scenes from the Buddha's previous lives, they impartially depicted princes and beggars, coolies and peasants, ascetic saints and bejewelled courtesans.

Inspired by Buddhist artists and builders, Jains and Hindus, too, developed rock architecture. Buddhists, Jains and Hindus cut 34 adjacent cave temples into the rock at Ellora (near Ajanta) between the fifth and eighth centuries AD. But the most marvellous achievement of the rock-cutters at Ellora was the great Temple of Kailasanatha, built by the Hindus in the eighth century AD. The site of this vast temple is 164 feet long and 96 feet high. The whole structure – chambers, stairways, pillars, gateways and statues – was carved out from solid rock.

Exotic temple sculptures

The Hindus built a beautiful group of temples at Khajuraho (about 100 miles southeast of Jhansi), in the tenth and eleventh centuries. The convex temple towers taper upwards for the whole of their height (about 100 feet), so that the whole group looks like a range of miniature mountains. But the Khajuraho temples are admired not so much for their architecture as for their lavish, delectably carved erotic sculptures. Other beautiful temples, also elaborately sculptured, are the Lingaraja temple at Bhubanasar, dedicated to Siva, and the Sun Temple at Konarak, both in Orissa state.

Dravidian people of southern India built massive granite temples from the eleventh and twelfth centuries onwards. The focal points of each temple site are the intricately sculptured *gopurams* (tapered towers) that stand over the main gateways. Each temple stood at the centre of a city, and the four main streets began at the

main gateways of the temple. The great Madurai temple, built in the seventeenth century, is perhaps the most impressive of these structures. The gopuram over the south gate is covered for its entire height with sculptured figures in human form, arranged in tiers as though sitting in boxes at the theatre. The walled site of the largest Indian temple, at Srirangam is about half a mile square. Six inner walls, each topped by sculptured gopurams, enclose the inner shrine.

2,000 years of metalwork

The Tamils of southern India produced outstanding artistic metalwork in the tenth and eleventh centuries. Indian metalwork is in fact very old. The Iron Pillar, a memorial erected at Delhi about AD 400, stands more than 23 feet high. It has technological rather than artistic interest. But it provides evidence of the skill of ancient India's iron-founders and metallurgists, for no single piece of iron of such size could have been produced in Europe until the middle of the nineteenth century. Although completely exposed in a monsoon climate it remains rustless.

Small works of artistic metal-ware have been produced in India for about 2,000 years. The Tamils became specialists in producing graceful bronze figures of the four-armed Siva as Lord of the Dance, encircled in a ring of fire. In these conventional Siva bronzes, one foot mounts a crushed demon, the other swirls with body and arms in the frenzy of an ecstatic dance. Siva and other subjects of the bronzes were usually modelled in wax, which was then covered with clay. The wax was then melted off, to leave a mould into which molten metal was poured.

The Hindus cast or sculpted their gods and goddesses according to conventional basic forms. They were, however, allowed sufficient freedom to create a variety of detail within the basic conventions. The wealthy Jains added distinctive styles and techniques to India's sculpture-architecture. Their marble temples at Mount Abu, in Rajastan state, have a gayer appearance than the heavier Hindu structures. One of these, Vimala, dedicated to their first *tirthankara* (legendary teacher of a past era), is full of fascinating sculptures depicting Jain mythological scenes. Giant nude tirthankaras, carved from the rock face at Gwalior in the fifteenth century, stare impassively into the distance, remote from the affairs of this world.

In the early thirteenth century, Kutub-ud-din, a Moslem conqueror, from Afghanistan, became the first Sultan of Delhi. Surprisingly, the great Kutub Minar (238 feet), a fluted minaret of marble and sandstone completed in 1231–32, was named not after him but after a migrant from Baghdad. The early Moslems contributed practically nothing to painting and sculpture because their religion barred image-making. But they introduced mosque architecture, particularly the dome and minaret, into India. Their traditional architectural styles gradually became 'Indianized' because Hindu craftsmen constructed their buildings.

More waves of invaders passed over

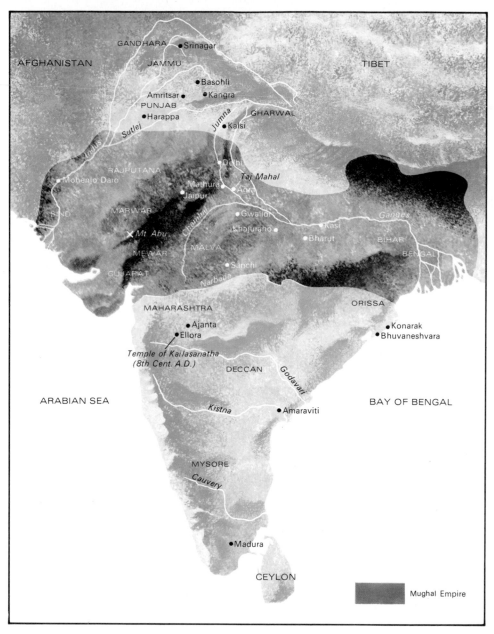

Mughal Empire

animal figures in art. Under the patronage of emperors like Akbar (ruled 1556–1605) Persian, central Asian and Indian painters developed a distinct Mughal style of painting. But European influences also crept into Mughal style, such as the halo, and sunset and cloud effects. Many miniatures were painted by more than one man. Artists painted their miniatures to please the wealthy men who paid them, and took secular rather than religious themes for their subjects. They painted innumerable portraits, and illustrated books with animal and bird pictures. When the Mughal empire began to disintegrate in the early eighteenth century, Mughal art declined.

Themes from epic, myth and music

Meanwhile, Hindu art had gained a new lease of life. Under the patronage of the princes of Rajputana, *Rajput* painters evolved a new style of miniatures, taking religious stories, myths and epics as their themes. The Rajput painters applied Mughal techniques to Hindu themes. The flirtations of the flute-playing god Krishna (conventionally blue-skinned) with the *gopis* (milkmaids) provided a fairly typical subject. The Rajput artists also looked to music for themes, and painted *Raga-Ragini* pictures to represent musical modes. Women dominate all Rajput painting. The sophisticated sensuousness of women painted by the Buddhists more than a thousand years earlier, contrasts with the Rajputs' characterless, lotus-eyed heroines whose faces showed no emotion but whose passion was conveyed by gestures and symbols.

Several schools of painting which derived from Mughal-Rajput art flourished in the Punjab and the northwest of India. Collectively they are called the *Kangra valley* School. The Kangra valley artists painted princely scenes in wonderfully glowing colours. Their women are altogether more convincing, more sophisticated, than the women of the Rajasthan painters. Kangra valley painters again remind us that Indians are the experts in the art and science of love, which they see as being of two main kinds: love in separation, and love together. In Kangra valley 'love in separation' paintings, various birds and animals represent absent mates. Lightning and storm clouds symbolize women's passionate desires. Peacocks perch on the lonely beds of fretting beauties while lightning flashes across the black sky; near-demented women brave snakes and goblins to journey through primeval jungles in search of their lovers.

By about the end of the nineteenth century the creativeness of the Mughal-Rajput schools of painting was exhausted. India's rulers thrust English education and European taste upon Indian intellectuals and artists, who consequently turned to Europe for inspiration and example. The Indo-European style that emerged in the early twentieth century was not of great merit. More recently, Indian artists have attempted to reconcile current artistic fashions of the Western world with their own deep-rooted tradition, rather than copying either, and evolve a more harmonious blend of styles.

northern India, and in 1526, Baber, a dispossessed part-Mongol Chaghatai Turkish king, established himself as *Mughal* (Mongol Moslem) emperor of India. Whereas in pre-Moslem India the Hindus had employed their architectural talent on temples, the Mughals also built splendid palaces and private tombs. Shah Jahan (ruled 1628–58) built the white marble Taj Mahal at Agra as a magnificent tomb for his most favoured wife. About 20,000 craftsmen worked on it for more than 20 years. Mughal architecture in India is decorated with beautiful calligraphy, and floral designs adapted from Italian motifs. Carved screens of alabaster or marble are special features of Mughal buildings. The Sikhs, who emerged as a separate sect in the fifteenth century, combined Hindu and Moslem ideas in both their religion and their art. The outstanding example of their architecture is the Golden Temple set in a pool at Amritsar. Built on old foundations, it was started in 1764 but not finished and gilded until the early nineteenth century.

The Mughal emperors enthusiastically supported art. Less orthodox than the earlier Moslem rulers of India, they encouraged rather than banned human and

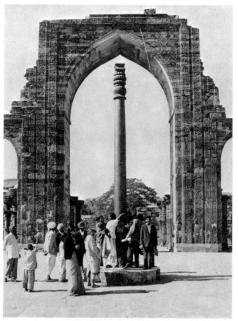

Top, the map of India shows the principal sites mentioned in the text. *Above,* Indians clasp their hands behind their backs round the famous Iron Pillar at Delhi to obtain good luck. It was cast in AD 400, but not until the nineteenth century could Europeans attempt a similar feat.

Magic and ritual shape Africa's art

Joy in life suffuses the art of Africa, affirming supernatural powers and the energy of human existence. Here these ancient cultures are enshrined, their meaning and their wisdom recorded.

UNTIL QUITE RECENTLY, it was fashionable among scholars to exclude pre-colonial Africa south of the Sahara from the study of world history. No written records existed, missionary-explorers returned with accounts of primitive and pagan practices, and their reports of social chaos – resulting largely from the disruptive slave trade – all contributed to a basic misconception. It seemed an inescapable conclusion that the desert wastes of the Sahara had sealed off Africa in historical times, and that in their isolation the Negro peoples had achieved no culture nor created any civilization. African tribal art, which lacked the true proportions of idealized classical European art, seemed crude and barbaric.

Despite the lack of written records, however, African myths and legends contain marvellous stories of past glories. The chronicles of Arab travellers in the Middle Ages give exotic descriptions of empires and kingdoms in western Africa that had all the glory and splendour of the *Arabian Nights*. From these chronicles, from the myths and from the pioneering work of archaeologists, the broad history of the rise and fall of the great West African empires has been pieced together.

Spiritual depth

The emergence of Cubism and other twentieth-century abstract art in Europe was partly inspired by African work. These art styles have helped us to appreciate African culture. We see that the distortions in African art were not evidence of the primitive and the unsophisticated, but were purposeful and part of a profoundly religious and philosophical tradition.

The sculpture of western Africa, forming the pinnacle of sub-Saharan art, covers a wide variety of forms from naturalism to abstraction, but the finest work reflects a sublime serenity, a spiritual depth and a dynamic force that stem from African tribal religion. The disregard for naturalism in much of African art, and the distorted representation of the human body, arise from the artist's belief in a 'vital force' or energy coming from God, and filling the universe and all living things. This force is the centre of all thought and action.

The agricultural peoples of western Africa had such highly advanced and deeply felt religious and philosophical beliefs that, first Moslem and later, Christian missionaries found it extremely difficult to implant new ideas and root out the old. Most of the Bantu-speaking peoples of western Africa and the Lower Congo region believed in one God who is all-powerful. Because God permeates the whole world, the Africans felt no need to

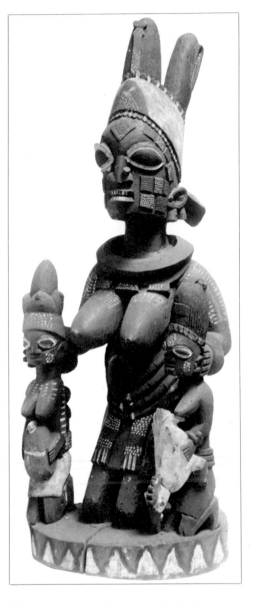

Three examples of the extraordinary variety of African tribal art: *top,* a finely worked gold badge from Ashanti in Ghana, worn by 'soul-washers' who shielded the king's soul from evil. *Above,* an amazing survival from 2,000 years ago, this terracotta head was found at Nok in Nigeria, an example of the earliest known African sculpture. *Right,* carved female figures represent devotees of the goddess of plenty and well-being.

worship him, and did not try to represent him in their art. Their worship was devoted to their ancestors, the most important being those first created by God, whose spirits were asked to intercede with God on their behalf. Artists made statues of ancestors which, if occupied by a spirit, became objects of great power, to which the farmer could address his request for a good harvest, or the barren woman her plea for children. Such statues were often adorned, sacrifices were made to them and offerings such as fresh beer and meat were placed before them.

Some artists believed that the more beautiful the statue representing an ancestor, the more likely the spirit was to occupy it. African sculptors did not strive for beauty in the European sense – their art was functional. They were trying to capture an effect which would serve a religious purpose. They concentrated, therefore, on investing their work with the

highest degree of spiritual significance; anything not essential to this purpose was excluded. The positions of the human figures are also related to their religious function. Many ancestor statues are seated in a state of repose, and are probably represented as living chiefs. A statue of an ancestor represents an attempt to make the invisible spirit visible.

Because of their belief in universal energy, it was not surprising that fertility was a vital aspect of the Africans' thought. Mother and child figures are examples of fertility. Further, breasts out of all proportion to the rest of the body, accentuated navels and swollen abdomens were common features of African statuary. The head was also, for our taste, generally too large for the body: because it was the seat of thought, the artist exaggerated it to show its true significance. The very material used by the artist reflected his belief in the vital force. Carving from

wood, the commonest material, invested in the statue the power of the living tree. Cutting the wood often became a ritual in which the artist begged the tree's forgiveness for harming it.

Although the human figure had special religious meaning, carvings of animals were important too. Animals also possessed the vital force, and the mythical ancestors of the tribe often appear as animals. Statues and other representations of animals were often stylized to convey the character of the animal: elephants and buffaloes represented strength; leopards implied ferocity; snakes were often the symbol for life and eternity; and tortoises suggested old age. Sometimes human and animal forms were combined in one figure, heightening the meaning of the object.

Many African tribes held the traditional artist in awe or even fear, regarding him as a magician or witch-doctor. Ritual and magic have a major bearing on African art. Some tribes used large, often fearsome, masks in ritual ceremonies. The masks, the forms of which had a considerable effect on the work of such European artists as Pablo Picasso and Amedeo Modigliani, represented examples of dynamic art, as opposed to the static quality of the statues.

One of the most important rituals in African life was the initiation or circumcision ceremony, through which children passed from childhood to adulthood. Masks were often used in these rites, some of which represented symbolically a state of childhood and were removed when the initiation rites were concluded. Masks were worn in ritual dances to deliver people possessed by demons. In rites of the dead, some tribes used white masks, the colour being associated with ghosts and spirits. Masks were also used by secret societies.

Fetishes and rock paintings

Magic was part of the religion of the Bantu-speaking peoples of eastern and southern Africa. The African saw the universe as a sea of forces imparting energy and he attempted to harness these forces to strengthen his own vital force. Witch-doctors made fetishes, objects that were consecrated for such purposes as protecting people against illness and misfortune. Some fetishes were crude models of people with nails driven all over the body. Sometimes fetishes were used to harm enemies. Perhaps because of hypnosis or auto-suggestion, such magic, even today, often seems extraordinarily effective. However, most fetishes were thrown away after use.

Magic permeated African art, and was even evident in rock paintings, the earliest known art in sub-Saharan Africa. On the walls of caves, the artists tried to establish a magical union between the painting and the object portrayed. Paintings often referred to hunting expeditions, war, fertility rites or the need for rain.

Such art can only survive as long as the beliefs on which it is based survive. Today, truly traditional religious art is produced in only a few areas, and the tourist who

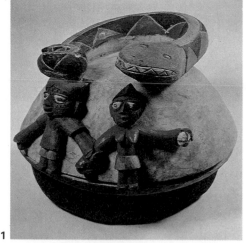

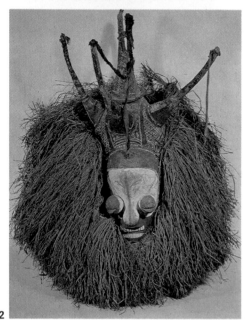

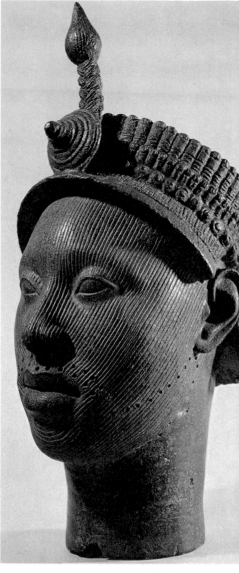

Rich in mythology, the African peoples commemorated their beliefs in their art. 1 On this carved and painted wooden bowl of the Yoruba in Nigeria, the python, symbol of life, curves protectingly over the man and woman, on whose union life depends. 2 Ritual and magic are deeply involved in African art. Masks were used in all kinds of ceremonies, in ritual dances to deliver people possessed of demons, in rites of the dead or in the important ceremonies for initiating children into the secrets of adulthood, like this one from the Bayaka of the Congo. 3 The Olokun head, discovered at Ife, Nigeria, probably represents a king. Such fine bronze heads, dating back to the thirteenth century, are still being unearthed at this sacred Yoruba city. 4 Suffering for the sake of elegance, the Ibo women of eastern Nigeria wore these gold anklets from adolescence onwards. 5 Man and woman, the life-giving force, face each other with arms entwined on this finely carved wooden headrest made by the Luba of the Congo region. 6 Ancestor figures were worshipped for their power to intercede with God the Creator. Belief in life after death is found all over Africa. This effigy of an ancestor, of wood covered with beaten brass, is from the Congo. 7 A calabash (gourd), surmounted by a bird, served to hold bones of ancestors.

collects souvenirs is unlikely to come across it. But where it does survive, this art offers striking proof of the continuity of art forms and styles. Anthropologists have discovered work made recently that is practically identical with work done a hundred years ago. The abstractions and unusual forms that characterize much of African art are the result of tradition, and represent the vision of a particular tribe or group, not of an individual artist though an individual's style is often evident.

The work of modern African artists, who are influenced by European styles, does not have a religious origin, and neither did the work of some earlier artists. The well-known Benin bronzes, many of which illustrate military themes, were made for decorative purposes under the patronage of the *Obas*, the god-like kings of Benin, in what is now south-central Nigeria. Work associated with other royal courts, such as Ashanti, Bakuba and Dahomey, served a similar decorative and generally non-religious function.

The art of the people of sub-Saharan Africa is expressed in many ways. Apart from the religious statues and masks, some tribes have constructed elegant buildings, decorated with paintings in geometric designs. Many homes are adorned by finely woven baskets and mats, as well as elegant domestic implements. Often the abstract patterns on such domestic products have considerable symbolic meaning. Pastoral tribes in some areas also produce fine leatherwork from the

4

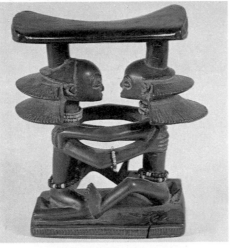

5

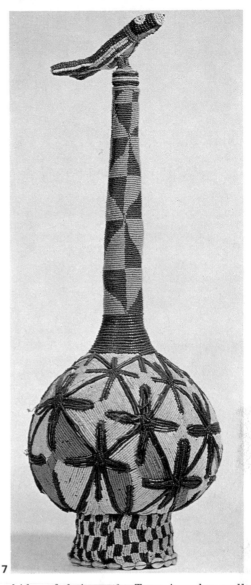

7

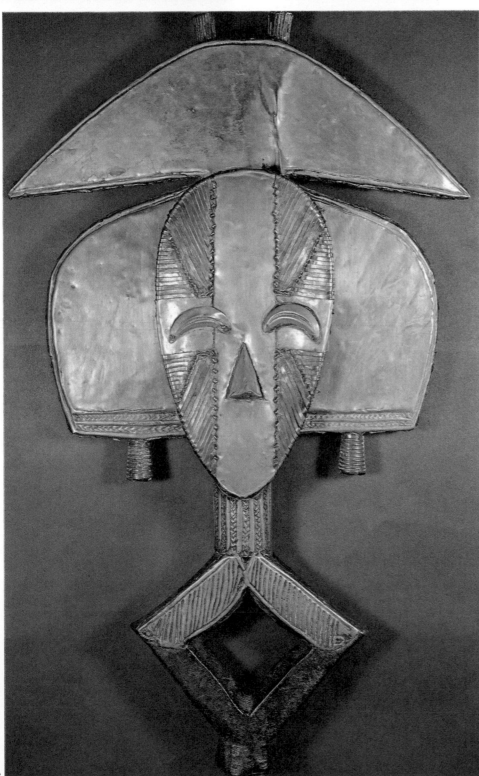

6

hides of their cattle. Towering above all other artistic achievements, however, is sculpture, which occurs most frequently in western Africa, especially Nigeria, and in the Congo Basin.

The most popular material used in sculpture is wood. Unfortunately, in a humid climate wooden objects have a short life, and their decay is generally completed by ants. For this reason few wooden objects of more than about 100 years old have survived. The wood is fashioned by an *adze,* an axe with a transverse blade, combining the functions of mallet and chisel. Fine details are supplied by knives and chisels. On completion, the artist must protect the fresh wood, and he uses several processes, including a coating of soot and grease. Many observers have commented that the tools employed in wood carving are the only primitive aspect of African art, because despite the difficulties of working the results can be incredibly fine.

Clay modelling is also popular, and is used in sculpture throughout West Africa and the Congo Basin. Perhaps the most impressive work was found at the sacred Yoruba city of Ife, in Nigeria, where magnificent terracotta heads were discovered. Terracotta-work was also found at Nok in Nigeria, and is the earliest known African sculpture. But clay objects are generally delicate and easily broken,

25

and as a result, most relics are in fragments. Metal was also found at Nok, and experts consider that iron was probably introduced to Nigeria around 400 BC. The so-called bronzes of western Africa rarely contain tin, and would be better named *cast brasses*. The main method used in metal casting was the *cire perdue* (lost wax process), whereby a rough clay form was coated with wax, and the detail was modelled upon it. The wax was then covered by another layer of clay, and the molten metal was poured in to replace the wax.

Other materials used by sculptors include ivory and bone. Stone is seldom used. The unusual and mysterious group of 750 stone statues discovered at Esie, a village in Nigeria, are in a poor state. The statues are presumably ancestor figures. The faces of the statues have been largely erased, the result perhaps of many sacrifices when blood was poured over their heads. We know from Arab chronicles that gold was often used at the courts of medieval West African empires, but presumably most of the gold objects were plundered and melted down. An expressive Ashanti mask is one of the few surviving pieces.

Scholars find it almost impossible to trace the historical development of styles and forms in African art, in the way that it is possible to do in Europe. Very little of early African art has yet been discovered. So many of the materials were perishable, so much work was destroyed in war or by zealous missionaries and so many objects were broken up by the members of the tribes themselves once their ritual purpose had been served.

The only historical record – and this is incomplete – has been traced in Nigeria. The earliest sculpture is the terracotta and polished stone which was found at sites of the Nok culture and is dated around 250 BC. The art of Nok was almost certainly not the first flowering of African sculpture, because the heads in particular are surprisingly mature. We know practically nothing about the Nok culture or the centuries that followed before the rise of Ife. From the twelfth to the fourteenth centuries, superb sculpture was made in this sacred city, perhaps the finest yet found in Africa. Historians believe that the artists of Ife must have been influenced by the much earlier Nok culture. The Ife heads and masks in bronze and terracotta are unusually lifelike and are possibly portraits.

The art of Benin

According to tradition, an Ife master visited Benin in the second half of the fourteenth century, and so a connection is established between these two cultures. The Portuguese visited Benin in 1486, and in 1686 a Dutch navigator described the city and its art in glowing terms. The finest Benin art dates from before the seventeenth century; thereafter it becomes stereotyped and imitative.

Among the great variety of bronzes are the heads of Benin rulers, and plaques showing kings waging war. Statuettes of fierce warriors and plaques of hunters have a virile tension. Animals were also used as subjects, particularly the leopard, a sacred beast of Benin. Ivory was used to carve masks and superb leopards. Benin

was finally destroyed at the end of the nineteenth century and most of the work is in museums throughout the world. Ife-Benin has attracted world-wide interest in African art, but we must remember that it is court art and differs from tribal religious art in that it is devoted to the secular as well as the religious power of the divine kings. As a result, it is unrepresentative of Nigerian and African art as a whole.

Many difficulties stand in the way of the scholar who tries to classify the thousands of styles represented in African art. The problems of dating have already been mentioned, but in addition styles overlap from group to group and even from village to village. The contrasts between naturalistic, stylized and abstract forms are difficult to establish. All three occur within most groups, and sometimes features of each are contained within one figure.

Sub-Saharan African art is sometimes referred to as Negro art to distinguish it from the art of Egypt and northern Africa. But this term implies that tribal art is much more widespread than in fact it is. Further, it is hardly evident in the work of American Negroes.

As we have already seen, tribal art owes its inspiration to deeply held religious and philosophical beliefs. These beliefs have been challenged and eroded for hundreds of years, first by the Moslems and later by the Europeans. The contemporary African artist has been brought up in a world where tribal traditions are breaking down. With justifiable pride in the past, but conscious of the dangers of tribalism in the present, he faces the problem of adapting indigenous African forms to his work.

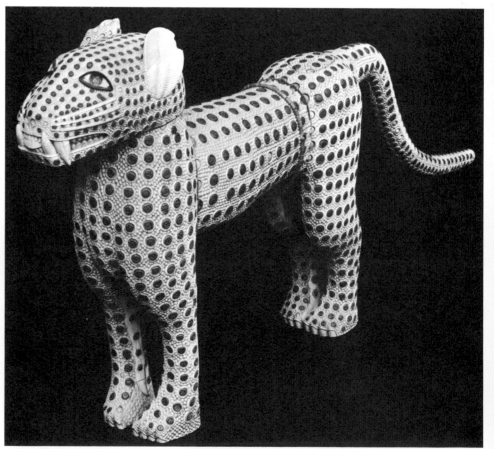

Magnificent bronze- and ivory-work, mostly decorative, was produced in Benin, in south-central Nigeria. *Left,* a sixteenth-century ivory mask representing the *Oba,* or king, of Benin, is topped with a tiara of miniature heads of Portuguese explorers. *Right,* this friendly animal carved in ivory is a leopard, a sacred beast of Benin. An African fable tells how the leopard got his spots – from a visit by his friend the Fire!

Ancient arts of Central America

The Spanish *Conquistadores* came to plunder the ancient kingdoms of Central America. Subsequent research has built up a picture of these civilizations through the richness and variety of their art.

THE ARTS of the American Indians have a certain unity of character which is more marked than among any other large group of nations. This is probably due to the fact that the people had a common origin. It is possible to draw parallels between the design styles of the Indians of British Columbia and the pre-Inca civilizations of Peru, or between the Plains Indians of the Missouri and the Forest tribes of the Amazon jungle. All the diverse peoples of America tended to use symbolic outline drawings of people and objects to build patterns which are almost a form of writing.

From the first millennium BC to AD 1500 the Central American area, from Mexico to Panama, was the scene of many specialized developments in design, though the designs developed from the techniques of weaving and pottery influenced all aspects of art. The level of civilization in the area did not determine the quality of design. We find elaborately painted pottery from Panama, made by people living in small groups of villages of a Neolithic cultural level, which rivals the magnificent painted pottery made in the most sophisticated city-states of the Maya of southern Mexico.

Paper from fig trees

However, over the whole area technical limitations conditioned the possibilities open to artists. There was no potter's wheel, so all pottery was made either by coiling rings of clay or moulding. There were only a few bronze tools made, and then only in western Mexico, so sculpture was almost entirely produced by means of stone tools. One true arch has been reported from an early Maya site, but the idea was not adopted, and for over 2,000 years, right up until the Spanish conquest in the sixteenth century, buildings were arranged with simple lintel and post construction.

In the northern half of the area, a few centuries before Christ, paper was known and used. It was made from the inner bark of young branches of a type of fig tree. This material was dried first, then laid out in several layers one over the other, soaked and then thoroughly felted by beating with wood- and stone-faced mallets. This material, known in Mexico as *amatl,* was used for painted books, which were rather like long, narrow fire screens covered with pictures telling a historical story or recounting a religious myth. Leather was also used for making books: long strips of softly tanned deer-skin were coated, like the paper, with a lime wash, which was smoothed and then painted upon with a form of lamp black made from soot, and colours, most of which were mineral. Red from the cochineal insect was also important.

Painting was perhaps the most impor-

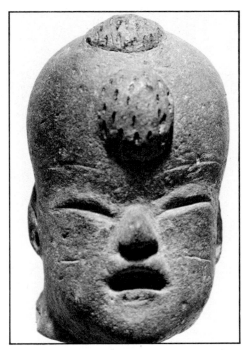

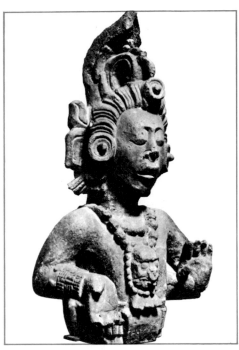

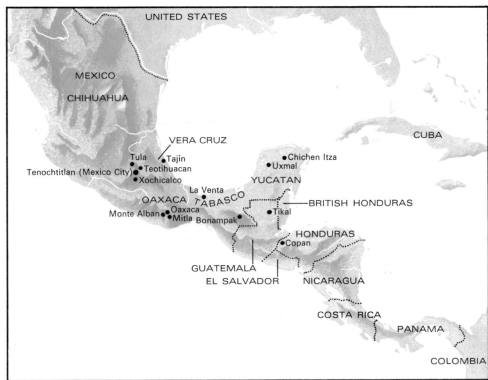

Many civilizations have risen and fallen in the area we know as Central America and their art remains to show us what they were like. The map pinpoints where the main developments took place. With the discovery and cultivation of maize, a regular food supply was ensured. Settled tribal groups were established and the opportunity was provided for elaborate civilizations to develop. *Top left,* an Olmec clay head from Mexico. *Top right,* a Maya maize god from Copan, Honduras.

tant of the arts, since all sculpture was painted, almost all pottery, and although many good dyes were known, a number of painted textiles also survive. The ideas associated with colour were important to all the different tribes of the region. They were mostly based on sky-colours at dif-ferent times of day: yellow for sunrise, blue and green for the south and the waters of fertility, red for the sunset, and black for the night and the north.

A very special form of painting was due to the typically American Indian desire for facial and body decoration. This varied

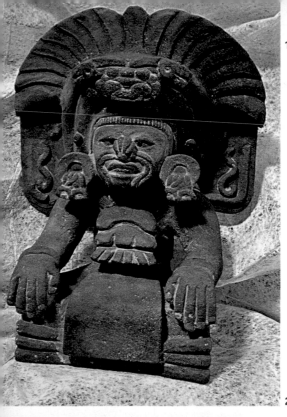

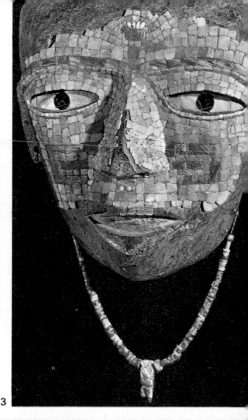

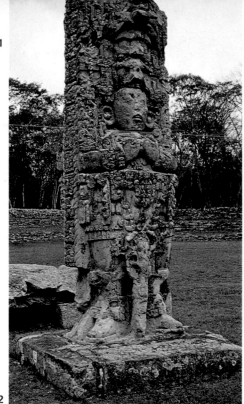

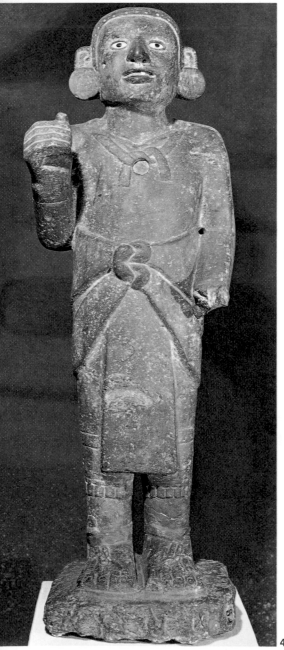

The Zapotecs of central Mexico made pottery figures of deities to stand at the entrance of tombs as guardian spirits. These were often in the shape of urns bearing offerings to the god, **1**. The Maya, further south, worked largely in stone. **2** Innumerable *stelae,* or pillars, were erected to mark steps in the complicated Maya calendar. **3** A funerary mask decorated largely in soft jade mosaic from the mysterious city of Teotihuacan on the Mexican plateau. The Aztecs were the last civilization to rise to power in Mexico before the Spanish Conquest. In architecture they based their style

on half-forgotten Tolmec traditions, but in sculpture they made notable advances. **4** A stone statue of Xiuhtecuhtli, god of fire. A common motif all over the region is the serpent, which symbolized strength, wisdom, the Earth, fire. **5** A turquoise mosaic ornament, probably Mixtec. **6** A detail from the *Borbonicus codex,* depicting part of the Maya calendar. Each day is guarded by gods: here Tezcatlipoca, god of all things of this world, wears the human skin of a sacrificial victim as the plumed serpent, also the green Earth, receives the body.

from the simple stripes of red, white and black on some of the wilder tribes of the mountains in Panama, to the sophisticated stamped designs which Aztec beauties used to decorate their yellow-powdered cheeks.

Gold working, which developed from about the first century A D, was restricted to two areas: Panama and Costa Rica in the south, and western Mexico in the north. The gold was not mined but was washed from stream beds. It was beaten into sheets and used for decoration in this form in both areas, and in Mexico it was cast in moulds to make small figurines and pendants. In the south the same process was

used for casting, but the metallurgists of the small village communities developed more sophisticated methods. They used copper, and mixtures of copper and gold, for casting the basic forms of bells and plaques. These they enriched by washing out the surface copper with vegetable acids, or by plating with gold in a mercury amalgam from which the mercury was later driven off by heat. In both processes the surface was finished by burnishing with polished stone.

In the southern regions, the contradiction between high artistic achievement and low material culture had been noted by the Spanish conquerors soon after A D

1500. Archaeologists have shown that the local cultures had reached a greater height of sophistication between AD 1000 and 1200, before breaking down as the result of intertribal wars. However, we know little of the archaeological past of this region. Research further north has established dating sequences of greater interest.

Settled village life

Even in Mexico, where a few palaeo-Indian carvings have been found dating to about 12,000 years ago, the real development of settled communities with considerable artwork began only in the second millennium BC. This was a period of agricultural village life which produced great numbers of very attractive little pottery figures of fertility spirits. They are usually naked girls wearing elaborate hair styles and a little jewellery. Some represent a mother goddess with a baby in her arms; a few show young men. This development occurs a few centuries later in Mexico than the development of simple buildings and pottery in Peru 4,000 miles to the south.

In Central America the development of large villages practising maize culture and using decorated pottery became general at an early stage. Development into a high civilization with ceremonial buildings and developed sculpture first occurred in the region of the Olmecs in southern Vera Cruz, Mexico. These people flourished between 900 and 400 BC. Their art shows some design elements which may have derived from the Mexican plateau in earlier times. In later times, after Olmec art had left Mexico, there are similar designs on pottery of the early centuries AD from the Mississippi valley.

The Olmec use of relief carving set in a decorative pattern of lines is apparently unique in Mexico, though in the overall field of American Indian art it is apparent from Peru to Alaska, and rather specially in the quite recent art of the carvers of totem poles in British Columbia. The Olmecs showed great skill in carving hard stones such as basalt and jade. Some of the themes of their sculpture – the jaguar-man, the Earth-dragon – recur throughout later Central American art. They express a typical group of religious ideas for the area. Another great step forward by the Olmec artists around 900 BC was the development of symbolic glyphs to form a kind of syllabic writing. The system developed in a simple form among the Zapotecs of Oaxaca in Mexico from 200 BC onwards, and they continued to decorate their famous pottery urns with symbols which were the names of their gods.

Zapotec arts are characterized by their use of applied decoration on pottery, the simple strong construction of their jade ornaments, and the powerful simplicity of their architecture at such sites as Monte Alban and Mitla. Their painting was, as far as we knew it, large in scale and uncomplicated when compared with the pictorial styles of surrounding peoples. They remained independent from the first few centuries BC to about AD 1480. The style of their art suffered no basic changes, though fashion was affected from time to time by the art of which ever people were dominant upon the neighbouring Mexican plateau.

South of Mexico and throughout San Salvador, Guatemala and parts of Nicaragua lived the Maya people. From the village communities of the second century BC developed a series of powerful and highly civilized city-states which began to erect great buildings and monumental stelae (stone pillars often used as grave stones) in the second century AD. These talented people reached their artistic zenith in the seventh and eighth centuries when their art was showing all the characteristics of the Baroque style of the seventeenth century in Europe in its love of decoration and flowing forms.

Pyramid temples

They achieved what appears to be true portraiture both in modelled stucco and in small clay figurines. Their painting rapidly developed from the formalism of pottery design to fresco, in which large groups of people could be shown in true spatial relationships and figures could be foreshortened. The frescoes at Bonampak are the most important witness to this unique achievement of American Indian painting.

The Maya developed a syllabic form of writing with about 700 glyphs, which appear in sculpture, pottery, wall painting and on the books of prophecy of which only three late examples survive. Their buildings were of lintel and post construction, and the temples were erected at the tops of huge pyramidal mounds which were also decorated with paintings. Temple buildings were heavily sculpted and, like all Maya constructions, they were elaborately painted in fresco.

In the early tenth century the Maya culture collapsed, and a rather more simple form of life and art developed in a revived Maya culture in the Yucatan Peninsula. Here it was greatly influenced by an invasion of Mexican Toltec clans who built a Mexican-style city at Chichen Itza soon after AD 1000. The Maya achieved complete independence by AD 1350, but continuous dynastic wars prevented them from achieving the high cultural levels of their ancestors. However the late Maya produced the books of Maya religion

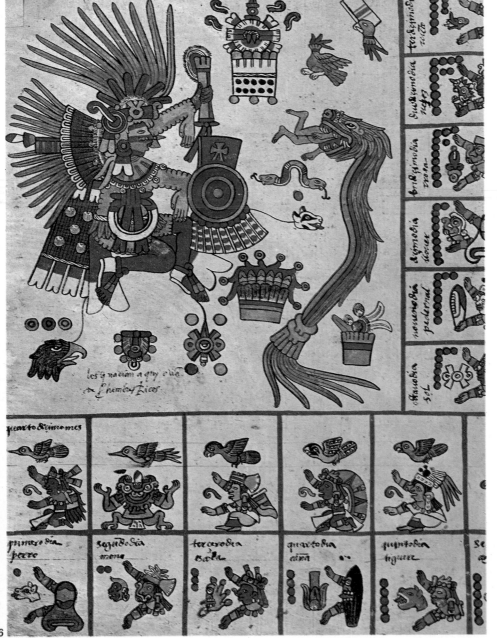

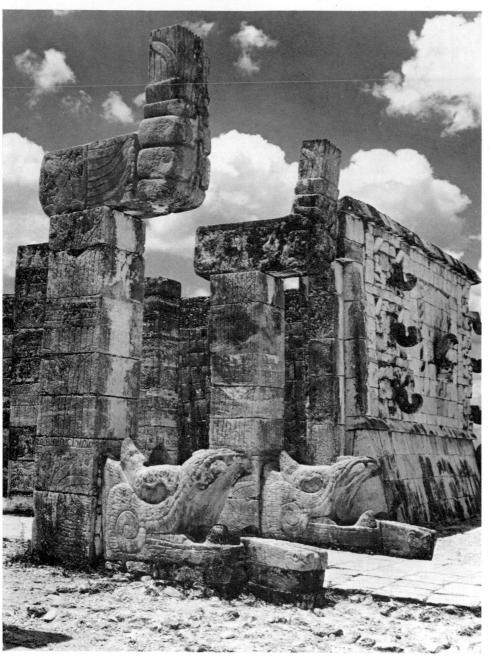

Quetzalcoatl is the plumed serpent, fierce-looking yet gentle god of Central American civilizations. Here serpent-pillars rear up at the approach to the Temple of the Warriors at Chichen Itza.

which have survived until the present day.

To the west of the Maya were the Pipiles, who appear to have been moving northwards along the Pacific coast in the early centuries A D, bringing a new art style and a system of written dates, first to the coasts of San Salvador and then to Guatemala. At Sta Lucia Cotzumahualpa their artists carved large reliefs depicting astronomical events. The stelae on which these lively works were carved have yielded dates as early as the fifth century A D. When this new art style reached southern Mexico in the seventh century A D, it began to replace the arts of the great city of Teotihuacan on the Mexican plateau.

Teotihuacan was a metropolis which had influenced art styles throughout Mexico from the second century B C until the fifth century A D. Its characteristic pottery figurines were well modelled, though formal in pattern. Painting was highly symbolic, and is confined to flat

wash drawing within black formal outlines. Pottery was incised with symbols, and sometimes even frescoed with colours painted over a coating of lime. Teotihuacano art spread to northern and eastern Mexico, and in Guatemala it reached along the Pacific coast to the mountains on the edge of the Maya country. The great city of nearly a million inhabitants fell, as it rose, for unknown reasons about A D 600. Its art disappeared, though many of the symbols can be seen in new adaptations in later art.

A period of disorganization followed the fall of Teotihuacan, but many art styles, mostly of formal design and elaborate symbolism, flourished. Notable among them were those associated with the sites of Xochicalco and Tajin. However after a time the Toltecs gained ascendancy and established a kind of leadership of the country from their city at Tula. They used the calendar of the Pipiles, and their art styles show many characteristics of that people. The Toltecs were remarkable for the development of palace building around courtyards, and for the concept of the temple as only part of the building

complex. Their art is strictly formal, and in many ways glorifies the military deities. Their traders penetrated far and brought turquoise from New Mexico, and imported golden ornaments from Panama. They were the first people to use metal tools in Mexico.

The Toltec ascendancy lasted from about A D 750 until late in the ninth century. After their capital was destroyed in a civil war, some of their leaders migrated to Chichen Itza in Yucatan and built there a Toltec city which decisively influenced Maya art.

After the fall of Tula, many Toltec traditions were continued by the Mixtec, a people of the mountains of Oaxaca. To the Mixtecs we are indebted for most of the surviving painted books of Mexican tradition. These are painted in black outline with many-coloured filling-in on lime-washed strips of tanned skin. They can now be read, and many of the historical records take us back well into Toltec times.

War and sacrifice

Some religious books in this artistic tradition derived from the Toltecs seem to have originated from other tribes in central and southern Mexico, but the tradition is so strong that it may well be that Mixtec artists were employed either as painters or teachers. The later Aztecs admitted their cultural debts to the Mixtecs in all fields of art.

The Aztecs rose to power only in the thirteenth century. They were contemporaries of the great Inca kingdom in Peru, but in all probability neither civilization had heard of the other.

Little of their textile art has survived, but painted books give clues to the brilliance and beauty of their woven cloth. They also made most elaborate garments and headdresses from the coloured feathers of tropical birds. Of these, half a dozen examples remain in European museums to testify to the wonders of this art. Their craftsmen under Mixtec instruction produced objects covered with micro-mosaics of turquoise and other semi-precious stones. Wood carving reached a high standard and was often partially gilded. Pottery also became more and more refined in the hands of the craftsmen and women of Mexico City, which was built on the site of the Aztec city of Tenochtitlán.

The brilliant achievements of the Aztecs were eclipsed by the Spanish invasion of 1518–21. Afterwards, terrible epidemics of smallpox reduced the population to a fifth of the former number. In the Spanish Colonial period, however, Aztec artists still worked on church sculpture and carving, giving a special flavour to the Mexican versions of Spanish Baroque and Churrigueresque art which had taken over the whole of Central American culture. It was only after the revolution of 1911 in Mexico that the real understanding of ancient arts could be achieved. The artists of modern Mexico acknowledge a great debt to the American Indian ancestors of their people, and have produced fine modern work which is the more vigorous because it derives both from Indian and European traditions.

Peacock, fish and anchor

Early Christian artists had to paint in symbols. A peacock stood for the Resurrection, a fish for Christ. This article describes the development of religious painting in Europe.

IT IS difficult for us to realize today that until recent times most art was inspired by religion. The earliest cave-paintings had a magical and secret significance which is now lost to us, although we know that their purpose was to worship and invoke the gods. Most of the temple reliefs or wall-painting of Ancient Egypt showed deities or religious ceremonies, and the statues of Babylonia and Assyria were as often as not cult figures.

Even in Greece, which had developed a magnificent, rational culture, statues and paintings usually portrayed gods and goddesses rather than human figures while, in the Far East, sculptures and paintings depicting Buddha and the numerous Hindu deities are today still produced in their thousands.

It was only in China that the representation of nature for its own sake played any important role in art at an early date, and only in Rome that everyday themes or purely imaginative compositions of a secular character were developed as recognized art forms.

The growth of Christianity in Europe held up the development of secular art for centuries. The earliest Christian art known to us is in the form of wall-paintings dating from the third century, when Christians were still a persecuted minority. Their art was only officially recognized when the Roman Emperor Constantine announced his conversion to Christianity in 313.

To escape persecution

The best known of these early paintings are preserved in the catacombs of Rome and Naples.

Most of the early Christian artists painted in symbols, because of the danger of persecution. To the uninitiated the pictures would have seemed innocent enough, but to the Christian they were full of hidden significance. The peacock, for example, symbolized the Resurrection; a fish meant Christ himself; an anchor stood for the Faith and a loaf for Holy Communion. After the official recognition of Christianity, a code of symbols was no longer necessary and scenes were portrayed directly. They were mainly of a narrative character, aiming at simple illustration of Old Testament stories.

In AD 330, Constantine moved his capital from Rome to Byzantium, which he renamed Constantinople, and which became the capital of the Roman Empire in the East. The move altered the course of Christian art: the Christian faith was no

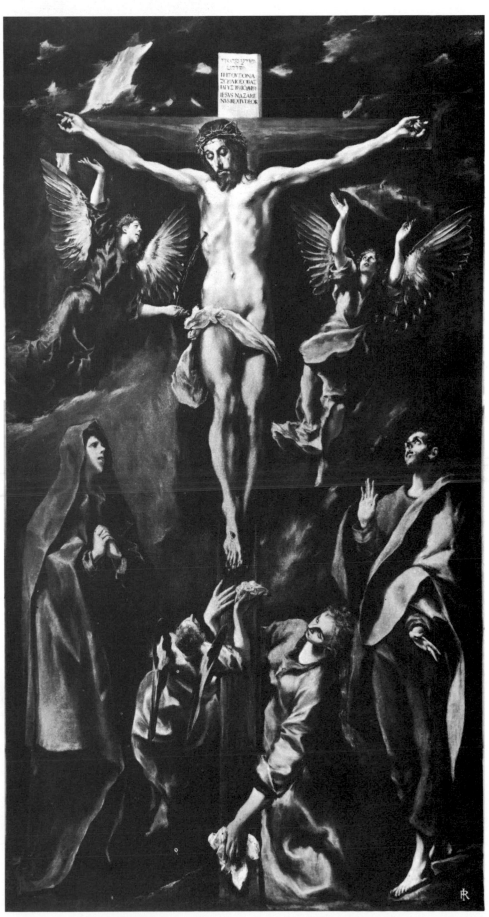

El Greco saw the Crucifixion with the eyes of a visionary. In contrast to the absolute stillness of the figure of Christ, the watchers convey intense emotion, while a great wind from another world blows the storm clouds and the angels.

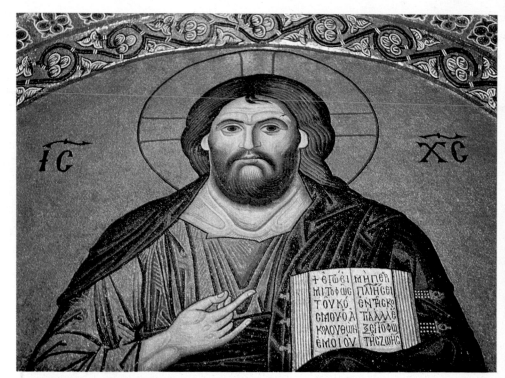

longer to be shaped by the practical mind of Rome but by the abstract and philosophical culture of Byzantium. Under the influence of this new culture, Christian art acquired a deeply symbolical and mystical outlook.

During the next two centuries, theologians became intensely preoccupied with the definition of their faith, and learned and illiterate alike took a great interest in these problems. This high seriousness was reflected in the art of the time, which attempted to express the magnificence of God and the spiritual nature of Man, rather than the physical beauty characteristic of pagan art.

By the sixth century this new outlook had become dominant, and it remained so throughout the period which in the West is called the Dark Ages but which in the East saw the golden age of Byzantine culture. The art of this great age was concerned with much more than merely illustrating the Christian story; it also tried to interpret it. The divine figures portrayed were expected to act in some mystical way as intermediaries between Man and God and were thought to provide access to the divine world. This idea became so exaggerated that the images themselves were endowed with divine powers and worshipped accordingly. This idolatry led to drastic counter-measures during the period known as the Iconoclast (730–843), when the representation of the saintly or divine form was forbidden altogether.

The founder of modern painting

After this period, the style of Byzantine art was considerably modified. Decoration was almost totally excluded, and the flat figures of Christ and the saints, executed in beautiful, brilliant colours, stand out against a gold background. This was to remain the predominant style of religious painting in the Middle Ages. After the Turks conquered Constantinople in 1453, the representation of sacred figures was denied official sponsorship, but the painting of icons in this style has lived on in the various Balkan lands almost till the present day.

Art in the West did not attain this degree of intensely mystical feeling, although for many centuries it was to remain primarily religious. Developments took place along less conservative and less uniform lines. Yet the arts that were developed in the periods known as the Carolingian (eighth and ninth centuries), Ottonian (tenth century) and Romanesque (eleventh century) were similar to early Christian or Byzantine art.

In about AD 1200 a new outlook was emerging in Europe. Man became more interested in himself, and this self-awareness was reflected in art. Renderings of Christ and the Virgin became less austere as painters began to emphasize their

human rather than their divine aspect.

With Giotto, working in Italy around 1300, the new outlook found its first great expression. An important influence on Giotto and his contemporaries was St Francis of Assisi, whose simple goodness and deep sense of brotherhood with his fellow men gave new emphasis to the importance of Man's part in the relationship with God. We can see this influence in Giotto's work.

Giotto was the first to break the stranglehold of traditional two-dimensional forms and give his figures a natural solidity. This astonishing leap forward in perspective techniques made possible the new mode of expression necessary for depicting the traditional religious themes in a new way. Giotto is aptly described as the founder of modern painting. Even so, the old formalism of Byzantine art still dominated in Italy as well as in northern Europe, and it was not until a century later that Giotto's breakthrough into the spatial world was pursued, notably by Masaccio (1401–28).

In northern Europe, artists still concerned themselves with a meticulous attention to detail. With the Flemish painter Jan Van Eyck (active 1422 – d. 1441), however, a concern with naturalism and perspective appeared, though this was still combined with a truly medieval feeling for detail, as in his *Madonna of Chancellor Rolin*.

An intensely pure, cool light suffuses this *Nativity* by Piero della Francesca. Its marvellously precise draughtsmanship and subtly varied blue tones give an overall effect of great serenity.

The German painter Matthias Grünewald (*c.* 1470–1528) was an exception. He used the techniques of perspective discovered by Giotto, but his work is the antithesis of the serene, classical style of the Renaissance in Italy. His use of the new visual language heightens the emotional impact made by his paintings: the terrible figure of Christ on the Cross on the Isenheim altarpiece does not spare us in its depiction of extreme mental and physical anguish. This truth to the reality of suffering persisted in the newly

Above, Stanley Spencer subdued his riotously prodigal style into an extreme concentration on pattern and design in this study for his *Last Supper.* But the strong workers' hands and feet show his basically realistic approach.

A devout and humble Christian, Rembrandt stands alone in the deep compassion and love for fallible humanity which shines out of his many religious pictures. *Below,* his *Christ Healing the Sick,* is a most moving study of resignation and hope.

Protestant countries of northern Europe.

In Italy, the interest in humanism, derived from classical ideals, reached its peak in Florence in the sixteenth century during the period known as the High Renaissance. Leonardo da Vinci, Michelangelo and Raphael depicted religious themes, but with an intense conviction of the dignity of man and his human form: Christ and the Madonna are living, suffering human beings, although possessing a divine nature. At the same time, devout religious painters such as Piero della Francesca and Fra Angelico continued to paint in the medieval Gothic style, but Giotto had begun a movement which was to span a period of 500 years.

El Greco (1541–1614) stands outside the main movements of his time. He left his native Crete to live in Spain, where he remained for the rest of his life. His pictures, however, are heavily influenced by the Byzantine style. El Greco was obsessed with the working of his own imagination and his pictures, such as his *Burial of Count Orgaz* and *Crucifixion,* have the unearthly, disturbing quality of visions. He produced many works of a strange and mystic nature which fit in admirably with the atmosphere of the Spanish Catholic churches for which many of them were painted. His death marks the end of the High Renaissance.

By the seventeenth century, the great achievements of the preceding century had exhausted themselves and art was in danger of becoming formalized and stereotyped. Caravaggio (1573–1610) injected new life into art by his real and often brutal portrayals of religious themes, and was very unpopular as a result. He was the precursor of such great painters as Rubens, who learnt much from him.

Religious subjects were no longer so popular, although one can point to exceptions. Such an exception is Rembrandt's marvellous etching known as *The Hundred Guilder Print,* produced in 1649, which demonstrates his ability to enter into the feelings of the ordinary people gathered round Christ as He healed the sick.

Later in the century, subjects from everyday life and new types of painting like landscapes and still-life were assuming a greater importance, and by the eighteenth century such religious paintings as were executed were produced without much conviction. People were becoming interested in scientific exploration, and art as an expression of religious awe and worship was in decline.

The nineteenth century saw some revival of religious painting. On the edge of this period is William Blake (1757–1827). Blake was a mystic and a solitary, who lived alone in his world of visions, inspired by the magnificent images of Hebrew poetry in the Old Testament. His objectives were the same as those of the Byzantines: 'to render visible the mysteries of the supra-natural world', and his perception of the forces which sway the human spirit was more real to him than anything in everyday life.

The upheavals caused in England by the Industrial Revolution and the beginning of the Machine Age made many look back to medieval times as an example of a simpler and more reverent age. Impassioned Revivalist preachers toured the country, while the Oxford Movement was inspired by the need for people to re-define their beliefs. This new religious consciousness had its expression in art, as we see in the work of the Pre-Raphaelites, who were concerned both with painting and crafts. Burne-Jones produced stained-glass windows like those in Gothic churches, while Dante Gabriel Rossetti's religious paintings are fraught with the mysticism of a former age.

A new directness and innocence

The Christian Church has survived the turbulence of conflicting ideas which characterized the last hundred years. Many artists in this century have returned to religious themes, presenting them in a new and personal way. In France, Gauguin freed himself from the Impressionist style and painted Christian subjects in a direct and innocent manner reminiscent of medieval religious art. *Miserere,* Rouault's series of religious figures and scenes, executed in black lines, exhibits a devout religious conviction.

In Britain, the literal interpretation of Gospel events by Stanley Spencer (1891–1959), are set in his own village of Cookham, giving the Christian story an immediacy and a relevance it has lacked for so long. He, like Graham Sutherland, was able to do some of his best work as a result of the revival of patronage,

Since World War II, the Church all over Europe has sponsored artists, together with architects and sculptors, to express the Christian faith in contemporary terms, and in the future, as in past centuries, may well provide a major stimulus for the painter.

The Renaissance in Italy

To the questing minds of artists in the Italy of Petrarch, the beauty of Man, of nature and of architecture was something to be glorified in itself, not seen only as an attribute of God.

THE RENAISSANCE signifies for us the marvellous achievements of men like Michelangelo, Leonardo da Vinci, Raphael – men who beautified their cities under the patronage of an enthusiastic aristocracy and a wealthy merchant class. But what does the term mean and where did it come from?

Renaissance means literally *rebirth,* and defines the extraordinary revival of art and letters in Italy from the fourteenth to the sixteenth century under the influence of classical models. The term gained currency after it was used in works like Jacob Burckhardt's *Civilization of the Renaissance in Italy,* first published in 1860.

It has gradually accumulated many connotations which are not strictly correct. In popular opinion, the Renaissance is thought to incorporate ideas of Classicism which are totally at odds with the tradition of the Middle Ages. This is an exaggeration. As far as Italy was concerned, it had always, although with varying emphasis, seen itself as the inheritor of ancient Rome and its culture. Nicola Pisano (1220–84), a medieval Italian sculptor, must have used as a model for his Baptistry at Pisa an antique sarcophagus now in the Campo Santo (cemetery) in the same city. This is deduced from the fact that the panels round the top of the pulpit contain figures which markedly resemble those on the sarcophagus.

Legacy of the Middle Ages

It was not only in Italy that the art of antiquity was a continuing force in the Middle Ages. The sculpted figures representing the Annunciation and the Visitation, which decorate the central portal of the west façade of Rheims Cathedral in France, were made about 30 years before Nicola's pulpit. They have long been admired for their noble Classicism, for their draperies which hang like those of sculpted Ancient Romans, and for their realism and movement, again reminiscent of the achievements of antique art.

When Charlemagne was made Holy Roman Emperor in 800 he set about reforming not only his administration but the whole culture of his kingdom, taking imperial Rome of antiquity as a model. But it must be admitted that the art which was one of the results of his policy was only superficially classical compared with the deeper understanding of classical art shown in all other medieval Classicism. That there was so much Classicism in the Middle Ages is not surprising when one remembers how much closer in time they were to antiquity.

Another popular view, which claims for the Renaissance an abruptly new concern with first-hand observation from nature, is

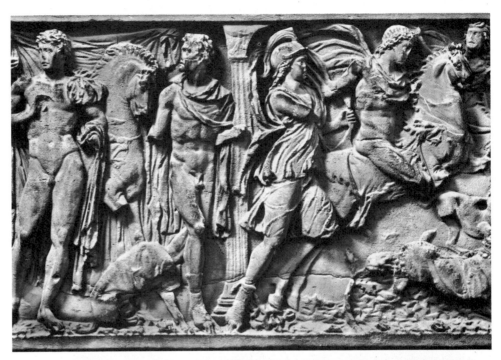

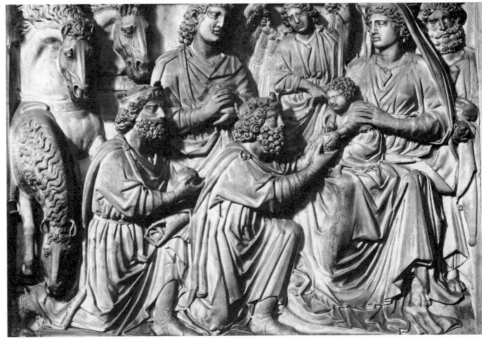

Although major innovations were made during the Renaissance, Italy had always seen herself as the inheritor of ancient Rome. About 1260, Nicola Pisano made a pulpit for the Baptistry at Pisa. He obviously used as a model the antique sarcophagus, detail *top,* for the figures on the panel around the top of the pulpit, shown *above,* resemble those on the sarcophagus to a marked degree.

equally misleading. Such a concern can be shown time and time again in medieval art. The margins of illuminated manuscripts and the carvings in Gothic cathedrals show plenty of direct observation and understanding of natural forms. The leaves, carved out of stone in the late thirteenth century, around the capitals of the chapter-house in Southwell Cathedral in England, are famous for their truth to nature as well as for their perfect integra-

tion with the architecture of the building.

A further misconception is that between the Middle Ages and the Renaissance there is an absolute difference between mysticism and logic. One has only to remember medieval theologians like Thomas Aquinas, who tempered mystical Christianity with classical philosophy, or the virtual fetish made of logic in medieval disputations.

This is not to belittle the stupendous

achievements of the Renaissance, but an attempt to see the period in the context of history. One of its most distinguishing points is the emphasis placed on the individual and his personal achievement. To medieval Man, history was a continuous evolution from the creation of the world up to his own time. With the Renaissance, a new era began.

The mind was stimulated by the discovery of classical texts, which were studied with enthusiasm by humanists all over the country. Men turned from the contemplation of God to the apprehension of their dignity as human beings. The imagination was stirred by tales of adventure overseas, new lands charted and conquered. Everywhere new ideas were springing to life, fertilizing the minds of the cultured, the aristocracy and the merchant class alike. Curiosity was rife: a new spirit was abroad. Inevitably this eagerness for new experience found its expression in art.

The idea of a breakdown in the continuum of the Middle Ages and a cultural rebirth had been introduced as early as the fourteenth century by the Italian poet Petrarch (1304–74). He called his own times 'deplorable' and traced their deterioration from a rot that set in with the conversion of the Emperor Constantine to Christianity in 313 and the subsequent loss of the culture and values of antiquity.

The High Renaissance

What Petrarch wanted was a political regeneration of Italy and a purification of Latin diction, patriotic and scholarly goals respectively. Renaissance art, however, was not just an academic and archaeological imitation of antiquity, but rather a discovery of its very soul, for nothing less could give the Renaissance full scope for its originality. Petrarch made no mention of fine art in the context but his idea of a rebirth was taken up by other Italians who applied it to this field.

Giotto, the Florentine painter who died in 1337, was hailed by the poet Boccaccio as having 'brought to light that art which had been buried for many centuries through the error of those who painted more to delight the eye of the ignorant than to please the intellect of the wise'. Others praised Giotto for his life-like qualities, for his convincingly rounded figures set in an illusion of space.

This combination of truth to nature and provision of intellectual pleasure, which has aptly been called 'scientific naturalism', is an aspect of the pursuit of truth which characterized all the giants of the Renaissance, scientists, artists, men of letters alike.

These men were concerned with the responsibility of the human individual for his own life. They put a new onus on man instead of leaving everything to God. Certainly the Middle Ages were interested in nature, and had their rationalists, too,

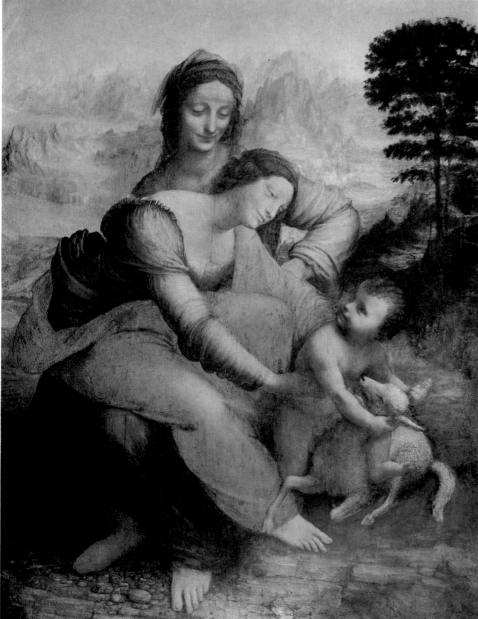

Above, the *Meeting at the Golden Gate* by Giotto depicts the meeting of Mary's parents. Rounded figures contrast with the flat figures of Byzantine art. Leonardo's *Virgin and Child with St Anne, left,* exhibits that perfect balance of composition so characteristic of his work.

but the men of the Renaissance redefined these ideas philosophically. To the Renaissance the Middle Ages were cowed by their attitude to God. The Renaissance had more faith in its own physical apprehension of the world and in its intellectual understanding: hence such pictures as the Flemish painter Jan van Eyck's *Arnolfini Marriage Group,* a virtual hymn of praise to first-hand observation. Pre-Renaissance art was not interested in such tangible reality for its own sake. The carved leaves which decorate Southwell chapter-house are not simply objective facts, they are there in order to *symbolize* the variety of God's kingdom.

This new philosophical stance, hinted at by Petrarch, and expanded by the humanists of early fifteenth-century Florence, is the key to the understanding of the Renaissance. The humanists wanted not only to equal the culture of antiquity but to better it. This was to be achieved by the synthesis of antique and modern knowledge and the shedding of what they claimed to be the handicap of medieval attitudes, the barbarism of the Goths and the Greeks (as they called the Byzantines).

By the end of the fifteenth century, Petrarch's idea of a regeneration for his country and its Latin language had broadened out into a rebirth not only for painting and the rest of the fine arts, but

The church of San Pietro in Montorio (1502) by Bramante, *above,* is characterized by its beauty of proportion. *Below, Diana and Actaeon* by Titian, showing his command of colour and expression.

for the culture generally, including the natural sciences.

It was probably the architect Brunelleschi (1377–1446) who first formulated the laws of perspective, with which the Renaissance artists could rationalize pictorial space. Although he retains the long nave of Gothic churches in his church of San Lorenzo in Florence, a glance at the ground plan of the church will reveal a highly ordered geometrical system in which all subdivisions are neat fractions of larger areas. Everything seems under tight control and to human scale.

A Gothic church would have proportions suggesting upward movement rather than enclosed space. Although his columns and capitals, for example, have a classical air, Brunelleschi was not committed to the out-and-out antiquarian attitude of his immediate successors, the architects Alberti and Michelozzo. He was more interested in practical problems of construction; so his dome for Florence Cathedral may use a technique of brickwork taken from antiquity, but its form is pointed and therefore Gothic in style.

Bramante's (1444–1514) dome for his circular Tempietto (little church) of San Pietro in Montorio, built in Rome in 1502, is hemispherical, a form much more closed in feeling than the still slightly upward-reaching Florentine dome. This compact

quality of the later work is further emphasized by the repetition in the upper floor of the ratio of height to width found in the ground floor. The building is like a piece of sculpture, and makes Brunelleschi's San Lorenzo look rambling in comparison.

It is Bramante's building, therefore, which recalls the massive volume of classical temples, and in this he marks a high point in the emulation of antiquity. This zenith of Renaissance aspiration has become known as the High Renaissance, and corresponding manifestations to its architectural embodiment can be found in painting.

But before dealing with them, the work of an earlier Renaissance painter should be mentioned at least by way of contrast: Masaccio, a Florentine who lived from 1401 until only about 1428, painted towards the end of his short life, on the wall in the Brancacci chapel of the church of Santa Maria Novella in Florence, a Trinity which clearly shows his debt to Brunelleschi's perspectival system. It is not only in this respect that he goes beyond Giotto, but also in the way the figures are modelled in light and dark, giving them a monumentality over and above that achieved by the earlier painter.

But in spite of this development in the convincing illusion of space and volume, his painting in turn looks old-fashioned when compared with the work of Leonardo da Vinci, Michelangelo and Raphael, all High Renaissance painters. The dates usually given for the High Renaissance are 1500 until 1527 (the sack of Rome).

A dictionary of poses

Michelangelo's preliminary drawings for a picture of the battle of Cascina scheduled for the Florentine Town Hall, which we know only from a copy, replaced Masaccio's frescoes in the Brancacci chapel as a kind of textbook for young painters. This was because the rules of proportion, perspective and anatomy were exhibited with amazing skill and variety in the Michelangelo work. The picture is almost a dictionary of poses and makes Masaccio seem static and wooden in comparison.

To modern eyes the later picture may seem too much of a good thing, but to the Renaissance it seemed as if antique art, which it regarded as a previous incarnation of scientific rules of proportion and anatomy, had been gloriously surpassed.

The objective study of nature and the overtaking of antiquity are inseparable at this stage in Renaissance art. While Giotto's pictures, to the earliest humanists, were merely more life-like than earlier art, by Michelangelo's day life-likeness and the look of antiquity were thought to be the same thing. For this life-likeness is not the realism of, for example, seventeenth-century Dutch *genre* painters, but rather a distillation of reality apprehended as much through averages of proportion as with the naked eye. Renaissance Man's reality was to a high degree idealized.

If Michelangelo seems to be showing off in his battle of Cascina drawing, Leonardo in his *Virgin and Child with St Anne* of about 1508–10, has reached a point of perfect balance. His figure composition

Masaccio went further than Giotto in his portrayal of solid, three-dimensional forms placed in a realistic architectural setting. A detail of his *Trinity* is shown *top left*. Brunelleschi was probably first to formulate laws of perspective and

proportion. The nave of San Lorenzo in Florence is shown *top right*. The drawing *above* is a copy of one made by Michelangelo and now lost. Complicated poses and emphasis on anatomy made it a valuable example for young painters.

has all the complexity of the Michelangelo drawing in the innumerable directions of the limbs and trunks of bodies, but they are all contained within an almost single image, which gives a greater feeling of balance than the Michelangelo drawing. There is also the balance between realism and idealism, and between convincing depth and two-dimensional designs.

This same perfect balance is shown in Raphael's *School of Athens* fresco in Pope Julius II's library in the Vatican, painted between 1508 and 1511. Gathered round Plato and Aristotle in the picture are representatives of the accumulated wisdom of philosophy. The scene is an allegorical one, and is not intended to represent any particular time or place, but is an expression of Raphael's own philosophy of painting. The whole great construction, figures and architecture, clicks into place when the spectator stands in

front of the centrally placed vanishing-point of the perspective system. It appeals to his intellect to confirm the artist's apprehension of a rational world.

In Venice in the early 1520s Titian painted a Bacchanalian scene for Duke Alfonso d'Este of Ferrara, the *Bacchus and Ariadne* now in the National Gallery in London. The remove from Raphael's exalted realm of Plato and Aristotle and their philosophical colleagues in the *School of Athens* is accompanied by the Venetian's correspondingly joyful brush-work, in oil, not fresco, and his lavish effects of colour. Not only is the High Renaissance achievement of a truly classical figure style still very evident but now the figures are galvanized into robust movement, not the artificial, stylized movement in the paintings of some of his contemporaries, such as Bronzino, but a naturalistic dance whose vigour gives a foretaste of Baroque.

Painting in the classical style

A classical tradition which consciously attempts to impose order through form and proportion inspired many Renaissance masterpieces. The same tradition is at work in geometric art today.

TO FEEL secure in a world which seems uncertain and disordered, men' have been impelled to discover ways to control the troublesome factors of their existence. The philosopher John Dewey said, 'The striving to make stability of meaning prevail over the instability of events is the main task of intelligent human effort.' We see this principle at work in all the various fields of human activity, and in all cases it is the same: an attempt to impose order on the apparent chaos of events.

The idea of the supremacy of the human mind is a legacy from ancient Greece, and although constantly modified, has never been abandoned. We shall see how the principle of harmony and order has been a constant ideal through many changing styles and fashions in painting.

For the Greeks, Man was the basis and standard of truth, so that even his gods were nothing but enlarged versions of himself. Both religion and art idealized the natural world, in which Man was seen as the culminating point of evolution. The ideal type of man was perfect in form and proportion. 'Man is the measure of all things', said Protagoras and this was not a figure of speech, but an actual fact, for the Greeks regarded the forms and proportions of the human body as scaled-down units of the whole Universe.

Truth in numbers

The study of forms in space led the Greeks to the theorems of geometry, which they saw as simple and perfect truths. Moreover, these truths could be more simply expressed in numbers. In their properties and relations there was seen to be a principle by which the whole fabric of the Universe could be understood.

The birth of the Renaissance in Italy saw a conscious return to classical ideals. It was an age of discovery and excitement when men looked back to Greece and Rome as models of excellence in every field. Painters shared the prevailing mood and the general emphasis on classical antiquity had a tremendous influence on painting.

Piero della Francesca (c. 1420–92), one of the great early Renaissance painters in Italy, acknowledged the notion that the Universe could be understood as a mathematical and harmonious structure. In his painting, actual experience of the world is always subordinated to an intellectual plan, so that every figure and object, while remaining definitely characterized, is placed within a clear system of proportional relationships. The result is an unbroken whole, simple and harmonious.

The discovery and use of the techniques of perspective, that is, constructing an illusion of space, was of great value to painters whose work was conceived in

The Marriage of the Virgin by Raphael is constructed like a pyramid. See how the figures in the foreground, although perfectly characterized, form only part of an overall, harmonious design.

terms of form and proportion. Piero wrote very specifically about the importance of perspective as a tool to 'discern every quantity proportionately, as in a true science'. Perspective, together with drawing and colouring, was one of the three main elements of painting, the unifying principle which conferred harmony on all the parts within the painting. Piero della Francesca, both in his painting and his writing, is an outstanding example of the spirit of the early Renaissance.

For a period of time during the Renaissance, Italy experienced tranquillity in her social and political life which was compatible with classical canons of order. After 1520, however, anti-classical tendencies disturbed the composure of the Renaissance framework. Italy underwent considerable social upheaval. External forces created an unsettled environment where the old, harmonious philosophy became foreign.

A change of aim occurred in painting with a departure from the sacrosanct rules of Classicism in favour of an expression of the artist's state of mind. Painting became more instinctual, improvised and personal, expressing a growing awareness of unique individuality.

During the reign of Louis XIV in France, classical ideals were revived; harmony and order were useful principles to invoke as propaganda for absolute monarchy. In 1648, the Academy of Painting and Sculpture, with its arduous curriculum of copying from the antique, was founded to perpetuate a style suitable for exalting Louis, the Sun King.

One of the greatest exponents of this style of painting was Nicolas Poussin (1594–1665). Born in France, he found his spiritual home in Rome, where he lived for most of his life. During the latter part of his career we see a return to the classical concepts so favoured by the Renaissance. His painting was no impersonal copying like that of many of his contemporaries, for Poussin saw his art as a personal interpretation of the antique in the interests of his own individual style.

'Arrangement, measure and form'

Poussin was very strict as far as subject-matter went. He was emphatic that pictures should depict only highly moral subjects and he was attracted by themes of Roman victory and sacrifice.

Parallel to this emphasis on content, Poussin reiterated the concept of order and harmony now familiar to us. In a letter to one of his patrons he states 'Our good ancient Greeks, inventors of all beautiful things, discovered certain "modes".... A "mode" is the system or the measure and form which we use in making something ... it compels us to employ evenness and moderation ... and therefore is nothing but a certain manner or order.'

'Arrangement, measure and form' were of paramount importance as they were for artists in the Renaissance. 'Arrangement means the relative position of the parts; measure refers to their size; and form consists of lines and colours.' Style was the artist's own personal way of expressing

The painting, *top*, of *The Flagellation of Christ* by Piero della Francesca shows the artist's concern with a mathematical plan. The scene is set in a building of severely classical pro- portions. Very different is the detail, *above*, of Cézanne's *Mountain of St Victoire and the Dark Château*, but Cézanne found his own ideal of harmony in the forms and shapes in nature.

Seurat wanted to find a logical way of composing his pictures. In *The Bathers*, *top*, the figures are simply expressed and the picture is unified by the use of light, translucent colours. Mondrian tried to impose order by rigorously reducing things to their basic geometric forms. In his *Composition in Red, Yellow and Blue, above*, he used the right angle with three primary colours.

his theme, arising from his own 'particular genius in application and use of the ideas'.

Poussin indicated the two goals that painting was to pursue more and more explicitly: either the manipulation of form, achieved by combination of line and colour, or the expression of personal ideas and experiences.

Devotion to draughtsmanship

The transfer of emphasis from rational principles to the expression of individual ideas encouraged painters to rely more consistently on what they perceived with their own senses. 'Battles, heroic actions and divine things', the themes suggested by Poussin, were rejected in favour of observing immediate reality.

The aims of the French painter Jean Simeon Chardin (1699–1779) were in accordance with this change of attitude. He tried to forget everything he had seen and learnt and set about giving a truthful rendering of the object before him, copying the general masses, lines and curves and effects of light and shade. This was a process of simplification, which, without distorting the motif, aimed at constructing the objects into a solid and enduring order.

Another element in Chardin's painting is the treatment of the picture surface. Thick layers of colour are applied in strokes using a patchwork principle. Consequently, close to, the surface blurs and forms lose their solidity. The surface organization of brush strokes is still related to the forms represented but is beginning to assume an independent life. This is an important element in the development of painting.

In the nineteenth century, conventional classical principles were again revived in what is now called the neo-classical period. Jacques Louis David (1748–1825) became a member of the Academy and demonstrated the same devotion to

draughtsmanship in his portrayal of classical themes as any of the earlier classical artists.

So rigid were the rules and conventions governing the neo-classical ideal, however, that this form of painting often degenerated into the mediocre, as in the later work of J.A. Dominique Ingres (1780–1867) and his imitators.

A logic of colour

Paul Cézanne (1839–1906) repudiated the use of formulas. Painting out of doors, he sought to represent forms and colours as he saw them, free from the modifying influence of emotion, intellect or known precept, to express himself according to his personal temperament. Enshrined in this desire to paint nature as he saw it was the wish to reduce the objects he saw to their basic forms, their primary elements out of which he could make his pictures.

While using the discoveries of his immediate predecessors, the Impressionists, Cézanne desired an art which was 'more solid and enduring, like the art of the museums', not one based solely on the transient effects of light and shade. He talked of 'painting a living Poussin in the open air with colour and light', a solid and durable vision of nature.

Up to now, we have discussed depth only in forms of linear perspective, that is in terms of drawing alone. Cézanne wanted to give his pictures depth and solidity and he began a phase in which depth is indicated by the relationships of different colours to each other. Representing objects in space by changes of colour ensures a consistent relationship between object, colour and surface. The surface effect is an apparent breaking up of colour areas into a mosaic of separate colour facets, but from a distance these all fall together to form a mountain or an object in a still-life. Colour was used as a means of expressing underlying forms.

Georges Seurat (1859–91) also wished to

The seventeenth century in France saw a revived interest in antiquity. *Shepherds in Arcadia,* *below,* by Poussin is a fine example of a classical composition, with figures like Roman gods.

Chardin painted the homely objects he lived among in eighteenth-century France, like those in his still-life, *Pipe and Jug, above.* He endowed them all with an enduring, monumental quality.

embody the discoveries of Impressionism in a more enduring form. He tried to find a scientific method for rationalizing the expression of light with true colours. He developed a method called *'pointillism'* where primary colours were transferred on to the canvas as small dots. It was left to the spectator's eye to reassemble these dots into a mixture of colours and shades, the intention being to preserve the colours of nature in all their intensity.

Pointillism was not an end in itself; having scientifically found a law of pictorial colour, Seurat attempted to find a similar logical system to compose a painting harmoniously. To him, art was harmony, which itself was composed of colour, tone and line. He achieved moods of sadness, calm and gaiety by varying the combination of these different elements.

The growing tendency to concentrate on the picture surface as an independent reality encouraged painters to depart from the traditional desire to represent nature directly. The actual means of expression was seen as adequate in itself for the projection of harmony and order.

Painting in right angles

The concern with form itself is seen to great effect in the work and concepts of Piet Mondrian (1872–1944). He abstracted from nature forms which for him embodied the essential harmony of the physical universe and his work was an individual attempt to express what these forms arouse in us.

His researches were directed towards establishing what he termed 'neutral forms' which have 'neither the complexity nor the particularities possessed by natural forms'. These embodied the essential harmonies of the physical universe. Geometric forms were the logical extreme of this rigorous aesthetic; Mondrian and his followers went so far as to advocate the exclusive use of the right angle, using three primary colours in conjunction with black, white and grey.

This strict adherence to geometric forms is a modern example of the concern to project a meaningful vision of the world, free from the confusion and complexities inherent in human experience. The beginnings of classical painting were marked by the attempt to conceive order and harmony in terms of a formula. At particular stages of its development, the ideals of Classicism were often abandoned, then revived and modified, subject to changes in the nature of painting or in the environment; but the fundamental need for some form of objective harmony has constantly recurred.

The painter and the nude

Whether at the wall of a tomb, on scaffolding high against a chapel ceiling, or before a canvas in his studio, the painter has always responded to his greatest challenge — the human body.

THERE IS no natural object quite as subtle and varied in its rounded shapes and surfaces as the body, no colours quite as elusive as its flesh tints. But the challenge of the body goes further than this: it, above all things, has the power of recalling the mystery of birth, of expressing hope for the future. Maturing or decaying, it is the place and centre of human existence. The nude painting is more than an attempt merely to solve problems of form and light and shade. It is also the record and result of a man meditating on a human body – one could almost say of Man meditating on himself. Since every brush-stroke is a painter's choice, the nude can encompass a *richness* of response and insight that at once exposes the poverty of photograph, diagram or furtive glance. Over the centuries, the painted nude has communicated the heroic affirmation of Michelangelo, Rembrandt's quiet humility, the exuberance of Rubens, the compassion of Toulouse-Lautrec, today the violence and disillusion of Francis Bacon.

Every portrayal of the human body (the same could possibly be said of all art) seems to evoke in some measure both the *mystery* of being human and the *banality* of being only another object in the world. Sometimes the first predominates as in the nudes of the masters, sometimes the second as in photographs of naked pin-ups. But here care should be taken not to identify banality with the sexual and the erotic, for these seem to lie also at the heart of the mystery. The erotic motive, a vital and undeniable aspect of humanity, has often tugged hard at the master's brush. It is clearly for more than formal reasons alone that a woman's body has usually pleased him most.

Heroes, athletes and gods

Paintings of the human figure, as stylized and two-dimensional as an alphabet, are the rule on the walls of ancient Egyptian burial chambers. Caught up in a tradition of religious ritual painting that spanned more than 3,000 years, the Egyptian artist dared not press his own ideas. His figures always look puzzlingly contradictory, because each part of the body is shown from its most familiar angle. The head is in profile, but the eye shown front view, almond-shaped; the top half of the body faces us, but the arms and legs are shown sideways, a belted kilt hiding the awkward twist through 90 degrees. Gods and kings are rigidly conventional and while lesser figures – huntsmen, dancing girls – may be shown in action, their faces are quite as expressionless. Yet these stylized figures already indicate a deep interest in the body and a first-hand knowledge of anatomical measurements – available in a culture that embalmed its dead.

In Greece, the simplified, triangulated figures found near Athens on burial urns dating from before 700 BC, gave way to the more realistic and anatomically correct figures painted with such great zest and ingenuity on Athenian vases of the fourth century BC. Yet for all their brilliance, the newer figures are still largely stylized images – of heroes, athletes and gods – not real people. The Greeks – as perhaps the work of the sculptors, Phidias, Myron and Praxiteles illustrates most strikingly – idealized their humanity (after all the gods themselves were virtually human) and strove only to define and portray the perfect male and female bodies which all real bodies were supposed to reflect imperfectly. But they had to begin by looking at real bodies.

Systematic anatomical observations from life, carefully recorded and studied in preliminary drawings, almost certainly underlie the classic conventions of Greek art. Although little evidence of these preliminary studies has survived, most students of the period are sure that the achievements of Greek painters and sculptors would have been impossible without them.

Later generations, dazzled by these achievements, forgot the secret of their creation and were content to copy from them and not from life, and continual copying led to a decline. Eventually the early impetus of the classic conventions was entirely lost; its original source had to be rediscovered and new conventions formulated. This is what happened in fifteenth-century Italy.

Michelangelo paints a ceiling

More than any other artist, Michelangelo Buonarroti (1475–1564), the Florentine sculptor, painter and poet, epitomizes the Renaissance spirit. His greatest achievement as a painter is the ceiling of the Sistine Chapel, in the Vatican. It took him four years to complete. Incredible as it seems now, he accepted Pope Julius II's commission with the greatest reluctance, considering himself a sculptor and not a painter. 'Painting is not my profession,'

Painting the nude, artists sometimes follow, sometimes rebel against the climate of their age. Goya's sensual *Naked Maja, top,* shocked the Spanish Church. Lucas Cranach's *Venus, right,* obeys the Gothic ideal of his time. But Renoir's *Judgement of Paris, left,* records one particular artist's idea of womanhood.

Exuberant and stylized, the heroic figures of Peter Paul Rubens, *left,* contrast with the simple informality of Toulouse-Lautrec's rapid crayon sketch, *right.* But both show the body truly alive, caught in movement and gesture. Rubens's *Judgement of Paris,* lost for many years, seems bathed in mellow light — a result of careful glazing. Lautrec's *Woman Putting on her Stocking,* in swift lines, reveals the artist's great gift for form.

he wrote at the time, 'I waste time without any results. God help me.' Yet the almost superhuman beings that 'thunder down' from his ceiling are the measure of figure painting in this most brilliant period in Italian art. The way he painted them is worth examining.

The Sistine ceiling is painted in *fresco,* so called because the water-colour paint used had to be applied while the plaster was still 'fresh', that is, wet. Michelangelo could not linger over his work and therefore had to plan and execute detailed study-drawings of his great Prophets and Sibyls before he could begin painting them. It is at the stage of making these indispensable drawings that his genius first expresses itself. Using chalk, pen and wash, Michelangelo worked from a living model, at the same time drawing heavily on his knowledge of Classical sculpture and human anatomy – he had even dissected cadavers in secret to learn more about the interrelation of muscle, bone and sinew.

First the figure is sketched in lightly. Here the artist's main concern is to establish the pose, and the size and proportions of body, head and limbs. Then he compares the drawing with the model in front of him and with the ideal in his head. Next, never erasing the wrong lines but using them as a guide, he alters them again and again, each time more firmly than before. Shading is produced by this constant correction and not by copying the light and shade on the model's skin. As a

result diffused light seems to come from within the drawn figure as if its skin were translucent. Carried over into the painting, this quality is strangely life-like; but deceptively so, for it takes us beyond the evidence of our eyes. It is much more than mere imitation of life. Michelangelo would have agreed with his great contemporary, Leonardo da Vinci (1452–1519), who said that painting is a 'spiritual thing'.

The spell cast by the greatness of the Florentines was to guide the Classic tradition in painting for three centuries to come. Certain painters, finding it impossible to add to the achievements of masters like Michelangelo and Leonardo, attempted to copy and combine the best of each in the hope that this would produce artistic perfection. They tended to exaggerate the technique of drawing and, in their attempts to display virtuosity, painted melodramatic figures that sometimes bordered on the ludicrous – a group in a Biblical scene would resemble a squad of athletes.

The naked portrait: a rival tradition

As time went on, technical skill became an obsession among the followers of Michelangelo. While, for example, the nudes of Jean-Dominique Ingres (1780–1867) are brilliantly executed they remain cold exercises in virtuosity. Unlike their master, the 'academic' painters of the nineteenth century were unable to breathe life into their canvases.

While the Italian Renaissance was in full flower, however, another tradition predominated in northern Europe where the Classical influence was always second-hand. Here the nude is painted in a more true-to-life way, paying tribute to the typical German or Flemish woman, with her long body, small breasts and heavy abdomen and thighs. Accordingly, when the German painter Lucas Cranach (1472–1553) paints Venus he simply portrays an attractive girl of his time – at first glance, brazenly naked and erotic in contrast to the provocative yet curiously innocent, idealized nudes of Italy.

Rembrandt Van Ryn (1606–69), probably the greatest Dutch painter, also worked outside the Classical tradition. When he makes his preliminary drawings he takes a typically lumpy model such as one might find in any art school today and draws her just as she is – sitting rather gracelessly, with sagging breasts and lined flesh. The resulting nude is disturbing, for without the support of Classical proportions the human body becomes a thing of pathos, an unconscious measuring of our ideals against the imperfection of familiar reality. Perhaps this is the difference between nudity and nakedness: the one ideal, strong, heroic, full of hope; the other real, weak, pathetic and doomed. Yet Rembrandt so transforms his model by a magical handling of light and shade that her uncompromising realism becomes an expression of humility and compassion.

Michelangelo approached painting as a sculptor. His sketch for the Libyan Sibyl, *top left,* and the completed fresco in the Sistine Chapel, *top right,* show paint used three-dimensionally. The female Sibyl, a mysterious and powerful figure, is clearly based on a study of a male torso. *Above,* Édouard Manet's *Déjeuner sur l'Herbe* of 1863 caused a scandal among Parisians by showing two men in contemporary dress with two unconcerned nudes.

Even Peter Paul Rubens (1577–1640), a Flemish master of Baroque painting with a passion for Classical scenes, was only partly influenced by the Classical style. His female nudes are realistic portraits of heavy, sensual Flemish women, joyous and alive, even when he depicts them as goddesses in an Olympian beauty contest.

But perhaps one of the most brazen nude portraits of all is that of the *Naked Maja* by the Spanish master, Francisco Goya (1746–1828). In Spain the Classical tradition was discouraged by a sternly puritanical Church. In fact the only previous nude in Spanish art had been the famous *Rokeby Venus* of Velazquez (1599–1660), showing a reclining goddess viewed from behind. It was the fact that the Maja was the portrait of a real woman in an immodest pose that shocked and provoked people into guessing her identity (the Duchess of Alba, some said). The naked portrait has a challenging quality that makes it seem indecent next to an impersonal tradition unaccustomed to such frankness.

Beauty in the plainest models

For much the same reason, indecency was the criticism levelled more than sixty years later at Édouard Manet's *Déjeuner sur l'Herbe* which shows a nude reclining in a landscape in the company of clothed men. Another Impressionist, Edgar Degas (1834–1917), was accused of worshipping ugliness in a perverted way because his ballet dancers are unidealized and his nudes are completely candid studies of women bathing or combing their hair. The realism of Henri de Toulouse-Lautrec (1864–1901) verges on caricature. He delighted in the plainest models and often took them from brothels. But these cruelly unattractive women are transformed by his dramatic handling of paint and his compassion. The resulting pictures are paradoxically beautiful.

The goddesses of Pierre-Auguste Renoir (1841–1919), are charmingly snub-nosed, wide-mouthed girls of a buxom type that particularly appealed to him. His nudes combine the radiant warmth of the anti-Classical study with all the calmness and repose of Classical impersonality. They magically unite realism and unreality and are painted for the love of form and colour and the art of painting. Yet another French Impressionist, Paul Cézanne (1839–1906), tried to combine Classical form with his observations from nature. Towards the end of his life he attempted a series of large pictures of bathers in a landscape, developing a way of reducing complex forms to simple areas of limited tone and colour.

Picasso recalls the past

The Cubists, like Pablo Picasso (b. 1881) and Georges Braque (1882–1963), seized on this new method and extended it, eliminating all detail in favour of the simplest concave or convex, curved or flat surfaces. There are relatively few paintings of the nude in this style, but an extreme example of it is Picasso's *Demoiselles d'Avignon,* in which the nude is transformed once more into an impersonal heroic ideal. We seem to have come full circle and are back with the Dipylon figures, with Egyptian wall-painting, with

Top, Cézanne's *Bathers* is more concerned with showing forms in space than painting beautiful nudes. *Left,* Degas's *Woman Washing* contrasts an angular table with the curved bathtub and figure. *Right,* Rembrandt's *Seated Woman* aims at the truth about the body, not at conventional beauty.

the art of Africa. Cubism is the most recent of the great movements in painting to have held the stage. Since the turn of the century the main traditions have fragmented. Painters of the nude have adopted many different styles. The great among them include the Impressionist, Pierre Bonnard (1867–1947), famous for his repeated portrayals of his wife lying in the bath or on a bed or standing in the morning sunlight; the Italian painter, Amedeo Modigliani (1884–1920), whose sophisticated nudes are distinctive for their long, elegant bodies and limbs and their delicate heads on impossibly slender necks; Henri Matisse (1869–1954) who paints his nudes swiftly and spontaneously in bold, vibrant colours; and Francis Bacon (b. 1910) whose nudes are contorted figures of violence. Despite these many different approaches, it still remains true that a painter either formulates and tests the fruitfulness of an abstract convention or alternatively relies on his personal vision and experience. He paints either a nude in the classical sense or a naked portrait.

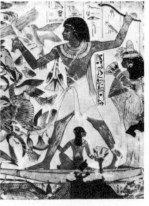

Left, seventh century B C amphora from the Dipylon Cemetery at Athens, showing the geometrical and stylized treatment of the figures. *Centre,* cup painted three centuries later, showing greater realism and emergence of classical Greek nude. *Right,* Egyptian tomb-painting dated 1450 B C in which a nobleman hunts waterfowl with his family. A tabby hunting cat, left, has got three already,

More than a good likeness

Does his subject matter to a portrait painter? Is he primarily concerned to please his sitter, to display his technical skill, or to make a personal statement about the human condition?

'THE PAINTER seeks the moment when the model looks most like himself. The portraitist's gift lies in the ability to spot this moment and hang on to it.' It sounds like a portrait painter summing up his craft, but in fact these words were written by the Russian novelist, Fyodor Dostoevsky, in his diary in 1873. As he implies, the art of portraiture demands sympathy and insight from its practitioners as well as the ability to handle paint magnificently. Few artists possess both, but those who do are the great masters of portrait painting.

As we look back over the centuries we see that this form of painting has flourished in times of political and economic stability. A poor nation, torn by wars or by internal wrangles, cannot sustain the portrait painter. On the other hand, a prosperous, peaceful country provides the right conditions for his work, since his art is one that is nourished by leisure. Thus an age which produces a number of great portraitists – like sixteenth-century Italy, seventeenth-century Holland or eighteenth-century England – tells us something about the countries they come from.

The earliest portraits were executed for religious reasons. The ancient Egyptians needed a durable portrait enough like the body of the dead person to deceive his *ka* (or double) so that it would not haunt his survivors. And so portraits of Egyptian rulers and court officials were made during their lifetime.

The Greeks and Romans, like the Egyptians, made their portraits mostly in stone, and only a few rather stylized portraits in paint have survived from Classical times. Since the ideal mattered more to these cultures than human individuality, there was little or no place for portraiture as we know it.

In the Middle Ages, too, when man was supposed to lose his identity in the contemplation of God, portraiture still had an insignificant role. The schools of Christian art which succeeded one another through the Dark Ages, the Romanesque and early medieval periods, were generally antagonistic to the very idea of portraying the real world. It is not until later Gothic art that a concern with personalities begins to assert itself, but by the fourteenth century portrait painting from life was developing both in Italy and in northern Europe.

Witness to a wedding

At this time Richard II, King of England, was painted kneeling under the protection of his patron saints before the Madonna and Child, in a work called the *Wilton Diptych*. The name of the artist is unknown, but what matters is that he has obviously attempted a likeness of the young king. Instead of using the three-quarter view of the face, as he has done for most of the other figures in the picture, in Richard's case the artist chose the angle from which a person's features are most easily remembered: the profile. The face is young, remote, sensitive; it is the face of an individual.

After 1400 depicting personal likeness rapidly became a regular activity of artists. One of the most celebrated portraits of this period is that by the Flemish painter Jan van Eyck (1385–1441) entitled *Giovanni Arnolfini and His Wife*. The couple are shown, not in the rather heraldic isolation of most early likenesses, but standing in their own room surrounded by their belongings. As their name suggests, they were Italian, and later research has revealed that the picture was intended as a marriage certificate, to be sent back home to their relatives as proof that they were actually married.

Portrait of a Man, by Titian, the greatest Venetian painter of the sixteenth century and the contemporary of the Florentine Raphael. His love of colour and sumptuous effects matches the Venetian love of pomp and splendour. The man in the picture is unknown and Titian emphasizes the characteristics of youth and arrogance rather than the aristocratic qualities depicted by Raphael.

and instituted a method which was followed by several subsequent generations of portrait painters.

His most famous immediate follower was his own pupil, Anthony van Dyck (1599–1641) who began as a collaborator in the Rubens workshop, and developed from his master's methods a new style of elegance which sometimes led him into flattery. Van Dyck's particular flair was for equestrian portraits, the most famous being that of Charles I.

Rubens died in 1640; van Dyck in 1641; Velazquez in 1660; Frans Hals in 1666; Rembrandt in 1669. With them the age of great portraiture was at an end, and a long-drawn out and relatively empty period followed. Portraiture in the later seventeenth century is punctuated by flatterers rather than masters. Lely and Kneller, the school of Lebrun in France – all these were pleasing stylists, whose work seems repetitive and generalized beside that of their immediate forbears. It is to England that we have to turn for the next outstanding school of portraitists.

From Hogarth onwards a great age in English portrait painting was inaugurated, served by such artists as Reynolds, Gainsborough, Wright, Romney, Raeburn, Ramsay and others. Reynolds (1723–92) and Gainsborough (1727–88) were the masters of the period. Of these, Reynolds was the more articulate, and he has left an illuminating comment on portraiture which should be borne in mind when looking at his own work and that of his contemporaries. He said: 'The portrait painter cannot make his hero talk like a great man, but he must make him look like one.' The common factor in the works of this age is a sense of shapeliness and grace. The individual is carefully merged in the type, and made to embody the contemporary ideal of good breeding. Gainsborough developed his personal style for painting

Detail of the *Man with a Cane,* by the Flemish painter Frans Hals, the first great portrait painter of the Low Countries. Most of his paintings portray the society of Haarlem in Holland.

his subjects out of doors and attained great heights both as a portrait painter and a landscape painter in *Mr and Mrs Andrews*. In his work feminine charm is seen at its most English, and its most delightful. His caressing, feathery brushstrokes give skin and garments alike a shimmering radiance. At his best – as in the magnificent full-length *Portrait of Countess Howe* – Gainsborough is incomparable.

The English school of portraiture declines after these masters, having an Indian summer in the enormous success of Thomas Lawrence (1769–1830) in the early nineteenth century. In France artistic development broke off abruptly with the political and social upheaval caused by the revolution in 1793. In Spain, however, a single great painter emerged during this otherwise barren period.

Francesco Goya (1747–1828) was one of the most brilliant and original of European

Detail of the famous portrait *Woman in a Straw Hat* by Rubens, the German-born painter who was trained in Italy. His style of portrait painting was copied by generations after his death in 1640.

masters, combining a sombrely personal sense of colour (his favourite is black) with strongly incisive and sardonic drawing. He is merciless in his treatment of male sitters – particularly when they happen to be old, ugly and aristocratic – but he portrays women with tender sensuality otherwise untypical of his work. He reveals the trappings, the splendour, the decadence and the utlimate emptiness of the corrupt Spanish court of his day.

In France the Revolution threw up a Classical reaction to the frivolities of Rococo painting, and men such as David (1748–1825) and Ingres (1780–1867) dominated French painting, until their Classicism itself provoked a reaction with its sequel in the Romantic painting of Delacroix. From the 1860s a new sort of painting blossomed, moving away from the abstract and intellectual towards the sensuous and colourful. This new school, Impressionism, excelled at portraiture. Manet (1832–83), Degas (1834–1917), Renoir (1841–1919), Monet (1840–1926) and finally van Gogh (1853–90) all produced portraits of distinction, and in some cases of genius, embodying discoveries about light and the application of paint.

Competition from the camera

In England some striking portraiture was produced during the same period by the pre-Raphaelites, especially Millais (1829–96); and by James Whistler (1834–1903).

In the twentieth century, we are still too close to be able to pass judgement. Portrait painting has been threatened – it is too early to say whether or not it has been extinguished – by the invention of the camera. The photographic portrait is the rival of the painted portrait. However, our century has produced a number of memorable likenesses, coming from artists such as Wyndham Lewis (1884–1957), Stanley Spencer (1891–1959), Graham Sutherland (b. 1903; best known for his abrasive portrait of Sir Winston Churchill), Oskar Kokoschka (b. 1886) and, supreme in this genre as in all others, Pablo Picasso (b. 1881). Perhaps posterity will decide that one or all of these has produced works in the great tradition of European portraiture.

A Graeco-Roman portrait of a man with a wreath, executed in wax on wood. Portraits were painted in Rome for a variety of reasons, sometimes, as now, to adorn libraries and private houses.

Detail of *Doña Isabel de Porcel,* by the Spanish painter Goya. A great satiric artist, Goya also delighted in portraying beautiful women and in painting the fine textures of lace and silk.

The quiet magic of still life

Food for the dead, incidental decorations, symbols of faith, reminders of death: not until the time of the sixteenth-century Dutch Masters was the beauty of everyday objects explored for its own sake.

A JUG, a saucepan, a cut-glass bowl or a silver candlestick, usually grouped with fruit, flowers or attractively textured foods like bread, cheese, game and fish are all objects typically represented in *still-life* painting.

The artist probably chooses to paint them not because they have any special value, an intended meaning or a story to tell, but because they enable him to study the interplay of light and form, colour and texture, with the least possible distraction. The only clear exceptions are found among the still lifes of ancient or primitive cultures. The fruit painted on the walls of Egyptian tombs is there as food for the soul on its journey into after life.

Still life simply as decoration first appeared in Roman times. Wall-paintings preserved under the volcanic ash of Vesuvius, at Herculaneum and Pompeii reveal that still-life painting was at a peak in the middle of the first century A D. On dining-room walls there are paintings of fruit and birds, arranged as if on shelves in the larder. These are representations of light held by glass and water showing an astonishing ability to translate the quality of transparency into paint.

Some of these murals are painted in a severe style with clear-cut, smoothly modelled forms, others loosely and impressionistically, full of dash and vigour. Sometimes they are called *frescos,* which is misleading, for fresco is a method of painting in water-colour on fresh plaster. In fact these paintings are of wax emulsion on plaster. The colour is mixed with beeswax or gum and some spirits of wine, applied, then set by passing a hot iron over the painting without touching the surface. This gives a slightly burnished, lustrous look, and the colour, depth and sparkle normally associated with varnished oil painting. The brush-strokes are clear. Every touch and dab of paint stands out on its own; there is no evened-out smoothness of shading.

Holland rediscovers still-life

This direct intensity of vision was not to reappear in still-life painting for over a thousand years. In the Middle Ages the observation was there, but painting was still mainly confined to religious themes and often commissioned by the Church. It would not have occurred to a medieval artist to paint a still life for its own sake. A hermit's study by the Italian painter Carpaccio (d. *c.* 1527), may have piles of books of devotional objects carefully grouped together so that one can virtually construct a still-life painting by isolating a detail; a portrait by the German painter, Holbein (1497–1543), may include a selection of personal possessions – letters, a signet ring, keys – to tell us more about the

The Impressionists sought to capture the surface qualities of objects, but Cézanne was anxious to do more than this. He wished to emphasize the basic form of his subjects underlying the shifting elements of light and texture. In his *Still Life and a Basket* each object is given a solid and durable aspect and his love of colour adds emphasis to the preoccupation with form.

sitter; but these objects, although enabling the artist to display his virtuosity in handling texture and grouping, remain incidental to his purpose.

It was in sixteenth-century Holland that still life first emerged as a distinct category in painting. The van Eyck brothers, Hubert (d. 1426) and Jan (d. 1441) had confirmed the Renaissance spirit and techniques in northern European painting, although remaining firmly outside the heroic and Classical tradition of the true Renaissance. They had set a standard of objective realism that was to find its highest expression in the portraits, seascapes and landscapes, interiors and still-life painting of the Dutch Masters of the sixteenth and seventeenth centuries.

The reasons for the sudden explosion of Dutch painting over a period of barely a hundred years were social, religious, economic, political and even geographic. Holland, at the mouth of the Rhine, was the gateway to Europe, and benefited fully from one of the greatest fruits of the Renaissance – the discovery of the New World of the West and the sea route to the East. This wealth found its way into the pockets not of princes but merchants and burghers. It also attracted Catholic French and Spanish invaders, and became a spur to Protestant independence. Anything savouring of the High Renaissance the Dutch associated with suppression and

tyranny, and considered anti-patriotic. Dutch merchant princes, who were the patrons of the van Eycks and their inheritors, were educated outside the Classical tradition in the universities of the Low Countries, with their strong emphasis on law, science and medicine. Prizing modesty as a great virtue, they lived in small houses without large public rooms. As a result, there was an excellent market for paintings. But pictures had to be small, and Classical and heroic subjects avoided. Moreover, while the patron had an eye for value, the painter took a pride in craftsmanship and execution. Geography had also forced the Dutch to cultivate planning capacity, care and precision, for much of their land had to be secured from the sea before they could build upon it.

The still-life was made to order. The painter need never run short of subject matter. He could work in a small studio rather than away from home. He need not even wait for a commission to arrive, but could paint as and when it suited him, and then sell his pictures himself. He was left alone to perfect his technique without his patron quibbling about flattering likenesses, suitable themes, or literal truth – many painters probably constructed their floral still-lifes from sketches and previous studies, for very often they combine in a single vase flowers of different seasons.

A power to evoke a feeling of quiet

security is typical of Dutch still-life painting. Part of the reason is obvious: the subject matter of the table and an abundance of good food – a theme never carried into absurdity. The more important reason is that the compositions are well planned and stable. A cup or glass is not only judged for its own beauty, but for the relationship of its ellipses to the picture as a whole. A spiral of lemon peel is an essay in geometry and brush control. Qualities such as the powdery bloom on a peach, the iridescence of an oyster shell or mother-of-pearl knife handle, the glint of gunmetal, the glass of wine simultaneously reflecting, holding and conducting light are all somehow observed and analysed with detachment and set down on canvas in such a way that the paint acquires these qualities itself. These still-lifes usually look as if they are contained in an aquarium of slightly tinted glass. The brush work is subdued and the hand of the artist concealed. It is only after careful study, for example, that the unsigned work of Pieter Claesz, (1591–1661), Wilhelm Heda (1594–1682) or de Heem can be recognized.

Silver plate, tulips, earthenware

The objects represented in many Dutch still-lifes were probably first grouped in a box, or surrounded by screens controlling the light, then viewed as a reflection in a tinted mirror. Such preparations would immediately give shadows and depth, and highlight the clear but subdued gleam of the seventeenth-century still-life.

There were three main periods in the development of still-life painting in Holland. The first was unpretentious: the picture might show bread and cheese or a few herrings on an earthenware plate. With increasing prosperity, tastes became more fastidious and luscious fruits would be temptingly piled up in glass or pewter bowls. Finally the pictures display Epicurean luxury – magnificent banquets – laid out on silver plate. The Masters of Dutch still-life painting at its height – about 1650 – were Jan de Heem (1606–84), Abraham van Beyeren (1620–75), Willem Kalf (1619–93) and van Aelst (1626–83).

Then in the early eighteenth century the Dutch still-life school suddenly col-

Top left, The Copper Fountain, painted in 1733 by Jean-Baptiste Chardin, is an early work, but in it his characteristic and highly individual surface texture – rough and gritty – is already beginning to appear. It is achieved with a loaded brush and several layers of colour. *Top right,* detail from Jan van Eyck's portrait of Arnolfini and his wife. The picture was intended as a marriage certificate, and the painter and another figure are reflected in the mirror as proof of their presence to witness the wedding. The dog and the chandelier are included as symbols of fidelity. *Below left,* a still-life by Pieter Claesz, typical of the final phase of this style of Dutch painting. Elaborate and magnificent objects only are shown, rendered with a meticulous care and detail, using an invisibly minute brush-stroke. *Below right,* detail from *Maidservant Pouring Milk,* painted in 1660. Notice Vermeer's colours – his favourites are shades of blue and yellow – and how realistically he could render the textures of the bread, cloth, basket and pottery. This painting has every characteristic of Vermeer's style. It is one of the few attributed to him whose authenticity has never been questioned.

lapsed. A glut of pictures coincided with a nation-wide slump brought on by expensive wars. Ironically, it was the widespread cultivation of tulip bulbs that finally weakened interest in painted flowers.

Jean-Baptiste Chardin (1699–1779) was both a still-life painter and a Frenchman; an unusual combination for his time. Although at first much influenced by the Dutch school, he gradually worked himself free and gave a new direction to still-life painting. Unlike the later Dutch masters, who painted extravagantly luxurious table settings, Chardin painted the commonplace objects of everyday life – not fine china but earthenware pottery, not silver cutlery and dishes but steel and pewter. To these modest subjects he brought an extraordinary painting technique. He simplified forms until they were little more than flat areas of tone and colour. The paint seems gritty and grainy and is thickly applied. Each area looks as if it is inlaid – fitted in in one piece against its neighbours. In Dutch still-lifes the colour tones are smoothly blended together; in Chardin's work they match like notes in a musical scale. Chardin painted what he knew best: the domestic interiors and utensils of a middle-class home – and in fact many of the articles in his pictures are mentioned in inventories of his personal belongings. There is one silver cup he must have been especially fond of, because it appears in his work time and again. It is interesting to notice that after his second marriage in 1744 to a fairly rich woman, the objects he paints become more elaborate.

On a café table

Chardin died not long before the French Revolution ushered in the nineteenth century. Still-life painting once more became incidental – a student's exercise or an occasional relief for a master such as

Poverty and eleven children: Jan Vermeer (1632–75) could rarely have known the calm his pictures reveal.

Little is known about the life of Jan Vermeer of Delft; his art provides the main clue we have to his life and character. We do know, however, that in order to support his large family he took over his father's business as an art dealer, and that he devoted more time to that than to his painting. Consequently his output of work is extremely small – fewer than 35 genuine paintings by him are in existence today. Although he was highly thought of as a painter during his lifetime, he fell into obscurity after his death, so much so that one of his pictures was not rediscovered for nearly 200 years. In 1882, it was sold for 4s 6d. Technically Vermeer should not be included in the category of still-life painters, since his works all contain human beings. It would be more correct to describe them as 'Still Life with People'. Yet Vermeer paints every familiar household object – bread, jugs, jewellery, needlework – with the characteristic and loving detail that is to be found in the true still-life. He captures a moment in time with a tranquillity and simplicity that turns a mundane domestic scene into a picture with the rare, unmistakable quality of pure magic.

John Bratby's *Still Life with Chip Fryer* has caught all the untidy, reassuring muddle of anybody's kitchen table, with its assorted food and cooking utensils. He was one of the first painters to give the attention of an artist to such details as the labels and structure of tins and packets. Today many artists in Britain and America specialize in recording objects of this nature.

Stanley Spencer (1891–1959) painted this string of onions, and its careful accuracy is typical of his loving observation of trivial details, such as the onions' splitting skin, the wooden slats in the greenhouse floor, and the blossom outside. His paintings came directly out of his experience of life and his subject matter remained the imaginative life of childhood.

Courbet, who portrayed his dishes of apples in the manner of Chardin.

The possibilities of the still-life painting were not rediscovered until the coming of Paul Cézanne (1839–1906). Cézanne found still life ideally suited to his long spells of contemplation at the easel – a habit which drove his live models to distraction. The shape and contours of apples and oranges, drapery and plaster casts, became studies in curving surfaces. Colours were less important than differences in tone: shadow was set against deeper shadow. Shape and volume are the real subjects of his pictures. Cézanne painted in firm, deliberate and separate brush-strokes, more like a tapestry maker than a painter.

The still-life painters of the seventeenth century took a camera's-eye view of their still-lifes. They constructed their table tops, plates and cups strictly according to the laws of perspective. Cézanne painted from one side of a table top to the other, plotting the position of objects in space by marking the points where their forms intersected and overlapped. Consequently the sides of a wide table will diverge instead of converging, and an edge of a plate will reappear from behind an object which cuts it at another level.

It was this aspect of Cézanne's art that the Cubists developed into their own even more abstract style.

Cézanne painted the still-lifes of a countryman: the Spanish painters Picasso, and Juan Gris, the French painters Braque and Albert Gleizes, took as their subjects the still-life of a café table, pipes and tobacco, newspapers and wine glasses, musical instruments.

They deliberately took simple, man-made objects rather than the fruits of nature. Then, by eliminating the smaller variations in form and exaggerating the roundness of a tube or sphere, the sharpness and hardness of an outline, they converted folds of drapery or paper into something near in appearance to sheet metal. A clay pipe or a glass takes on the monumental appearance of a prefabricated component in a shipyard. The distorted space of Cézanne's still-lifes arises unconsciously out of his method of painting. Smooth surfaces cross and intersect each other, are broken smaller and smaller, and shaded from edge to edge, in an often contradictory manner.

The 'kitchen sink' painters

In a conventional still-life it is possible to estimate the space to the 'back' of the canvas – say the width of a table top. In a Cézanne the table top may appear to be tilted up, reducing the space in the canvas to a foot or so; in a classical Cubist still-life the back may apparently be only an inch or two into the canvas, as if in a sculptural bas-relief. Cubism once more asserts the abstract, timeless quality typical of Egyptian and medieval painting and has an affinity with the drawing of the architect or engineer, in contrast to the camera-eye view of everyday life.

Conventional still-life painting continues today with painters finding delight in the never-ending variations in form and colour of fruit and flowers, and in contrasting them with man-made objects. The elevation of everyday things on to the walls of galleries has become increasingly aggressive in the hands of the 'kitchen sink' painters, who emphasize the shabbiness and disorder of things in use; and in the hands of the pop painters who turn the still-life into an immaculate cult object.

The English painter, John Bratby (b. 1928), shows a half-finished packet of corn flakes, a chip-fryer dangling from the corner of a chair, a table crammed with kitchen utensils, groceries and refuse. Datable as these objects are, the timeless quality of the still-life is still present. Perhaps a painter who typifies the power of the still-life to reveal a philosophic depth in the deceptively simple is Giorgio Morandi (b. 1890). He devoted his life to the contemplation of objects on a shelf, yet succeeded in portraying in them a deep mystery.

Painting the face of nature

Each landscape and marine painting reveals an artist's response to some part of Man's natural environment. Chiefly idealized in the past, today Nature is used as a vehicle of personal feeling.

FEW CAN RESIST the appeal of landscape and marine painting, which transforms raw pigment into images of cloud, earth and sea. Yet artists have not always concerned themselves with the external world in this way. The ancient Greeks were content to present landscape in crude symbol, merely painting a few horizontal lines across the picture.

From these token beginnings in late Greek art, the Romans developed a landscape art which conveyed sensations of space, light and atmosphere. Two Roman achievements – a series illustrating Homer's Odyssey and a number of wax emulsion mural paintings from the Casa Livia – are among the most beautiful landscapes ever painted.

Despite such hopeful beginnings, for some twelve centuries, from ancient Roman to early Gothic times, landscape appeared mainly as a symbolic background to themes dominated by human figures. For much of this period the monastic doctrine that what delights the senses is sinful added to the general mistrust of nature, and the dangers of forest and ocean discouraged interest in realism.

Then in the thirteenth century a strong vein of naturalism appeared in manuscript illuminations. Secular as well as religious subjects appear in the frescoes of the Papal Palace in Avignon, and foreshadow the freely developed landscape art of the early fifteenth century. After 1400, landscape painting began to develop along diverse lines encompassing the fantastic backgrounds in Renaissance painting, as in Benozzo Gozzoli's *Journey of the Magi*; the beautiful records of places visited on a journey by Albrecht Dürer; and the realistic panoramic backgrounds to works like Piero Pollaiuolo's *Martyrdom of St Sebastian*.

Leon Alberti's book, *Della Pittura* (About Pictures), published in 1436, contains the first scientific treatise on perspective. Widely used by Italian painters such as Piero della Francesca and Paolo Uccello, the theories were of limited value to the problems of landscape.

Alpine snows and hell-fire

More helpful was his 'magic box' device, the *camera obscura*, which was much used by the seventeenth- and eighteenth-century Venetian and Dutch landscape masters. It consisted of a cloth-covered framework with a lens at the top surmounted by a mirror. The mirror reflected the external scene on to a horizontal surface, so making it possible to trace out visual relationships of shape and size.

The analysis of landscape structures, especially geological and botanical, was among the many scientific interests of Leonardo da Vinci (1452–1519). He made many intricate drawings of rock formation and panoramic landscapes. Most of these remained in his personal sketch books and, as a result, his influence on landscape painting was not especially strong, except perhaps through the backgrounds to his *Mona Lisa* and the *Virgin of the Rocks*. In general, however, the field of landscape painting is one in which the High Renaissance had comparatively little to contribute.

It was in northern Europe, relatively

A Dark Day in February by the Flemish painter Pieter Brueghel (*c.* 1525/30–69), who had deep feeling for the countryside and all rural activities. In this picture the inhabitants are repairing the damage a storm has done to their village.

John Constable (1776–1837) was one of the most important influences in the development of landscape painting. This tranquil scene, *right,* shows Dedham Mill in Essex with its meadows, water and dappled skies and is typical of his work.

unaffected by Italian humanist culture, that landscape painting really began to develop as a mode of painting in its own right. Conrad Witz's *Miraculous Draught of Fishes,* painted in 1444, shows a view of Geneva and the distant Alps. It is one of the first pictures in which the landscape predominates and represents a specific place.

Flemish landscape realism and the landscape construction of Italian artists like Piero della Francesca fuse in the work of Giovanni Bellini (1431–1516). His emotional response to light effects creates strong poetic overtones to his keen observation of places. Many of his landscape backgrounds can be identified among the towns of the Veneto. More than any other early painter, Bellini foreshadowed in his work the achievements of seventeenth-and eighteenth-century landscape masters.

In the North, the wild, hell-fire backgrounds of Hieronymus Bosch (1450–1516) and Matthias Grünewald (1475–1528) exemplify a quite different approach to landscape. Landscape forms and the more violent effects of light are convulsed and intensified to express mystical states and a spiritual rapture. Albrecht Altdorfer (1480–1538) had a more moderate response to landscape: his little *St George* in Munich is one of the first romantic landscape pictures.

The Flemish painter Pieter Brueghel's (c. 1525–69) contribution to landscape is specially important. While much of his work is similar to the fantasy world of Bosch, it is clear that he felt compelled to record details of the countryside, the seasons and all the human activities associated with them. The result was a series of landscapes showing the cycle of the months of the year and included in these are sections of marine painting to which Brueghel made a significant contribution (e.g. *Storm at Sea,* now in Vienna).

Energy and atmosphere

Peter Paul Rubens (1577–1640) brought to landscape the same splendid energy that invests all his paintings. He handled the forms of landscape with high sensitivity, characteristically using spirals and arcs as the basic geometry. The theatrical effects of nature – rainbows in stormy skies, meteors, bursts of sunshine and cataracts of water – delighted him.

By the early seventeenth century Rome had become the principal centre of art. Distinguished painters from the North formed colonies there. Two of France's greatest painters, Claude Lorrain (1600–82) and Nicolas Poussin (1593–1665), spent

Above right, The Earthly Paradise, by the fifteenth-century Venetian painter Giovanni Bellini, where the landscape in the background emphasizes the peace and tranquillity of the scene. Bellini's influence was felt throughout Europe, not least by Albrecht Dürer (1471–1528), whose *View of Arco* is shown *right.* Dürer visited Venice and must then have painted this Italian town. A landscape is rarely the whole subject of the painting at this date.

almost the whole of their working lives in Rome.

For Poussin, landscape was frequently just a setting for the drama enacted by the figures in the foreground, but towards the end of his life the landscape itself began to play the dominant role, contributing to the mood and sentiment of the subject matter. His aim was to impose classical order on to direct experience of nature.

Claude Lorrain by comparison was a dreamer, musing on themes from antiquity yet depending on a strong emotional response to the ever-changing aspects of nature. This is especially well demonstrated in his water-colour drawings, which are some of the most beautiful of all landscapes. The magical qualities of light to be seen in his work later affected the development of the English artist J. M. W. Turner (1775–1851).

Seventeenth-century academics thought that painting should be judged by its moral, historical and philosophical content. Such theories were not helpful to the development of landscape. Not surprisingly, during this century the main centre for this art was the Low Countries, where there was little or no classical tradition. Protestantism here discouraged religious painting, and respectable, middle-class patrons were far more interested in straightforward pictorial records than in idealized compositions.

These painters from the Low Countries seem to have been magnetically drawn to the image of their countryside: it was a flat landscape of vast skies and waterways, calculated to arouse an interest in atmospheric effect. The generalizations typical of so much earlier painting were useless in solving the problems of place, time and weather which had to be faced by the Dutch painters of sea and sky and flat, receding plains. Van Goyen (1596–1656), Jacob Ruisdael (1629–82), Meindert Hobbema (1638–1709) and Aelbert Cuyp (1620–91) are the great figures, with Jan van der Cappelle (1624–79), Adriaen and Willem van de Velde (1633–1707) representing the best of the marine painters.

Constable and Turner

Rembrandt van Ryn (1606–69) also painted a dozen or so impressive landscapes, but they are so charged with 'inwardness' that they are landscapes of the spirit rather than representative examples of the Dutch style.

England in the late eighteenth century

J. M. W. Turner, the English marine painter of the nineteenth century, is famous for his use of light effects in his pictures. *Above, Snowstorm – Steamboat off a Harbour's Mouth.* The artist was actually in the boat, lashed to the mast, in order to observe the storm at really close quarters.

was much affected by the example of Dutch landscape and marine art. East Anglia, with its long-standing commercial ties with the Low Countries and a countryside similar in parts to that of Holland, became the source of much English landscape painting. Thomas Gainsborough (1727–88), John Crome (1768–1821) and John Constable (1776–1837) were all influenced by the Dutch masters.

Constable and Turner were themselves amongst the great formative influences in the development of landscape and marine painting. The whole field of nineteenth-century landscape painting is foreshadowed in their work. Constable speaks of the art of painting as being 'scientific' as well as 'poetic', and in his vast output of sketches he made many scrupulous notes about cloud formations and conditions of frost and dew. Scientific observation led to a freshness and naturalization in his work. Nature moved him deeply and,

57

in his later years his landscape paintings came to express his own inner life.

These pictures were incidentally to have a deep influence, some 30 or 40 years later, upon the French Romantics. The methods adopted by Constable and Turner greatly extended the technical range of painting. Such techniques as *glazing* (applying a transparent layer of oil paint over a solid one, so modifying the colour of the first) and *impasto* (when the paint is so thickly applied, by brush or palette knife, that it stands up from the canvas in lumps) were used with a new freedom.

French artists throughout the nineteenth century responded with enthusiasm to the work of Constable and Turner. Their example and genius inspired a new flowering of romantic painting in France, influencing Eugène Delacroix (1798–1863), Jean-François Millet (1814–75) and, later, the Impressionists.

Heralding the astonishing landscape achievements of mid-nineteenth-century France was the work of Jean Baptiste Corot (1796–1875), Gustave Courbet (1819–77) and Eugène Boudin (1824–98). The Impressionist painters who followed them learnt much from their direct way of responding to landscape. Corot was able to approach landscape without the pre-judgements of earlier landscape conventions. Boudin exerted a similar influence through his pupil Monet. Courbet used paint richly and sensuously, and spread his impasto so as to give his landscapes and seascapes a superb massive effect. Monumental cliffs, curling waves, dense foliage – all become vividly real.

A question of 'eternity'

From the systematic study of colour and visual perception evolved Impressionism, a new theory and practice of painting, increasingly removed from the simple description of a scene. One group of artists, among them Georges Seurat (1859–91) and Paul Signac (1863–1935) constructed pictures from *pointilles,* myriads of tiny points of pure colour. To the eye of the viewer, the points seem to fuse to create subtler colours.

Paul Gauguin (1848–1903) used landscape symbols as ways of expressing thoughts, dreams, and recollections rather than as a report of direct experience. Similarly, the art of Vincent van Gogh (1853–90) became increasingly a reflection of inner turbulence and final chaotic despair, rather than of the external world. These three different viewpoints – the technical innovations of Seurat, the decorative symbolism of Gauguin, and the passionate immediacy of Van Gogh, were all influential in the work of a group known as the *Nabis* (prophets) which included Bonnard and Vuillard, and of the *Fauves* (wild beasts) such as Matisse, Derain, Marquet and others.

Paul Cézanne (1839–1906), though he too had an early Impressionist phase, turned his attention to controlling colour so that it came to indicate spatial relationships. He also constructed forms on the canvas in an organized manner recalling the disciplined classicism of Poussin. His land-

Above, *A Windmill by a River* by the Dutch landscape painter Jan van Goyen (1596–1656). The Low Countries produced many great painters who were drawn to the flat landscapes and myriad waterways of their countryside and who portrayed them in their work. This painting is very simple in composition and relies for its effect on the low horizon and the broad sweep of the sky.

This is a panel of *St John the Baptist Returning to the Desert* from an altarpiece by the Sienese painter Giovanni di Paolo (*c.* 1399–1482). The panel depicts St John leaving his town and then appearing later on in his journey. Giotto's discovery of perspective techniques was not well known at this time, and St John is lost in the formal landscape of rocks, woods and fields.

scapes were massive and solid. He said of them, 'Our art should enable us to feel Nature as eternal.'

The first half of the twentieth century unleashed violence that shook Man's confidence in the image of nature as eternal. Perhaps it is as a result of this uncertainty that landscape painting has declined. No national schools have emerged since 1900, but a number of individual artists continued to respond to landscape.

Among the first exploratory works of Cubism are several based on the landscapes around the hill towns of Spain, the French Pyrenees and Provence. The landscapes of Kokoschka fuse the colour qualities of late Impressionism and the restlessness of Northern expressionism – Soutine's landscapes carry these intensities to their furthest extreme – and many of the Surrealist painters used land-

scapes as a setting for their fantasies.

In France, Jacques Villon, Dunoyer de Segonzac and Nicolas de Stael continued the landscape tradition in their various ways, while in America an artist like Milton Avery has made highly personal extensions to the shapes and emblems of Gauguin's landscapes.

In England, Paul Nash and Graham Sutherland have developed a landscape of symbols (introduced over a century earlier in the visionary works of Samuel Palmer), and Ivon Hitchens has caught the mood of the Sussex countryside in subtleties of colour. They are swept on to the canvas with all the freshness of his deep knowledge and love of the area where he has lived nearly all his life. All these artists use landscape as a sounding-board for their own emotional or intellectual concerns, rather than as a means of expressing a faith in the stability of the natural order.

The French Impressionists

With new, shimmering colours and a breathless informality of technique, this group of young men forced their reluctant contemporaries to look at nature in a completely different light.

IN 1894 THE painter Gustave Caillebotte bequeathed 67 Impressionist paintings to the Louvre in Paris. Official embarrassment and public reaction was characterized by the words of an Academician: 'Only great moral depravity could bring the State to accept such rubbish. These artists are all anarchists and madmen.' Such hostile opposition had faced the Impressionist painters since their first collective exhibition in 1874.

They were not the first French painters to challenge bourgeois public taste and the traditional values of Academic art. Gustave Courbet, with his aggressive opposition to long-standing artistic conventions in the 1850s and Édouard Manet in the 1860s had set the precedent. Manet had been a key figure in the famous Salon des Refusés of 1863, where works rejected by the official Salon were hung. His intention was to create an art free of conventional artifice. He wanted to paint directly from the subject, guided only by his visual sensations and his aesthetic sensibility. In this lay his great originality and in these respects he anticipated the Impressionists.

They painted what they saw

Without the decorum of Classical idealism Manet's nudes appeared vulgar and indecent; without any strong narrative or allegorical basis his figure compositions seemed pointless. Technically his paintings lacked most of the solid attributes of draughtsmanship, perspective and refined tonal modelling of contemporary Academic art.

When the Impressionists came to the critics' attention they were immediately linked with Manet, as much for their break with convention as for any specific common ground. He was widely thought to be their leader. At the first group exhibition in 1874, all the important Impressionist painters – Monet, Renoir, Pissarro and Sisley – were among the 31 artists who took part. Manet refused to exhibit with them. He retained an extraordinary sense of obligation to the Salon as 'the real field of battle', but he supported them morally and financially when he could. His notoriety naturally endowed him with an elevated status in the eyes of young radicals. His was an art of sensation; he painted what he saw, true to his responses. This was central to their own concept of painting.

The Impressionists painted on the spot, in the open air. Their concern was with light, colour and atmosphere in nature. With this principal interest Manet had little in common. The real ancestors of the Impressionists were the nineteenth-century landscape painters; Constable and Turner in England; Corot, Courbet and

Manet's break with convention linked his name with the Impressionists. *Above,* his *Olympia* caused a great scandal, for the figure's real-life appearance was offensive to the public. *Below,* study of a dancer by Degas – a masterpiece of arrested movement captured with a few swift strokes.

the Barbizon painters in France (the name Barbizon comes from the village of Barbizon near the Forest of Fontainebleau, where Théodore Rousseau, Millet, Corot, Daubigny, Diaz and others worked in the mid nineteenth century).

The young Impressionists met in Paris in the 1860s. Claude Monet (1840–1926), Auguste Renoir (1841–1919) and Alfred Sisley (1839–99), fellow students at the École des Beaux-Arts, made several painting excursions to Fontainebleau during these years and came into personal contact with the Barbizon painters. Camille Pis-

sarro (1830–1903), older and at this stage a more isolated figure, was more influenced by Courbet and Corot. The sort of advice these young men received from the older generation of painters predisposed them to break completely with the concepts of their Academic tutors in Paris. Courbet advised them to 'sit down anywhere and paint what you like'; Corot insisted that the first impression of the subject was all-important and that this alone should determine the painting's values. Monet received similar advice from Boudin, painter of seascapes from his home-town Le Havre.

The graduation from these precedents and theoretical standpoints to the first Impressionist paintings of the early 1870s was the combined achievement of Monet and Renoir. Both were gifted with a rare facility of touch. Renoir, trained as a porcelain painter, painted from the start with an almost abandoned enjoyment of his medium and with a very original and delicate sense of colour. Monet, the dominant figure of Impressionism throughout the movement's history, also possessed a prodigious ability to achieve a likeness. Through his inspired judgement of tone values in the simplified main areas and the judicious placing of a few points of emphatic light and colour, he effortlessly realized Corot's concept of nature contained in an 'atmospheric envelope'.

For a while in 1865–6 he attempted to reconcile this sort of spontaneous perception with large-scale figure compositions, emulating the *pastorale* idea of Manet's *Déjeuner sur l'Herbe* and conforming more to the Salon tradition of paintings with some sort of agreeable narrative theme.

Renoir and Monet — the two great giants of Impressionism — committed to canvas their first, spontaneous responses. Renoir was captivated by scenes of Parisian life like the *Dance at the 'Moulin de la Galette', above.* In his late pictures of water-lilies, *right,* Monet applied a haze of colour diffused by shimmering, shifting pools of light.

This whole idea conflicted with his basic principle of an immediate visual *rapport* between the artist and his subject, and after several attempts he abandoned the idea. By 1869 he and Renoir were resolved to paint *only* in front of the subject, to paint small, portable pictures and above all, to concentrate all their resources on one single objective: to capture the unique moment of experience.

As Impressionism matured, the actual identity of the subject became less important. Monet wrote that you should 'try to forget what objects you have before you' and record only the coloured shapes your eye could see. In effect, the elusive nature of perception itself became their subject.

In this extreme sense, Impressionist landscape painting of the 1870s stood for the most limited objective of all European art. Their painting had no intellectual or conceptual framework, no symbolic or narrative subject-matter. What is more, they abandoned all traditional concepts of technique, finish and composition. The technique that they evolved, part conscious, part intuitive, was revolutionary in two respects: in its colour and in the freedom of its brush-marks.

To take colour first: because of the unprejudiced honesty of their vision, they actually saw colour in a new way. It is generally true to say that before the

Monet's passion for truth to nature led him to paint the same theme over and over again to capture different effects of light. This picture of Rouen Cathedral, *left,* was painted in the evening. *Below left, The Flood at Port Marly* by Sisley shows a more subdued handling of colour, but the same truth to visual sensation is apparent.

Impressionists, colour in painting was tied to the concept of 'known' local colours. If an object was seen and known to be red, then it was painted red in all circumstances. Apart from variations of colour in the interests of expression, this tonal system had not been seriously questioned since its perfection in the fifteenth century.

In the course of their intensive investigations of natural appearances, it became increasingly apparent to Monet and Renoir that colour was in reality not constant: that a shadow cast on any object did not just darken, but actually changed its visible colour. They recognized that all colours in nature were conditioned by light and atmospheric conditions and were constantly subject to change. When they introduced these ideas into their painting, a perceptive critic realized that their colour was 'so true and so natural that one might well find it false'.

What applies to the impermanence of colour under atmospheric conditions also applies to the impermanence of form. The recognition of three-dimensional solidity and stability is another 'known' rationalization of perception. The destruction of this second constant of traditional art – form – was the essence of the other technical revolution achieved by the Impressionists. This was the loose, separate and 'unfinished' quality of their brushwork, with no contours, no stable boundaries.

'Only an eye'

By comparison with any painting exhibited previously, the 1870s paintings of Monet and Renoir were extraordinarily incomplete and indefinite. They did not present the viewer with a comprehensive reconstruction of a visual experience, but with the simultaneous impact of many fragmentary sensations. The pleasurable shock of recognition that we experience when our eyes and minds collate these sensations to some extent reproduces our purely visual experience when suddenly confronted with an unfamiliar view. In the same way a familiar Impressionist painting can never quite recapture that first stimulating moment of confrontation. In this sense Impressionism is an extreme form of illusionism.

Cézanne later criticized Monet as 'only an eye', and certainly his paintings were not the synthetic products of eye and mind. We are not led into the picture from one object to another; there is no sequence, no focal climax. The whole surface is equally articulate, or rather equally inarticulate, alive with incomplete raw material.

The separate brush-strokes contribute to the sense of immediate spontaneity; they carry a sense of breathless gesture. To some extent they were a matter of expediency: the short life of a particular atmospheric condition demanded rapid

Almost all the women Renoir painted have the same soft and gentle appearance. The curving forms in this detail from *The Umbrellas, left,* are echoed in the shapes of hoop and umbrellas. Pissaro was the most consistent of the Impressionists, and the only one to exhibit in all eight of their exhibitions. The clever interplay of light and shade in *Entry to the Village, right,* make the spectator feel he is part of the scene.

execution. But they also allowed the painter to separate component colours and to preserve the shimmering vibration of complementaries by inviting the colours to blend in the viewer's eye rather than on the painter's palette. Monet's seascapes are full of iridescent greys made from small interwoven marks of yellow, pink, violet and blue. But their use of complementaries was never scientific or systematic. Their whole way of working called for rapid selection and instant decisions.

Knowing this, it is obvious that we can talk of 'an Impressionist technique' only in a very loose sense. Although their ambition was objectivity, the very nature of a first visual impression is intimately personal. The subdued sensitivity of Sisley and the more considered formality of Pissarro set them slightly apart from the extreme attitudes of Monet and Renoir. Their technique is less audacious, their colour less spectacular. The choice of subject, too, varied with temperament. Pissarro's domestic peasants, Renoir's gay Parisian life and Monet's railways and boulevards are personal and original aspects of the late nineteenth-century painters' repertoire.

Edgar Degas (1834–1917), who shared in their exhibitions and is always linked with the movement, was scarcely an Impressionist at all. He despised spontaneous open-air painting and was by preference a draughtsman with a true Academic's instinct for experiment, research and completeness. His affinity with the Impressionists lay in his brilliant perception of light and arrested movement. Exclusively a figure painter, his paintings, pastels and drawing of contemporary life married his accuracy of vision to a Classical sense of design, closer to Manet than Monet.

Pissarro alone contributed to all eight

Impressionist exhibitions: to him it was almost a matter of moral and political principle. By 1886, the year of the last exhibition, the homogeneity of the original group had dissolved and the mood of progressive painting in Paris had been transformed.

The 1880s were the heroic decade of what is called Post-Impressionism. The art of its great figures, Cézanne, Seurat, Van Gogh and Gauguin, all bears some relationship to Impressionism. For all of them the latter was inadequate – 'only a way of seeing' to Cézanne, too unscientific for the 'Neo-Impressionist' Seurat, too scientific for Gauguin, too 'sloppily painted' and objective for Van Gogh. All reacted to some extent against the Impressionists' concern with appearances.

Within the Impressionist group itself, Renoir's later Classicism and Pissarro's flirtation with Neo-Impressionism were symptomatic of the dissatisfied 1880s, leaning towards a more monumental form of constructive painting. But it is also true that the technical revolutions of Impressionism already anticipated this new concern in surface organization.

Coloured stitches

The heightened colour and gestural brushmarks drew unprecedented attention to the picture surface. The Impressionist surface was an intricate tapestry of coloured stitches. As outraged critics complained, you were aware of the coloured marks before you recognized the subject.

The more systematic organization of paintings by Seurat, Cézanne and Van Gogh derives directly from the fabrics of marks that Monet and Renoir created. The idealistic vision behind these works was also an expansion and an enrichment of the Impressionist act of looking. Only Gauguin, who exhibited at four of their

exhibitions, completely abandoned both their objective vision and their small-unit technique.

While others were withdrawing from the exclusive Impressionist disciplines, Monet in the 1880s concentrated more and more tightly on elusive momentary appearances. To overcome the problems of atmospheric change, he evolved the technique of painting a series of pictures of each subject, changing canvases in time with nature. In the 1890s, during the *Poplars* series, he worked for only seven minutes at a time on each canvas before changing, and became terrified of reworking the *Rouen Cathedral* pictures for fear of damaging the accuracy of the original impression. For a series of Thames pictures around 1900, he had at one point over 90 canvases stacked against the wall by his side.

The discipline of his ambition created intolerable strain and anguished frustration ('the sun sets so fast I can't follow it'). Right up to his death in 1926, he considered himself an Impressionist, but in his late paintings of his water garden at Giverny, his heightened perception achieved the intensity of a nature mystic. Painted on a mural scale, his images drift informally across the surface, vast expressive decorations. The rarefied atmosphere of these last canvases is comparable to the ecstatic vision of nature in Van Gogh's Arles landscapes and Cézanne's paintings of Mont-Saint-Victoire.

The heritage of Impressionism is many-sided. Man's way of looking at things was irrevocably conditioned by the acute Impressionist vision. In the artist's social context, the group's collective gesture of independence created a lasting precedent. Historically their art was a conclusion and a beginning: both a consummation of the European tradition of illusory naturalism and a daring advance in the fields of colour and sensation.

Painters of protest

Moved to anger by the wars, poverty and unemp[loyment]
Realist painters deliberately aimed at appeal to th[e]

ART AS the American painter Ben Shahn says, can arise from something stronger than stimulation or even inspiration. It can, he says, take fire from something closer to provocation.

This was particularly true in the nineteenth century, when the stresses and strains of nationalism and industrialization produced one crisis after another, and alienated the more thoughtful and progressive artists from society. Rumbling discontent preceded organized revolt. Sides were taken with varying degrees of personal commitment. Under the militant influence of anarchism and Marxism, this resulted in realistic forms of art being developed as a weapon in what was universally and sincerely felt to be a fight for 'better times' – usually in the shape of some utopian concept of a future society.

This art, which is known as Social Realism, derived from the realistic tradition of the Renaissance. It has at various times moved from one form of art to another, while endeavouring to maintain

points of contact with a popul[ar]
The graphic accusations of [Goya were a]
source of inspiration, as were t[he etchings]
of Rembrandt and the moral [tradition of]
William Hogarth. Througho[ut the nine-]
teenth century their influenc[e grew]
and had its biggest impact in [Victorian]
England, where the innovati[ons of litho-]
graphy and wood-engravin[g provided]
artists with new media of pi[ctorial com-]
munication, stimulating the [development]
of social comment.

Hard-hitting social satir[e]

Lithography is a cheap proce[ss for pro-]
ducing an image drawn on li[the stone by]
the artist himself. In France, [a vigorous]
radical Press introduced Hono[ré Daumier]
(1808–79), who made some [4000 litho-]
graphs. His engaging human[ity softened]
the hard-hitting punch of a[n ardent]
partisan of social and politica[l justice. In]
England, the application of wo[od-engrav-]
ing to journalism was a mea[ns of pro-]
ducing a re-drawn version of[...]

Fantastic and surrealistic painting

Bosch's denizens of Hell, the visions of William Blake, the incongruous imagery of Max Ernst and Salvador Dali – are they chance figments of a dream world or symbols of a super-reality?

AN ELEMENT of the supernatural is found in art from its very beginnings in the cave-paintings of the Palaeolithic period. Certain representations of the human figure, such as the so-called 'sorcerer' of Les Trois Frères (Ariège, France), a man covered with the pelt of a reindeer, are interpreted as evidence of religious or magical practices in these remote ages. Throughout its history art has been associated with the supernatural elements in religion, but this article is concerned rather with the supernatural elements in art itself, those which spring from the artist's own imagination.

Such elements are of two kinds – those which are consciously invented by the artist, and those which, in the manner of dream-images, arise spontaneously from the repressed or unconscious levels of his mind. The Greeks tended to regard the arts of painting and sculpture as conscious crafts – only certain forms of poetry, according to Plato, were 'divine and from the gods'.

Nevertheless, there is in classical art and in the art of the Ancient World in general a symbolic element derived from the supernatural world of the gods, but it is never a personal art, never a representation of the artist's own fantasy. Angels and demons, gods and goddesses, supernatural beings of every kind may be represented, but the manner in which this is done is strictly prescribed.

Dream-images and nightmares

Generally speaking the same is true of early Christian art, which in its beginnings takes over and adapts the conventions of Roman art. New symbolic forms gradually emerge to express a new spiritual belief, but these are 'icons', that is to say, sacred images strictly controlled by the priesthood. Such control extends throughout the Byzantine period, and it is only with Gothic art that an element of the artist's own fantasy begins to intrude.

Already in the Byzantine period, however, the Church became very conscious of this disturbing element, and various efforts were made to control it, beginning with the movement known as Iconoclasm in the eighth and ninth centuries. These persisted throughout the Middle Ages, culminating in the extreme forms of Puritanism in the period of the Reformation.

The release of the artist's private world of fantasy had to wait for the Renaissance, and even then it first took the form of conscious fantasy. We associate the Renaissance with the revival of Classicism, but the greater part of Renaissance art is still devoted to Christian iconography, although admittedly some degree of fantasy could be introduced into the

The landscape of a dream, this woodcut, *above*, is a detail of an illustration printed in Venice in 1499. One of a series, it accompanied the romance entitled *The Dream of Poliphilus*. These pictures are among the first examples of the conscious use of dream-imagery in Western art.

Strange echoes of classical architecture appear in the paintings of Giorgio de Chirico, an Italian painter who helped to create the Surrealist Movement in art. *The Disquieting Muses, above,* with its empty vistas, exaggerated perspective and curiously calm figures has all the elements of de Chirico's early style. Later, the artist turned to visions of interiors peopled by mannequins and mechanical instruments. In the 1930s, he rejected the modern style in painting altogether, returning from dreams to naturalism in his art.

interpretation of the Christian legends.

An element of dream-imagery begins to enter into Italian Renaissance art with such works as *The Dream of Poliphilus*, a series of woodcuts illustrating an allegorical and architectural romance by Fra Francesco Colonna, printed at Venice by Aldus Manutius in 1499. This romance is actually the narration of a dream, and may be considered as a prototype of all subsequent art of the dream world.

Pure fantasy, however, first appears in the work of a contemporary of Francesco Colonna, Hieronymus Bosch, born at 's Hertogenbosch in Holland about 1450. It is important to emphasize the northern origin of this artist, because already in Celtic and Viking art there is an element of the grotesque altogether foreign to the classical (Graeco-Roman) art of the Renaissance, and there is also a rich source of irrational imagery in northern sagas, fairy-tales and folk-lore.

Bosch begins as an allegorical painter, with illustrations of such subjects as the Seven Deadly Sins. Other subjects, such as *The Conjuror, The Cure of Folly* and *The Ship of Fools*, are derived from folk-lore and popular parables. His great masterpieces, however, are of a different order,

by a group of writers and artists in Zurich in 1916.

Futurism began as a movement inspired by the machine, and by such abstract concepts as movement, energy and speed; but it rejected all forms of realism or naturalism, and has superficial relations with Cubism, the style evolved by Braque and Picasso in Paris in 1907. From Cubism Picasso developed a new style partly (but decisively) influenced by African tribal art, and gradually irrational images began to dominate his paintings. *The Three Dancers* of 1925 is his first major painting in the surrealist style.

Meanwhile, in Italy another painter had appeared who was to be one of the formative influences on the Surrealist Movement, Giorgio de Chirico (b. 1888). His compositions assembled fantastic architecture of a pseudo-classical kind, monumental sculpture, dummy figures, maps, geometrical designs and occasionally an incongruous railway engine. The general effect is dream-like, but poetic rather than terrifying.

The original element contributed by Dada, for which Hans (Jean) Arp was mainly responsible, was 'the law of chance'. Arp would tear up a piece of paper, let the fragments fall and fix them in the arbitrary pattern they assumed. Many other methods of 'assemblage' were practised by Arp and his fellow Dadaists in Switzerland (Francis Picabia), Germany (Max Ernst, Kurt Schwitters) and the United States (Marcel Duchamp).

Though some of these experiments were not strictly speaking 'surrealistic' in the sense of relying on unconscious imagery, they produced effects which, to the public, were certainly fantastic. When the First World War came to an end, some of the

Dadaists, notably Ar_ to move to Paris an_ Surrealist Movement._

Breton published t_ 1924, 1930 and 1934. In_ a coherent theory of '_ able to all forms of art_ but perhaps especially_ – it inspired one majo_ Éluard (1895–1952).

In addition to th_ mentioned (Arp, Ern_ group included severa_ to attain world-wide _ Miró, Salvador Dali, _ though never formally_ group, Marc Chagal_ (1879–1940). Klee, in_ made the greatest co_ artist since Bosch to 't_ world'. The relation o_ symbolic', he said, and_ best illustration of thi_

Liberating the unc_

Breton, who had a me_ scientific knowledge _ also deeply influenced_ Hegel and Marx.

His philosophy was d_ say, its aim was to effe_ between opposite aspe_ tence – to 'enable the_ barrier set up for it by_ reason and dreaming, r_ feeling and represent_ constitute the major o_ thought'.

He renounced the av_ or nihilistic aims of D_ an art 'in the service _ the social revolution o_ But such an art must c_

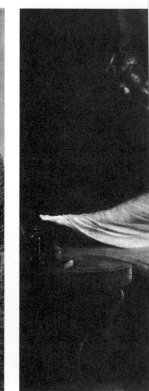

Goya satirized the manners of his day in a series of etchings called *Los Caprichos*. The abject, crouching figure is a miser; although over 80, with only a month to live, he is still afraid to spend money. Earl_ century, a vogue for horr_ works of a terrifying natur_ literature. *The Nightmare* l_

Braque's painting of the *Houses at L'Estaque* shows the influence of Cézanne. The use of solid geometric shapes directly foreshadows Cubism.

in Germany in 1919 – a significant act.

The Bauhaus was a school of design where the craft and design aspects of art were to be given equal importance with painting. Painting and sculpture as such were not taught as separate subjects, but from the start Gropius employed important painters like Klee to teach there. Kandinsky was invited to become Deputy Director in 1922 shortly after leaving Russia. In 1923 the Hungarian artist Moholy-Nagy joined the staff and from this period dates a change of approach: the emphasis shifted from a conjunction of arts and crafts (based on Morris's ideas) to an emphasis on design and technology.

When the Bauhaus moved to Dessau in 1925, close ties were formed with local industries. Although they were never on the staff, the influence of the ideas of van Doesburg and Lissitzky were important as well as those of Moholy-Nagy. Kandinsky and Klee produced some of their finest paintings at the Bauhaus. Moholy-Nagy and two former Bauhaus students Josef Albers and Max Bill spread the Bauhaus idea in art education, Moholy-Nagy in Chicago, Albers at Black Moun-tain College, North Carolina and later at Yale, Bill at Ulm. All three produced important work in their own right.

The development of painting and sculpture from Cubism through Russian Constructivism (abstract sculpture made of a variety of materials like wire and metal),

Picasso's early paintings in his 'Blue' and 'Rose' period are representational, unlike his later Cubist pictures. *Above, Self-Portrait.*

through the Dutch de Stijl movement to the Bauhaus can perhaps be seen as the 'central tradition' of twentieth-century art. It has a close connection with the modern movement in architecture and design. It is not however the only tradition. There exists also what the young American critic Gene Swenson has called the 'other tradition' of Dadaism and Surrealism. Where the central tradition has been essentially constructive and optimistic in the belief that painting, architecture and design can contribute directly to Man's physical well-being and spiritual enrichment, Dadaism was deliberately destructive, taking a hatred of the 'art of the museums' far further and less romantically than the Futurists. Dada began during the First World War in Zürich and spread to Paris, Berlin and New York.

The Dadaists introduced the important concept that what the artist does essentially is to choose, not to make; the former painter, Marcel Duchamp, constructed a series of 'ready-mades' from everyday manufactured objects like a comb and a bicycle wheel. These, by being selected, signed and exhibited by the artist, were transformed into 'art' or rather anti-art.

Freud and the unconscious

Surrealism as a movement began at the end of the First World War, but was actually preceded by the work of the Italian painter de Chirico, who painted dream-like, deserted townscapes based partly on the piazzas of Turin, and combinations of incongruous objects to give a strong effect of nostalgia and hallucination. The Surrealists were heavily influenced by Freud's theories of psycho-analysis and aimed to exploit the subconscious symbolism of dreams, aligning themselves with the anti-rational and the unconscious as against the 'reasoned and conscious' creation that Kandinsky foresaw in 1910 and which the central tradition of 'geometric abstraction' in painting and sculpture had realized. Like Dadaism, Surrealism was an important movement in literature as well as in art, and in fact most Surrealist painting has a highly 'literary' flavour.

Although the main tendencies of twentieth-century art have been towards abstraction, a strong figurative tradition has remained throughout. After painting monumental, slightly sentimentalized Neo-Classical nudes in the early 1920s, Picasso produced paintings and sculptures in the early thirties which have a Surrealist character and which are perhaps his best work. After the end of the war the Brücke group had lost its force and only Kirchner produced work of any importance. Of the Blaue Reiter group Marc and Macke had been killed during the war, and the two important survivors, Klee and Kandinsky, had gone to the Bauhaus. Max Beckmann, who had always been an isolated Expressionist, however, produced some of the most mature of all Expressionist works in the allegorical series he painted in the thirties on the brutalities of the Nazi régime, which drove him from Germany into exile in America.

The Modern Movement II

America exerts a powerful influence on art today, although a strong European tradition can be traced. Artists are concerned with the world of 'now' and with their own deeply felt responses.

IN THE late forties and early fifties American art emerged as an important force which could rival Europe, where, by this time, the modern movement was moribund. Picasso had produced his finest work in the early and middle thirties. The later work of Braque, who died in 1963, although perfect of its kind, had become limited in range and static since the days of late Cubism.

Mondrian and Kandinsky, however (who both died in 1944), and Matisse (who died in 1954) produced some of their most important work in their last years. Mondrian moved from Paris to London and then to New York, where the intensity and pace of life stimulated him to produce dynamic works full of the rhythms of jazz and city life. During the late thirties and early forties, Kandinsky worked quietly on his own in a suburb of Paris painting complex and vital works which, while remaining abstract, have the suggestion of organic or structural forms. Towards the end of his life, while bedridden, Matisse evolved a technique of enormous painted paper cut-outs in brilliant colour contrasts which are often almost entirely abstract and which represent the culmination of his long career. But in Europe it seemed that there were no important successors to these great pioneers.

American art, provincial during the nineteenth century, had made an early response to the revolutionary developments in France, Germany and Italy. In 1913 an enormous exhibition of modern European and American painting was shown in a disused armoury building in New York, and during the war years the photographer Alfred Steiglitz supported *avant-garde* artists and showed their work in his gallery. Probably the most important artist working in America at this time was one of his protégés, Max Weber, who had studied in Paris. His development of Cubism towards geometrical abstraction in some ways anticipates optical art.

Everyday subject matter

After the First World War, interest in the experiments in Europe waned, and although some artists incorporated the surface mannerisms of Cubism and abstraction, their work was mostly figurative or illustrational with an interest in everyday subject matter which has characterized American painting since its earliest days.

Between the wars, the two most important artists were Edward Hopper and Stuart Davis. Hopper's painting has superficial similarities to the Ashcan school of American realists of the early 1900s who painted the sordid realities of slum life, but his haunting, muffled paintings of slum and suburban streets, usually deserted except for one or two lonely individuals,

Pure, clean geometric abstractions like this *White Relief* were produced by Ben Nicholson in the 1930s. A champion of abstract art in Britain, his style derives from Mondrian and the Cubists.

are concerned with the isolation of people in the great cities. Where Hopper's attitude to the characteristic American urban environment is deeply pessimistic and melancholy, that of Davis is exuberant and joyful; his incorporation of advertisements and lettering looks forward to the Pop Art of the late fifties and early sixties.

Like many American painters, Davis started as a magazine illustrator. The Armory show was a crucial influence on his work, and during the twenties he developed a style which combines the structural qualities of the Cubists with the respect for the flat picture plane and the clean, optimistic colour of Matisse. In the *Egg Beater* series of 1927–8 Davis set up a still-life of an egg beater, an electric fan and a rubber glove and painted them again and again until they represented to him not real objects but relationships of colour, line and shape, in a style which was almost completely abstract. His later work sees the elimination of any suggestion of the illusion of three-dimensionality. This bears a strong relationship to Matisse's own late works, although it was probably independent of them.

During the Depression years the Roose-

velt administration set up the Federal Art Project within the Works Progress Administration, whereby sculptors, painters and graphic artists were employed by the government on a monthly salary to execute murals and similar public works of art in schools, air terminals, radio stations and other public buildings. Although Davis was employed under the FAP scheme, as were many of the artists who were to contribute to the Abstract Expressionist movement in the late forties and early fifties, few really important works were produced, and most of those that were have since been destroyed. What it did do was to tide artists over a very difficult period and, perhaps most important of all, give them a taste for working on a big scale which was a crucial influence on later developments in American art.

Amongst the younger painters were Arshile Gorky, Willem de Kooning and Jackson Pollock. Gorky had been born in Armenia, and during the twenties and thirties had carefully assimilated the work of Cézanne, Picasso, Miró and Kandinsky. Later, his contact with the Surrealists and their interest in automatic procedures of working and the use of chance and accidental effect gave him the stimulus to his own original contribution, a combination of free-flowing line and areas of colour which hint at floating, organic forms.

Response to Surrealism

During the 1930s there had been an exodus of artists from continental Europe. When the Nazis finally closed the Bauhaus school of design in 1933 the two most influential teachers went to America, Albers directly and Moholy-Nagy after spending some years in England. Later, after the outbreak of war, the Surrealists Masson and Ernst arrived.

Although the geometrical and constructivist ideals of Mondrian, Albers and Moholy-Nagy were to be an important influence on American design immediately, this influence was not to emerge directly in painting until the late fifties and sixties. Possibly because of the bitterness of the Depression years and the impending catastrophe of war, American painters found their mood far more responsive to Surrealism and Expressionism than to the optimistic idealism of geometric art.

De Kooning had been born in Holland, but had spent most of his life in America. He, unlike Pollock, was not so much influenced by Surrealism as by the simplified, emotionally loaded style of Expressionism and by Picasso's agonized figures of the period of *Guernica* which express the artist's abhorrence of war. De Kooning's Abstract Expressionist paintings begin from his still figurative Expressionist studies of women; the brushwork becomes more and more feverish until it seems to convey the impassioned gestures of the artist himself as he works, rather than any recognizable forms.

Pollock's work also derives from his earlier interest in the figure and in the post-Cubist work of Picasso, but unlike de Kooning he drew directly from the automatic experiments of the Surrealists.

Top left, Excavation, by Willem de Kooning, one of the leading New York group of abstract painters, hovers between realism and abstraction. *Above left,* one of Josef Albers' series of paintings he called *Homage to the Square;* where subtle colour combinations are explored using the same basic form – the square. Albers was influential as a teacher at the Bauhaus. *Top right, Blue, Black and Red,* by Ellsworth Kelly, who said, 'I am not interested in outlines, but in masses and in colour; the outline serves me only to give quietness to the image.' *Above right, Hugh Gaitskell as a Famous Monster of Filmland* by the English artist Richard Hamilton, a photograph distorted by paint, is a protest against the late Labour leader's nuclear policy.

He allowed the subconscious to take over in a seemingly random application of paint which covers the whole surface of the canvas in a kind of Expressionist arabesque. Pollock worked directly on unstretched unprimed canvases, using house-paint dribbled and flicked on with a stick or straight from the can. The painting became a record of the artist's actual activity as he moved round the canvas applying paint from all directions and at all angles in a seemingly random manner. When the painting was judged complete, the canvas would be cut and mounted on a stretcher.

To be successful, such a technique demands an ability to control this very free style which came from Pollock's long apprenticeship with more conventional methods of painting. His imitators, who by-passed this apprenticeship, were not able to achieve this. The Abstract Expressionist style was very quickly debased because it seemed to provide an unrestricted licence for free self-expression. Just at the time as Pollock and de Kooning were getting recognition – although some time after they had formed their characteristic style – a reaction towards a far less impulsive and more conscious manner of working, less open to self-indulgence, was growing amongst younger American painters.

In England a lively movement had arisen just before the First World War in the wake of Cubism and more particularly Futurism. This movement, known as Vorticism, had a vitality of its own, which seems to owe something to architects' and engineers' plans, and to aerial photographs. After the war, however, the two most important members of the group, Wyndham Lewis and Edward Wadsworth, and David Bomberg who was associated

In his late works, Kandinsky's forms float lightly through space bearing no rational relationship to each other. *Above, Ribbon and Squares.*

with it, reverted to a figurative style. During the early thirties Wadsworth again produced some abstract paintings for a short time and was associated with Abstraction-Creation in Paris, a loose grouping of artists who worked in the geometric style.

The modern movement seemed to have got off to a false start in Britain, and the 1920s was a barren period. It was not until the arrival of Naum Gabo, Mondrian and Moholy-Nagy in England in the thirties (all *en route* for America) that British art again contributed anything important. During the middle and late thirties Ben Nicholson produced his geometric abstractions based on the circle and the square, and the sculptors Henry Moore and Barbara Hepworth did their best work in which a Surrealist element is quite successfully mixed with a clean, cool abstraction.

Pop Art and action painting

Like the First World War, the Second World War seemed once again to produce a rather tired figurative romanticism. This gave way in the 1950s to a worried, spiky Expressionism in sculpture which gained some international recognition but which looks rather dated today.

In the early and middle fifties, painters in England and America were experimenting independently of each other in a manner of styles loosely known as Pop Art. Pop Art is not so much a style itself as an attitude towards material or subject matter. The subject matter of Abstract Expressionism – action painting – was the artist's own sensibility, as revealed directly in the marks he makes on the canvas; it was nearly impossible, or at least very difficult, to achieve any degree of detachment or objectivity. The younger painters felt that the Abstract Expressionists were retreating into a private world of self-communion. Unwittingly

they had devalued art, because in elevating self-expression they had helped to bring about a situation where virtually any expressive gesture or act produced by anyone calling himself an artist was liable to be treated with respect. This was self-expression and individualism reduced to absurdity.

It was against this situation that the Pop artists reacted. Roy Lichtenstein has said in an interview: 'It was hard to get a painting that was despicable enough so that no one would hang it – everybody was hanging everything. It was almost acceptable to hang a dripping paint rag, everybody was accustomed to this.' In this situation artists like Lichtenstein found it necessary to find material which *was* despised – commercial art, comic strips, advertising hoardings, motor car styling – and by incorporating this subject matter directly into their paintings, in the poet Ezra Pound's phrase, 'to make it new'.

Assemblage (the incorporation of objects and photographs) leads to the work of Ed Keinholtz and George Segal. Their hor-

In *Farmer's Wife No 2* the Scottish painter Alan Davie explores the private world of his imagination using a technique of scribbled lines.

rific tableaux of melancholy lonely plaster figures belong to a tradition of social protest which has its roots in the Depression years of the thirties. Richard Hamilton's blow-up of a screen photograph, hideously distorted by the application of paint, *Hugh Gaitskell as a Famous Monster of Filmland,* is virtually the only British example, painted in protest against the late Labour leader's nuclear policy.

Many of the younger American painters like Rauschenberg, Johns, Stella and Noland had studied under Albers at Black Mountain College in North Carolina or at Yale University. With Moholy-Nagy, Albers had devised and run the Basic Course at the Bauhaus, where students were encouraged to experiment with materials of all kinds, discovering for themselves the nature of form and relations of volume, mass, plane and surface. In America, Albers extended this into a very thorough education in colour. At the same time as he was teaching at Yale, he was producing his own series of masterly colour variations, the *Homage to the Square* series. Here innumerable subtle colour relations are explored in virtually identical formats of squares within squares.

Advertising and packaging

Although most of Albers' pupils have adopted styles which seem to have little in common with his own work, the subtle use of large areas of colour divorced from particular forms probably owes much to his example. In England some abstract painters like John Hoyland adopted these methods. In America two different painters have explored very different approaches to colour. Morris Louis poured diluted acrylic paint on to unprimed, unstretched canvas so that it sank into the material like a dye. He folded the canvas so that the colours ran down and blossomed into burgeoning, flower-like forms of soft-edged stripes. Ellsworth Kelly juxtaposes hard-edged areas of very clear, almost Matisse-like colours, so that they do not interact so much as sing against each other in strident, exhilarating discords.

In California, artists like Richard Diebenkorn have evolved a style that has its roots in Abstract Expressionism, and the English painter David Hockney, who was initially linked with the Pop movement, has caught the despair underlying the clean, hygienic surface of life on the American West Coast.

Alan Jones, also an exponent of British Pop Art, has evolved a style based on the overt sexual titillation of advertising which seems more ironic and detached than that of American equivalents like Tom Wesselmann and James Rosenquist. Richard Smith has lived for long periods in New York but his forms derived from American packaging and advertising, and his colour that reflects the sweetness of modern colour photography, reveal the romantic attitude to the American way of life of an outsider. So do the rather tougher works of a younger British painter, Peter Phillips, who has also lived in the United States.

Art goes Pop

Embracing material hitherto despised — science fiction, comic strips, pin-ups — Pop has created a revolution in the art world by questioning the very notion of what art should be.

Pop is characterized by a predilection for mass media. An important innovator in America is Robert Rauschenberg, who accepts the society in which he lives, and incorporates its images in his work. His *Short Stop* is shown, *left. Right,* using a 1930s' style, the young English artist

Patrick Caulfield transformed *Greece Expiring on the Ruins of Missolonghi* by Delacroix and rendered it in a simplified, anonymous fashion.

IN 1957, Richard Hamilton, one of the first artists to produce Pop, put on paper a rough working definition of what Pop is. It is: intended for a mass audience, transient, expendable, mass-produced and cheap, young, witty, sexy, gimmicky, glamorous and deeply involved in Big Business.

This definition radically opposes all the traditional ideas of what 'Art' should be like. According to the majority of writers and artists ever to have attempted the difficult task of defining the nature and purpose of art, it is: intended for a select few, enduring, precious, unique and costly.

Such a radical reappraisal of 'Art' and 'culture' is the most important aspect of Pop. Pop artists force us to ask questions about the nature of 'culture' itself. What exactly *is* art? What can 'cultured' people permit themselves to enjoy, and what must they recognize as beneath them? Is not our notion of 'fine art' and 'culture' snobbish, narrow-minded and out of date? In terms of such a wide reassessment of basic concepts Pop Art came into being.

No style ever came to fame – or notoriety – as rapidly as Pop did. It appeared, was given the solid critical seal of approval by the writers and museums, and was taken up by the public at large within the space of something like ten years.

Pop is both English and American. More precisely, it is London and New York, and was born first in London. Its artists are rooted in the city, but their view of the city is not a deeply philosophical one, as Mondrian's was. They see it rather as a scene thick with symbols, criss-crossed with the tracks of human activity.

The Institute of Contemporary Arts in London (the ICA) is a club for artists, musicians and writers. Beginning in 1952, discussions of an unusual kind took place there and were held for several years. They were organized by a group who called themselves the Independent Group (known as the IG).

Fit for undeveloped minds

The IG did not talk about the Idea of Perspective in the Renaissance, or the Post-Impressionist Revolution, but about Science Fiction, automobile styling, popular music, gangster films. Interest in this sort of thing was regarded as a mark of semi-literacy, fit only for the under-developed minds and sensibilities of those unfortunately unable to appreciate anything better.

The first IG discussion directly related to what we now understand as 'Pop' was in 1952 when the sculptor Eduardo Paolozzi showed slides of images culled from magazines, comic books, billboards and films. With that, as one of those present later wrote: 'the very notion of culture changed before one's eyes'. It was of course the very notion of culture that the IG was trying to change. They had the nerve to suggest that comics and all the good things forbidden them as children by anxious parents were there to be enjoyed, and were in fact enjoyable. In them, the IG recognized a more complete expression of the times than in the art, literature and music self-consciously produced as 'culture'.

In 1954 Lawrence Alloway, the critic and one of the IG's guiding lights, lumped all these good things together under the term 'Pop Art'. To begin with the term was therefore not applied to 'art' at all, but to the products of the modern urban Admass society: the ads, comics, movies and so on. In other words Alloway meant something like 'Contemporary Folk Art'. Much later the word came to be applied, both in Britain and America, to the work of artists adapting, in one way or another, the imagery of commercialism to their work.

Most of the IG's members admired, almost revered, America. The magazines, the films, the writing and the ads which the IG members liked best of all came from America. One of them returned from a trip with a trunk-load of *Playboys, Mads, Esquires* and so on which were something of a revelation.

America had been traditionally regarded as a pale imitation of Europe as far as culture was concerned. Now its real culture the 'art' which most completely expresses everything American, was discovered by

the Old World, as it had once discovered the continent itself. This discovery led to America being regarded as the fountainhead of everything modern. Whereas in the eighteenth century the cultured gentleman had made his Grand Tour to Italy, younger artists now began to go to America for their general education.

The IG organized exhibitions related to its discussion programme, and the first phase of the IG, and of English Pop (1953–8), reveals a predominant interest in technology. In 1955 Richard Hamilton, a painter, teacher, and beside Alloway the IG's strongest intellectual force, organized an exhibition at the ICA called 'Man Machine Motion' in which he explored the visual explosion of the twentieth century as a source of imagery.

A cheesecake nude

More important was the 'This is Tomorrow' exhibition at the Whitechapel Gallery a year later. It explored the possibilities of collaboration between architects, painters and sculptors. It was not an 'art exhibition' in any conventional sense; there were no 'pictures' as such.

Hamilton himself, for example, worked on an environment which was similar to something from a fun-fair, with a false perspective and soft floors. The exhibition also included what is now taken to be the first definite piece of Pop Art: a photographic collage by Hamilton entitled *'Just what is it that makes today's homes so different, so appealing?'* This shows an interior with a cheesecake nude, a bodybuilder, a framed cover of an American film magazine on the wall, a lolly on which the word 'pop' appears, and a view of a cinema through a window. Transient, expendable, cheap, young, witty, sexy and gimmicky. In 1957 Hamilton executed a painting using Pop imagery – *Homage à Chrysler Corp* – in which the shapes derived from automobile design are combined to create a paradoxically sensual effect.

Paolozzi and Hamilton had part-time jobs at the Royal College of Art (the RCA) and the College soon became the centre of the second, in some ways the more

Pop Art burst on London and New York independently in the 1950s. American artist Roy Lichtenstein shattered notions that art should be artistic by his re-creations of comic-strip scenes, *top left*. In London, the sculptor Eduardo Paolozzi led artists to look at images from every day. His creation, *The City of the Circle and the Square* is shown, *left*. The paintings of many Pop artists have an impersonal and ambiguous character: *top, A Bigger Splash* by David Hockney; *above, Towards a Definite Statement of the Coming Trends in Men's Wear* by Richard Hamilton.

typical, phase of Pop. Their influence was enormous, but so too was that of R. Kitaj, an American at the College under the G.I. Bill, and Peter Blake, who graduated from the RCA in 1956.

Kitaj's work is mainly based on collage techniques. He combines hand-drawn, hand-painted passages with photographically reproduced images and reproductions of real material in compositions which cannot be understood without following up the references Kitaj actually

gives in the paintings and prints themselves: famous murder trials, works of philosophy and literary criticism.

Blake's work is much more accessible. Although he uses American-derived imagery in some of his work (Bo Diddley, Elvis, Marilyn Monroe), he cultivates a feeling for paint which is thoroughly English. Most Pop Art uses imagery which expresses nostalgia for the more or less immediate past. The great number of pictures in homage to Marilyn Monroe, for example, were done after her death. Blake's roots lie further back, in Victoriana. He paints things like Victorian postcards and music-hall stars. One of the most obviously Pop gestures Blake performed was to design, with his wife, the cover of the Beatles' 'Sergeant Pepper' LP, which itself includes parodies of the old-time music hall.

The students stimulated and influenced at the RCA by Paolozzi, Hamilton, Kataj and Blake, emerged on the scene at the Young Contemporaries exhibition of 1961. Richard Smith, Derek Boshier, Patrick Caulfield and David Hockney exhibited together with Alan Jones, Peter Phillips and Anthony Donaldson.

The essential spirit of Pop

Hockney transforms Pop imagery (Typhoo Tea Packets, badly designed 'modern' furniture) with an apparently graphic style, often reminiscent of scurrilous graffiti. He gives the spectator a wry dig in the ribs accompanied by a knowing wink. Caulfield takes traditionally 'artistic' motifs – landscapes, still-lifes, often even the work of other painters (Delacroix for example) – and renders them in a colourful but brutally simplified and anonymous way. The result may seem tasteless, even sacrilegious, but never ugly. Alan Jones's most persistent characteristic is a kinky eroticism, a preoccupation with stockings, high-heeled shoes, panties and suspender-belts, which he transforms into colourful, mixed images. Lately a self-conscious seriousness seems to have crept into his work, at variance with the essential spirit of Pop Art: without wit and a certain throw-away quality it begins to lose its point.

Perhaps the most interesting and original of these artists is Richard Smith. His sources are commercial, but he uses them in far less direct way than most of his contemporaries. To begin with he took the look, the three-dimensional quality of packaging – cigarette packets, detergent packets – and transformed them into more purely 'artistic' images, made the raw material 'art' by transforming it to that point where its source was almost but not quite, unrecognizable. It led him to use shaped canvases, and it is his work in this direction which seems most capable of further development.

In the 1950s the great figures of English art, Moore, Nicolson, Pasmore and Sutherland, were considered to be old-fashioned, irrelevant to any new art. Pop is as unlike anything proposed by these artists as it possibly could be. Pop artists asked questions like 'How close to its source can a work of art be and preserve its identity?'

and 'How can you paint a picture so that it is as vulgar as possible, as far removed from ideas of conventional taste and beauty as possible?' This is a measure of how radically British Pop artists questioned traditional notions of 'art'.

Although similar to British Pop, American Pop is by no means identical. Its parents were quite different. Unlike Britain, it was drawing on its own culture. The British Pop artists looked across the Atlantic with a kind of awe, honouring in a romantic way a country most of them knew only second-hand from movies and magazines. American Pop artists recognized that their country's true culture was not European but was the modern folk art of the hoardings, the movies and the whole spectrum of technological progress.

The roots of American Pop are not theoretical. Its immediate forebears are two painters, Robert Rauschenberg and Jasper Johns, who forged a link between Abstract Expressionism – 'action painting' – and the return to figuration which was Pop's final destination.

Patina of paint

Johns, in 1955, set himself the problem of painting an abstract work which had at the same time a recognizable image. Paradoxical though it may sound, Johns in fact succeeded. He took as geometrical an image as he could – a target, then the American flag – and then painted it in such a way that the beauty of the paint itself, its texture, inherent qualities, emerged strongly. So attractive is the patina of paint, the surface quality of Johns's pictures, that the motif, the image, becomes less and less important. He therefore hinted at the same sort of problem the British painters had posed: What is the relationship between the source of the picture and what is made out of it?

The artists of the Dada movement, and most notably Marcel Duchamp, had been concerned with similar ideas. Duchamp had at one time exhibited what he called 'ready-mades': a shovel, a urinal, a bottle-rack. Johns and Rauschenberg (who also included real objects – rubber tyres, Coca Cola bottles – in his work) thus forged the link between the Dada artists, the Abstract Expressionists and a younger group of artists who were concerned with bringing back figurative imagery into their work.

Duchamp was not the only influence from the past. Stuart Davis, a pre-war American painter, had, for example, partly influenced by Cubist collage, done paintings of Lucky Strike cigarette packets. Moreover Léger, the French painter who humanized mechanical forms, was in America for a time and claimed that without the 'bad taste' of New York he would have been unable to produce what he did.

It was not until the spring of 1961 that the first pure American Pop artists emerged. Rosenquist, Lichtenstein, Oldenburg, Warhol and Wesselman, however, although influenced to a greater or lesser degree by Johns, Rauschenberg or the Dadaists, do count as Pop artists, and by

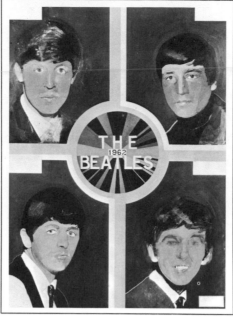

The Beatles, foremost symbol of British popular culture. It was painted in oil on canvas by Peter Blake, one of Britain's foremost Pop artists who studied at the Royal College of Art.

1962 they were so in evidence in the New York galleries that critics began to coin phrases to describe the new art. 'Neo-Dada' was proposed, as was 'OK-Art'. One critic even went so far as to christen them the 'new vulgarians'. Finally the British term triumphed.

Roy Lichtenstein was responsible for very large canvases, on which he reproduced single frames of coloured comic strips. At first sight they appear to be large-size replicas, but compared with the original frames he copied, the finished Lichtensteins are models of simplification and 'improvement'. He clarifies compositional crudities, simplifies the forms and

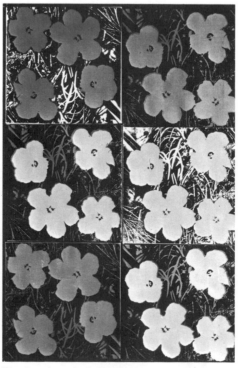

The American Andy Warhol has used silk screening to reproduce his images. He printed them on white or monochrome canvas, sometimes in different shades of intensity. *Flowers* is shown *above*.

makes something tight, complete and arresting out of his source. Moreover, taken out of their context, the situations presented in the single frames have a sort of Surrealist detachment. A girl weeps and says something urgent to her boy-friend. What went before and comes after is denied us.

The problem for British and American Pop artists is very similar. They have to avoid everything that can be seen to be art by people who hold traditional views about what 'art' is. That is why not all commercial subject-matter will do as source material for a Pop painter. Some ads are so good, so subtle, that they themselves become art. The Pop artist must choose bad commercial art which is tasteless or clichéd or both. In this way he can pose the problems he wishes to pose in more urgent a fashion.

Warhol, a notorious painter and film-maker, plays a similar game to Lichtenstein's. He reached notoriety with his reproductions of Campbell's soup cans and Brillo boxes, true to the originals in every detail, except that now and again they are painted in various colours. Often Warhol has nothing to do with the execution of his work at all, simply getting others to photograph the originals, make stencils or negatives and then print them on canvas or paper. Need an artist be personally involved with the execution of a picture, or is the idea behind it enough to make it 'art' and his own work? Warhol makes this always intensely difficult problem even harder to answer by sticking so close to his originals that New York housewives have taken to exhibiting real soup cans and real Brillo boxes as works of art in their own right.

From trousers to hamburgers

Tom Wesselman is much more obviously concerned with cliché than either Lichtenstein or Warhol. His *Great American Nudes* are most often compositions consisting of pink forms on which closely observed details, like pubic hair, lips and teeth in conventional 'cheesecake' grimace, appear. The completed pictures are a mixture of cliché and sensuality.

Claes Oldenburg specializes in reproducing in enlarged size any number of objects – from trousers to hamburgers – in substances as far removed from the originals as possible. He makes ice-lollies from plastic stuffed with kapok, pairs of trousers five times their original size, hamburgers from plaster. Again the character of the original object and its relationship to the finished 'art' product is put in question.

American Pop brought about as much of a revolution as British Pop did. It brought recognizable subject-matter back into art without making art 'literary' again, without making it tell stories. As Roy Lichtenstein said: 'Art since Cézanne has become extremely romantic and unrealistic, feeding on art . . . it has had less and less to do with the world. Pop Art looks out into the world; it appears to accept its environment, which is not good or bad, but different, another state of mind.'

Op's eye-bending world

Flickering, vibrating, in a perpetual dazzle of real or illusory motion, 'Op' and Kinetic Art have in this century opened up for artists an entirely new and exciting dimension of movement.

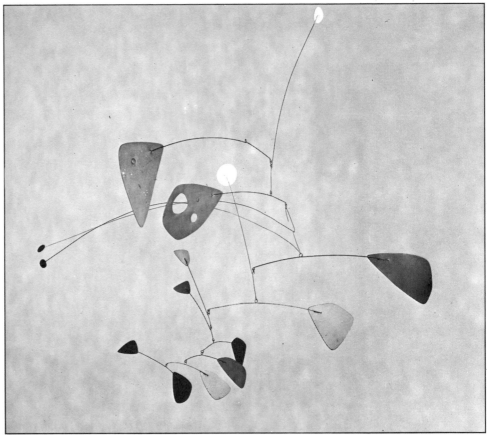

Left, Naum Gabo's *Kinetic Sculpture, Standing Wave* was first exhibited in Berlin in 1922. The metal rod's high-frequency mechanized vibrations testify to his rejection of the static in art.

Right, Antennae with Red and Blue Dots. With his wire-figure constructions Alexander Calder broke new, exciting ground. They are constantly moving through beautiful, complex configurations.

'OP' IS SHORT FOR 'OPTICAL', and 'kinetic' comes from the Greek word for movement. Op Art and Kinetic Art have one important factor in common: *movement.* But whereas a Kinetic artist uses *actual* movement in his work, an Op artist is interested in creating the *illusion* of movement – what apparently moves in fact remains static.

Shortly after it first appeared on the scene, Op Art was taken up lock, stock and barrel by the popular press. Journalists, not always careful about the way they use their terms, applied the word Op to a bewildering number of things – to anything vaguely modern, or vaguely abstract. Fashion and furniture designers and everyone in the communications business began to produce posters, shoes, clothes and interior designs which were largely based on the work of Op artists. 'Be an Op-Art Optimist' was a headline in one women's magazine. Even though the publicity people dropped Op as quickly as they had taken it up and went over to something else, the result has been to blur the intentions of Op Art and to detract from its real meaning and significance.

All art relies on optical tricks and all art is a form of illusion. Whether Leonardo paints the Virgin, Chardin a still-life or Monet a landscape, the game is still the same: they are trying to make us see something that is not really there. A painting is the illusion of a window out on to the world or inward into the artist's mind.

The creation of illusion is a very complex business. It was not until the middle of the nineteenth century, when scientists began to investigate the ways in which the perceptive faculties work, that the extent of its complexity was first realized.

Tricked by illusion

Op Art uses to artistic ends what science knows of optical effects and illusionism. Op paintings tend to be composed of shapes arranged and articulated to have an immediate, powerful and disturbing effect on the eye. They create illusions of movement, colour and volume, and play with the eyes as capriciously as a cat plays with a mouse. They dazzle, flicker and vibrate in a state of permanent unrest. They *act* on the spectator sometimes so aggressively that they are almost impossible to look at for any length of time.

If you look at a white square on a black background for long enough, and then look

suddenly at the ceiling, you will see a black square on white there. It will also jump and vibrate before it gradually fades away completely. If you draw two parallel lines and then cross them diagonally with lines of unequal length, the two original lines will look anything but parallel. Such classic demonstrations of the eccentricities of the eye recur in a sophisticated form in Op Art. The eye is fallible, it can be tricked and misled. But it can be tricked in prearranged ways. This, briefly, is the theory behind Op.

The Primary function of Op, however, is not to aggravate the eye. Michael Kidner, for example, a British painter who learned from Op without becoming an Op artist, says that he uses optics as a means to a much bigger end: 'a good painting'. 'Optics is a tool, as perspective once was.' Op, like every other serious art form, did not suddenly happen. It has a past. This past needs to be briefly considered if we are to know anything about Op.

Op Art's Impressionist past

As we know, scientists began investigating the problem of optics and perception around the middle of the nineteenth century. Gradually their findings began to filter through to artists. The Impressionists welcomed scientific experiments with open arms, for they were above all intent on reproducing nature more truthfully than it had been done before, and they could only do this if they knew how we see and perceive. They based some of their paintings on what science told them about the nature of colour and form.

Seurat and his fellow Neo-Impressionists took Impressionism one stage further and proceeded in an expressly scientific fashion, surrounding themselves with pots of paint in the colours of the spectrum, from red to violet, to build up their pictures with tiny spots of pure, unmixed colour. Their studios were like laboratories. In working along these lines, they believed that they were painting reality even more faithfully than their friends the Impressionists had done. The results are, ironically, less realistic than Impressionist work, but they have an undeniable beauty, shimmering with brightness as though they conceal within them their own personal light source.

No one would call the Neo-Impressionists 'Op artists' – the term is in any case exclusively applied to work produced in the last ten years or so – but Seurat and his colleagues were the first to be consciously interested in the way the eye works, and rigorously to apply scientific findings to art. We have to wait some time before we again find the science of optics being used in art in such a thoroughgoing way.

The biggest problem faced by all abstract artists is that of subject, of 'content'. If all reference to the real world is cut out, what saves the painting from being decoration and nothing more? (Decoration may be beautiful, but it is not thought to be as worthy as 'real' art.) Abstract artists have traditionally tried to solve this problem by recourse to the 'spiritual'. In other words, they claim that their abstract

1

2

configurations either speak directly to the spectator's soul (and much more clearly than realistic works can) or else reveal something of the universal laws which control the Universe. Op artists solve the problem by appealing to science, by controlling the spectator's eye completely, by stimulating definite responses according to the rules discovered by scientists and perceptual psychologists.

In the work of some Geometric Abstractionists – Mondrian and Albers for example – optical effects are used with consequence

but never exclusively. The first artist, influenced by Mondrian and Albers, to rely exclusively on optical effects is Victor Vasarely. A Hungarian aristocrat turned Frenchman, Vasarely denies that he is the 'Father of Op', but admits that he was among the first to isolate qualities like ambiguity and the juxtaposition of colour and shape to give the illusion of movement or vibration, and he began to do this as early as 1935.

Vasarely, for a time alone in his experiments, has had an enormous influence.

5

6

3

4

1 Four moments in the metamorphosis of *Imoos VI* by Bryan Wynter. Strange, lyrical effects are achieved by coloured cards rotating before a concave mirror in a box. Because the reverse sides of the planes are more brilliant, their images appear more real than the actuality. The planes are, furthermore, so placed that the images constantly surge forward into the world of the viewer. **2** The Futurist Giocomo Balla attempted to create the illusion of movement by superimposing images one on top of the other. His *Rhythm of a Violinist* demonstrates his success. **3** Sometimes termed the 'Father of Op', Victor Vasarely created the illusion of movement by skilful juxtaposition of contrasting shapes and colours, as in his *Cassiopée*. **4** Bridget Riley's characteristic use of parallel lines — their changing curvature and thickness create an intensely provoking optical effect, which the spectator may very well consider is downright disturbing. **5** *Flasher* by Brian Rice combines the optical illusions of space and receding distance with rich, decisive colour. **6** One of the most forward-looking of the Abstractionists, Kenneth Noland's works are proof that even without actual composition, a picture may still be coherent. Primacy given to colour lightens the rigid geometric form of his *Apart.*

In England the leading Op artist is a woman, Bridget Riley, whose work, although it can be analysed scientifically, does not directly stem from a knowledge of science – of optics or mathematics. Her work first came to the notice of the public about ten years ago and she says that she is above all interested in the way patterns affect the emotions. Riley thus stands somewhat apart from Vasarely, whose work has a much more technical slant, and who describes his studio as 'a laboratory of visual sensations'.

In an age of speed and mass communication, the concept of movement must be important to philosophers and scientists as well as artists. As soon as the Industrial Revolution got under way, artists began to be interested in moving subjects. Many writers have tried to draw parallels between the beginnings of mass production and the interest of the Impressionists in steam, moving crowds and racing horses.

The first unmistakable sign of an artistic concern with movement was the Futurist

manifesto of 1910. The Futurists, all of them Italians, praised the City as a thing of great beauty and announced that phenomena like movement, power and energy need to be taken into consideration by artists attempting to be modern. A racing car was to them, as they said in a famous passage, more beautiful than the classical statue of the winged Victory of Samothrace.

Taking a lead from photography, they painted multiple images of their subjects in an attempt to reproduce movement

within the static space of a canvas. This is what Duchamp's *Nude Descending a Staircase* of 1912 is doing, and what Balla's *Dog on a Lead* of the same year does. Boccioni's running man, which he called *Unique Forms of Continuity in Space* (1913), demonstrates the same idea in three dimensions. It is ironic that the Victory of Samothrace, which Futurists were so rude about, should have anticipated the distorted forms of this sculpture by many centuries.

But the Futurists were not Kinetic artists. They never introduced *actual* movement into their work. In 1920 the brothers Pevsner, two Russian sculptors, issued a manifesto which announced the birth of Constructivism. Constructivism is a concept of sculpture very different from Futurism, but it in part derives from a similar concern with modern technology. Naum Gabo (he changed his name from Pevsner to avoid being mixed up with his brother) produced a kinetic sculpture powered by an electric motor in 1920, and in view of the fact that movement is a quality so stressed in the manifesto, it is perhaps strange that it remained for Gabo a unique experiment.

Moholy-Nagy, an astoundingly versatile Hungarian artist, made experiments in many art forms, mostly when he was a teacher at the Bauhaus, and he not only became convinced that movement was vital to art, but went about realizing his ideas in a thoroughgoing fashion. In 1922 he summed up his philosophy in the following way: 'We must substitute dynamics for the static principles of classical art.'

Moholy-Nagy not only wanted to create effects with movement, but also with light, and in 1930 he created a 'Light Display Machine' which was powered by a motor and had transparent and perforated parts. These controlled and manipulated various coloured lights. The results were far more beautiful and amazing than Moholy-Nagy had imagined.

A new range of materials

Movement is also used to great effect by the American sculptor Alexander Calder. Although from time to time he builds objects powered by motors he began in the 1930s to create 'mobiles' – a form of sculpture he invented. These are constructions of many separate elements, often of huge proportions, which are so finely balanced that the slightest breath sets them in motion and through a beautiful complex series of configurations.

The use of motors, of light and of balance and air are the basic elements in Kinetic Art. Since the fifties, the ideas of such forerunners as Moholy-Nagy, Calder, Gabo and the Futurists have come together in a world-wide movement with centres in Germany (The Zero Group, Düsseldorf), France (Group for Visual Research, Paris) and in South America, particularly the Argentine. Many artists insist on working together, thus substituting the idea of co-operation for the old artistic notion of individuality. The materials used are many and various. Jesus Raphael Soto will use a spotlight to illuminate and, by

Above, Julio le Parc's work is fundamentally experimental, but the ingenious structure, luminous mechanisms and subtle effects of his *Continuel-Mobile* transport the viewer into a magical world. *Top,* Pol Bury's *White Dots on an Oval Ground* consists in fact of electrically-driven plastic threads. Never chaotic, his kinetic assemblages always create a consciously poetic image.

warming the air, to set in motion polished metal plates hung at various angles on vertical strings, so that the spectator is surrounded by moving lights, some fast, some lingeringly slow. The Greek artist Takis uses rods of sprung metal which are then made to vibrate. Nicholas Schöffer powers machines with lights in them to cast ever-changing patterns in a multitude of colours on the walls around them. The Swiss artist Jean Tinguely is the humorist of Kinetic Art, collecting junk from a variety of sources, building it up to make

very sophisticated mechanical machinery, which not only works but often actually destroys itself in a blaze of light and a variety of accompanying noises.

At the moment Kinetic Art is still in the experimental stage, even though many works of great beauty have been made. Op Art, which has tried in a similar way to extend art's horizons, is at a similar stage, and we can only wait to see what artists make of the discoveries made by Kinetic and Op artists. It is certainly a fruitful area for research.

Where painting and sculpture meet

From the secret tombs of ancient Egypt to the puzzling designs of the modern day, relief sculpture has occupied a special place in art. But will this still be true for the future?

RELIEF SCULPTURE holds a position half-way between painting and sculpture: like painting it is set upon a fixed surface, and yet, by carving and shaping it is given a certain amount of three-dimensional form.

The prehistoric figure carvings which still exist show us that the technique of cutting shapes into a surface probably originated to ensure the permanence of magical and religious images. It was the Egyptians, however, who first employed relief with any measure of sophistication.

Already by the beginning of the Old Kingdom (c. 2613 BC) relief had been developed to a very high standard of execution. The major part of this relief output, however, was sealed into the darkness of the king's tomb and was not for mortal eyes. Instead it was intended for the use of the *Ka*, or spirit of the dead person. By showing him for ever partaking of mortal activities it would ensure his immortality and enable him to continue to enjoy his earthly pleasures. The most important factor was the permanency of the representation: if it faded, the *Ka* would have no resting place. So, a shallow *bas-relief* (low relief) was employed, the figures standing out only very slightly from the rock, making a sort of modelled painting.

Such a carving could not withstand the bite of sand and termites, however, unless it were made more durable still. So the Egyptians developed a different technique for outdoor carving, called *en creux*. Instead of cutting back the surface to leave the figures raised from the ground, the surface was left intact around the figures. These, although modelled in the same way as before, were now sunk into the stone and less exposed to wear.

The fact that carving was less spon-

taneous than painting did not matter at all. A lifelike picture was not the concern of the artist; he was bound by the inflexible laws of tradition to a particular mode of portrayal, which remained almost unchanged for nearly 3,000 years. The rigid stance of the human form is, therefore, deliberate.

The kings of Egypt were considered demi-gods – and to show their people just how great and powerful they were, they commissioned reliefs showing them in conversation with the great gods or glorifying their exploits. In the kings' Sacred Way at Sakkâra there is even part of a relief showing starving Asiatics on the roads of Egypt, a traceable historical event.

Whereas the Egyptians had been a unified kingdom from the days of the first dynasty, with a single cultural tradition, the Greeks sprang from a number of tribal kingdoms with widely differing cultures absorbed from far afield. We must not be surprised, therefore, to see that their early art styles are based on those of Egypt. The

Left, the head of a young man (*c.* 1370 BC), a fine example of sunk relief used in outdoor carving in ancient Egypt. Large, graceful figures fill the surface, on the processional frieze of the *Ara Pacis* in Rome, *below,* the back row partially immersed in the stone to suggest space.

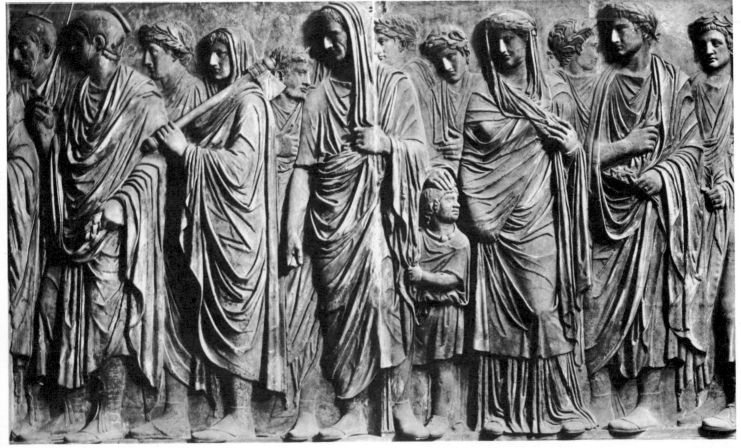

stelae, or funerary monuments, of ancient Greece are similar to Egyptian tomb relief in technique – but there the similarity ends.

From the late sixth century B C, Athens was a democracy, and therefore the right to have tombstones was no longer restricted to the king and a few select courtiers as it had been in Egypt. There was a large private demand for stelae to stand in family burial plots, and the standard of execution was accordingly high.

On the slab was generally a representation of the dead person, in profile, with certain attributes to indicate his position in life. Although not a portrait, it is nevertheless a most convincing likeness of the human form.

The conventions governing early statues were very restricting to the Greek artist, allowing little variety of pose. The temples of the gods, however, offered great potential for sculptural additions in the pediments, the triangular part of a building over the porch, and the bands of decoration called friezes, for these added to the sanctity of the building.

Consequently, the upper regions of the temples became animated by the stories of the deeds of gods and heroes, battles being most popular for the awkward triangular shape of the pediment, for the corner could be filled with prostrate forms of the dead and dying.

In the fifth century B C, under the direction of Phidias, one of the few Greek sculptors we know by name, this form of relief reached an unsurpassed climax of beauty and skill. The frieze on the Parthenon which stands on the Acropolis in Athens extended right round the inside of the temple. Most of it is in the British Museum under the name of the Elgin marbles, after Lord Elgin, who bought these carvings from the occupying Turks and shipped them to England at enormous difficulty and expense between 1803 and 1812.

Procession of Athene

Forty feet high and over 500 feet long, the frieze depicts in continuous relief the ritual procession of the Panathenaic festival where citizens are bringing a robe for the goddess Athene. It starts with the preparation for the event in the town and culminates in the ceremonies themselves in the presence of onlooking deities.

As in the Egyptian bas-reliefs, the rounded contours of man and beast are reduced on the nearside to the minimum of depth in carving. But because of the dimness of the temple interior, the frieze figures are silhouetted sharply against the background by cutting parts of them completely free.

Conversely, the pediment groups are treated as free-standing statuary carved completely in the round and merely placed into the pediment frame. This was to obtain the maximum of contrast between light and shade to stand in balance with the lights and darks of the massive colonnade below.

The Hellenistic age (323–30 B C) sought to vary the traditional poses, which resulted in the exaggerated portrayal of

emotion by contortions of face and body. This exaggeration is best exemplified by the colossal frieze encircling the altar of Zeus at Pergamum in Turkey. Although it represents the Battle of the Gods, it is in fact an allegorical reference to the victories of the Pergamenes over the Gauls. The action seethes round the monument and the writhing bodies are no longer contained within a framework, but spill over the ledges, climbing and crawling up the steps to the sacrificial platform.

Direct representation of historical scenes was rare in Greece, but appealed strongly as an art form to the Romans in their desire to glorify the empire and its great deeds. Public events are portrayed in an 'official' art programme which also served as propaganda for the individuals partaking in them; the gods suffered a decline in publicity. As a result of this strong human element, the emperor on the processional frieze on the *Ara Pacis* (Altar of Peace) is not immediately noticeable

A precious treasure of Florence is the gilded bronze door of the Baptistery, which depicts Old Testament themes. Executed by Ghiberti, Michelangelo called it the 'Gate of Paradise'.

amongst the crowd which surrounds him. Instead we recognize him by his features, and other members of his retinue are likewise individually portrayed. The technique is basically Greek, probably executed by Greek artists working in Italy, with monumental figures filling the surface, but space is indicated by the partial immersion in the stone of the back row of figures.

In the Arch of Titus, this feeling for space is furthered. The figures not only move across the surface; they also move towards us and then away again. Set convincingly some distance behind them is the city gate.

But this preoccupation with space was short-lived. On Trajan's column we can follow the whole story of the Dacian cam-

The feeling for space in the Baptistery doors is furthered in the work of Donatello. His genius for organizing his figures is displayed in the depiction of the martyrdom of St Lawrence, *above left,* a detail from one of the twin pulpits he made for the Church of San Lorenzo in Florence. *Above,* a charming relief of a grandmother and child figures on this tombstone of ancient Greece, a form of sculpture which developed very high standards. *Left,* galloping horsemen in full career, an illusion of movement and vigour which has never been surpassed, animate the frieze which once encircled the inside of the Parthenon in Athens, climax of Greek relief sculpture. *Below,* Egyptian sculpture was hidden away in tombs for the delight of the *Ka,* or soul.

paigns in one long, continuous narrative, starting at the base and winding upwards. To get the maximum information into the available space the artists have dispensed with realistic illusion and have crammed the story with little figures and squat, abbreviated stage sets shown in a mixture of frontal and bird's-eye views, rather like a picture map. The accuracy and quantity of the detail must be attributed to eyewitness sketches made actually during the campaign.

Formal artistic style

From the beginning of the third century A D barbarian invasions shook the empire. The emperor had increasing difficulty in maintaining his position, and succession by murder became a regular occurrence. Combined with influence coming in from the East, this gave rise to a more formal artistic style, where the figure of the emperor is singled out from ordinary mortals by its size and frontality and its position on a higher level. The figures become squat and stiff, and any indication of depth has gone.

With the advent of the Christian empire under Constantine, historical and public scenes were replaced by Biblical ones, in which the wealth of content was far more important than aesthetic principles. Figures were still depicted from the front in the stylized manner, but when the empire collapsed any unity of style disappeared. Christianity was diffused throughout Europe and its art became absorbed into individual cultures. Sculptural activity was discouraged, partly because of its association with pagan idols. The only continuing tradition was in small-scale objects.

In the eleventh century, monastic reform gave a new spur to Christianity, especially in northern Europe. Vast cathedrals were erected. Their doorways were covered with vivid narrative carvings expounding Christian doctrine, which served to educate the illiterate in their faith.

In the Italy of the thirteenth century a great classical revival began to take place. Interest in the antique as the source of all that was good in art and letters was widespread. The many fragments of Roman buildings, statuary and sarcophagi had never been hidden away; they had always been there for everyone to see, but the Tuscan sculptor Nicola Pisano (*c.* 1220–84) was one of the first to look at them in order

Trajan's column in Rome, *above* (detail), depicts the whole story of the Dacian campaigns of A D 101–2 and 105–6. Furiously fighting figures wind up the column, crammed one upon another; so accurate is the detail that eyewitness sketches must have been used. In contrast, *left,* a modern relief in white wood by Serfio de Camargo is in the traditional style, though abstract in form.

to learn from them and to try to re-create a classical style.

With Giovanni, his son, he produced a number of pulpits carved in high relief consciously imitating Roman forms. No longer are we faced with symbolic sculpture, but instead we are shown the events of the Bible as real, human scenes. The deep cutting which characterizes high relief, and large, round forms show their preoccupation with reproducing the volume and heaviness of the human form.

A little later, this imitation of the antique produced an even more conscious revival of the classical art form. A series of three sets of doors, in bronze with inset panels in relief, was executed for the Baptistery in Florence.

Lorenzo Ghiberti (1378–1455), who won the competition for the second door, proved himself so great a master of the bronze-working technique that he was entrusted with the execution of the third door as well. This was one of the wonders of the day, and even Michelangelo went so far as to call it the 'Gate of Paradise'. Looking at it we can see why everyone marvelled at it. The figures are no longer heaped upon each other but move freely and elegantly through and around the airy buildings. The care lavished on these settings shows the new preoccupation with the depiction of pictorial space, based on the recently discovered laws of perspective.

Compared to Donatello (1386–1466), however, Ghiberti's attempts at perspective were only limitedly successful. Donatello realized that the bright gilding applied to the bronze served to emphasize

the solidity of the background – which therefore could not be seen as infinite space. He therefore filled his bronze reliefs with complicated but highly organized architectural settings forcing the spectator's eye into depth.

Donatello's development was such that his last works, twin bronze pulpits for the Church of San Lorenzo in Florence, were little understood in his own day. He died before they were completed, and the technique is so summary that even now there is uncertainty as to whether they were finished according to his ideas.

A minor role

There was no one to follow Donatello in the field of relief sculpture. In the sixteenth century, doors were opened to seemingly infinite possibilities in the fields of painting, architecture and sculpture, but for solving current artistic problems relief had distinct limitations. It was relegated to play a minor role, often as a decorative addition or an extension of one of the major arts. Funerary monuments alone continued to provide a steady demand for relief work.

Nevertheless the new set of doors for St Peter's in Rome, which were commissioned in 1950 from the sculptor Giacomo Manzu, are a conscious echo of the bronze tradition of the fifteenth century. Manzu is an artist who stands apart from the mainstream of twentieth-century ideas. Like Donatello, the key to his success lies in his technique. Using a very low relief emphasized by boldly incised lines, Manzu realizes and fully exploits the

sketchiness of execution made possible by the soft clay.

The twentieth century has witnessed the most radical changes in the theory and practice of art, beginning with the belief that art need not imitate or represent natural objects. The breaking down of boundaries between painting and sculpture was another important step, and from these two ideas, Picasso and Braque developed the collage technique. Instead of simulating textures in paint, they stuck on to their canvas scraps of *real* texture, mainly different sorts of paper and material. From there it was only a short step to the use of pieces of solid materials – wood, glass and so on – which they stuck on to the surface as well. They therefore produced works with an *actual* three-dimensional quality.

But where do these works stand? Although definitively 'relief' and therefore sculptural, they are inextricably tied up with the collage paintings and provide an extension of the ideas behind them. Moreover, these ideas are almost impossible to translate into sculpture in the round because they rely on illusion just as pictures do.

Modern theory is incessantly pushing out feelers in different directions – experimenting with new ideas and breaking down the old conventions so that definitions of artistic category can no longer stand so firm. A sculpture is suspended by wires across the corner of a room, and is therefore called a relief because of its pictorial link with wall and background – although the traditional frame or visual limit to the 'surface' has been dispensed with and the sculpture could just as well hang from the centre of the room. From this we can see that the boundaries which served to classify painting and sculpture so clearly, have become indistinct, and relief, which once stood definable in its own right, now exists only as a term, to be used by either.

Adornment for the house of God

To his places of worship, Man has always brought a special quality of artistic creativity. And these images of his faith are always a deep expression of the worship they watch over.

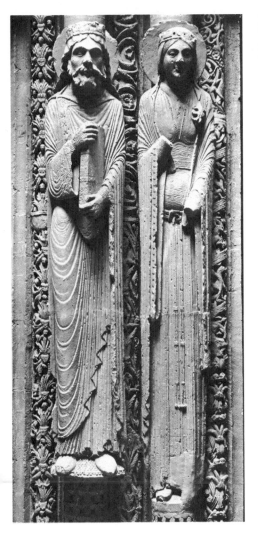

Left, the tall figures of crowned saints grace the Royal Portal of Chartres Cathedral in France. They are motionless, their elongated bodies blending with the pillars of which they form an integral part. Only their expression of calm serenity seems to speak to us. Contrast them with the life-like figure of the 'Smiling Angel' from Rheims Cathedral, *above,* built a century later.

EVEN AT THE EARLIEST STAGES of tribal society men carved images of the spirits by which they identified themselves with the world around them. In Sumerian, Egyptian and above all in Greek art we see this concept of a superman-like deity depicted in statues which became more and more life-like as the sculptor's technique and understanding of the human body developed. This increase in naturalism depended very largely on the gods being identified more closely with the heads of state, which culminated in the emperor-worship of late Roman times.

Such gods and their images required a physical home. It was natural, therefore, that the Greeks should build their temples in the form of an ordinary Greek house. The box-like *cella,* or body of the building, contained the statue and the altar of the god, and a porch at one end or both completed the building. Because they were the homes of gods, however, such 'houses' were much larger and grander than ordinary ones. They were built of marble and splendidly decorated with colonnades, painting and sculpture. Although the Greek temple was in the form of a house, it was given religious power by the columns of the architect and the historical or ritual scenes of the sculptor.

Greek temple sculpture is of two kinds: the *statue* of the god, carved in the round, and the *relief,* used round the top of the walls of the cella and in the pediments of the roof. By far the fullest known programme is that of the Parthenon on the Acropolis in Athens, built under the direction of the sculptor Phidias and the architect Ictinus, from 447 to 432 BC. It is dedicated to Athene, patron goddess of the city. Her statue, known only from poor copies, once stood in the cella, 40 feet high and made of ivory and gold. Her godly power is shown in her enormous size and in the lavish sphinxes and winged horses on her helmet and shield, and by the *aegis,* her father Zeus' garment, which had magical properties, over her shoulders.

Simple scenes, deep relief

Over the colonnade are scenes depicting the battles of the mythological centaurs and lapiths and of the Greeks and Amazons. These represent the triumph of Greek, and particularly Athenian, civilization over the barbarians. They are simple scenes of two or three figures only, depicted from the front or in profile. They are carved in very deep relief, almost sculpture in the round. The centaurs' torsos often twist around to a frontal view and one holds a lion skin which stresses in its shape the general symmetry of the scenes. The theme is athletic energy, emphasized by the simple but natural forms of the nude.

On the wall behind this colonnade a frieze runs round the cella, showing the main feast of the Parthenon, the Panathenaea, at which a robe was brought from the city for a sacred image of Athene. This procession displays the civic and religious splendour of Periclean Athens. The procession is shown as a whole, from the figures preparing to mount to the cantering horsemen on the middle of the north and south sides. On the north are musicians and water-carriers, on the south the sacrificial oxen. On the east face, the gods sit to receive the robe.

The pediment of the temple depicts the birth of Athene and her triumph over Poseidon, god of the sea, in a contest for the possession of Athens. These are the

most important events concerning the patron goddess of the city. The figures of gods observing the scenes are carved in the round to be clearly visible from ground level. The pediment forms a triangle behind, into which the groups are carefully fitted: a reclining river god fills the corner of one scene, while a horse rises up towards the central space in which Athene and Poseidon stand upright. The grandeur of the wide torsos and the magnificently clear twisting of the muscles of the reclining gods is remarkable; they have human bodies but are finer in proportion and more mighty than any of the human athletes of the frieze.

Hinduism's Greek influence

The Hindu religion of India has similarities with Greek philosophy. The universal *Ideas* which Plato held to lie behind all material appearances were echoed in the Hindu concept of universal *modes*. For Hindus these modes are expressed in material forms known as *rasas*. Indian sculptors expressed them with figures which derived their naturalism and their simplified beauty from Greek sculpture. Hindu sculpture is erotic, and piled up in tier upon tier on solid mounds of rock. Since the ceremonies take place in the open air, the sculpture has to be outside too. Its forms draw their inspiration from dancing, and the subtle rhythms of the temples have been compared to those of Indian music. The fully rounded figures are fitted into deep, cave-like recesses and fit closely with the surface of the temple.

The Mosaic law of the Jews represented a major advance in religious thought, as man realized that physical contact with the gods was impossible. Several mystic religions developed in the later history of Rome, but Christianity came to dominate them all. Since Christianity inherited the Mosaic law, with its injunction 'thou shalt not make unto thyself any graven image', it is not surprising that any physical representation of God should be avoided for fear of idolatry.

With the disappearance of the idol, the idea of the temple as a house was dropped also. The early Christians called their church a *basilica,* the name given to Roman assembly halls, and adopted many aspects of the plans of these halls. The altar remained, but a new kind of sacrifice was made on the Christian altar, the mystical sacrifice of the Son of Man. The

ideas expressed in the decoration of the church were therefore also mystical.

The early Church did not use sculpture as a part of this decoration. By the twelfth century, however, it was normal to use paint, mosaic and glass for interior decoration. Sculpture was used to glorify the exterior, where its greater strength served to resist the elements, and its greater monumentality impressed the passer-by.

Chartres Cathedral in France possesses the finest display of Gothic sculpture. The style of the reliefs is remarkably simple and clear. Whereas the Greek relief used simple geometric shapes to relate many figures to a shallow space and a low relief surface, the early Gothic sculptor uses the rhythm of simple outlines to make the figures attractive. The absence of any overlapping of figures makes the picture clear and flat; there is no attempt to create an illusion of realistic space or of action.

The figures beside the door are life-size, and some of them have faces which seem almost to speak to us as living people. They are more expressive than Greek statues. Yet they remain less realistic, because the sculptor used a trick which we notice at once: they are all extremely tall and thin, and their heads are too small to be naturalistic. He has made them similar to the columns behind them, so that they become part of the building. Unlike Greek figures they are *motionless*. This emphasis on the human expression of the face as opposed to the human form echoes the emotional quality of Christianity.

Elegance of style

It seems that by 1200 French sculptors were influenced by classical sculpture to make their figures more realistic. At Rheims Cathedral the Visitation pair look very like Roman statues. They turn towards each other, breaking with the column idea. The Gothic sculptors seemed to find this too dramatic, and in the later 'Smiling Angel' at Rheims they created a new style. The Angel is life-like yet more elegant. His smile is more mystical and his figure taller than a real-life figure. Christ and his angels become similar to human form but elevated by the stress on elegance of style, on flowing figures and crisply cut draperies. At the same time there is an increasing interest in realistic detail, in depicting buckles and belts, for example.

The Gothic sculpture of France is concerned above all to express an elaborate

set of ideas: the relation of God to men, of the Prophets to the saints, of the Church to the Virgin and to Christ. In Germany, French Gothic sculpture exerted great influence both on the style of the carving and the subjects shown. But the treatment of the themes is far more expressive. The most extreme example is in the West Choir of Naumburg. The figures are partly historical and imitate living models closely. The screen displays scenes of the Passion, shown with a remarkable closeness of observation. The apostles in the Last Supper gulp their wine or stuff grapes into their mouths, while the water poured by Pilate is actually shown falling. This adds drama, makes us feel that we are watching these moving events happening before us, and to enter the choir we pass physically under the life-size arms of Christ on the Cross. At one and the same time, Christ is a man of the people but a spiritual leader too.

The sculpture is detached from the church as a building; usually it is on removable furniture like the screen, a pulpit or on detachable slabs, as at Bamberg in Germany. Similarly, in Italy, Nicola and Giovanni Pisano's pulpits dominate the interiors of several churches as does the screen at Naumburg. But of the architectural sculpture which dominates the portals of French cathedrals there is very little.

With the Renaissance, sculpture ceased to play a leading part in Christian worship. The humanists, with their increased awareness of the physical world, saw

1 Michelangelo's Pieta, a moving portrayal of Nicodemus mourning over the dead Christ, stands in Florence Cathedral **2** Nicola Pisano and his son Giovanni (both active in the thirteenth century) sought inspiration in the antique art of Rome, but paradoxically have been called the creators of modern sculpture. This pulpit in Pisa Cathedral was made by Giovanni. **3** The south façade of the Khajuraho Parshvanathra Temple exemplifies the traditional style of Indian temple sculpture, where figures of gods and heavenly maidens are piled up in tiers. **4** The Royal Portal of Chartres Cathedral is a superb example of early Gothic sculpture in France. Its subject is the glorification of Christ the Saviour. **5** Figures carved in the round fill the triangular shape of the pediment of the Parthenon. Reclining gods and rearing horses acclaim the triumph of Athene, patron goddess of Athens, over the sea-god Poseidon in their contest for the city.

5

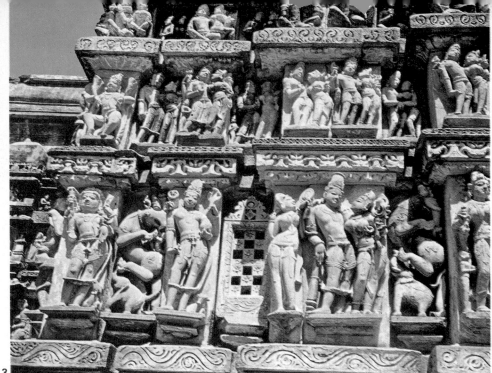

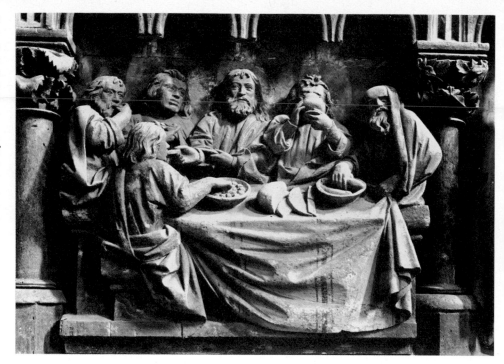

Right, a most realistic portrayal of the Last Supper in the West Choir of the thirteenth-century cathedral of Naumburg in Germany. The apostles gulp their wine and break bread in such fashion that the event seems to be taking place before our eyes. *Below,* a dramatic bronze group of St Michael triumphing over Lucifer, executed by Epstein for the wall of Coventry Cathedral.

their God in abstract terms. In the setting for worship the abstract beauty of architecture dominated, its bare white walls expressing the purity of the geometry of its ground-plan, while the emotional and realistic forms of sculpture were often just decorative furniture, self-conscious works of art inspiring admiration, rather than symbols of the Christian ritual. The religious sculpture of Michelangelo is a notable exception.

In the seventeenth century artists reacted against the obsession with style which had possessed those of the late sixteenth. They tried to make art as expressive as possible; the work of Bernini is its finest product in the field of religious sculpture.

In 1645–52, Bernini built a chapel in the Church of Sta Maria della Vittoria, in Rome for the Cornaro family. Inside he placed a group of the Ecstasy of St Teresa in a tabernacle on the window wall (see vol. I, page 346). In this scene he depicts St Teresa's vision of an angel who pierced her heart with an arrow of fire. St Teresa herself gives an account of it and describes it as an experience of great spiritual pain and rapture. Bernini's figure is dissolved in writhing folds of drapery culminating in her ecstatically gasping face, while the angel's whole body is in flux as he withdraws the arrow.

Physical immediacy

The forceful expression of the statuary is made more realistic by light falling from a hidden window above as though from heaven itself, and when we look up, the vault is lit with the same radiance. The whole chapel is a theatre in which the spiritual drama is enacted, and the visitor becomes the audience, drawn into the action. But the illusion goes further; the sides of the chapel have figures of the Cornaro family also watching the scene from theatre boxes set in the walls. The church as a building becomes a setting for the action, a reversal of the roles of the past, when sculpture was a decoration for the building. Even medieval German sculpture stopped short of the physical immediacy of this work.

The art of Bernini was too sensational even for some of his contemporaries; his successors lacked his intensity. The use of sculpture deteriorated into the charming but purely decorative statues on the altar of the church at Vierzehnheiligen in Germany. In the twentieth century very little of the major sculpture has been religious in the traditional Christian sense. Coventry Cathedral relies for its effect upon stained glass, while the figure of St Michael by Epstein outside is but loosely related to the wall surface. It is more of an emblem than a symbol of divinity.

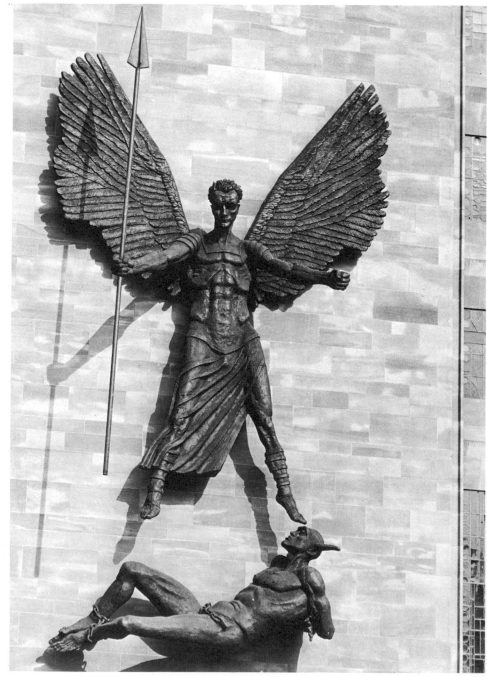

The shape of primitive sculpture

The tremendously bold and vital experiments of primitive sculpture are part of the effort Man makes to understand the meaning of his world. His creations belong to the history of ideas.

A THOUGHT may be expressed in words. But it may also be represented in forms that we can see and touch. Many ideas have been passed on from person to person in this way by means of visual symbols, that is, in picture language. 'Primitive' arts are part of this history of human thought. They express ideas. They do not represent 'things'. And the ideas they express may be very subtle and interesting, even though they cannot be stated properly in words.

Primitive sculpture represents a phase of Man's efforts to uncover truth. Things only matter to an animal because they can be eaten, because they cause fear, or hurt, or attract by their smell, and so on. But men try to see and understand and discover the significance behind objects in the world about them. The primitive sculptors who carved plump 'Venuses' found on several Stone-Age sites were expressing their effort to understand fertility, pregnancy and birth. They were not creating images of particular people. When we look at the range of 'primitive' sculpture we are not just concerned with the distant past. We use the term to cover a stage in the history of many peoples both past and present.

Perishable materials

It may well be that ancient peoples had traditions – now vanished – of sculpting in perishable materials. Recently most nature-peoples have used the materials nearest to hand – softwoods in Africa and Northwest America, walrus ivory in the Arctic, woods, treefern, basketry and shell in the South Seas. This kind of art perishes quickly and needs renewing continually, so the art-language is kept vital.

Only relatively few nature-peoples, like those from Easter Island and the Marquesas, and some Australians, have carved stone, which involves a special conception of permanence. Some, like the Yoruba of Nigeria, have used clay, fired or unfired, and terracottas are very common from the early phases of the classic ancient civilizations. Usually form is supplemented by colour or a coating of some magical substance; but occasionally useful objects, like boomerangs from Australia, emphasize the beauty of a natural material. We

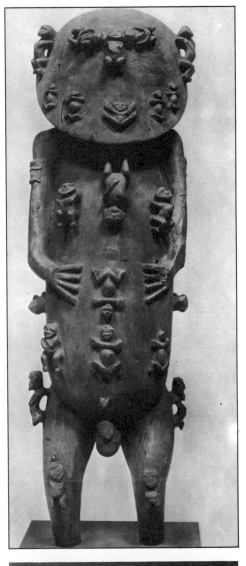

Top right, lesser gods and men sprout from the body of the great god Tangaroa as he stands with knees bent in the act of creation — a symbol of power, order and harmony (Polynesian carving in ironwood). *Far right,* a carved wooden ancestor-figure from Easter Island. Although the style is peculiar to this area, it is common all over the primitive world to make statues to contain the spirits of the dead. *Right,* this twentieth-century Eskimo spoon from Alaska carved from a walrus's shoulder is delicately incised with scenes of animal and human life in the Arctic.

must also allow for the fact that some primitive sculpture has been influenced by contact with that of sophisticated civilizations.

The best approach in the study of primitive sculpture is to analyse the ways in which some fundamental human ideas have been expressed there. Human beings, like other animals, use and respond to sets of display signals used predominantly in sexual activity and warfare. These include a number of facial expressions, such as protuberant, fully opened eyes, displayed teeth, erect hair and so on. In addition many peoples use natural objects such as feathers or skins, scarring or tattooing in different ways to enhance display. These characteristics get stylized and incorporated into the expression of sculptural images.

Superhuman power

Certain sights highly charged with emotion are common to all men, including the wasted and pallid appearance of those dead of disease; blood and entrails; the swollen form of the pregnant belly; and, in tropical regions, fruit, filled gourds and tangled stems. Most men experience contact with living creatures more powerful or swifter than themselves. Often they may sacrifice them ritually, and sometimes depend on them for life. Attributes of such creatures may be sculpted to symbolize meanings related to superhuman power of some sort. Among them are the killer whale (Haida art of Alaska), the bear (Siberia, Blackfoot Indians), the buffalo (Plains Redskins of North America), the crocodile (South America), the leopard (Nigerian Benin) and the hippopotamus (African Ijo).

Many peoples believe that various parts of the animal or human body and aspects of the outer world are specially imbued with vitality or life. Among these are fat, the spine, the head and its protuberances like horns, the genital organs, sun, rain and lightning. The main sense organs – eyes, nose and mouth – are always given special importance.

In view of Man's natural concern with life, fertility and increase, particularly significant are those objects which show in their visible form the attributes of growth, such as shells and horns, often abstracted as spirals which 'grow' outward from a centre. This common basis of formal symbolism is, of course, modified and extended by the experiences of human groups in different environments and societies.

Probably the beginnings of sculpture consisted of modifying slightly a symbolic natural object, such as a stone, shell or antler. In a sense one can say that the Stone Ages everywhere were ages of sculpture, for stone tools are sculptures of a sort. Many highly complex ritual tools of Central America and the polished Neolithic axes of South East Asia are indeed works of art. They may well have crystallized an image of power.

Humanity's oldest known sculptures come from Old Stone-Age sites, including caves, in western Europe. Their dates are very uncertain, but range from something

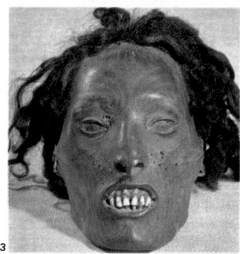

Depictions of the female figure as a symbol of fertility can be traced back to the beginnings of time when Man first made images to represent his world. A highly stylized mother goddess typical of the Indus civilization of India of the third century BC, **1**, is made of terracotta. In contrast, the *Uli* figures of Melanesia are very much part of the physical world. Ulis are bi-sexual and represent collective ancestor-figures, often with children clinging round them, **2**. The head is recognized in most cultures as the home of the spirit. Sometimes the actual skulls of an ancestor are preserved, like this fearsome one from New Zealand, **3**, where the skin is decorated

with spirals. **4** A long-armed squatting figure scares away the devils of disease at the entrances to villages on the Nicobar Islands in the Indian Ocean. **5** Maori chieftains wore jade *tikis*, pendants representing their ancestor Tiki, whose spirit they hoped would protect them. The spiral motif is a very ancient pattern which occurs in primitive sculpture round the world. The abstract decoration on a Chinese tiger's head dating back to the Chou dynasty (c. 1027–221 BC), **6**, is based on this design. Another famous motif, the serpent, figures on a magnificently carved canoe-prow from Cameroon, **7**, together with strange beasts – and uniformed Europeans!

like 100000 BC to 8000 BC. Many are on pieces of bone or horn, incised or carved in fuller relief with animal figures; some were used as implements, such as spear-throwers. There are also some larger animal reliefs, like the stone-cut ibex (Roc de Sers) or the modelled clay bisons (Tuc d'Andoubert) which parallel the well-known cave paintings at these sites in France. Such beautifully formulated figures, probably connected with ritual, show a grasp of truth that is far from primitive.

Most fascinating of all is the group of plump 'Venuses', some stone-cut in relief at Laussel, others in full round at Willen-

dorf and Lespugne. These may indicate a complex concept 'fat – pregnant – birth – increase – fertility – and eventually death'. The plump-woman image survives into Megalithic-Neolithic times in such terracottas as those found in Hacilar, North India. In stone relief it appears on Megalithic communal graves in the Mediterranean, Portugal and France. Sometimes here it is stylized into grouped spirals (sometimes called 'eye-icons') which may have meant: Man returns dead to 'Mother Earth' whose evolutionary function the spiral represents.

There are, broadly speaking, five major

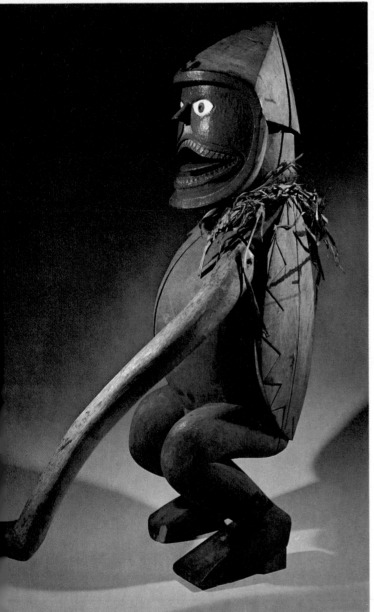

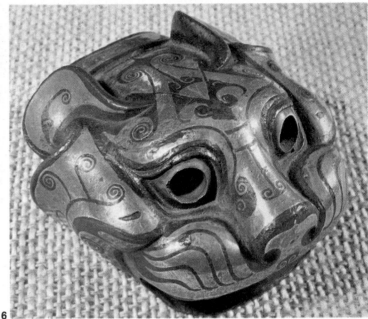

6

7

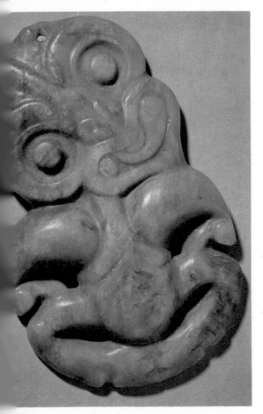

categories of recent primitive sculpture representing many different races. First is the spirit-figure in which the head features prominently and serves as a 'habitation' for spirits of the dead. At the same time it demonstrates the specifically human as something special beyond the ordinary realm of nature, for the head is usually recognized as the most spiritual part of the body. Nigerian skin heads represent an early stage; the skull is removed from a dead body's head, and the skin is stretched over a basketwork frame, pegged in at the corners of the features. Such a head, placed over a basket of the bones of the dead, is occupied by the spirit and can give oracles.

African copper, Maori jade

Amongst many head-hunting peoples the heads of slain enemies are often used in a similar fashion. Purely sculptured heads, for example those of the Congo Fang (Pangwe) can likewise serve as houses for the spirit. Some of these heads can be so highly stylized as scarcely to resemble a face at all, like the copper and brass heads of the African Bakota. This is quite reasonable in that a spirit is not a human being.

Among many peoples of the South Seas,

heads, or whole figures with large heads, are made for a similar purpose, to stand in ancestral grounds. In the Sepik river region of Papua, even the living have their 'spirit-figure' carved, which is stored after death in the house of the ancestors. The famous Maori jade *tikis* representing the deified ancestor Tiki are similar 'external souls'.

Secondly, the icon or fetish embodies a more general sort of power. It appears in two main forms. Most primitive are those natural objects which, with or without being touched up, serve as symbols of the divine. In India, or among the Nigerian Yoruba, shrines may have stylized emblems of the male and female genitals.

The second type of icon is a god in the shape of a man, and probably derives in principle from the type of the ancestor figure of the chief or king. Such figures are still preserved today in the royal shrines of African tribes, but in more developed form they can convey more complex ideas. Among the Polynesians a 'creator god' is represented as a vast human shape from whose body men bud like blisters.

A wargod of the Zuni Indians sprouts from his navel-centre a 'feather-staff' shaped like a shoot, emblematic of creative

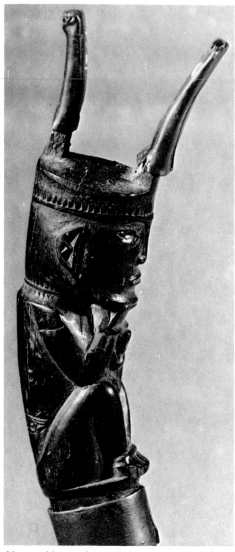

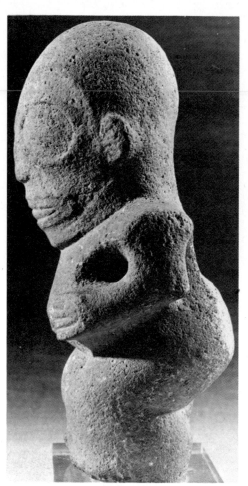

ate symbolic forms (New Hebrides, African Baga and Basonge).

Sometimes, as with the Northwestern American Tlingit, the mask may have moving parts worked by strings which can make the 'spirit' seem to speak. We must never forget that masks were meant to be seen in the vivid movements of a ritual dance, so they are never complete when we see them in museums. Part of the explanation of the forms they take is in the way they are used. For example, the leaping antelope masks of the African Bambara are completed by appropriate dance movements, the tall Dogon masks of Mali by wide sweeping gestures of the head. Obviously the meaning of most face-masks will be conveyed in terms of stylized facial expressions. But the more elaborate masks carried on the head can contain a very complex mixture of imagery without much specific reference to the idea of a face.

Weapons and canoes

Fourthly, objects of use can often be very beautiful. The bamboo beer vessels of the Nagas of India, carved in relief with figures of lizards and slain enemies, and the betel boxes of the Dayaks of Indonesia are good examples. But weapons – upon which the survival of primitive man depends – are specially important. They very often have spiritual force given to them by added masks or eyes (Marquesas clubs). Archaic weapons with a purely ritual purpose may also be given symbolic shapes or attributes (Trobriand Islands dance shields, Kabui dancing swords). Canoes among the islands of the South Pacific commonly have eyes or painted designs on them, to give them the supernatural power to do their job. Some commoner objects of use have a 'spiritual' meaning of other kinds. Sometimes small figures of wood or terracotta are made as puppets to initiate young people into the mysteries of adult sexual life.

There are a few kinds of sculptures which have a special non-material spiritual use. Among them are the funeral display sculptures of the Nagas, designed to show the dead man's power. But perhaps most interesting are the fantastic constructions of wood, string and cloth which Tibetan shamans use to maintain contact with the airy spirit world. Many peoples, too, have made figures for the purpose of practical magic.

Finally must be mentioned one most extraordinary, unique group of primitive works of art, the burial pottery of the Chimu and Nazca tribes of Peru. This was made to represent an extraordinary variety of aspects of everyday life as well as cult. In this respect it is probably unique. Only the Eskimos have made anything comparable in their bone and walrus ivory carvings.

Primitive arts, then, are rarely meant for decoration. Rather, the many and varied forms are important for their spiritual or magical effectiveness and the ideas they represent. The significance of the forms themselves lies in the reference they have to a people's everyday experience of life and death and their understanding of good and evil.

Above, objects of everyday use are often carved or decorated with symbols to give them the supernatural power to perform their task. This ancestor-figure squatting on a knife from Sumatra must aid the hunter in his work, for on him survival depends. *Above right,* a Polynesian figure from the Marquesas Islands carved in stone, an unusual medium for primitive sculpture. *Right,* an eighth-century Japanese dance mask, worn to represent a spirit, is made of wood, covered with plaster and then brightly painted.

power. A Yoruba female spirit appears as a suckling woman. In many parts of Africa fetishes have attached to them all kinds of objects which add to their potency, such as shells, charms, 'medicine' or iron blades. In Central and South America gold symbolized the power of the sun and was used in sculpture either as a decoration or as the main material.

Masks for magicians

Many peoples decorate their house-posts with icons either of the creative spirit, or of the power of their chief. Certain Indians of Northwest America made huge 'totem-poles' emblematic both of clan-identity and its social power. Other peoples make house-posts with a similar intent. Nigerian Yoruba chiefs may have elaborately carved thrones and house-posts with female figures holding axes and swords meant to display the supernatural sources of their power.

Thirdly, far the best known kind of

primitive art are masks. They were made in the Arctic, America, Siberia, India, Ceylon, the South Seas and many parts of Africa. They are used in many different kinds of ceremonies, worn by human magicians or dancers, but always for the same purpose – to represent a spirit which has 'descended' into the dancer and taken possession of him. The mask may represent the healing spirit possessing a shaman (priest), a hero god, an oracle or a spirit protecting a ceremonial enclosure. The spirit may be quite individual and characterized, or it may be very generalized. The mask may be made of anything, from straw and feathers, shell and bamboo, to wood carved with the greatest skill into elabor-

Ancient and classical sculpture

For 3,000 years, sculptors of the ancient and classical world wrested images of gods and men from blocks of stone and wood. Behind their skill lie fascinating theories of proportion and form.

THE ANNUAL Nile flood provided the Egyptians with a constant symbol of the renewal of life after death on which their religion was based. Images of the dead were placed in the tombs to provide a permanent resting-place for the Ka, or soul, in addition to the mummified body which eventually decayed. The Ka's immortality was assured by the presence of a body to occupy and food and drink as nourishment. His amusement was catered for by the activities of mortal life painted on the tomb walls.

All statues were potentially inhabited by the life force of the person or god represented, so they had to be made to last. The rectangular shape of the block determined the simple volumes of the form, in keeping with their monumental architectural setting. The materials were hard and not easily destroyed. The standing figure was strengthened by a back support and the even distribution of weight between the stout pillar-like legs. The left leg was thrust forward in the male, while the feet stood together in the female; arms were clenched to the side and the body was established in a frontal symmetrical position.

A canon or law of proportion, established by the third dynasty, c. 2700 BC, changed very little over 2,500 years and Egyptian art became formalized and conventional, bound by strict rules.

In contrast to this strict formalism, the greatest goal of the Greeks was the conquest of the human form. In 200 years of development, from the seventh century BC, they broke down the rigid Egyptian formulae upon which their early art was based, and mastered the body's structure, the shifts in its contour caused by movement. An ideal of the perfect physical form to represent their gods and heroes replaced the stereotyped Egyptian figures.

In the service of the empire

The Romans took a third step – from symbol to ideal to fact. They excelled in realistic portraits of their emperors and sometimes of more humble people, too. The native character of their art first asserted itself during the Republic in the first century BC as the Hellenistic empire was dying. Under the emperor Augustus (23 BC), art was put to the service of the empire, a function it fulfilled until the decay of the Roman civilization and its art in the fourth century AD.

The ancient and classical world thus spanned 3,000 years, a period seven times longer than post-Renaissance history. The key to its civilizations lies in the museums.

In Egyptian sculpture a strict canon controlled the proportion of each part of the body. The head from hairline to shoulder was the unit of measurement.

Above, this delicate figure of a young maiden, or *kore,* exhibits the naturalism apparent in Greek sculpture as early as the sixth century BC. The Greeks understood the human body and depicted it in all its different stances, in move-

ment or at rest. Statues of their gods and heroes conform to an ideal concept of physical perfection, like this head of a fifth-century BC Poseidon, *top right.* The Romans were masters of realistic portraiture. *Above right,* head of the emperor Trajan.

The figure was nine units tall. The body was always sculpted in a frontal position, arranged symmetrically about a central axis through the middle of the head, and ended in the big toe of the back foot in a male standing figure. A limited number of poses became traditional: standing male and female figures, enthroned god or monarch, the two-figure group with the woman clasping her husband's waist, the three-figure group with the tallest figure in the centre, and the squatting scribe.

The sculptor drew a grid on all four sides of the rectangular block. Each square of the grid was equal to half a unit (the face occupied two squares of length and two of

width and the standing figure was 18 squares tall). Once the outline of the chosen pose was carefully measured out on the grid in front and profile views, the end result was a foregone conclusion. Form quickly crystallized into formula. Thus the king wore a royal headcloth, a pleated loincloth and a false beard: he either stood stiffly or sat on his throne.

Individual characteristics still had an influence on the type, however, and shades of meaning were conveyed by combining symbols. Thus in the fourth-dynasty (c. 2600 BC) statue of Chephren, the king is the sky-god Horus incarnate. The falcon over his head and high-backed throne are

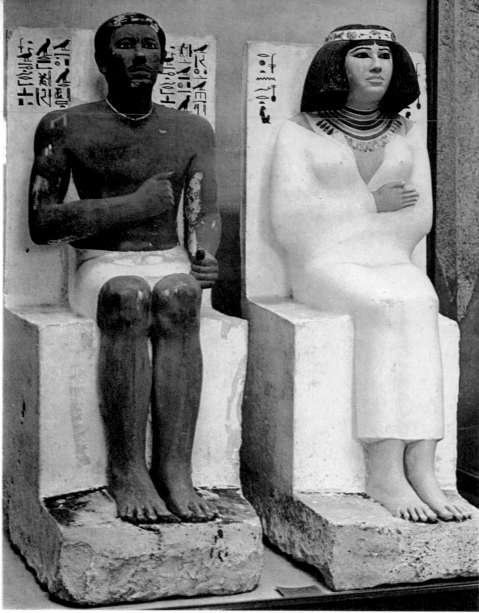

Traditional poses in ancient Egyptian sculpture became formalized very early on and hardly altered for 2,500 years. Even so, Old Kingdom sculptors sought realism within the strict conventions sometimes by life-like painting, as in *Prince Rahotep and his wife Nofret, above left,* whose eyes are inlaid with polished limestone and rock crystal. A New Kingdom pillar statue of the fanatical Pharaoh Ikhnaton, *below right,* is stylized but the face is strangely realistic. *Above right,* a sixth-century *kouros,* or naked boy from Greece, based on ancient Egyptian conventions.

symbols of deity. Royal control of the United Kingdom is stressed in the intertwined plants of Upper and Lower Egypt on the throne. Divine power and youthful dignity are shown in the face.

Middle Kingdom (2133–1786 BC) monarchs, particularly Sesostris III, convey their burden of responsibility in sad gloomy expressions. New Kingdom (1567–1085 BC) royal images are conventional except during the Amarna period when Ikhnaton rejected the state worship of Amen at Thebes and made himself apostle to the one universal sun-god Aton. A strange bulbous figure style replaced the old canon, and portraiture was astonishingly realistic. The forbidding features of Ikhnaton in a Cairo museum pillar statue suggest his fanatical character. The attributes of double crown, beard and loincloth are traditional, but the broad hips, decorative stylization and bracelets inscribed with hieroglyphics give a strange effect.

Ancient wooden cult figures, *xoana*, perhaps a survival from very early Greek (Minoan) times, were the earliest statues of the Greeks. The stiff, tree-like forms, dressed in a woven *peplos* (an outer robe worn by women), was the probable origin of archaic stone female figures called *korai*, like the *Peplos Kore* from the Acropolis in Athens. The naked male *kouros* was influenced by Egyptian standing figures as the taut arms and advanced left foot suggest.

Two parts fitted

A similar grid system was used to determine the outlines so that statues could be roughed out in the quarry to within one inch of the final surface to ease transport costs, and finished by the sculptor near their destination. The standard of precision was such that Telekles and Theodorus working at Samos and Ephesus respectively, constructed an Apollo in two parts that fitted perfectly together.

The Egyptians worked with limestone or hard stones – diorite, basalt, granite. Coarse red granite was used for giant statues called *colossi,* often made in parts in different workshops. Wooden statues were made in parts joined by a square peg

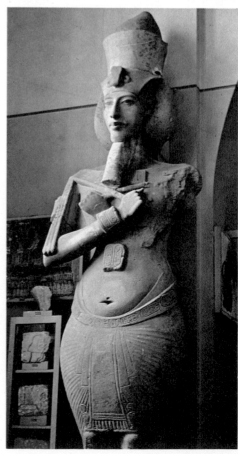

Above left, Marcus Aurelius, once emperor of Imperial Rome. This famous bronze group is typical of the classical revival of the second century AD and was probably executed to commemorate the emperor's victories. *Top right,* the slim, soft, almost female body of Hermes cradling the child Bacchus in his arm. The relaxed leaning pose and the casually tumbling drapery are all characteristic of the fourth-century BC sculptor Praxiteles. *Above right,* movement is arrested in this little bronze jockey boy of the third century BC in Greece. Admiration for the human form, so characteristic of the Greeks, revived with the Renaissance in Italy. Michelangelo's *David, left,* is perhaps the most perfect example of the harmonious classical style of this period.

and socket. Many classical marbles have lost limbs or drapery which were attached in this way. Egyptian hard stone was broken out of the quarry by stone hammers; limestone and marble were split by drilling holes, driving in wooden wedges which were swollen with water to enlarge the gaps. The Egyptians used copper tools on soft stone, hammer and punches on granite, to rough out the square masses of the form according to the block drawing. More detailed areas were worked up by drilling holes and cutting or hammering the rest away. The surface was rubbed and polished with sand, then painted.

The Greeks had the advantage of softer stone, and iron tools. They were not satisfied for very long with stiff Egyptian models. The transition from a very formalized figure like the early kouroi of the seventh and early sixth centuries BC to the male nudes of the fifth century BC, is rapid by archaic standards. This was possible only by discarding the ancient method of cutting the block in layers from all four sides and then rounding off the edges.

The Greek sculptor began to carve in curved volumes, not flat planes, working all areas to the same degree at once, first breaking down the surface with hammers, punches and points, then moulding the forms with chisels, using the drill for the grooves of folds in drapery, for hair and eyes, smoothing the surface with a rasp and polishing it with emery.

The 'lost wax' method

Bronzes were hollow, cast in one piece in classical times by the 'lost wax' method: the more organic approach of modelling the figure first in clay, not carving out a block, freed the sculptor from stiff archaic forms. A thin layer of wax was applied between model and mould, then melted out and replaced by liquid metal.

In the fifth century BC Athens reached her zenith under the great statesman Pericles. Phidias, the sculptor of the Parthenon, and his school perfected the classical ideal of beauty based on a lithe

athletic physical type, the male figures nude, female figures draped in the traditional thin tunic. The Parthenon frieze and pediment sculptures are a precious survival from this golden age. The forty-foot cult images of ivory and gold of Zeus at Olympia and Athena Parthenos by Phidias must have been overwhelming. The bronze athletes of Polycleitus of the late fifth century BC are known to us only in Roman marble copies. The *Doryphorus*, or spear-holder, illustrates a canon of proportion based on the palm of the hand, a very different standard from the Egyptian use of the head as a measurement.

Hellenistic art

The vivacity of the bronze is lost in copying. Tree-trunk props were often introduced to support the marble figure, which was unnecessary in the bronze original, and a dead quality results from a dry relief treatment of details originally engraved or inlaid.

The *Hermes with the infant Bacchus,* by Praxiteles, is a superb marble original of about 340 BC. It was found tumbled off its pedestal in its original position in the temple of Hera at Olympia. The relaxed standing pose follows fifth-century practice but the treatment is softer, more elegant. The body is highly polished by constant bees-waxing. It was this sensuous quality which made his *Cnidian Aphrodite* one of the most famous depictions of that goddess in the ancient world.

It was the opinion of the Roman scholar Pliny that Greek art died in the third century BC. During the Hellenistic empire (330–100 BC) sculptors explored the range of technical polish, realistic movement and emotion, broadening the range of subject matter at the expense of classical balance and beauty. Many sometimes undeservedly famous works have survived from centres at Alexandria, Rhodes, Pergamum and Antioch – the *Venus de Milo*; the *Victory of Samothrace,* a superb study of form and drapery in movement; the violent *Laocoön* group, of great influence on the classical tradition from its excavation in Rome at the height of the Renaissance in 1506; character studies of drunken peasants, children and conquered races.

The Egyptians made the likeness of a person specifically as a substitute in the afterlife. In the second century BC, the Greeks commemorated their famous statesmen and philosophers by portraits in public squares, but a trace of idealization of the individual's features still remained. The more prosaic character of the Romans produced factual portraiture and energetic relief sculpture, but very dull statuary. The custom of preserving wax *imagines,* death-mask portraits of their ancestors by private families, contributed to the vigour of portraiture under the Republic (first century BC). The stern character of Roman senators is recorded with almost brutal accuracy. In the statue of Augustus (27 BC–AD 14) from the villa of Livia at Prima Porta near Rome, the ideals of a powerful but peace-loving ruler are personified. His breastplate is decorated with symbols of his diplomacy.

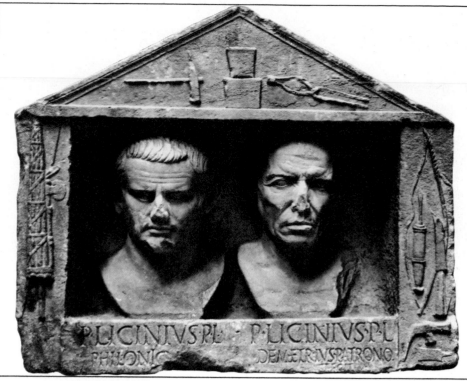

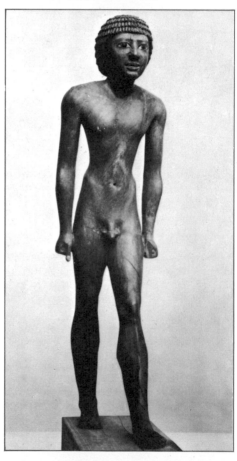

The more humble realism of portraiture in the first century AD was followed by a classical revival under the emperor Hadrian in the second century. Characteristic of the age is the Antinous head in the Louvre in Paris. Antinous sacrificed himself in the Nile to save the emperor from a prophecy, and was deified. The Phidian-style head is crisply outlined, the hair drilled, the flesh highly polished. Of similar style and textural virtuosity is the famous bronze Marcus Aurelius on horseback, now on the Capitoline Hill. The decadence of the Antonine emperors is

The Romans sometimes portrayed humble folk in their sculpture of the first century AD. These two men in marble, *above,* are actually Greek freedmen and their characters can easily be read in their faces. The eager expression of the face and the accurate observation of the body's structure in the wooden Egyptian figure, *left,* are quite amazing, for it dates back to 2200 BC.

clear in an eccentric bust of Commodus, murdered in 192 BC. He was worshipped as the deified god Hercules, whose symbols of lion-skin and club are a ridiculous contrast to his foppish features.

With the fall of the Roman empire in the fifth century AD, art reverted to symbol and formula in the service of religion. The classical ideal was revived in fifteenth- and sixteenth-century Italy after its long sleep in the Dark and Middle Ages. Men rediscovered the importance of knowledge and human achievement through the study of antiquity. They reasserted the Greek ideal of the perfect human form as a reflection of the divine harmony of the Universe. Michelangelo's *David* (1501–4), though more vital and less timeless, has much in common with the *Doryphorus*.

The practice of copying antique and Renaissance old masters in the Academies still survives in the tradition of drawing from casts in art colleges today. The classical emphasis on perfect form and line maintained in painting by the Florentines in the sixteenth century, by Poussin in the seventeenth century and Ingres in the nineteenth, was pushed to extremes by their opposers – Titian, Rubens and Delacroix – who favoured colour and technical freedom. The academic exercises of the nineteenth century neo-classical sculptors such as Canova are uninspired. Rodin's interpretation of the athletic nude in the *Age of Bronze* (1877), combining spiritual content and vitality with physical beauty in the tradition of Phidias and Michelangelo, stands on the bridge between classical and modern ideals of form.

Sculpture in the modern world 1

In the nineteenth century sculpture had become decadent and repetitive; the poet Baudelaire thought it a boring art. Degas, Daumier, Rodin and their followers proved how wrong he was.

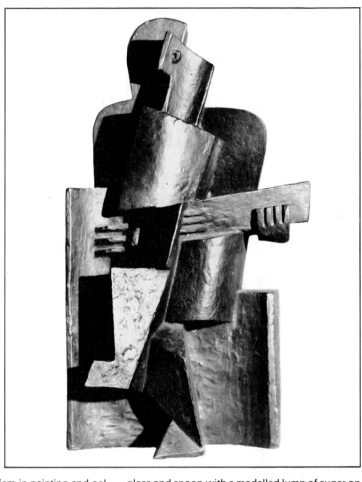

A HUNDRED YEARS AGO every piece of sculpture was made in bronze or stone. Sculptors themselves hardly bothered to carve any more, and those who worked on their own were in a minority. Most had a small army of expert craftsmen to help them. If the sculptor wanted the end product in bronze he would make a clay model, cast it in plaster and finally have it cast in bronze. After the early stages, the craftsmen took over, making the plaster and bronze casts frequently without the sculptor's supervision.

Sadly the end results often had nothing to do with the original models. But the disadvantages of this unartistic way of producing bronze casts are small compared with those which arose when clay models were translated into stone. The craftsmen again took over after the early stages; the artist produced a clay or wax model, the craftsmen then enlarged and copied it in stone.

They did this with a 'pointing machine', a simple construction which exactly measures all the dimensions of a three-dimensional object, just as a pantograph measures and reproduces to any size a drawing or diagram. The sculptor retreated to the privacy of his home while the craftsmen carved. The result in stone is a poor mechanical copy of the original

The development of Cubism in painting and collage had enormous consequences for sculpture. *Left, The Absinthe Glass* by Picasso, arguably the greatest innovator of the modern period. A real

which would have been better left unmade.

It was not only such mechanical processes which made the sculpture of a century ago more decadent than it had ever been before. The attitude of most sculptors was narrow, small-minded and bogged down in the past. Most of them were trying in their inflated monuments, in their sentimental studies and near-pornographic essays into eroticism, to conserve and continue the qualities of sculpture in its long-past period of greatness. In an age of industrialism they tried to outdo the ancient Greeks and Michelangelo. They failed.

Is sculpture boring?

In 1846 the French poet Baudelaire wrote an essay called *Why sculpture is boring*. Because the sculpture he saw exhibited was indeed boring, no one could blame him for coming to such conclusions about sculpture in general. If he were writing about the art today he would need to be blind to find it boring. Today sculpture is even more original and alive than painting, particularly in America and Britain.

glass and spoon with a modelled lump of sugar on top were cast in bronze and brightly painted. *Right,* in *The Guitarist,* Lipchitz translates the flat planes of Cubist painting into a sculpture.

The difference between a piece of modern sculpture and one of a century ago is even more startling than that between two paintings separated by the same time-lag. Today, instead of being restricted to bronze and stone, the sculptor welds, assembles, carves and casts in iron, steel, fibreglass, plastic, wood; in short, he uses everything and anything. He may paint his work, he may set it on a pedestal or arrange it in sections on the floor. Today, too, most modern sculpture is abstract; it neither reproduces the human figure nor does it provide us with something to recognize or make comparisons with nature. It is difficult art, extremely hard to understand and come to terms with.

But like all modern art, modern sculpture is easier to grasp if we know something about its history. What follows is by no means an inclusive history of modern sculpture, but it is an attempt to trace its genesis and evolution. Several problems will recur; several questions will continually be asked: Which materials are suitable for the making of sculpture? Which subjects can be used by a sculptor?

Above left, Rodin's masterpiece, *Monument to Balzac,* dominates the Boulevard Raspail, Paris. Only the head is treated in detail; the rest of the figure is almost untouched, its bulk suggesting the stature of the writer. *Above right,* the work of Maillol exhibits a strong classical influence which saved his forms from triteness. *The Three Nymphs* typifies his idealized conception of the female nude. *Below,* Rodin's *Age of Bronze,* a man slowly rousing himself from sleep, was so sensational at the time that the sculptor was accused of making a cast from a living model.

Is a sculpture a solid, three-dimensional mass, a lump of material which has been altered by the artist, or is it an open, rangy collection of elements which are less important in themselves than as they are controllers of the space around and within them?

In spite of the generally dismal state of the sculpture of a century ago, much really creative work was being done. And it was done not by sculptors but by people who are officially regarded as painters: Théodore Géricault, Honoré Daumier, Edgar Degas, and Paul Gauguin. Time and time again great painters turn out great pieces of sculpture. Michelangelo apart, it is not often that great sculptors are also painters of distinction.

It is perhaps not surprising that painters should have been the most original sculptors in the nineteenth century. The sculptors of the period were obsessed by the past, the painters by originality and experimentation. At that time, originality meant reality. From Courbet to Cézanne, painters tried to reproduce nature, or what they thought was nature, as faithfully as possible.

Degas' *Little Dancer* (1881) must consequently be seen as something of a breakthrough, because as Realism it is breathtakingly successful. When Degas made her she looked even more true to life, for she was not then cast in bronze, but existed in painted wax and wore real clothes, shoes and hair-ribbons.

Daumier's sculptures, earlier than those of Degas, are just as striking. Perhaps the most important thing about them is that they avoid the fine, smooth, assiduously cultivated surfaces of the craftsman-made objects of his contemporaries. Daumier's surfaces are uneven; he left the marks of his fingers and manner of working all over them. Precisely this gives his sculptures life.

Articulated surfaces

The painter-sculptors had no direct followers, however. The first sculptor to bring something new to the art and to have an enormous influence on the subsequent development of sculpture was Auguste Rodin (1840–1917). At about the same time as Degas, Rodin was attempting on a broader front to solve the problems of Realism in sculpture. He had learned a great deal from the Greeks and Michelangelo, but he had learned it better than his contemporaries, and eventually went much further than they.

Rodin so successfully created a Realist sculpture that when he showed *The Age of Bronze* (a man rousing himself from sleep)

The Impressionist painters at the end of the nineteenth century wanted to portray the world as truthfully as they could. Degas' *Little Dancer*, executed in 1881, was a remarkably successful attempt to translate this ideal into sculpture.

in an exhibition in 1877, he was accused of taking a plaster cast from a live figure and then casting it in bronze. This was, in fact, frequently done by academic sculptors, but with disastrous results.

Rodin's figure was not, of course, cast from a human being. It simply looked more real than anything visitors to the exhibition had ever seen. Rodin understood that certain conventions, tricks if you like, were necessary to make a sculpture look life-like. Copying, however precise, can never be successful. Rodin also understood that one of the most important conventions was the way a sculptor treats the surface of a sculpture and makes it work for him. He had noticed that the surface of a Greek statue was not smooth but rough, and that it was precisely this roughness which gave it life. Rodin therefore worked on his surfaces, articulated them so that they controlled light and used it to great effect. Rodin could model a surface to attract light, to make light explain a shape, to diffuse light or to concentrate it.

But the Frenchman's contribution to sculpture does not end with his discovery of light as a medium nor with his masterly gift for creating realistic sculpture. The story of his statue *The Walking Man* is as interesting as it is instructive. It was originally made as a smaller-than-life study for his larger-than-life *John the Baptist Preaching,* and when it was in the studio it was damaged.

Heroic gesture

Rodin immediately perceived the power of a headless and armless figure as a startling image, and he continued to work on it (from 1877 to 1900) without restoring the bits which had fallen off. As a result, not only is the attitude of walking emphasized so that it becomes grand, an almost heroic gesture, but the imperfections of the surface on the torso have a power, an abstract quality as material, which was at that time quite new to sculpture. The thing is less than three feet high and yet it is as powerful as an object four times its size. It is certainly much more memorable than the finished *John the Baptist* over twice as big.

The English sculptor Henry Moore owns a cast of *The Walking Man* and if you compare it with one of Henry Moore's bronze figures it is not difficult to see why. Certainly this single piece by Rodin has had a greater influence on the work of his successors than anything else by him.

The Walking Man is also important for its subject, or rather for its lack of a subject, for here is an image without any religious, literary or ancestoral association. It does not need a story to give it life. It exists as a sculptural image, as something three-dimensional which gains in power as you walk round it. It is nothing more.

The *Monument to Balzac* (1898) provides a startling contrast with the other monuments done at the same time by other artists. Rodin's Balzac is not done up in phoney classical costume and he has not adopted a false head-on-hands thinking pose either. Larger than life, the figure towers above us. The sensual head is the only thing treated in detail. The greater part of the sculpture is left to suggest the bulk of the man beneath. The pose, the angle of the head not only affirm Balzac's characteristics as a writer, his self-confident, head-on acceptance and glorification of life, but also his stature.

Rodin proved in an age of Realism that it was possible to create a type of sculpture which retained the art's traditional virtues without becoming trite or imitative. At the same time it was a contemporary type of sculpture which extended the range of the art and demonstrated possibilities for further exploration. It is an achievement

which younger artists fruitfully drew on for more than half a century.

Rodin was undeniably a Realist. A slightly younger sculptor, Aristide Maillol (1861–1944) proved in a similar way that to create monumental sculptures in the traditional style was also possible without falling into the traps set by anachronism and triteness which his contemporaries fell into to be lost for ever. Although Maillol cannot be compared with Rodin in stature, his regular, schematized and idealized studies of naked women (almost his only subject) had a considerable influence.

The Cubists

Since Cézanne, and more particularly Gauguin and Van Gogh, painting moved away from Realism with gathering conviction. By 1910 the Fauves (a school of painters called the 'wild beasts' because of their riotous colours) had successfully created a form of painting in which colour and form were used in a wilful and arbitrary fashion. The Cubists had turned the conception of reality and the history of painting upside down. Moreover, the first truly abstract pictures were being dreamed up in studios across Europe. Not Realism but precisely its opposite was in the air.

This put sculpture in a very difficult position, for a sculpture is clearly more *real* than a painting. Traditionally a painting gives you the *illusion* of something, it strives to disguise the fact that it is in reality a canvas covered with paint. Although a sculpture is also an illusion, pretending to be a man or a woman, it finds it harder to spirit away the fact of its material substance. This is why sculptors have preferred to deal with the human figure: a human being is the most real thing there is.

When Picasso and Braque created Cubism in painting they seemed to offer not only a new way of looking at nature, but also a new set of forms for artists to use, a new vocabulary of shapes and a new theory of composition. Briefly, Cubism analysed an object from several points of view and crystallized these various aspects into one composite image. Moreover, it analysed an object not in terms of its mass and volume but in terms of its surfaces, its planes.

After Picasso demonstrated in, for example, his *Head* of 1909, that the precepts of Cubism could be translated into three dimensions, many sculptors greeted the new language eagerly. They believed that it provided them with a way out of the dilemma presented by the death of Realism. Thus, for example, Jacques Lipchitz (born 1891) and Ossip Zadkine (1890-1967) began to create figures which rearrange reality. They are divided into clearly defined parts, put together with an eye for balance, decoration and often expressive power.

But Cubism has a logic in painting which cannot be translated into the more solid medium so directly. You can only look at a painting from the front. There is no point in trying to crystallize into a sculptural image what you see of (say) a head from several viewpoints when you can walk round a sculpture anyway.

Cubism, however, had enormous consequences for sculpture, but Zadkine and Lipchitz did not lead the way. The lead again came from a painter. By 1912 Picasso and Braque had taken Cubist analysis so far that the subjects they were analysing completely disappeared. They could either take the final step and paint thoroughly abstract pictures or they could once again introduce positive links with reality into their work. They chose the latter course, and instead of *imitating* real objects (which was the starting-point for Cubism), they began to *incorporate* real objects in their painting – wood veneer, pieces of rope, pieces of actual newspaper.

These *montages* or *collages,* as they came to be called, can be seen as a sort

of sculpture. Painting is no longer an art of illusion when instead of imitating objects it uses the real thing within a frame. This phase of Cubism was, therefore, much more fruitful for sculpture than the 'analyst' phase which went before. ·

Picasso himself carried these ideas over into sculpture. In 1914, for example, he made the *Absinthe Glass,* which incorporates a glass with a real spoon and a modelled lump of sugar on the top of it. The whole was cast in bronze and brightly painted. The implications of this method of working are enormous. By 'assembling' a sculpture Picasso suggested that, instead of being modelled or carved from one solid lump, sculpture can just as well be put together so that the whole is a combination (but more than the sum) of its component parts.

Witty and mysterious

Picasso also discovered the importance of junk as a source for sculpture. He transformed apparently worthless materials, as if by magic, into often witty, often mysterious artistic configurations. He took, for example, a bicycle saddle and handlebars, put them together to make a bull's head. His *Baboon* looks like a normal, if humorous, piece of sculpture. Very suddenly, at second glance, you notice that the baboon's face has been made out of a child's motor car.

As in his painting, Picasso often pursued several lines of development at once in sculpture. Although he cast his Cubist heads and figures in bronze, his 'painting/sculpture' assemblages are made up from many materials. He also made sculpture in iron, and again, his use of this metal had enormous consequences for the development of sculpture.

Iron cannot be cast. It can be welded and it can be cut and shaped, although it is one of the most intractable materials. Picasso was not the first to use it. A fellow Spaniard, Julio Gonzalez (1876–1942), had made iron sculpture as early as 1927, but when he worked together with Picasso during 1929 and 1934 his work improved enormously and the true potential of iron as a medium became clear.

These iron sculptures are assembled rather than modelled and it is the two-dimensional profile of a Picasso iron sculpture which gives it its power; he uses iron to make shapes in the air. The discovery that sculpture could be graphic, that it could describe space as a line in a drawing describes a solid, was something of a revolution, with important consequences in the future. Picasso paved the way for sculptors to face the challenge of abstract art, to rid themselves of conventional notions of form and technique, and to experiment with a wide range of new materials.

Sculpture in the modern world II

Today sculpture is at its most exciting and experimental. Traditional concepts are abandoned: any and all materials are used to hammer, weld or mould into quixotic shapes and structures.

AROUND 1910, the painters Braque and Picasso were developing an exciting new approach to painting, which developed into Cubism. Instead of portraying an object from an angle, Cubist painters analyzed it from several different points of view, compressing all these several aspects into one single image. Cubism was thus a new way of regarding reality. It provided artists with a new set of forms and a new theory of composition. The language of Cubism was taken up by many artists outside France. Put to new purposes, it led to further developments in painting and sculpture.

The modern city

One of the most important movements to redirect the discoveries of Cubism was Futurism. Futurism was Italian, passionate and political. It praised brute strength, believed in war and proposed revolution. For the Futurists the most beautiful artistic object in the world was the modern city itself, its crowds, its machines, its speed, its tumult. To them a racing car was more beautiful than a Greek statue. In attempting to introduce the qualities of the modern city into their art, the Futurists relied on the Cubist vocabulary of quasi-geometric forms and planes.

The history of modern sculpture is in part the story of the introduction of new materials. Picasso worked with wood and iron, even assembling some of his sculptures from pieces of scrap. The Futurists proposed an even more radical use of materials in sculpture. In 1912 Umberto Boccioni (1882–1916) published *The Technical Manifesto of Futurist Sculpture,* an odd thing to do since at that time Boccioni had done no sculpture himself. In his *Manifesto* he said that sculptors ought to work with 'twenty different materials – glass, wood, cardboard, iron, cement, horse-hair, leather, cloth, mirrors, electric light etc.'. In view of very recent developments in sculpture this was a startlingly accurate prophecy. For Boccioni it remained a prophecy, for he later executed only a few sculptures in bronze and then went back to painting.

Boccioni is, nevertheless, the most important Futurist sculptor. His best-known work is the *Unique Forms of Continuity in Space* (1913), which, as its title implies, is about movement. This is expressed through the figure of a striding man. The figure in fact has almost disappeared beneath the signs of rhythm and movement. Flowing planes have been added to the basic shapes to make the sculpture work in a similar way to comic strips which attempt to reproduce movement by presenting us with a double or multiple image of an object.

Abstraction has been the most important development in the art of this century. Although not an abstract sculptor himself, the Romanian Constantin Brancusi (1876–1957) created an atmosphere in which other artists found it possible to create completely abstract work.

The son of a peasant, Brancusi studied wood-carving and came to Paris to learn sculpture in 1904. At that time the predominant style was that created by Rodin.

1 In *Unique Forms of Continuity in Space,* Umberto Boccioni portrays the rhythm and movement expressed in the striding figure of a man.
2 Lyn Chadwick's almost predatory *Winged Figures* cast in bronze, surface highly modelled.

1 Henry Moore's *Reclining Figure* in wood lacks strictly human proportions but impresses the spectator with its strength and power.
2 His bronze *Reclining Figure* is a more obvious depiction of the human form, its outdoor setting emphasizing its grandeur.

For all his revolutionary ideas, Rodin was never quite a modern sculptor. In spite of his innovations he still remains firmly in the same tradition that the Greeks began and Michelangelo continued. Brancusi found this tradition unsatisfactory. What he most disliked about Rodin's work was its emphasis on surface. Although in Rodin and Michelangelo there is due emphasis on qualities like weight and volume, the object depicted is described through its surface. The mass of the sculpture, its weight, is less important than its shell which is modelled or carved and which tells us what the object is. Brancusi believed that 'it is not the outward form that is real, but the essence of things . . . it is impossible to express anything real by imitating the outer surface of things'.

A smooth ovoid

Brancusi wanted to strip the object of all unnecessary detail, to pare it down to the minimum, the essential – to reach the essence of things. A good example of his aims and method is the series of sculptures following from the *Sleeping Muse* (1908), a Realist head more or less in the Rodin fashion. The *Sleeping Muse II* of two years later is a highly simplified version with an unmodelled surface. By 1924 what is in effect the same subject has been reduced to a smooth ovoid. It is now called *The Beginning of the World*. What began as the specific has become the general. What was at first literal is now symbolic.

Brancusi's life's work was to reduce the particular to some generalized or symbolic form by cutting out all surface detail. His favourite subjects, the *Bird in Space*,

the *Seal,* the *Fish,* are all dealt with in the same way. All the same, he was never a completely abstract sculptor; his works are clearly meant to represent something. But he had an enormous influence on artists who rejected the use of recognizable subject-matter altogether. Henry Moore said that Brancusi made people 'shape-conscious', and it is impossible to look at the work of Hans Arp (1887–1967) or at that of the contemporary Swiss artist Max Bill without being aware of Brancusi's example.

Very different from Brancusi but important as initiators of abstract sculpture were two Russian brothers, Naum Gabo (born 1890) and Antoine Pevsner (1884–1962). (Naum changed his name to avoid getting confused with his brother.) They were the creators of what came to be known as Constructivism. The work of Gabo and Pevsner is very similar and the ideas behind their work are almost identical. Here we shall concentrate on Gabo.

Gabo had studied philosophy and engineering and felt that the art of sculpture was behind the times, out of step with current ideas in philosophy and science. Sculpture, if it were to be truly modern, needed to speak not of human beings but

of abstract concepts like time and space.

At first Gabo used what he knew of Cubism, and particularly of the Cubist technique of assemblage, which was a way of constructing sculpture from individual pieces of material and not from one solid mass. Gabo's *Constructed Head No. 2* of 1916, for example, shows that mass, volume and surface can be created in an essentially unsolid fashion. Everything is suggested by flat planes.

But the breakthrough for Gabo came in Russia after the Revolution of 1917, where experiment and innovation in the arts was as thoroughgoing and as high-powered as in politics. After a great deal of thought, Gabo and Pevsner published what is now known as the *Constructivist Manifesto* (1920). In this significant document they proclaimed that the sculpture of the future must reject modelling, volume and mass in favour of space and movement. This was similar to what the Futurists had demanded from a modern art.

Mathematical laws

But Gabo proceeded to put his ideas into practice in a way very different from that of the Futurists. He began to make sculptures like pieces of mini-engineering in which wires, stretched and bent into position, describe rhythms expressing certain dynamic mathematical laws. Gabo claimed that these are the same laws which control every object in the Universe. Gabo's sculptures are in fact more like architecture – the Eiffel Tower, for example – and it is significant that he actually designed monuments on an enormous scale, most of which were unfortunately never realized.

Obvious of course is the complete lack of any 'subject matter' in a Constructivist sculpture. Brancusi's work is abstracted rather than abstract. A work by Gabo is thoroughly abstract, drawing its life from qualities which can only be understood in terms of sculpture itself. New materials were also important to him. In order to describe space, to make it visible, he needed to contain it without enclosing it. He thus required some transparent material. At first he used glass but when synthetic materials came in he used plastic sheet and nylon thread.

Possibly the greatest sculptor of our times is Henry Moore. After the First World War all the arts were in a state of flux, and experimentation was the keynote. Moore took account of traditional sculpture and of all the experiments. He used both to consolidate the art of sculpture, to create a language which, although uncompromisingly modern, nevertheless gains from its close links with the traditional.

A statement by Moore, published in 1934 and later called *The Sculptor's Aims,* shows what he was after. Important to him are: nature and 'truth to materials'. The

1 Anthony Caro uses prepared metal – in this case iron painted yellow – and composes structures which the spectator can walk around in.

2 In *La Négresse Blonde,* Constantin Brancusi tried to capture 'the essence of things', stripping the form of unnecessary detail.

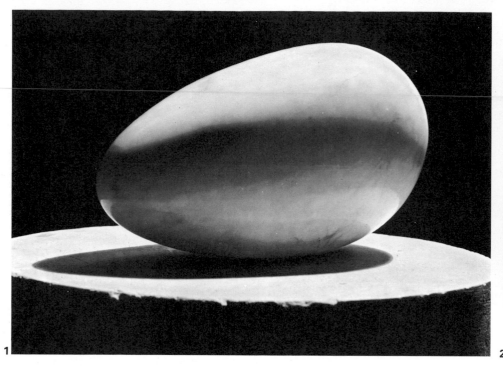

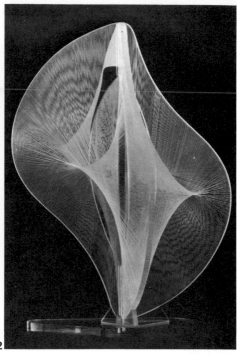

latter means that the material chosen for a particular work should influence the work itself, that the two should grow together. Granite cannot be carved like marble; the qualities of wood are very different from those of stone. 'Stone for example is hard and concentrated and should not be falsified to look like soft flesh', he said.

The importance of nature is also a prime concern, and not only in the sense that Moore's subjects are drawn from nature. He is fascinated by small pebbles, bones and other natural objects, which he frequently uses as sources for his much larger sculptures. These finished works have something of the small pebble about them but they also have strong connections with an entire landscape, with hills, caverns and rolling plains.

Sculptor of 'holes'

The reclining figure is central to his work. The reasons for this are clear. First, such figures are easier to support technically than standing figures, and secondly they are capable of almost infinite variation, of transformation without losing touch with their human source.

Moore is popularly known as the sculptor of 'holes'. He recognized that concavities are as expressive of form as convexities and can be as expressive of mass, weight and volume. Moreover, a hole will often best bring out the natural qualities of the material.

After the war there was no one of Henry Moore's stature. But many artists felt that his essentially Romantic attitudes were as outdated as his reliance on carving and casting. Others went further and claimed that with his emphasis on a few themes like the reclining figure Moore had become repetitive.

Gaining from the knowledge that England, too, could produce great artists, post-Moore British sculptors, in reacting against Moore, have established Britain as a world leader in sculpture. The first group of sculptors with something new to say emerged in the 1950s. Chief among

them are Lyn Chadwick and Kenneth Armitage. Although proposing an alternative solution to Moore, they still have much in common with their great contemporary. They cast in bronze, cultivate surface qualities and their work always has some connection – however slight – with the human figure. But the feeling of being at one with nature has gone. Whereas the majority of Moore's creations are serene, the work of Chadwick, for example, is often frightening. His predatory birds, unspecific scavengers, evoke what the art historian Herbert Read tellingly called 'the geometry of fear'.

Powerful as the work of Armitage and Chadwick is, it did not suggest a clear enough line of development away from Moore's awesomely solid achievement. It was not until Anthony Caro (born 1924), once an assistant of Moore, returned from a trip to America that the new sculpture was born. Caro turned the idea of sculpture upside down and produced something so exciting that disciples sprang up over-

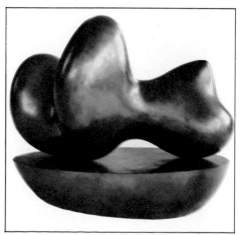

Hans Arp was fascinated by shape. His *Concrétion Humaine* in bronze is a highly stylized version of the human form.

night, and Caro-influenced work became the dominant mode on both sides of the Atlantic.

In the States Caro had got to know many of the most advanced painters and the most advanced sculptor, David Smith, and all helped him break through to his revolutionary conception. What Caro did was work exclusively with metal, which he then painted. The use of metal was in itself not revolutionary, of course, but Caro took prepared metal – I-beams, T-beams, pipes, wire mesh – and then arranged them in a way which had nothing to do with the human figure.

Sculpture to walk around in

The sculptures are arranged on the floor, not on a pedestal or plinth, and they are enormous, stretching out in all directions for several yards. Moreover, the paint (usually one colour) is applied in such a way that the sort of material it covers is disguised. Yellow iron, for example, can be made to look as light as a feather. Most important is that the spectator is presented with a sculpture he looks at from above and which he can walk around in. Caro thus destroys all the traditional ways of looking at sculpture.

In Caro's work, space is controlled in an entirely new way. Further, the sculpture is not a thing to be apprehended as a solid, three-dimensional image. It unfolds as you walk in it and around it.

Caro's achievement is enormous. Since he first exhibited, sculptors in Britain, America and Europe have been quick to develop his discoveries, and sculpture is changing now probably faster than it has ever done in its history. Whatever happens in the future, one thing is certain, within a few years Caro's work will itself appear outdated and sculptors will be seeking again for new materials and a new application.

Holding a mirror up to nature

Hamlet's advice to the players who arrived at Elsinore was a plea for realistic performances. But the craft of acting, like those who practise it, has worn many faces in its long history.

TRADITION HAS IT that it was the Greek poet, Thespis of Icaria, who mounted a cart to declaim his verse, and became the first actor. This is, however, just a picturesque way of saying that the organized theatre of Europe began in the dramatic competitions got up by the Greek city-states six centuries or so before Christ. A poet called Thespis did, in fact, carry off the prize at Athens in 534 BC, and actors have since been called thespians after him, but the roots of acting go back thousands of years before this.

It seems likely that from his earliest existence as a social being, Man performed symbolic actions to placate his gods, the ancestors or the elements, to bring about success in war or hunting, or abundant crops. Half-understood traditions of this kind survive in the mummers' plays, still performed in English villages, celebrating the eternal battles between Winter and Summer, Evil and Good.

In some areas of the world, like West Africa, such ritual dramas still have a vital function in society, preserving the history, religious beliefs and social customs of the tribal group. Here a man may still be born an actor, destined to take down from the wall of his hut the family

1 Traditionally the Chorus in Greek drama provided most of the action, but in *Hecuba* and other plays by Euripides (c 485–407 BC) it grew more detached, often merely commenting on events.
2 David Garrick was the greatest English actor of the eighteenth century, revolutionizing acting by his free, natural movements and mobile features. King Lear is one of his most famous tragic roles.
3 A woodcut represents the boy-actor Nathan Field in female costume for his performance in Kyd's *Spanish Tragedy* (c. 1589). Women did not appear on the stage until the seventeenth century.
4 Scapino and Captain Zerbino were famous 'personages' of the *commedia dell'arte,* a popular form of theatre combining acrobatics, mime and comedy which flourished in sixteenth-century Italy.

mask and costume, enact the annual return of the 'ancestor' or become the 'scapegoat', beaten out of the village to carry away its sins. From such ritual dramas we can get some idea of the mysterious origins of the art of the actor, the man licensed to act out life's mysteries for us, free from penalties; to carry away our guilt and, as the Greek philosopher Aristotle put it, 'to purge the mind of pity and fear'.

Greek education placed very great emphasis on the development of personal resources; of the body, in sport and in dance; and of a man's command over language. This was natural enough, since on these accomplishments the survival of the state, the rule of law and the practice of democracy depended. Happily, these studies were also the basis of an actor's training, and in consequence the little state of Athens found it possible to provide actors and choruses, not for just one play, but for a whole series of competing plays, lasting for several days. The voices

1 Designed by the French painter Charles Lebrun, 16 facial expressions that can be used to convey the passions figure in a seventeenth-century manual on acting.
2 The ancient art of mime has once more come in to its own; by telling gesture and expression the Israeli mime artist Samy Molcho creates a magical world of make-believe.

had to be capable of carrying in the open air to an audience numbering tens of thousands – almost the entire population, plus many visitors.

Drama seems to have originated with the chorus only, dancing rhythmically in procession and chanting hymns in honour of Dionysus, god of wine and plenty. The individual actor stepped from the chorus to impersonate the god. In later festivals, a second actor appeared in order to create a dialogue, and finally a third, providing even greater dramatic variety. However many parts the story may have required, it would seem that the Greek dramatist had to arrange his play so that all roles, male and female, could be played by not more than three actors, constantly changing masks and costumes. In tragic plays the actor who played the king may have been raised up on platform boots, and heavily padded, to show to the most distant spectator his importance in relation to the lowly, barefooted, scantily clad slave. The hero's acting was limited to declamation and solemn gesture; the real action was provided by the energetic chanting and dancing of the chorus.

In the beginning the Greek actor was an amateur. It was a privilege and a mark of accomplishment to be chosen to act. When the art became more demanding of time, talent and training, acting became a profession, controlled by the guild of Dionysus. These professionals carried their art all over the Greek world and, through Greek settlements in southern Italy, to Rome, at a time when all things Greek were in vogue. Roman comedy, blended with native traditions of farce, never approached the heights of satire achieved by the Greek playwright Aristophanes. The Roman theatre was remembered mainly for the horror and indecency

enacted on the stage. It never achieved the dignity and status of the Greek festival. The actor, often a slave, rarely enjoyed the full privileges of a citizen. The early Christian Church forbade its clergy to attend plays and no actor could become a Christian.

The organized theatre did not long outlive Rome. When the city was sacked and audiences dwindled, the actors took to the road in search of new patrons. For a thousand years they wandered through Europe, sought after here, persecuted there, passing on to their children the traditions and plots of the half-remembered Roman plays. They became bard and minstrel, acrobat and juggler, dancing-master, puppet-master – whatever would bring them money.

These strolling players, like those that entertain Christopher Sly in Shakespeare's *The Taming of the Shrew*, carried with them the traditions of the ancient theatre, until it could be born again. How ironic that it should be born again, in the Middle Ages, from the ceremonies of that very Church that had so long tried to suppress the actor! The Church absentmindedly reinvented the drama as a visual aid to bring alive to its largely illiterate congregations the chief mysteries of Christianity.

At first the actor is a young priest; his costume is a church vestment, chosen as most suitable·to impersonate the angel watching over the tomb of Christ, or his mother coming to seek him there. The script, which is very short, is authorized

1 The Restoration comedy of manners in England needed elegant delivery and stylish gesture. Sir John Vanbrugh's *The Relapse* has a great many characters and a relatively unimportant plot.

2 A modern performance of *Oedipus Rex* by Sophocles, at the restored Herodas Atticus Theatre in Athens, keeps alive the great tradition of Greek acting which developed in the fifth century B C.

settled home, a generous patron and protector and good plays to act. All these he achieved in the latter days of Elizabeth I.

It was James Burbage, joiner turned actor, who built the first English public theatre in London, in 1576. A large open platform, flanked on three sides by a courtyard and several galleries, provided the actor with facilities and a closer relationship to a greater number of spectators than he had had before. Hamlet's (and, it may be argued, Shakespeare's) advice to the Players, 25 years later, 'o'erstep not the modesty of nature, for anything so overdone is from the purpose of playing' was an appeal for the more natural style of acting that the new facilities had made possible.

Acting is an ephemeral art, and it is impossible to describe precisely the style or accomplishment of the actors of the past. But is it conceivable that Shakespeare would have created the succession of great parts that he did if his actors had not been equal to them? Acting was now an organized and a thriving profession. Boys were apprenticed to the craft as they might be to a shoemaker or carpenter. They lived with their master, served him, and learnt their business. Their youthful voices and complexions made them especially suitable for female roles, and here again we must suppose that they developed a high degree of expertise.

An actor of authority

The Civil War closed the English theatre and the actor was on his travels again, mostly abroad. When the monarchy was restored in 1660, the buildings were unusable and the acting tradition was lost. Both had to be re-created, largely with foreign models in mind. Two kinds of drama and acting flourished – both very artificial: these were the bombastic heroic tragedy in stiff couplets, and the comedy of manners, in equally affected prose. The great stage had shrunk and the live actor now competed with a background of changeable scenery, removing the need for fine poetic description. Even more serious, he now had to compete with the woman player who had invaded the stage. The scandalous nature of happenings, both onstage and backstage, alienated the greater part of society, until the eighteenth century. Acting was mannered and audiences ill-mannered, until an actor of authority – David Garrick – arrived to discipline them.

It is not surprising that Restoration acting was so artificial. Art, it was argued, is above nature, presenting its essence rather than its detailed exterior. A more practical reason was that the theatregoing public was small and plays had to be changed almost daily. Actors barely had time to learn the words, much less to achieve any depth of characterization. They depended instead on vocal and physical tricks and mannerisms. Charles Macklin seems to have started a movement for a more natural style when, in 1741, after a period of close study of the manners and appearance of business-men, he presented a Shylock that could be taken seriously – 'the Jew that Shakespeare

by the bishop. The theatre is the church. Soon, as the idea grows, the building is too small, the clergy too few to serve the purpose. The great trade and craft guilds that rule the city are set to work. The actor is a shoemaker or a carpenter. The play is the story of the world from creation to judgement. Only the streets of the city are big enough to serve as the theatre, and then the stages are often on wheels so that each scene may be repeated to many separate audiences around the town.

The guilds were, above all, business-like, and actors were paid for their trouble and

loss of earnings. Perhaps this moved some workmen of special talent to leave their old crafts and take to playing God or Satan professionally, moving from one town to another. They merged with the strolling players of the old tradition to bring into being a more convenient and regular kind of drama that could be performed at any time. The typical forms, the morality play and the interlude, required relatively few actors and a short playing time. When the Reformation took away the restraining hand of the Church of Rome the strolling player dreamed of a reputable craft, a

113

drew' in *The Merchant of Venice*.

In the same year David Garrick, aged 24, became the talk of London for his complete transformation of himself in *Richard III*. He demonstrated his versatility by playing 19 well-contrasted roles, 150 performances, in that season. Far from richly endowed either physically or vocally and totally without training, Garrick won his audiences largely through the energy and intelligence with which he tackled every role. The same might be said of Edmund Kean, 'a little man with an inharmonious voice and almost every physical disadvantage', who in 1814 conquered London with his performance as Shylock after only one rehearsal. Or Henry Irving, idol of the latter half of the century who, the actress Ellen Terry tells us, 'at first could not speak, walk or look'. From this one might infer that the greatest actors have been those who, lacking natural endowments that they could easily exploit, were forced to make the effort of will and imagination for a complete transformation of themselves.

Since the actor is mainly an interpreter, the dominant style of acting in a period will be influenced by the demands of the plays most in fashion. The dominant mode of the nineteenth-century theatre was melodrama and even actors who were thought in their time to 'follow nature' might seem to us most unnatural. A new movement in European writing, the naturalistic movement was sweeping Europe and changing the styles of play-writing, stage design and acting. In the 1860s the plays of Tom Robertson, acted by Marie Wilton and her husband Squire Bancroft were thought to be the ultimate in realism; but this was little more than the surface realism of the drawing-room tea-table with little psychological depth.

The most systematic attempt to achieve realism was made in Russia in the 1890s. It arose from the demands made by the plays of Chekhov on the acting of a new experimental set-up by Nemerovich-Danchenko and Constantin Stanislavsky – the Moscow Art Theatre. Chekhov's first important play *The Seagull* was a complete disaster when performed in the old-fashioned stereotyped style of the Imperial Theatre. He might have stopped writing plays altogether had the Moscow Art Theatre not undertaken to present the play in its own more sensitive and detailed interpretation. The symbol of the Seagull, which still adorns the front curtain of the Art Theatre, commemorates this historical breakthrough in theatrical representation.

In place of the selfish star-system, the Art Theatre offered the dedication of the ensemble; in the place of ignorance and dogmatism, the search for truth in acting; instead of the arrogance of the actor-manager, a proper study and interpretation of the author's text. Where earlier actors had refused to rehearse, or even to read the whole play, the Moscow Art Theatre thought two years not too long to study a play like Chekhov's *The Cherry Orchard*. Few teachers of acting have set down their findings so fully as Stanislavsky, and his ideas have been popularized by his disciples in many countries, in studios like the Actors' Studio in New York, under the title of 'the Method'.

No longer a rogue

It was not long after the foundation of the Moscow Art Theatre that the first professional acting schools were set up in England. Acting was becoming something different from what it was the century before: in *Nicholas Nickleby* Dickens tells us how the old barnstorming actor, Vincent Crummles, takes Nicholas into his company as an actor and playwright on the strength of his good looks, education and a couple of rehearsals alone.

Today both plays and audiences make demands on the actor that cannot be so lightly met. Actors must, in some way, prepare themselves in their craft. Happily, the actor is no longer generally regarded as a rogue and vagabond. A long line of theatrical knights, beginning with Sir Henry Irving, have restored to the profession some of the prestige it enjoyed with the Greeks and the Elizabethans. The successful actor is better rewarded than ever before, particularly through the invention of new forms of theatrical presentation – the cinema and television. On the screen the actor may be seen by more people in a single performance than Shakespeare entertained in his whole lifetime. Moreover, such is the magnifying power of the camera that the tiniest change of expression on the actor's face can be seen with equal clarity by every one of those millions watching. The sensitivity of the microphone ensures that the merest whisper will suffice, if that is appropriate to the play.

Now at last the actor, freed from the problems of distance and acoustics posed by even the best theatres, can really follow Hamlet's admonitions, 'to hold as 'twere the mirror up to Nature', and 'suit the action to the word, the word to the action'.

1 Members of the Moscow Art Theatre, founded in 1898 by Nemirovich-Danchenko and Stanislavsky, gather round Chekhov as he reads his play *The Seagull*. Stanislavsky's naturalistic style of acting (the Method) has been widely followed. 2 A scene from a rehearsal of *Blues for Mr Charlie* by James Baldwin which concerns racial conflict in the American South.

1

2

Miracle and morality plays

Key events in the life of Christ and stories from the Old Testament were popular themes in medieval miracle plays. Morality plays personified the vices and virtues: their aim was to instruct.

MEDIEVAL DRAMA, the earliest writing for the stage in England, is very far removed from us in time and in choice of subject. The earliest extant copies of plays date from the thirteenth century, and by the sixteenth century drama had passed on to a new and richer stage in its history. Medieval theatre is rarely revived on the contemporary stage, even though much of it was written only a century before Shakespeare lived and died. The reason for this general neglect is because its standpoint is, for the most part, unfamiliar to us now.

To medieval writers, Man was a wretched being at the mercy of sin and all too easily persuaded to hellish ways. In the mystery or miracle plays, moreover, the early dramatist took his theme from biblical stories and reinterpreted the myths on which his religion was founded.

Religious preoccupations

Audiences today are not accustomed to such a representation of themselves; although the best drama often has a 'moral', it is not overt sermonizing but part of the structure of the play. Again, England has had a secular drama since the sixteenth century, a drama in which the Church has played no part and with which it has often been at loggerheads. The exclusively religious preoccupations of the writers of miracle and morality plays may now strike us as strange and narrow.

But this view is in itself too narrow and is calculated to make us lose much that is valuable and entertaining. Certainly, medieval drama does require that we take an imaginative leap and place ourselves in a medieval context, where death was always present (in the shape of the plague, or in wars, or in premature old age) and where the Church was at once the repository of learning, shelter for the homeless and the promise of a better life.

The Church was the cultural as well as the religious centre for medieval Man. The Bible was his literature, religious paintings and tapestry his art, chanting his music and the Mass his drama. The priest

breaking the bread and offering the wine was (and still is) a dramatic symbol for Christ's offering of his body. For centuries, drama was confined to these religious rituals. In the twelfth and thirteenth centuries, however, the liturgy came to be embellished with more overt dramatic elements.

The beginnings of drama proper are to be found in the *trope* which was a literary or musical addition to the authorized liturgy. These tropes were short verses, usually utterances of jubilation. In the 'Easter Trope' of the tenth century, there are a few lines of dialogue, of question and answer, which would have been chanted by the priest. Later, these short pieces of dialogue were extended into longer plays concerned with a particular piece of ritual, such as the Christmas play of the Nativity. A well-known example of the later development of this form is the *Ludus Danieli* (The Play of Daniel), composed by the students of the monastery of

Beauvais in France (1180). The entire play was meant to be sung or chanted – it is closer to what we would now call an opera than to a play – but the characters were distinct from each other and were supposed to be costumed and to act in character.

Up until this time, all dramatic activity was confined to the Church, with priests and Church officers as the 'actors'. But from the very earliest days of drama, there was a strong secularizing influence, which was soon to bring Church and drama into sharp conflict. The *Mystery Play of Adam*, an Anglo-Norman composition of about the same time as the Beauvais play, exhibits such a trend. It was written as a play, not as an addition to Church ceremonial, and contains notes on acting, costumes and sets. The dialogue is realistic and at times fast moving, and the characters of Adam and Eve, Cain and Abel are, if not fully rounded, at least more than biblical stereotypes. Here are a few lines from the second part, a dialogue between Cain and Abel:

ABEL: All my faith is in God.
CAIN: He won't be of much use against me.
ABEL: He can easily put hindrance in your way.
CAIN: He cannot rescue you from death.
ABEL: I put myself wholly in his hands.
CAIN: Do you want to hear why I'm going to kill you?
ABEL: Tell me then.
CAIN: I shall tell you. You became too

1 Through the Middle Ages, trade guilds enacted miracle plays dramatizing themes from the Bible. The story of Noah's Ark was very popular: it was often played by the Water Carriers.
2 Each scene in a cycle of miracle plays was presented on a wagon, sometimes quite elaborately staged. Here Joseph and Mary arrive in Bethlehem to find no room in the inn.
3 Christ harrowing hell was a favourite subject of miracle plays. The porter of hell is blowing a blast on his trumpet to arouse the fiendish hosts in defence.

intimate with God; because of you he has refused me everthing; because of you he refused my offering. Do you think I shan't pay you what you deserve? I'm going to give your reward. Today you'll lie dead on the ground.

It is not known how this kind of drama developed into the miracle plays first recorded in the fourteenth century. There were, however, other influences apart from the Church which played a part in shaping the form they took. Pageant and tournament formed the main secular ceremonials of the Middle Ages, and both were extremely popular. The tournaments, or 'jousting' were, of course, confined to the aristocratic knights but everyone could watch. The pageants, on the other hand, were the province of the common people: they consisted of a procession of wagons through the streets, each one bearing a tableau representing this or that scene. Pageant survives very much in the same form to this day – the annual Lord Mayor's Show in London is an example of a modern-day pageant.

Different stages

It is possible that it was from pageants that the miracle plays drew their inspiration for staging. The miracle plays depicted the main events of the Old and New Testaments in a series of plays on the central theme of redemption; two or three days was the longest that could be spent in acting them, so there was a need for a large number of different groups of actors portraying these events on different stages. These sets of plays are known as 'cycles', of which only four survive complete: the Chester cycle, of about 1375, the York cycle of 1378, the Wakefield cycle of 1430, and the 'N-town' (possibly Coventry) cycle (fifteenth century). Of these, the York and the Wakefield cycles are the most interesting.

The presentation of these plays was the

1 In the tradition of miracle plays are modern adaptations of biblical stories, like Benjamin Britten's opera *The Prodigal Son*.
2 The staging of the Passion at Valenciennes, France, in 1574. Various locations may be distinguished, among them (from left to right) heaven Nazareth, Jerusalem and hell.
3 A contemporary representation by Frans Verbeec of a Flemish miracle play, probably drawn from an actual performance.
4 The Glorification of Christ, from a Passion play at Oberammergau, Bavaria. In 1634 the first performance of the Passion play was given as an expression of gratitude for the end of the plague. From 1680 on the play has been performed every ten years, except in wartime.

Here is an example from the play *The Coming of the Three Kings to Herod*, in Middle English and modern translation:

> Hayle! Ye fairest of felde folk for to
> fynde;
> Fro the fende and his feeres faithefully
> vs fende.
> Hayle! Ye best yat shall be borne to
> vnbynde
> All ye barnes yat are borne and in bale
> boune

this is translated as:

> Hail! Fairest of free folk to find;
> From the fiend and his fellows in faith
> us defend.
> Hail, the best that shall be born to
> unbind
> All the bairns that are born and in bale
> bound.

The York cycle contains 100 speaking parts, together with crowd scenes demanding as many more 'extras'. Of these parts, the best were those which gave scope for comedy and satire: these were traditionally the part of Satan, of Herod, of Noah's and Pilate's wives. In the Wakefield cycle especially, Noah's wife has become such a shrew and poor Noah so tormented by her that it has been suggested that the couple were modelled on a famous local pair of the time. Since these cycles were specifically local events, this is quite possible.

The miracle plays existed to teach, to warn and to amuse. Though frowned on by the elderly clerics, they were allowed

responsibility of the trade guilds of the town in which they were performed. These guilds were rather like medieval trade unions; there was a guild for every trade – a goldsmiths' guild, a weavers' guild, a tailors' guild and so on. Each guild presented a different play – in Norwich, for example, the grocers presented the play of Adam and Eve – and actors were paid for their services on a scale of importance. The members of the guilds were comparatively rich, and could afford quite

elaborate costuming and reasonably detailed sets. Noah's Ark, for example, by the evidence of Noah's soliloquy in the Wakefield cycle, had a sail, mast, forecastle and three cabins set on a wheeled platform.

The York cycle, the most complete of the four cycles, is still regularly presented in York. It was revived first in 1951, and the Middle English alliterative rhyming verse has been rendered into a modern English equivalent by Canon J. B. Purvis.

to take place; the attitude of the more enlightened churchmen probably being that they did much good in reminding the people of the biblical stories. There was a moral in most of the stories, though they were far less didactic than the later morality plays, and there was much farce and satire. The satire was often vicious, directed at the excesses of local nobles or crooked lawyers. From the farcical elements can be seen the first beginnings of the native comic spirit.

The *Second Shepherds' Play*, in the Wakefield cycle, is one such early comic masterpiece and exhibits the first comic sub-plot. The three shepherds are watching their flocks. They are joined by Mak, a thief, who steals one of their sheep while they rest and goes home with it. Suspicious of him, the shepherds pursue him to his house; there they find Mak and his wife, with a new-born baby in its cradle. The scene where they discover that the 'baby' is really their lost sheep wrapped in linen is very amusing indeed:

3RD SHEP.: Gyf me lefe hym to kys, and lyft up the clowtt. What the dewill is this? He has a long snowte.
1ST SHEP.: He is merkyd amys. We wate ill abowte [We are wasting our time].
2ND SHEP.: Ill-spon weft, Iwys, ay commys foull owte [always comes out badly].

The first extant copy of an English morality play is dated about 1425, but the morality play drew on a tradition much older than that, the tradition of allegory. Allegory can be defined as a representation in narrative of virtues and vices in disguised, usually personified form. The morality play *Everyman*, written about 1500 and the finest of its genre in existence, may be taken as an example of the style generally.

Everyman deals with the transitory nature of wordly things, and on the necessity for a Christian way of life to secure the life everlasting. Everyman himself is meant to represent all humanity. At first he is endowed with worldly wealth in all its forms: he has friends and relations, possessions, beauty, strength, discretion and the five wits. All these are represented

by actors. Kindred and Friends, then Possessions, desert him, the last one cynically remarking that he will find some other fool to keep him for a while. Beauty, Strength, Discretion and Five Wits swear to go with him to the grave, but at the graveside they also leave him. All Everyman has left is Good Deeds, who teaches him this harsh lesson:

All erthly thyngs is but vanyte
Beaute, Strength and Dyscrecyoun do man forsake,
Folysshe frendes and kynnes men that fayre spake,
All fleeth save Good Deedes, and that am I.

The tone of the morality was parallel to that of the fire-and-brimstone popular sermons preached from every pulpit; they contained little or no comic relief, and for this reason perhaps they were neither as popular in their day nor as attractive to modern readers as the earlier miracle plays. They were not tragedies, since the idea of death is never anything more than inevitable and the protagonist is rarely more than a stock allegorical figure, but they were the closest thing to it in medieval drama, and must have inspired something of the same degree of awe and terror in the audience. The most horrifying figure was that of Death, usually an actor dressed in a black habit on which was painted a skeleton.

A later and more sophisticated form, which was to lead directly to the work of the Elizabethan playwrights, was the interlude. Shorter than the morality or the miracle, it required comparatively few actors, and dealt with only a part of Man's life – the folly of youth, perhaps, or the world's vanity. Morality plays attempted to deal with Man's life as a whole, miracle plays with the main events of the faith.

More importantly, the themes of the interludes showed a marked difference from the earlier plays. They were often almost totally secular in content, and

though they might have a strong moral flavour, the morality was as much a social as a religious one. One of the finest is a Scots play, Sir David Lindsay's *Ane Satyre of three Estaitis* (A Satire of the Three Estates). The satire in the play is directed chiefly against a corrupt nobility and an equally corrupt clergy, who are often more concerned to make a good living from their flock than to show them a good life. Here is an exchange between a poor man and a pardoner:

PAUPER: My haly father, quhat [what] will that pardon cost?
PARDONER: Let se quhat mony thou bearest in thy bag.
PAUPER: I have ane grot [groat] heir bound into ane rag.
PARDONER: Hes thou nae vther silver bot ane grot?
PAUPER: Gif I have mair [more] sir cum and rype my coat.
PARDONER: Gif me that grot man, if thou hast na mair.

Elizabethan drama did not, of course, spring from this tradition alone; the native drama merged with the classical influence, which had led an 'underground' existence in monasteries throughout much of the Middle Ages, and burst into new life during the Renaissance. The classics were to give the new playwrights form and structure, as well as a definition of what composed tragedy. But the medieval drama was to remind them of the popular, native tradition, of the comedy and commonplaceness of daily life. It gave them, too, a hard and unsentimental realism which was to provide the backbone to the finest works of the next century.

1 Christ staggers under the weight of the cross in a contemporary performance of the York cycle of miracle plays presented within the nave of the ruined abbey.
2 *Everyman* is the most famous example of the late-medieval drama known as the morality play, where the characters are personifications of such abstractions as fellowship, beauty and death.
3 The miracle play developed from the Church liturgy, gradually becoming secularized and moving outside into the street.

'A world of profit and delight'

Such was the reward coveted by Marlowe's Dr Faustus in his contract with the devil: dominion over a world that expressed through its drama the strength and optimism of Elizabethan England.

THE PERIOD from the latter half of the sixteenth century to 1642 remains to this day the richest period in the history of English drama. Elizabeth I reigned from 1558 to 1603 (the Elizabethan period), James I from 1603 to 1625 (the Jacobean period) and Charles I from 1625 to 1649 (the Caroline period). Though Charles was not executed until 1649, the Puritans gained power in 1642, and in that year the playhouses closed and drama went underground, to re-emerge in a changed form in 1660.

Within the span of less than 100 years, a mighty dramatic form grew, flourished and decayed. It gave birth to Marlowe and Jonson, geniuses whose work at the same time commemorated and condemned the immense flowering of wealth and power that was the Renaissance; to Lyly, Kyd, Greene, Peele, Webster, Tourneur, Middleton, Beaumont and Fletcher, Chapman, Dekker and Shirley, dramatists of talent in their own rights; and, of course, to Shakespeare, who towered above them all.

Though naturally the growth of a vital English drama was part of the European Renaissance of culture as a whole, the particular form it took in England owed much to the nature of the society and that, in turn, to the character of the monarch and her reign. England grew powerful in Elizabeth's time, and London, the royal seat, became more and more the centre for the arts. Though actors and plays were still viewed with disapproval by a large section of the middle classes, the court tolerated and indeed furthered the establishment of playhouses and the increasing respectability of the actors. The first theatre was built in 1576, under the patron-

age of the Earl of Leicester; others followed shortly after, the famous Globe being one of the last, in 1598.

Into these theatres in the last years of the sixteenth century and the first of the seventeenth came all classes of Elizabethan and Jacobean society – workmen, tradespeople, squires from the country, students, lawyers, aristocrats. For a very few years – perhaps 30 in all – the theatre was a truly democratic meeting-place (though, of course, then as now, seats differed in price and consequently in social status). The plays were written and acted for no one group or interest; they contained something for everyone, and the tastes of each section of society complemented those of the others. The uneducated workmen demanded action that

A madhouse scene from *The Changeling*, a tragedy of intrigue by Thomas Middleton and William Rowley. In Jacobean times tragedy was still the most popular dramatic form.

The Shoemaker's Holiday, a comedy by Thomas Dekker, is a lively portrayal of London life: a nobleman disguises himself as a shoemaker to pursue his suit for the Lord Mayor's daughter.

could be easily understood and a good deal of clowning, and these the plays contained. But this served only to enrich the poetry and symbolism of the deeper structure of the plays.

Thus drama became lucrative, both for actor and author. It was this change in status that first created a body of professional dramatists, men with a university education whose way of life lay outside the Church, the traditional home for scholars and artists. These men have come to be known as the 'University Wits'. They were all born in the mid-sixteenth century, creating in their short and sometimes violent lives almost all the forms of the next century's drama. They inherited a vital but crude theatrical tradition which had its origins in folk ritual and Church ceremony; to this they applied their knowledge of the rules of classical theatre, especially the Roman comedies of Plautus and Terence and the tragedies of Seneca.

Apart from Marlowe, these dramatists wrote few plays of great stature, and none (with the same exception) is still widely performed. But they did set a form and a style: John Lyly wrote courtly comedies, for performance at the private theatres or at court; *Campaspe* (c. 1584) is his best, combining mythology and sentiment in a skilful manner. Shakespeare was to use this vein in his *A Midsummer Night's Dream*. George Peele wrote the quaint *Old Wives' Tale* in 1591 which used both the vernacular and courtly language. Robert Greene first developed what is called 'romantic comedy' – his *Friar Bacon and Friar Bungay* tells of a simple girl's love idyll with a nobleman. *Twelfth Night*

Revenge was a popular theme in Jacobean drama. *The Revenger's Tragedy* by Cyril Tourneur has a melodramatic plot, redeemed by its strongly drawn hero and passages of magnificent poetry.

and *As You Like It* echo its enchanted-forest atmosphere.

Together with romantic comedy, there grew up romantic tragedy, notably in the work of Thomas Kyd. His most famous play, and one immensely popular at the time, was *The Spanish Tragedy,* produced in the 1580s. It is a revenge play as well as a tragedy, containing many gory killings followed by heavy moralizing. But unlike the degenerate revenge plays of late-Jacobean and Caroline times, *The Spanish Tragedy* has power and pace; it contains many favourite Elizabethan themes in embryo: the revenge theme, the play within a play, and the Machiavellian figure. Though eclipsed both by Marlowe's and Shakespeare's tragedies, it is arguable that their achievements would not have been possible without Kyd's groundwork.

Killed in a brawl

Marlowe, who died before he was 30, was the most talented of that talented group. His life in a way mirrored the storming, frantic careers he gave his tragic heroes: he was killed in a tavern brawl in 1593, while supposedly on a secret government mission. His two finest plays are *Tamburlaine The Great* (parts I and II) and *Dr Faustus,* though *The Jew of Malta* and *Edward II* also deserve praise.

But it is in the first two plays that the Marlovian tragic hero is best seen: Tamburlaine is the all-conquering hero, invincible and cruel in war, whose tragedy is his own death. His victories are fabulous, his pride immense. In the following speech he addresses the defeated kings who act as his chariot-horses:

> Holla, ye pampered jades of Asia:
> What, can ye draw but twenty miles a
> day,
> And have so proud a chariot at your
> heels,
> And such a coachman as great Tambur-
> laine?

Faustus resembles Tamburlaine in his ambitions, but the learned doctor's goal is that of a man of intellect, who longs for the ultimate mental power bestowed by black magic:

> O, what a world of profit and delight
> Is promised to the studious artisan!
> All things that move between the quiet
> poles
> Shall be at my command.

To this end, he sells his soul to the devil, and his tragedy too, is his death.

Marlowe was the first to give tragic (even epic) dimensions to a new kind of hero, a man who, though doomed to fall, still approached in his lifetime very close to a god. This new hero was an expression of the optimism and vigour of the Renaissance.

The Wits were the first to give English dramatic language style and point. Writing in verse, as did all the dramatists of that age, they first forged an instrument which was to be extended by Marlowe, perfected by Shakespeare and Jonson, deteriorating slowly in the work of Beaumont and Fletcher and their followers. Here, in a few lines from Marlowe's *Dr Faustus,* the hero is exclaiming over the

1 David Garrick in the part of Don John finds himself in the unexpected possession of a baby: a scene from Beaumont and Fletcher's *The Chances,* painted by De Loutherbourg.
2 Actor Edward Alleyn excelled in the title roles of Marlowe's plays, especially in *The Jew of Malta, Doctor Faustus* and *Tamburlaine the Great.* His greatest rival in the profession during his lifetime (1566–1626) was Richard Burbage.
3 Ben Jonson's best plays are satires, which use vividly drawn 'types' like Volpone, the fox and Mosca, the fly to expose society's evils. During the eighteenth century he was considered a greater playwright than Shakespeare.
4 Christopher Marlowe's second tragedy *Doctor Faustus* dramatizes the medieval legend of the man who sold his soul to the devil for earthly power. The play is faulty in structure, but in places achieves a fusion of poetry and drama never attained before.
5 The first editions of two of Marlowe's plays and of his narrative poem *Hero and Leander.*

beauty of Helen of Troy, whom his magic has conjured up:

> Was this the face that launched a
> thousand ships
> And burned the topless towers of Ilium?
> Sweet Helen, make me immortal with a
> kiss.
> Her lips suck forth my soul, see where it
> flies.

The phrase 'the face that launched a thousand ships' has, of course, become a literary cliché, but the original force remains. The beauty of Helen's face is expressed in an image of power, a beauty that has spurred men on to battle and great deeds. In the next two lines is

1

developed the idea of Helen's power to make Faustus 'immortal', and with it the rather sinister image of 'her lips suck forth my soul'. It is the flexibility of the verse that makes it great: it can suggest so many things at one time, can comprehend poetry, science and metaphysics, war and debate, love and clowning. The cultured Englishman in the seventeenth century saw knowledge as an integral part of his world; learning was not then, as it is now, split into many divisions incomprehensible to anyone other than the specialist.

Shakespeare's last years were spent under the reign of a new monarch, James I, who came to the throne in 1603. James was an intelligent man and a lover of the arts. Although astute enough to avoid serious trouble in his lifetime, he annoyed the growing Puritan faction by the luxury of his court and the extremity of his views on privilege – it was he who insisted on the Divine Right of Kings. The times were marked by a more detailed inquiry on the part of thinkers and artists into moral and political questions, since there were no longer foreign wars to occupy the imagination and energies of the nation.

A cunning miser

Ben Jonson's plays, contemporary with the later work of Shakespeare, display this searching and harshly critical side of the Jacobean intellect at work. His best works are satires, his characters vividly drawn 'types' rather than well-rounded characters: *Every Man in his Humour* (1598), *Every Man out of his Humour* (1599), *The Poetaster* (1601), *Volpone or The Fox* (1606), *Epicoene or the Silent Women* (1609), *The Alchemist* (1610) and *Bartholomew Fair* (1614). *Volpone* is the best, and still the most popular today. Volpone, the play's 'hero', is a cunning miser, in love with his gold, who contrives, with the assistance of his servant Mosca, to convince his friends that he is close to death. They bring gifts to his deathbed in the hope of winning all his wealth in his will. In the end, Mosca overreaches himself, the plot is discovered and the guilty parties punished. The conclusion restores order; but in the course of the play, Jonson has laid bare a whole world of deceit, greed and self-interest: men, he says, will prostitute their wives (as one character literally does) in order to gain gold.

Jonson also wrote elegant poetry:

Beauties, have you seen this toy
Called love, a little boy
Almost naked, wanton, blind
Cruel now, and then as kind?
If he be among you, say:
He is Venus' runaway.

The dramatists who followed Jonson are often referred to as the 'lesser' Jacobean playwrights. Lesser than Shakespeare, Jonson and Marlowe they certainly are, but these standards are of the highest. For the 'lesser' playwrights – George Chapman, Thomas Heywood, Thomas Dekker, Cyril Tourneur, John Webster and Thomas Middleton – all wrote plays of some quality, a few of them outstanding.

Their favourite themes were still those most successfully exploited in the Elizabethan period. The playhouses were even more popular in Jacobean times, and plays were very commonly printed in cheap editions quite soon after they had been written. The financial rewards in the theatre were very great – Shakespeare himself grew wealthy from the proceeds of his plays and many dramatists wrote prolifically to earn their living. This fact does not, of course, mean that all their work was bad; what it does mean is that there was an increase in the number of second-rate plays.

Heywood, Dekker and Middleton were all highly professional writers with a large body of work ascribed to them. Heywood, for example, claimed to have 'had an entire hand or at least a main finger in two hundred and twenty plays'. His best is *A Woman Killed with Kindness* (1603) which, for all its faults, is a good example (as well as being the first) of the 'domestic tragedy', tragedy set among common people instead of in courts or on the battlefield.

Dekker's characters, too, are low-life, but his strength is comedy, like *The Shoemaker's Holiday* (1599). Middleton wrote comedies in the realistic mode as well, but is best remembered for his tragedy, *The Changeling*. This sombre piece concerns a woman who orders an admirer to kill for her, places herself in his power, becomes his mistress and finally dies without marrying the man she loves. Here is part of her speech to her father before she dies, showing that the verse of the time still retained great power and economy:

O come not near me sir, I shall defile
you!
I that am of your blood, was taken from
you
For your better health; look no more
upon't,
But cast it to the ground regardlessly

Let the common sewer take it from
distinction . . .

Tragedy was still both the most powerful and the most popular dramatic form. Tourneur's *The Revenger's Tragedy* (1607) and Webster's *The Duchess of Malfi* (c. 1614) were among the best. Both were 'revenge' tragedies, which contained their fill of horror, taking an apparent delight in piling misery on misery. Such an element obviously mars a play, and many tenth-rate plays with revenge as their theme were indeed produced. But these two stand above the others, for both authors had the sense not to let the horrific and melodramatic elements run away with the play. Even when the Duchess of

1 John Webster based his plot for *The Duchess of Malfi* on Italian history. Although the incidents are extremely horrible, the play is more than a crude melodrama.

2 One of Ben Jonson's talents was his ability to manipulate plot, an ability seen at its best in *The Alchemist,* where different lines of intrigue converge to form a perfect climax.

3 *Tamburlaine the Great* was Marlowe's first tragedy. Its long, rambling action traces the rise to power of a Scythian robber-shepherd, his triumphs and his death.

Malfi's house is surrounded by lunatics from an asylum, Webster wisely focuses attention on the Duchess, and endows her with dignity when she proclaims amid the tumult: 'I am Duchess of Malfi still.'

The plays of Beaumont and Fletcher, Philip Massinger, John Ford and John Shirley mark the end of an era. Shirley was still an active writer when the theatres were closed in 1642, but it is arguable whether the lode which had been so rich in Elizabethan and Jacobean times had much more wealth to offer in the Caroline period. One or two plays survive the test of years: Beaumont and Fletcher's *Philaster* (1610) is well constructed and elegant, Massinger's *The City Madam* (1632) is still comic, Ford's exploration of illicit love in play after play has a certain psychological interest, and his *'Tis Pity She's a Whore* (1632) is often revived. But in the main these men put their talents at the service of public whim and wrote for financial success. With the Restoration in 1660 there was a new burst of energy; it is arguable, indeed, that the theatres benefited from 18 years' breathing space.

Still, though the end was disappointing, the great years of Elizabethan and Jacobean drama from 1590 to 1620 – have never been surpassed. It was an age in which, for a short time, everything seemed possible; the flourishing of genius in the theatre was one of its greatest achievements.

Myriad-minded Shakespeare'

Little is known about Shakespeare's life, but his plays and poems reveal a consummate skill in writing and an insight into human problems that is as relevant today as it was to the Elizabethans.

IT IS SOMETIMES FORGOTTEN that William Shakespeare, whose work inspires millions of scholarly words each year, was the most popular dramatist of his time, not least with the uneducated classes. Yet this fact is important, for it explains much about the nature of his art and also about his continuing position as the most famous writer in the world.

Shakespeare's scope is immense: his heroes are men of action like Henry V, introspective philosophers like Hamlet, romantic and passionate lovers like Romeo, overambitious noblemen like Macbeth. His plots are magical, or romantic, or realistic, or tragic, often all these elements combined; his characters exist at once in the real world and in the shadowy world of their creator's imagination. Though indisputably of their time and place, Shakespeare's people, whether Venetian clown or Danish prince, are recognizably Englishmen of the sixteenth and seventeenth centuries. But most importantly they embody a spirit of humanity which has remained essentially unchanged to the present day. No one can write now as Shakespeare wrote, but everyone may recognize the quality of his world without difficulty.

Shakespeare's early life

Shakespeare had certain advantages for a writer. He is possibly the most sensitive playwright who ever lived, but his sensitivity was tempered by the comparative poverty of his early years and his struggle to find a foothold in the theatre. Although little enough is known about Shakespeare's early life, it is clear that he was born in Stratford-upon-Avon in 1564, that his father, once a man of substance and position in the town, lost his money and went into debt; and that as a result Shakespeare was taken away from school and put to work. He married Anne Hathaway, a woman eight years older than himself, in 1582, when he was 18; they had a child in 1583 and twins in 1585; in the same year, it is probable that they moved to London, where Shakespeare first started working in the theatre with the job – so tradition has it – of holding horses for twopence a day.

About this period of his life there are no records but, by 1592, George Peele, an established playwright, sounded a note of alarm about a young actor-playwright who could beat the recognized playwrights at their own game. He called him a 'Johannes Fac Totum', or a jack-of-all-trades, which suggests that Shakespeare's main task in his company was to rewrite old plays for a more up-to-date presentation.

But he did not merely rework old dramas; it is from this early period that his first plays probably date – *Love's Labour's Lost, The Comedy of Errors, Two Gentlemen of Verona,* the three parts of *Henry VI, Titus Andronicus* and *Richard III.* Dates given to the composition of groups of plays or individual works of Shakespeare are always a matter of conjecture; the plays above are simply those which most scholars agree were written first.

Not surprisingly, none of these plays constitutes his best work, or even approaches it, with the possible exception of *Richard III.* Yet even if he had died leaving only these plays, he would have been a major Elizabethan dramatist. What is most impressive about the early plays is that they are full of *ideas,* both thematic and stylistic, which were to be developed later. *Love's Labour's Lost* and *The Comedy of Errors* are pure comedy, with none of the seriousness which distinguishes and enriches the later comedies, but they are full of wit, surprise and delightful invention.

Richard III, which tells of the Duke of Gloucester's usurpation of power by murder, marks a transitionary period in Shakespeare's work: here we see the first emergence of the Shakespearean hero, in this case a villain, sly, clever and unscrupulous, yet not entirely unsympathetic. He points the way to more complex characters like Macbeth, Iago of *Othello* and Edmund of *King Lear.* These later villains reveal their vices and their virtues naturally as the play unfolds. Gloucester, more crudely, is made to reveal himself in an introductory speech:

Mr. WILLIAM
SHAKESPEARES
COMEDIES,
HISTORIES, &
TRAGEDIES.

Published according to the True Originall Copies.

LONDON
Printed by Isaac Iaggard, and Ed. Blount. 1623.

1 A collection of 'Mr Shakespeare's Comedies, Histories and Tragedies', known as the First Folio, was printed in 1623. The contents include 36 plays, 18 of them published for the first time.
2 The frontispiece to the first illustrated edition of Shakespeare, published in 1709, portrays Hamlet and Gertrude in the bed-chamber scene – in eighteenth-century costume.

'. . . Why I, in this weak, piping time of peace,
Have no delight to pass away the time,
Unless to spy my shadow in the sun,
And descant on mine own deformity:
And therefore, since I cannot prove a lover,
To entertain these fair, well-spoken days,
I am determined to prove a villain,
And hate the idle pleasures of these days.
Plots have I laid, inductions dangerous. . . .'

It is generally thought that Shakespeare wrote his two long poems 'Venus and Adonis' and 'The Rape of Lucrece' round about 1592, as well as the sonnets and other smaller poems. This break from being a popular and reasonably successful young playwright to becoming a private poet is less surprising when the circumstances of his life are taken into account. The plague hit London in this year. To escape it, Shakespeare probably joined a band of travelling players, presenting old tragedies and farces to audiences in the provinces. From being a rewriter of plays for a cultured audience, Shakespeare became merely another actor (and not, it is thought, a very good one), playing in stock favourite pieces which the country audiences wanted to see in their unchanged state. So he found a patron – the young Earl of Southampton – and wrote the two long poems and probably the sonnets for him.

The best sonnets of this 'master of all trades' are among the most beautiful

1 'Friends, Romans, countrymen, lend me your ears': in an artful address in *Julius Caesar* Mark Antony incites the crowd against Brutus and Cassius, chief conspirators in Caesar's murder.
2 The Shakespeare jubilee in Stratford-upon-Avon in 1769. Shakespeare's birthplace has become a Mecca for tourists and playgoers; the first Shakespeare Memorial Theatre was built in 1879.

3 A model of the Globe, built in 1598, a typical Elizabethan theatre. Shakespeare was a shareholder and several of his plays were performed there. In 1613 it burned down.
4 The 'Chandos' portrait, traditionally supposed to be of Shakespeare. Little enough is known of his life; some people, indeed, believe that the plays were written by someone else.

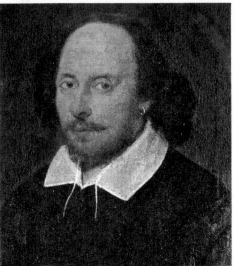

poems in the language. Some are addressed to a young man, some to the famous 'Dark Lady'; their identity remains a mystery. Some are reproachful, some full of gratitude, some melancholy, some gay. They are, like all good sonnets, delicate but they are not flimsy, and are never simply fanciful – Shakespeare was too much of a realist for that. At times, he is deliberately anti-romantic, satirizing the high-flown sonnets of his contemporaries:

My mistress' eyes are nothing like the sun;
Coral is far more red than her lips' red;
If snow be white, why then her breasts are dun;
If hairs be wires, black wires grow on her head.
I have seen roses damask'd, red and white,
But no such roses see I in her cheeks . . .
(Sonnet 130)

It is assumed that Shakespeare returned to London and to the theatre about 1594. The period from that year to 1602, when *Hamlet* was completed, is known as his 'middle period' and refers both to his life and to his work. It is to this period that the bulk of his plays have been ascribed. These are, in tentative chronological order, *Romeo and Juliet, Richard II, A Midsummer Night's Dream, King John, The Merchant of Venice, The Taming of the Shrew, Henry IV Parts 1 and 2, Henry V, The Merry Wives of Windsor, Much Ado about Nothing, Julius Caesar, As You Like It, Twelfth Night, All's Well That Ends Well, Troilus and Cressida, Measure for Measure* and *Hamlet.*

Prince Hal and Falstaff

Though bracketed between *Romeo and Juliet,* his first tragedy, and *Hamlet,* his first 'great' tragedy, the period is best remembered and best loved for its comedies. Most popular of all in Shakespeare's time, though less so now, were the two parts of *Henry IV* and *Henry V.* The reason was the character of Prince Hal (King Henry V of the later play) and his drinking companion, Sir John Falstaff. The combination of the passionate, wilful, libertine prince and the gross, good-humoured, drunken old knight captured the imaginations of Elizabethan audiences. Here is Falstaff, looking forward to the time when his 'Hal' shall be king:

'Marry, then, sweet wag, when thou art king, let not us that are squires of the night's body be called thieves of the day's beauty; let us be Diana's foresters, gentlemen of the shade, minions of the moon; and let men say, we be men of good government, being governed as the sea is, by our noble mistress the moon, under whose countenance we steal.'

But this riotous companionship was doomed to end when the prince became king, and Falstaff does not appear in *Henry V* (though Shakespeare was later forced to resurrect him, by popular and royal acclaim, in *The Merry Wives of Windsor*) except in the speeches of his friends, who report him dying of a broken heart. For Henry could no longer afford to

5 A scene from a Royal Shakespeare production of *Love's Labour's Lost,* an early comedy performed at court in 1605. It was the first of Shakespeare's plays to be published with his name.
6 Hamlet, feigning madness to avoid suspicion at the court of his father's murderer, makes game of Polonius, pompous adviser to the king.
7 Although in Shakespeare's day women were not allowed on the stage, a modern all-male production of *As You Like It* at the National Theatre, London in 1968 provoked mixed reactions.

waste his nights in drinking – he became the proud king (Henry V) who led his country to victory in France.

Most popular now are the romantic comedies, plays like *A Midsummer Night's Dream, As You Like It* and *Twelfth Night*. The first of these displays Shakespeare in his most magical mood; the wood in which the action takes place is as full of surprises and as magical as the poet's mind itself – it is a kind of light-hearted prototype of Prospero's enchanted island in *The Tempest. Twelfth Night,* on the other hand, though romantic in form, approaches nearer to harsh reality. Sir Toby Belch and his companions are roistering tavern-knights; Feste, the clown, is cynical, detached and even melancholy – we are not to see a more 'bitter fool' until the fool of *King Lear.* Though the play's tone is in general light-hearted, and ends happily, it touches on issues, like the faithlessness of woman, which were to become important themes for Shakespeare in his 'tragic' period.

Two of the late plays of this period were *Troilus and Cressida* and *Measure for Measure.* These have come to be known as 'problem plays', for though the first has a 'sad' ending and the second a 'happy ending', they are not comedy or tragedy. Rather than 'problem', it might be better to say they are 'realist' plays: in them, good and evil, happiness and melancholy, true and false are mixed, as they are in life. In both, too, there is the feeling that the society is fundamentally corrupt, that all men's actions are equivocal. In *Troilus,* Prince Troilus is faced with this unpalatable fact when he sees himself betrayed by Cressida:

'This she? no, this is Diomed's Cressid.
If beauty have a soul, this is not she;
If souls guide vows, if vows be sanctimony,
If sanctimony be the gods' delight,
If there be rule in unity itself,
This is not she. O madness of discourse,
That cause sets up with and against itself!'

Hamlet marks at once the end of this period and the beginning of the last, in which the four great tragedies *Hamlet, Othello, Macbeth* and *King Lear* were written. Also to this period belong the bitter-sweet last plays – *Antony and Cleopatra, Coriolanus, Timon of Athens, Pericles, Cymbeline, The Winter's Tale* and, the culminating glory, *The Tempest.*

Prince Hamlet is the finest and last example of the Shakespearean man, a character whom, we may assume, was modelled on his creator's conception of himself; he was the only Shakespearean character, as one critic has said, who could have written Shakespeare's plays. He acts decisively only twice, both times in rage when he kills first Polonius (in mistake for the king) and then the king himself. The rest of the time he is brooding, introspective, unsure. The famous soliloquy:

'To be, or not to be, that is the question.
Whether 'tis nobler in the mind to suffer
The slings and arrows of outrageous fortune
Or by opposing, end them.'

is indicative of his nature. He is a philosopher, a man of peace who finds himself in a tragic situation and is forced to act against his nature. Above all, he is entirely aware of his situation.

Tragic heroes

The other tragic figures – Macbeth, Othello and Lear – are not of this kind. Their tragedy is brought upon them partly by the tragic flaw in their own natures and partly by cruel chance. To a greater or lesser degree they are unaware of their true character until too late. Macbeth and Othello commit murder before they realize quite what they are doing, and Lear undergoes terrible humiliation before he can recognize true love from false. Here is Othello's 'moment of truth', after he realizes he has killed his beloved Desdemona through mistaken suspicion:

'. . . then, must you speak,
Of one that lov'd not wisely, but too well;
Of one not easily jealous, but, being wrought.

Perplex'd in the extreme; of one whose hand
Like the base Indian, threw a pearl away
Richer than all his tribe.'

These tragedies were written when Shakespeare was at the height of his powers, a fully mature and tremendously popular artist. He had become wealthy through his art and redeemed the family fortunes; he had purchased one of the best houses in Stratford and had received a coat of arms, of which he was very proud. Shakespeare's last plays nevertheless reflect the sadness of a man who is declining into old age. They are never sentimental, but rather seem to contain a half-wistful delight in the beauty of an art he knew he would soon be unable to practise. This finds a fitting summation in the speech of Prospero:

'Our revels now are ended. These our actors,
As I foretold you, were all spirits and
Are melted into air, into thin air:
And, like the baseless fabric of this vision,
The cloud-capp'd towers, the gorgeous palaces,
The solemn temples, the great globe itself,
Yea, all which it inherit, shall dissolve
And, like this insubstantial pageant faded
Leave not a rack behind. We are such stuff
As dreams are made on, and our little life
Is rounded with a sleep.'

Shakespeare's death was in 1616. He probably wrote nothing later than 1613. It is tempting to adduce from this that he himself knew that his creative life was over, and considered *The Tempest* to be its culmination, before his own life was 'rounded with a sleep'. It *was* a little life – his writings all took place within the space of 20 years – but it proved to be the richest life of any writer who has ever lived.

Playing out the tragedy

Thousands of years have passed since the Greeks enacted tales of great men brought low by human error. The theme of tragic drama, however, is still the portrayal of Man failing himself and others.

DRAMA SHARES with the novel and the cinema the quality of mirroring the age which produces it, of displaying the social, political and moral aspects of its time. The poet and the dramatist both create according to their talents, temperament and interests, but while the poet has scope to concentrate on his own sensations, the dramatist's world is one of character and action, of tension and interplay between imaginary people who become, once the actors give the play life, people of flesh and blood.

The playwright's task is to give his abstract ideas the form of action: he must show their realization in concrete and human terms. And since most dramatists, even if they are writing a play on a historical subject, use the ideas, situations and idioms of the age they live in, it follows that the play will reflect the temper of it very faithfully. This is especially true of the type of play we call the tragedy; the idea of what it should be, and the forms which it took, have varied enormously from age to age.

But before looking at the history of the tragedy, which is a history of the changes in the tragic view, it may be that there is a definition of tragedy which is common to all ages.

In the first place, it seems that tragedy usually has one single hero, whereas comedy may get along with a pair (usually man and woman) or more. More than this, such a man is very much an individual, distinguished quite markedly from his fellows. Aristotle, the Greek philosopher who was the first to define tragedy, says this of the tragic figure: 'A character of this kind is one who neither excels in virtue or justice, nor is changed through vice or depravity into misfortune from a state of great renown and prosperity, but has experienced this change through some human error.' It is his 'human error', the tragic flaw in his nature, which is his undoing.

This definition of the hero applies to many of the great English tragedies. In the domestic tragedy, on the other hand, which deals with characters who are not distinguished by rank or fame, the flaw has often shifted from being part of the hero's nature to being inherent in the situation of the play itself. This type of tragedy, though in a quieter and less noble vein than heroic tragedy, nevertheless poses important questions about the nature of tragic justice.

In the heroic tragedies – and the four great tragedies of Shakespeare (*Macbeth, Othello, King Lear* and *Hamlet*) are of this kind – the hero's character is flawed and he suffers for it. But in a tragedy in which the hero has no flaw, why does he suffer? He suffers, the dramatist implies, because

The hero's fall in Marlowe's *The Jew of Malta* is quite literal. Having betrayed Malta and killed his daughter's lover, Barabas plunges through a trap door into a boiling cauldron.

it is Man's fate to suffer, whether he leads a good life or an evil life. Taken to its logical conclusion, as this idea has been in our own day, tragedy is no longer a relevant concept, for if the universe is cruel and arbitrary, there can be no surprise or awe at the sight of a man stripped of all he has.

Scholars believe that Greek tragedy, the earliest and most celebrated dramatic form in the West, grew out of religious ceremonial. The ceremonial songs, they think, were elaborated into narrative dialogue, interspersed with common chanting. Gradually, the chanting took up less time and acquired a definite function, becoming the chorus, which commented upon the main body of the play – a dialogue between two or more actors.

The three great Greek tragedians were Aeschylus, Sophocles and Euripides; the last two were almost contemporaneous, living till the end of the fifth century B C. Aeschylus was born some years before, in 525 B C. The link with religion in all their plays is always strong. All the citizens attended the performances, held in great amphitheatres seating thousands, which were put on during the Athenian religious festivals. The themes of the plays concerned men's relation to the gods, and moral questions of great importance. As an example, let us take Euripides' play *Hippolytus*.

The play's story tells of the love of Phaedra, wife of Theseus, King of Athens,

Eighteenth-century tragedy closely followed Greek and Roman models. *Cato,* by Addison, tells of Cato's vain attempt to defend liberty by opposing the dictator Caesar.

for Hippolytus, Theseus' bastard son. Phaedra is tortured by her incestuous passion; seeing her agony, her nurse tells Hippolytus of Phaedra's desire for him, but Hippolytus, who is pure and follows Artemis, goddess of chastity, angrily rebuffs her. Phaedra commits suicide, leaving a note telling of an incestuous relationship with Hippolytus as the reason for her death. Theseus reads the note, and curses Hippolytus with death. The curse is effective, but Theseus learns before Hippolytus finally dies that he is innocent, and is condemned to live on under a burden of guilt.

The example is chosen because *Hippolytus* is in many ways an odd man out in Greek tragedy. A century later, when Aristotle set down a number of laws concerning the drama, he did so mainly with the work of Sophocles in mind, and with *Oedipus the King* in particular. *Hippolytus* is very different from this model of tragedy. In the first place, there is no one tragic hero – both Hippolytus and Theseus are equally unfortunate in the end. In the second place, the agents of their downfall are the gods, not, as in classical tragedy, another human being or a flaw within themselves. Of course they are all flawed to some extent – Hippolytus is cold and proud, Theseus is over-hasty, Phaedra lies in her letter – but the faults are slight compared with the fates which befall them. Finally, the gods are treated with little respect – they are shown to be no better,

indeed worse, than human beings.

Euripides, of course, knew the classic model well enough, but it did not quite fit his purpose. His vision was not, like that of Sophocles, of a stable society where tragedy came chiefly to the man who had committed a terrible act (as Oedipus did, though unknowingly). Euripides saw that the gods are not just, and that all humanity suffers for no good reason. Thus when Theseus cries:

> Land of Athens! Frontiers of a famous
> city!
>
> When was man more noble?
> When was loss more bitter?

he is mourning not only the loss of his son, but the cruel fate which attends mankind. Part of the nature of being human is to err from human ideals; it is also part of that nature to suffer and to die.

Native English drama

The Elizabethan dramatists, of whom Shakespeare was one, are among the greatest writers of tragedy in the world. Part of their success springs from a knowledge of the Greek dramatists and their Roman imitators. But only part; more importantly, they owed their position to a vital tradition of native English drama.

This tradition, like the Greek drama, sprang from the ritual of religion: as drama became more and more popular, its themes moved further away from the Church and became more secularized. Once playwriting had made a break with religion, the ground was fertile for the growth of tragedy, which in many ways is an anti-Christian form. Many influences combined to form the first tragedies. An important factor was the new classical learning, which demanded that tragedy should have no comic elements mixed in it, in direct opposition to the practice of the time, which jumbled comedy, tragedy and farce together. *Gorboduc,* written by

1 By sweeping away the old ideas of tragedy, Henrik Ibsen gave new life to the drama. The hero of *The Master Builder* dies trying to live up to the hopes and ideas of his youth.
2 The tragic hero meets his fate because of some flaw in his character. Vanity clouds the common sense of Shakespeare's King Lear, who dies mad, having lost everything he prized.

Thomas Norton and Thomas Sackville and first presented in 1561 is an example of the 'neo-classical' tragedy. It is not an inspired play, but showed some originality of technique and did not slavishly copy its classical models; the chorus, for example, was cut out. What this and other tragedies like it did was to evolve a coherent form of tragic expression for the later, more skilled writers.

The tragic hero was almost always noble by birth or position – Shakespeare's Hamlet and Macbeth, Christopher Marlowe's Tamburlaine, Thomas Kyd's Hieronimo are all good examples. Occupying this position, often accompanied in the earlier part of the play with honours and good fortune, the tragic hero has the further to fall. Again, in such a position, he exists in a world of ambition and power;

the first he usually possesses to excess, the second he often desires more than anything else. In Marlowe's plays, the heroes are tied to the wheel of ambition and lust for earthly power in some form. Here are some lines from one of Tamburlaine's speeches:

> Nature, that framed us of foure elements,
> Warring within our breasts for regiment,
> Doth teach us all to have aspiring minds:
> Our soules, whose faculties can comprehend
> The wondrous architecture of the world,
> And measure every wandring planets
> course,
> Still climing after knowledge infinite,
> And alwaies moving as the restless
> spheres,
> Will us to wear ourselves and never rest,

Until we reach the ripest fruit of all,
That perfect blisse and sole felicity,
The sweet fruition of an earthly crown.

The tragedy was usually effected, as it was in classical Greek drama, by the working out of some flaw or character defect in the hero. So, in *Macbeth,* the hero shows ambition to an inordinate degree, and allows his wife to compensate for the lack of decisions he shows in accomplishing his ends. He achieves his aim – to be King of Scotland – but destroys himself, his family and his good name forever. For Marlowe's heroes Tamburlaine and Dr Faustus, death itself is their tragedy, for after attaining the power which is their heart's desire, they must leave it for an earthly grave.

The most notable feature of these tragedies, especially the tragedies of Shakespeare, is the profundity and strength of their themes and structure. The dignity of the tragic hero is never in question, though his morality may be; his inevitable fall inspires not pathos, but reverence. He may have been ruled by earthly passions, but these passions are on a grand scale and his obsession with them all too understandable. Nothing in the history of the English theatre compares with these works; after Shakespeare, tragedy went into a long decline from which it was not to recover until the present century.

In retrospect, it is easy to see that the dramatic spirit was bound to weaken soon after the early triumphs: the first flush of the Renaissance in Britain, coupled with England's powerful and wealthy position in Europe was naturally counterparted by great strength and confidence in the theatre. Tragedy after Shakespeare diminished, with sentimental and horrific elements incorporated for the increasingly coarsened sensibilities of the audiences. The 'horror tragedy' became popular for a time, a form which placed a large amount of importance on the cruelty and savagery of the hero, showing innocence treated in a barbaric fashion. This was more than proof of fate's tendency to reward innocence with blows, it was brutality for its own sake. Many plays, which otherwise showed great skill in construction, were weakened by this element, plays like Philip Massinger's *The Virgin Martyr* (1620) and John Ford's *'Tis Pity She's a Whore* (published 1633).

Goodness and generosity

More important than these plays, but still far from the greatness of Shakespeare, were a few which have come to be called 'domestic tragedies' – so called because their heroes were undistinguished by rank or nobility and their themes were comparatively trivial. Thomas Heywood's *A Woman Killed with Kindness* (1603) is the finest example in this genre. The theme is simple. It concerns a woman who, forgiven by her generous husband for committing adultery, afterwards pines away and dies. It is presented without sentimentality and with insight into the nature of goodness and generosity.

Unfortunately, it was not the simpler domestic tragedy but the high-flown heroic tragedy that the next generation was to choose as its vogue. The dramatists of the Restoration period and of the eighteenth century wrote tragedies in a style borrowed from the French classical theatre of the time, mostly in rhymed verse. Rhymed verse can be used skilfully and to effect, but it rarely was in those plays. Heroism tended towards a display of heroics, speeches towards bombast and love lyrics to the artificial and the stilted. A few lines

1 'Thou power that madst me, send me a gleam of hope', cries Beverley in Edward Moore's *The Gamester*. The play is a domestic tragedy of ruin brought on by the vice of gambling.

2 At the end of the seventeenth century the stage was dominated by tragedies such as *Venice Preserved* by Thomas Otway. Many of these plays were filled with false heroics and bombast.

3 Ford's *'Tis Pity She's a Whore* involves incest, vengeance and violent murder. Such 'horror tragedies', written after the Elizabethan age, revelled in brutality and sensationalism.

from John Dryden's *The Conquest of Granada* (1670) shows how badly even the best of this verse (and Dryden was the best dramatist of his age) compares with the earlier dramatic poetry:

> ALMANZOR: 'A hollow wind comes whistling through that door,
> And a cold shiv'ring seizes me all o'er.
> My teeth, too, chatter with a sudden fright:
> These are the raptures of too fierce delight
> The combat of the Tyrants, Hope and Fear:
> Which hearts, for want of field room, cannot bear;'

In the eighteenth century, heroic tragedy became more strictly imitative of the Greek and Latin models, but with less effect – Addison's *Cato* (1713) is the best work in this style. The domestic tragedy survived better, notably in Edward Moore's *The Gamester* (1753) which has a genuine tragic intensity and a grimly concentrated effect.

By the beginning of the nineteenth century, tragedy had effectively ceased to function at all. On the one hand are the plays of the Romantic poets – Wordsworth's *Borderers* (1796), Coleridge's *Remorse* (1813), Keats's *Otho the Great* (1819) and Byron's *Cain* (1821), plays hardly intended for performance, but to be read and appreciated as literary works. And on the other hand, the stage showed nothing but melodrama, farces and opera, with some revivals of earlier works. Melodrama is the abasement of tragedy – it relies on stock figures, like the Wicked Lord, or the Poor but Innocent Maiden, and on an often absurdly sentimental plot for its effect.

The revival of drama in general began in the latter part of the century, and is very much the history of the drama of our own times. And in this, the concept of tragedy discussed so far must largely be abandoned, for it has been abandoned by the majority of modern playwrights.

A study of tragedy proper would be incomplete without a mention of Henrik Ibsen (1828–1906), a Norwegian playwright who was to revive the failing dramatic spirit of Europe. Ibsen swept away all the old ideas of nobility and grandeur, of classical tragic form, as being irrelevant to the demands of the new age. For the old form he substituted a more intimate, probing and realistic one – he dissects the motives and pretences of his middle-class characters relentlessly; the grandeur of the old heroic gesture was replaced by the subtlety of the mind's reasoning.

Yet there is tragedy in his plays, the kind of tragedy found in the work of all the greatest writers, the tragedy of human beings failing to live up to their own hopes and ideals. And so, although Ibsen marks the death of tragedy as a form, he gives the tragic emotions new life, and points the way for a new drama.

Playing for laughs

The essence of comedy is humour, often at someone else's expense. But besides diverting and delighting, comedy can be a valuable tool to demolish conceit and criticize the excesses of society.

COMEDY, IT IS OFTEN SAID, is the reverse side of the coin from tragedy. This has become a commonly accepted truth, but what exactly is meant by it? And how far is it true?

The main essential of comedy, of course, is that it is comic. This does not mean that it must make us roar with laughter constantly, though most comedies contain farcical elements which do. The comedy of manners which came into its own in the Restoration period (about 1660), works generally on an essentially quieter and more restrained level than that of the broad joke. The farce, on the other hand, relies on a good deal of clowning, slapstick and ridiculous characterization for its effect.

Though the types of comedy differ widely, it is possible to trace in all of them a shared assumption of what constitutes the laughable. Comedy is nearly always concerned with the failure of men and women to live up to the ideals they have of themselves and of others. The writer of comedies works on the assumption that human beings are fallible creatures, and that in almost any situation they will fail to achieve what they mean to.

Take the classic comic situation of the man slipping on a banana skin and landing in the mud: this is funny because there is a sudden loss of dignity, brief proof that Man, for all his knowledge, is subject

to the same laws as the animal. Naturally, the more dignified or pompous the man the funnier his fall.

Laughter, the pure enjoyment of a ridiculous situation, is not subject to any moral or sentimental considerations. It is not until we have had a few seconds of laughter that we think about whether or not the man may be hurt. Comedy is usually at the expense of someone else,

and thus our laughter often has a degree of cruelty in it. The best kind of comedy is that which makes us forget the cruelty in some way, either by compensating the comic victim or by making us feel he deserved it. Malvolio, for example, in Shakespeare's *Twelfth Night,* is pompous and egotistical, and we feel he deserves his 'gulling' at the hands of Sir Toby Belch.

From the example with the banana skin it can be seen that comedy is not far removed from tragedy. The all-important difference (sometimes an uncomfortably small one) is in the playwright's point of view. The tragic hero is often gifted, courageous and imaginative; his fellows are at once in awe of him and fear him. The comic figure, too, is an abnormality among his fellow creatures, either because of his wit or his ridiculous qualities. If he does come to a sticky end, he may become a 'sadder and wiser man', or he may continue on his blundering way – in either event, he is an occasion for laughter. And often – especially if he is a witty character – he will win out of any given situation because he has put his wit and ingenuity to good use.

An almost tragic figure

Comedy very often includes situations which, if not tragic in themselves, only fail to be so because the dramatist has not fully developed their tragic potential. Lord Angelo, Deputy Duke of Vienna in Shakespeare's *Measure for Measure* is a good instance of an almost-tragic figure. He believes himself to be pure and free from sin but when given temporary power, he gives way, at first with reluctance, later with increasing abandonment, to long repressed lust. Angelo possesses nobility, imagination and great ambition. However he is not the major character in the play, his career is not terminated by fate but by a just temporal power in the form of the true Duke of Vienna. Thus he can be contained within the structure of a comedy, though that comedy is one of the grimmest Shakespeare ever wrote.

Comedy, like tragedy, has classical models – Aristophanes, the Greek satirist and comedian of the fifth century BC, and the Roman comedians, Plautus and Terence of the second century BC. It is for his satires that Aristophanes is remembered. In assuming that there was a rule of reason which could control society, Aristophanes was in an excellent position to ridicule the excesses of those who broke these rules of rational behaviour. His Elizabethan disciple, Ben Jonson, was to transform satire into a bitterly sharp instrument; but for Aristophanes, and for Plautus and Terence, it was not far removed from broad comedy.

It was farce that formed the first native

1 An awkward moment in Sheridan's *A School for Scandal*: Lady Teazle peeps guiltily from behind a screen as her unsuspecting husband converses with the hypocritical Joseph Surface (left).

2 Lords, ladies, fairies and menials are equally at home in Shakespeare's *A Midsummer Night's Dream.* Under the magic spell of Puck, Titania caresses Bottom, adorned with an ass's head.

English comedies. In the Middle Ages, before the development of secular drama, the ceremonials of the Church were satirized in a grotesque fashion in the ceremonials of the boy bishop and the feast of the asses. This farcical element was soon adopted into the mystery plays – certain biblical characters became stock comic figures, like Satan, who was constantly represented as losing his dignity and pride. Such crude humour sometimes took on a more sophisticated form; in the Wakefield cycle of mystery plays there is a comic scene between Christ's four torturers as they struggle to erect the cross.

Farce has remained a constant force in the comic theatre throughout its history. Generally, however, it has not been the predominant type of stage comedy in any age since medieval times, with the exception of the nineteenth century. And at that time, drama had sunk very low; farce can only dominate when the dramatic comic spirit of the time is in abeyance.

Master of farce

This is not to deny any merit to the farce form – though its characters may be stock ones, and essentially incredible, their ridiculous qualities are still those present in all humanity, though in a less exaggerated form. And in the hands of a master like Feydeau, the late nineteenth-century French dramatist, farce can be both hilariously funny and socially critical.

As with tragedy, it was the classical models that gave birth to comedy as we know it. Nicholas Udall's comedy *Ralph Roister Doister* (1552) was an imitation of the Roman comedies of Terence in form; for the first time there is story, incident and order. But the stuff of the comedy is traditional and native. This and other early comedies paved the way for the romantic comedies of Peele, Greene, Lyly and Shakespeare.

A stricter imitator of the Greek comic mode was Ben Jonson, who wrote his plays about the beginning of the seventeenth century, at the time when Shakespeare was producing his great tragedies. Classical comedy was, in the main, satirical – it held up the follies and excesses of the time to ridicule. So, in *Every Man out of his Humour* (1599), *Volpone* (1606), *The Alchemist* (1610) and others, Jonson created a gallery of grotesque figures who each embodied a particular vice. Here is a speech from Volpone, one of his finest creations, the epitome of greed and cunning:

Good morning to the day, and next my gold:
Open the shrine, that I may see my saint.
Hail the world's soul and mine. More glad than is
The teeming earth to see the long'd for sun
Peep through the horns of the celestial Ram,
An I, to view thy splendour darkening his.

Volpone calls his gold his 'saint', claims it is more splendid than the sun. Yet, avaricious as he is, Jonson's genius is to use him as a touchstone for the greed of

1 Congreve's *Way of the World* is the best example of the witty, bawdy comedy of manners written for the Restoration stage, remarkable for the elegance and beauty of the language.

2 Lysistrata (centre), heroine of Aristophanes' comedy of that name, encouraged the women of Athens to withhold conjugal rights in an effort to stop the Peloponnesian War.

amend them.'

The comedy of manners, which grew up in the Restoration period, is a comedy as intellectual as that of Jonson's, but in a different way. The comedy of manners at its best works on wit – sharp, satirical and often cruel. The protagonists in Restoration comedies are aristocratic; they have money and leisure, and spend their time in amorous intrigues and in playing elaborate jokes on their more foolish companions. Great importance is placed on the intelligence – the butts suffer because they are stupid, often because they do not have the wit they pretend to. In this, the men and women are equal – every witty hero has his counterpart in an equally clever heroine: generally, they recognize each other's worth, and marry at the end. Sir George Etherege, William Wycherley, William Congreve, George Farquhar and Sir John Vanbrugh were the foremost artists in the comedy of manners – we may take as a representative of their work *The Way of the World* (1700) by Congreve.

The hero, Mirabell, and the heroine, Millamant, are matched perfectly in wit: it is not hard to guess that they will marry, but at first both seem set against it. Around them a galaxy of lesser characters revolve – Fainall, Witwoud and his brother Sir Willfull Witwoud, Lady Wishfort, Mrs Marwood and others. Their names suggest their dramatic functions – they are all in one way or another lacking in self-awareness, blinded with greed, or pride, or vanity. Only Mirabell and Millamant escape the general folly of the times, and only they achieve true happiness, one based very much upon mutual respect and

1 A scene from the French dramatist Georges Feydeau's farce *The Cat Among the Pigeons.* As in all his plays, the action, which is fast and furious, arises out of a misunderstanding.
2 Beatrice and Benedick, hero and heroine of Shakespeare's *Much Ado About Nothing,* indulge in a witty sparring-match before declaring their love for one another.
3 Malvolio, pompous, conceited steward to Olivia in Shakespeare's *Twelfth Night,* is a minor character, but he and his encounters with Sir Toby Belch provide much of the play's humour.

the world, a world peopled with ravenously greedy and self-interested vultures, willing to prostitute their wives and sell their souls for riches.

Satire has never since reached such heights in the theatre as in Jonson's plays. At the same time, like farce, it is a continuing influence and has come into its own again in our own times, notably in the realm of political satire.

The great romantic comedians – George Peele, Robert Greene, John Lyly and especially William Shakespeare produced some of the most pleasant and enchanting comedies in the English language. It is tempting to see the earlier writers' work as merely a preface to Shakespeare for in comedy, as in tragedy, he was pre-eminent. But that would be unjust to the many excellences in their work.

Romantic comedy, of course, concerns the actions of lovers, often of more than one pair of lovers. The world in which the lovers move is usually magical, mythic, peopled with classical or supernatural figures who exist quite comfortably beside contemporary characters.

Greene's *Friar Bacon and Friar Bungay* (1589) shows this intermixture of different worlds in one action. Friar Bacon and Friar Bungay are magicians who are constant rivals; Margaret is the beautiful daughter of a country gamekeeper, in love with her are two lords, Edward, Prince of Wales and Lacy, Earl of Lincoln. So the magical, the rural and the aristocratic are bound together. Shakespeare's *Midsummer Night's Dream* is in the same style, with its dukes, fairies and workmen all tumbling over each other in the enchanted forest. At the end of the play, the duke, commenting on the workman's masque, gives what amounts to a vindication and a definition of romantic comedy: 'The best in this kind are but shadows, and the worst are no worse, if imagination

Lady Bracknell assures Ernest that it is impossible for her daughter to marry an orphan found in a handbag: a famous scene from Oscar Wilde's *The Importance of Being Earnest.*

common sense. The following is an excerpt from the famous scene in which they agree, on the surface reluctantly, to marry:

MILLA: My dear liberty, shall I leave thee? My faithful solitude, my darling contemplation, must I bid you then adieu? ... I can't do't, 'tis more than impossible – Positively, Mirabell, I'll lye abed in the morning as long as I please.

MIRA: Then I'll get up in a morning as early as I please.

MILLA: Ah! Idle creature, get up when you will! – And d'ye hear, I won't be called names after I'm married; positively I won't be called names.

MIRA: Names!

MILLA: Ay, as wife, spouse, my dear, joy, jewel, love, sweetheart and the rest of that nauseous cant in which men and their wives are so fulsomely familiar . . . let us be as strange as if we had married a great while; and as well bred as if we were not married at all.

This type of comedy, like so many other dramatic types, was censored by an increasingly puritanical authority, and declined in the mid-eighteenth century. It survived, however, in a somewhat changed form in Goldsmith (*She Stoops to Conquer*, 1773) and Sheridan (*The School for Scandal*, 1777).

Modern comedy is a mixture of the styles, though it owes most to the comedy of manners. George Bernard Shaw's comedies, or 'Plays Pleasant', as he called them, are often satirical in tone, very witty, but far more socially orientated than any comedy had been before. Shaw's women – Candida in the play of the same name is a good instance – are as strong as any Restoration comedy heroine, and much of the comedy stems from the woman's unsureness in her newly emancipated role.

Oscar Wilde is far more in the mainstream of mannered comedy – like Congreve's Mirabell, his Algernon Moncrieff,

Volpone or The Fox by Ben Jonson exposes a world of greed and cunning: Volpone, a rich Venetian, pretends to be dying in order to attract rich presents from would-be heirs.

in *The Importance of Being Earnest,* has nothing to do except fall in love and think of schemes. Wilde, however, is more interested than Congreve in the witty saying, the epigram and the paradox – much of his dialogue is an exchange of this kind of wit, like these lines from *The Importance of Being Earnest:*

JACK: I am in love with Gwendolyn. I have come up to town expressly to propose to her.

ALGER: I thought you had come up for pleasure? I call that business.

JACK: How utterly unromantic you are!

ALGER: I don't see anything romantic about proposing. It is very romantic to be in love. But there is nothing romantic about a definite proposal. Why, one may be accepted. One usually is, I believe. The excitement is all over. The very essence of romance is uncertainty. If ever I get married, I'll certainly try to forget the fact.

JACK: I've no doubt about that, dear Algy. The Divorce Court was specially invented for people whose memories are so curiously constituted.

In the present century, comedy has

tended to become more grim and meaningful than in any previous age; indeed, the barrier between comedy and tragedy has largely disappeared. In Samuel Beckett's play *Waiting for Godot* (published 1953), the two tramps who are the central characters converse endlessly, and sometimes very funnily, but the comedy is very close to despair, and is in the end only a means to make time pass. In a world where moral values are confused, the comedy of despair is seen by many dramatists to be the only valid kind there is.

Yet at the same time this comedy displays similarities with the more conventional comic form; at every stage of its development, the best comedy has been more than simply funny. From Aristophanes onwards, playwrights have used comedy as a means of exposing human folly and satirizing human vices. Laughter, however grim its cause, has proved to be a liberating activity, expressing our refusal to be daunted by dark and hostile forces.

Wycherley's *A Country Wife* attempts to satirize the degeneracy of Restoration society through a plot based on the exaggerated jealousy and credulity of lovers.

The slam of the Doll's House door

Melodrama and farce provided a pleasant evening's light entertainment at the theatre for most of the last century, until Ibsen's frank treatment of human problems gave drama a new dimension.

DURING THE FIRST HALF of the nineteenth century, drama in England was at its lowest ebb since the closing of the theatres in 1642. At that time, theatre had died by law; in the nineteenth century it seemed about to die of mediocrity and neglect. The reasons for this decline were as much social as artistic, though the artists' contemptuous spurning of the theatre at this time was without precedent.

Drama had never been entirely healthy in the eighteenth century. The early part of it saw the end of the splendid school of Restoration comedy, but by the 1800s, the protests of the Puritan element had drowned out the 'immoral' plays of Congreve, Wycherley, Farquhar and their fellows. Sheridan and Goldsmith did much to revive the witty mode of comedy in a slightly new form, and though not so successful nor as accomplished as their predecessors, their best works, Goldsmith's *She Stoops to Conquer* and Sheridan's *The School for Scandal,* are brilliant comedies of manners.

With their death, comedy, the only vital dramatic mode in existence at this time, died too. In the late 1780s and 1790s, the Theatre Royal in Covent Garden and the Drury Lane Theatre were rebuilt and enlarged considerably. Joanna Baillie, a playwright of the time, complained: 'The largeness of our two regular theatres, so unfavourable for hearing clearly, has changed in a great measure the character of pieces exhibited within their walls.'

Simple and spectacular

The change was entirely for the worse. In order to be clearly heard and understood, the acting became bombastic and crude. The actors could no longer portray subtle movements or sophisticated asides. Plays written for these theatres had to be simple in plot or purely spectacular. And so for the first time a very real break occurred between the popular and the 'artistic' in drama, and for this the 'serious' artist must take a large share of the blame.

The late eighteenth century saw the growth of the Romantic movement. Starting in Germany, it quickly swept across Europe in a wave of reaction to the 'Age of Reason' that had preceded it. One of the effects of this aesthetic revolution was a new conception of the artist. Before this time he had been more or less a member of society; however gifted, he was not regarded, nor did he regard himself, as remote from his fellows; in fact he was often concerned to be very much one of them. The Romantic artist, especially the poet, cut a very different figure: he severed himself from society, often, like Wordsworth, living in seclusion and cultivating his vision in private.

This attitude naturally led to an almost total neglect of the theatre by the better writers of the age. It led, too, to the growth of the 'literary drama', plays written by poets which were either never intended for production or failed utterly when they were produced. Determined not to compromise their art in any way, the poets never attempted to raise the standard of drama to even a decent level.

These 'literary' plays are not without interest, however. Wordsworth's *Borderers* (1795–6), Coleridge's *Remorse* (1813), Keats's *Otho the Great* (1819) and Shelley's *The Cenci* (1819) contain fine passages of verse and may still be read with pleasure. 'Read', however, is the operative word; it is hardly possible to present them on the stage for anything more than curiosity value.

Lord Byron was the most successful

1 In the nineteenth century many poets wrote 'literary' plays which were rarely performed. Shelley's *The Cenci* is a drama of incest and murder.
2 Shaw's *Candida* concerns the heroine's relationship with two men — her husband and a young poet. Her decision that her husband's need is greater is the play's conclusion and its message.
3 Ibsen created a revolution in the theatre, by treating realistically the personal and social problems of the day. The theme of *Ghosts* — the effects of congenital syphilis — and other plays shocked conservative Norwegian audiences.

dramatist-poet. Like the earlier tragedian Christopher Marlowe, his own life was a fit subject for drama. *Werner,* produced in 1830, is the best of his plays, though *Manfred* (1817) and *Cain* (1821) are of interest, too. *Werner* is full of creaking Gothick machinery – dark castles, mysterious crimes and the like – but the dialogue moves fairly swiftly and the characters are well defined.

Novelty was everything

Many other minor writers and poets turned their hand to this form, but with no more practical success. The theatre was left to the 'professional' playwrights who, for the most part, turned out dozens of plays in a year. If they were to make their living in this fashion, they were forced to be prolific; novelty was everything in the theatres and not many plays had more than a few nights' run. Melodrama was the most popular form, derived from German romantic tragedies, from plays by Goethe, Schiller and especially Kotzebue. The English imitators, however, adopted their worst elements, the dramatic machinery without the poetry.

At first, romantic and medieval themes were the order of the day. William Dimond's *The Foundling of the Forest* (1809) is a typical example: the villain is a wicked baron; he plots to seduce an innocent maiden and is thwarted by a foundling who turns out to be a rich man's son and brother to the maiden. The sentimental elements in such a story are obvious and were exploited to the full.

Most melodramas relied on the basic plot of villainy thwarted and virtue rewarded; they contained an echo of the morality plays but without the realism, humour and vitality of the older form.

There was, however, a development of a sort in melodrama. Once history had been ransacked for plots, playwrights began to take their stories from more recent times, from the novels of Defoe and Dickens which were being published about this time, as well as from contemporary incidents. Two of the better writers of 'realistic' melodrama were Tom Taylor and Charles Reade, the latter best known today for his novels, especially *The Cloister and the Hearth* (1861). Melodrama became more realistic, and began to point forward to the general dramatic revival.

As tragedy became melodrama, so comedy became farce and burlesque. The farce was plain foolery; the burlesque was a little more sophisticated, being crude satire, often of established works like *Hamlet.* The only author to achieve any merit in this genre was James Planché, whose extravaganzas showed some delicacy and imagination. A development of this style can be seen in the work of W.S. Gilbert, the writer of the 'Savoy Operas', which Arthur Sullivan set to music. Gilbert and Sullivan became a national institution in their own day and remain one still. Their operas were brilliant, satirical and lively and not infrequently caused a scandal.

These were signs of change, but the struggle that was to culminate in the

1 In the tradition of James Planché and other playwrights of the age, Sir W.S. Gilbert wrote comic, satirical extravaganzas like *The Gondoliers* which Sir Arthur Sullivan set to music.
2 A scene from a television production of *An Ideal Husband.* The plays of Oscar Wilde display the sparkling wit and elegance of style for which his conversation was famous.
3 Frustration, futility, isolation are themes which permeate all Chekhov's plays. His first, *Ivanov,* tells of a man blighted by his inability to realize his talents.
4 Neurotic and tormented, Strindberg had three unhappy marriages which convinced him that all women were hostile and voracious. *The Dance of Death* is his most brilliant play on this theme.
5 In Chekhov's *The Three Sisters,* the sisters talk only of the day when they can return to Moscow, but they never leave the isolation of their provincial home.

4

renewed vitality of the drama in the late nineteenth and early twentieth centuries was a long one. In this struggle, the Theatre Act of 1843 was of some help, though it was not immediately felt. The act withdrew the exclusive rights of dramatic performances from the Theatre Royal and Drury Lane, so that other theatres, which had previously been little more than music halls, could present 'serious' drama. Again, the temper of the age had changed; respectability was the fashion and the theatres were no longer the haunt of prostitutes and drunkards. Order, if not taste, began to show itself.

Ibsen's revolution

Playwrights soon responded to these social changes. In 1865, T. W. Robertson wrote a comedy called *Society*. It was an attempt, though shallow and full of prejudice, to tackle social problems; its language, generally, is much freer and more natural than the common run of plays. His other plays, *Ours* (1866) and *Caste* (1867), show the same traits – an improvement, but not a revolution.

The revolution had happened elsewhere, and it centred upon the achievement of the Norwegian playwright Henrik Ibsen. He began writing in the 1850s and produced a number of fine historical plays. It was not till his later work, however, that he found his true strain in his stern dramas set in domestic surroundings. *A Doll's House* (1879), *Ghosts* (1881) and *An Enemy of the People* (1882) are examples of this time. The important point about Ibsen's art is that it was a wholly serious attempt to examine character and social structure in a dramatic manner. He was concerned both with individual suffering and with the pressures and hypocrisies of society. His plays, though it is hard to

realize this now, shocked and outraged conservative opinion of the time; they were often presented amid uproar, and theatres were closed down for showing them.

Ibsen created once again a climate in which drama was taken seriously. He wrote plays that dealt with the very essentials of life and society. Before him, plays of the nineteenth century had been almost exclusively for 'amusement': amusement which was empty, forgotten as soon as seen. The pleasure gained from watching an Ibsen play, or any play of some worth, is infinitely richer and more satisfying.

Boredom and futility

Two other dramatists reached world fame at the same time as Ibsen: Anton Pavlovich Chekhov, a Russian, and August Strindberg, a Swede. Chekhov's plays, the most famous of which are *The Three Sisters, The Cherry Orchard, Uncle Vanya* and *The Seagull,* did not cause the same furore as Ibsen's when first produced, but were still works of great originality and brilliance. Depending almost entirely on the conversation of their characters rather than on action, his plays are lyrical and melancholy, their themes the boredom and futility of Russian provincial life. Strindberg's plays – *Miss Julie, The Father, The Dance of Death* and others – have as a recurring theme the domination or destruction of men by women. In *The Father,* a husband is driven mad by hints from his wife that he is not the father of his beloved daughter. Unlike those of Ibsen and Chekhov, and later Shaw, Strindberg's plays make only passing reference to the contemporary social scene; they are set in the hothouse atmosphere of a crumbling marriage or a male-female battle for supremacy.

In Britain Ibsen's work was slow to arrive; he was not translated until the 1880s when he was already writing his

The work of T. W. Robertson brought a new realism to the nineteenth-century stage in plays like *Ours,* together with a willingness to tackle social problems.

major works. Two British playwrights who wrote their best work under his influence were Sir Arthur Wing Pinero and Henry Arthur Jones. Pinero's *The Second Mrs Tanqueray* (1893) and Jones's *Breaking a Butterfly* (1884) displayed realism and a desire to tackle real problems, especially social hypocrisy. Both men wrote *drame* rather than tragedy, a form of play which, though serious and often moving, never attempts to reach tragic heights. Both, too, wrote perfectly constructed plays in a theatrical sense – indeed, it has been held against them that their construction was often too perfect and was achieved at the expense of feeling and art.

The line of the *drame* was continued worthily, if not with brilliance, by Sir James Barrie and John Galsworthy, who wrote at the turn of the century. Barrie's *The Admirable Crichton* (1902) and Galsworthy's *Justice* (1910) dealt with themes that were very much in revolt against Victorian orthodoxy; but they wrote in an age which itself was not orthodox, and so their criticism was superfluous.

The most considerable dramatists round the turn of the century were all, curiously enough, Irish: George Bernard Shaw, Oscar Wilde, William Butler Yeats and John Millington Synge. Shaw's dramatic career, of course, lasted well into the twentieth century – he lived long enough to write a fable of the atom bomb. In the 1890s and early 1900s, he was a socialist, but in attacking prejudice, he did not simply lay it bare and then destroy it, as many lesser dramatists were doing – he dramatized it. In *Man and Superman* (1903) it becomes apparent that his socialism is part of a larger vision of life which is ultimately religious, a vision which held

that men would eventually become as gods.

Since Shaw's characters are never simply 'right' and 'wrong', the Shavian stage is always full of brilliant debate and counter-debate, and some of the most pressing social problems of his day were thrashed out in play after play. *Widowers' Houses,* produced in 1892, employs the arguments for and against slum property and the morality of rich liberalism in brilliant dialectical form. Shaw's most successful non-comic type is his warrior-saint, an ideal of human greatness most convincingly portrayed in *St Joan* (1923).

As light as an epigram

Like Shaw, Wilde was an Anglo-Irishman who lived and worked in England. There are few other similarities. Although as critical of society as Shaw, Wilde's plays contain little criticism that is not as light as an epigram. His characters converse in a flow of repartee and witty sayings like these words from Algernon Moncrieff in *The Importance of Being Earnest* (1894):

ALGERNON: I love hearing my relations abused. It is the only thing that makes me put up with them at all. Relations are simply a tedious pack of people who haven't got the remotest knowledge of how to live, nor the smallest instinct about when to die.

And again from Algernon:
'All women become like their mothers. That is their tragedy. No man does. That is his.'

Yeats, who helped found the famous Abbey Theatre in Dublin, wrote poetic drama in a highly stylized manner; yet *The Countess Cathleen* (1892) was powerful enough to cause riots at its first performance. His plays resemble his poetry in their rich personal symbolism, and his intention was in part to revitalize his countrymen's pride in themselves. It cannot be said that Yeats' plays had a great effect upon other playwrights of the time or after, nor that they remain popular today. Like T. S. Eliot, who wrote verse plays later in the century, his was art for a few, and many consider that his plays are better read than acted; his later plays, indeed, were intended only for reading.

J. M. Synge, the last of this talented quartet, is even further from the 'mainstream' drama than Yeats. Like Yeats, he capitalized on the rich language of the Irish for the speeches of his plays, with notable success. Writing of his comic masterpiece, *The Playboy of the Western World* (1907), he said: 'In a good play, every speech should be as fully flavoured as a nut or apple, and such speeches cannot be written by anyone who works among people who have shut their lips on poetry.'

Much of what was begun and in a sense belonged to the Victorian era was still being written well into the twentieth century, even after a world war which swept away many of the established values in art as in every other aspect of life. The new century was to further these experiments and changes with an interest in theatre and drama throughout the world unknown in any age before.

Playing a part

Dramatists in our own century have been increasingly concerned to make the theatre their mouthpiece, to involve the audience emotionally, mentally or even physically with the action on the stage.

IN *The Bald Prima Donna*, by the French-Rumanian dramatist Eugène Ionesco, there is the following piece of dialogue:

MME MARTIN: What's the moral?
FIREMAN: That's for you to find out.

These two lines may stand as preface to much of the best drama of the twentieth century. Through all the various movements in the theatre – the Theatre of the Absurd, the Theatre of Cruelty, Bertolt Brecht's Theatre of Alienation – one broad tendency may be noted: the desire of the playwright to *involve* the audience more and more intimately with the performance, to break down in some fashion the barrier that exists between actor and spectator. In much of the best twentieth-century drama it is the audience's task to participate emotionally and intellectually in order to 'find out' the moral or the meaning of the piece they witness.

To make this possible, the modern dramatist has entirely to rethink the very nature of the theatre. The main obstacle has proved to be the tradition of the 'well-made play', of which the work of A. W. Pinero in the latter half of the nineteenth century was a classic example. This type of play had a clearly defined theme and plot; it set out a dramatic problem at the beginning, developed it in the middle, brought it to a climax and disposed of it at the end. Although both Ibsen and Shaw

deepened the theme and scope of the play, they did not really attempt to break down its formal structure, nor involve the audience to any great extent. Their plays both shocked and stimulated, but they used the dramatists' familiar stock-in-trade – dramatic tension, comedy, surprise, sudden revelation and the like. They remained solidly on the far side of the footlights.

Reality and illusion

The work of the Italian Luigi Pirandello was instrumental in setting a new style in the theatre. Pirandello's plays, especially *Six Characters in Search of an Author* (1921) and *Henry IV* (1922) have as their constant theme the nature of reality and illusion. In *Henry IV* a man chooses to live out his fantasy that he is Henry IV of England in a villa in twentieth-century Italy; he knows very well that it is a fantasy and further, that everyone else plays a part to a greater or lesser degree. To the visitors who come to 'cure' him, he says:

I know perfectly well that I'm playing the madman here! And I do it very quietly. You are the ones to be pitied, for you live out your madness in a state of constant agitation . . . without seeing it . . . without knowing it.

This is addressed as much to the audience

as to the other characters on stage.

In *Six Characters in Search of an Author*, the Pirandellian reality/illusion theme is presented directly to the audience: six nameless 'characters' turn up at a play-rehearsal with no lines to say, no plot to follow, only memories of old melodramas. As one of the 'characters' points out, the reality of a stage figure is always constant; Hamlet is always Hamlet, but for a human being, reality changes so fast and so constantly that it can hardly be said to be reality at all. A large part of Pirandello's achievement is that he presented the human predicament as part of the very world in which his audience existed.

Bertolt Brecht, a German playwright who became a Marxist in 1927, draws the audience into his plays in quite a different way; indeed, the method of which he spoke was called *Verfremdung*, which may be translated as 'a distancing effect', and seems at first sight to keep the audience away rather than bring it close to the dramatic piece. What Brecht meant by 'distancing', however, was that members of the audience should not become emotionally involved in his plays – they should not identify with the characters to the extent of wishing for a happy ending, or endowing them with a real existence outside their stage one. Rather he wished the audience to use their intellect to understand the message of the play, which was

1 *Murder in the Cathedral,* which dramatizes the death of Thomas à Becket, is the most successful of T.S. Eliot's verse plays and the one most frequently performed.

2 A scene from Harold Pinter's *The Homecoming.* One of Pinter's most striking qualities is his ability to convey humour or menace or hopelessness through the most banal conversation.

3 Luigi Pirandello questioned accepted distinctions between reality and illusion, sanity and madness. In *Henry IV* a man acts out his fantasy in a villa in twentieth-century Italy.

often a political one.

Brecht himself described *The Good Woman of Setzuan* (1939) as a parable play, and the description illuminates something of the nature of his work. Shen Teh, who is the good woman, is constantly exploited because of her generosity. Three gods, who appear as arbiters of her actions, approve her goodness but cannot help her. Reduced to poverty, she bitterly addresses the gods who command her to be good at all costs:

> Your world is not an easy one, illustrious ones!
> When we extend our hand to a beggar, he tears it off for us.
> When we help the lost, we are lost ourselves.
> And so
> Since not to eat is to die
> Who can long refuse to be bad?

The meaning of the parable is that goodness by itself is not enough in the world as it is now; an obvious message for the Marxist, who believes in a strong egalitarian government. But Brecht's plays are never simply Marxist; their meaning is universal. Brecht used the parable technique in several of his best works, including *The Caucasian Chalk Circle* (1944) and *Mother Courage and her Children* (1938).

Theatrical devices

Eugene O'Neill, an Irish-American writer, also tried to bridge the gap between audience and actor, though generally much less successfully, because less radically, than Pirandello or Brecht. He used masks, soliloquies and asides – all the devices which the so-called 'naturalistic' theatre had dispensed with – to achieve a richer effect. In *Desire Under the Elms* (1924) and *Mourning Becomes Electra* (1931), the characters voice their thoughts to some effect, though not altogether avoiding tediousness.

Pirandello, Brecht and O'Neill, especially the first two, attempt a closer relationship with the audience in completely different ways. But many dramatists of this century continued the well-made play tradition with commercial success, and continue to do so. Indeed, the majority of plays presented are of this kind: comedies, adventure plays, romances

1

and the like. Few make any demands upon the audience, beyond the ability to follow the plot; these are the plays that run for months, sometimes years. Somerset Maugham and Noel Coward, whose work appeared in the 1920s and 1930s, wrote witty, satirical comedies in this mode, better than most and still sure of success. Coward, especially, came close to Wilde in wit: his play *Private Lives,* though very much of the 1920s, still amuses modern audiences.

A more serious use of the conventional form was made by Sean O'Casey, an Irish writer. O'Casey had been a member of the I.R.A., (the Irish Republican Army) and his best plays deal with the time of the 'troubles': *Shadow of a Gunman* (1923), *Juno and the Paycock* (1924) and *The*

2

Plough and the Stars (1926). Although he was influenced to some extent by his countrymen, W. B. Yeats and J. M. Synge, his was not a poetic drama in form; the poetry exists in the way his characters speak:

SEUMAS: I wish to God it was all over. The country is gone mad. Instead of countin' their beads now they're countin' bullets; their Hail Marys and Paternosters are burstin' bombs – burstin' bombs, an' the rattle of machine guns; petrol is their holy water; their mass is a burnin' buildin'; their 'De Profundis' is 'The Soldier's Song', an' their creed is, I believe in the gun almighty maker of heaven an' earth – an' it's all for the glory o' God an' the honour o' Ireland.

(Shadow of a Gunman)

Other dramatists have constructed their

3

plays in conventional fashion, most notably the American playwrights Tennessee Williams and Arthur Miller. Many of Williams's plays – *Baby Doll* and *A Streetcar Named Desire* are two of them – have gained world fame as films. Miller, perhaps the best-known of contemporary American dramatists, is most famed for his *The Death of a Salesman,* in which he created Willy Loman, a silk-stocking salesman, a victim of the success-myth of modern materialist society. The play traces his breakdown which leads to his suicide; Linda, his wife, defends him against his son's attack:

LINDA: I don't say he's a great man. Willy Loman never made a lot of money, his name was never in the papers. He's not the finest character who ever lived. But he's a human being, and a terrible

thing is happening to him. So attention must be paid. He's not to be allowed to fall into his grave like an old dog. Attention, attention must finally be paid to such a person.

The new English dramatists – 'the angry young men' – were more concerned with social and political problems than with problems of form and audience-involvement. The work of John Osborne, Arnold Wesker, Bernard Kops and others shocked the audiences at the time; the production of Osborne's *Look Back in Anger* in 1956 was heralded by the critics as a great landmark in the English theatre. The play has now an almost nostalgic 'period' flavour and has lost much of its initial attack. At the time, however, almost no serious drama was being performed on the English stage, apart from foreign works

and revivals of Shaw and O'Casey. And the speeches of Jimmy Porter, the original 'angry young man' himself, retain some power, while the bitterly satirical shafts he aims at establishment figures still ring true.

One movement in the theatre that was to fail mainly because of its lack of theatricality was the poetic drama of T.S. Eliot and others, notably Christopher Fry. Eliot's attempts to revive verse plays were wholly serious and considered; indeed his first play *Murder in the Cathedral* (1935) succeeded very well as theatre, possibly because the characters were historical, and verse sounded 'natural' from them.

Mouthpieces for poetry

The Cocktail Party and *The Family Reunion,* however, were set in contemporary upper-middle class society, and Eliot used techniques of Greek drama, as well as symbolism adopted from his own poems. He did not aim at naturalism; he was interested in something deeper. But in reducing his characters to mere mouthpieces for poetry, he lost the action and much of the tension upon which a play functions. And he could not, as could the Greek tragedian, count on his audience's knowledge of the myths and symbols essential to an understanding of the plays. His later plays remain, like the dramatic work of the Romantic poets, more satisfying to read than to see. In this speech by Sir Henry Harcourt-Reilly in *The Cocktail Party* can be detected echoes of Eliot's poem 'The Love Song of J. Alfred Prufrock':

When you've dressed for a party
And are going downstairs, with everything about you
Arranged to support you in the role you have chosen,
Then sometimes, when you come to the bottom step
There's a step more than your feet expected

4

1 *Juno and the Paycock,* by the Irish playwright Sean O'Casey, is a tragi-comedy set in Ireland in the aftermath of the revolutionary troubles.
2 Four of the inmates of the Charenton Asylum in Peter Weiss's play *The Death of Marat.* The play is a supposed reconstruction of a drama written by the Marquis de Sade for the inmates when he was confined there.
3 One of the aims of twentieth-century theatre is to break down the barriers between audience and actors. The Royal Shakespeare production of *US* in 1966, a montage of songs and sketches, was designed to involve the audience in responsibility for the war in Vietnam.
4 Bertolt Brecht's 'Theatre of Alienation' aims at creating a distance between audience and stage, since he claimed that drama should not attempt to create the illusion of reality. The *Caucasian Chalk Circle* and other plays are composed of loosely connected scenes and demand a highly stylized acting technique.
5 A gesture of despair from *End Game* typifies the world portrayed by Samuel Beckett, whose characters are sunk in a desolation of loneliness where only cruelty and indifference exist.
6 A scene from *The Blacks,* by Jean Genet. The plays of the French novelist and playwright deal with the psychology of the delinquent and the homosexual.

5

6

Arthur Miller's plays are tragedies of the ordinary man. *A View from the Bridge* is the story of Eddie Carbone, a New York longshoreman who falls in love with his stepdaughter.

Beckett's work has been enormously influential throughout the world. An English dramatist who owes a lot to him and who is considered by many to be the best contemporary English dramatist, is Harold Pinter, whose first success was *The Birthday Party* in 1957. He has subsequently confirmed his early promise with such plays as *The Caretaker* (1960), *The Collection* (1961) and *The Lovers* (1963). Like Beckett's, his characters live on the edge of a void, but they are much closer to 'recognizable people', especially in their speech. Part of Pinter's genius is his ability to reproduce the banalities of everyday speech and make it sound menacing, or desperate, or hopeless. He is also a master at creating funny dialogue and comic situations.

Audience involvement

Experiment continues, and makes any judgement on the art of the contemporary dramatist necessarily an open one. Continuing the search for more audience involvement, some companies encourage their audiences to participate actively in the plays they present, or bring the audience on to the stage, or go themselves into the auditorium. The Polish Theatre Laboratory and the Living Theatre of New York both stage their plays as an all-out assault upon the audience, to force them to react, to be drawn in. They produce shock, horror and dislike, especially among the critics (rather like Ibsen and Shaw in the early part of the century). Without such experiments, based on a constant re-examination of the theatre's place in contemporary society, drama, as a living force, will die.

And you come down with a jolt. Just for
 a moment
You have experience of being an object
At the mercy of a malevolent staircase.

Of all the experimental movements in twentieth-century drama, the most exciting and perhaps the most fruitful has been the work of that body of dramatists which constitutes the 'Theatre of the Absurd'; Samuel Beckett, Eugène Ionesco, Jean Genet, Harold Pinter, Edward Albee and others are part of it. The connecting link between these authors of different nationalities is that they are all concerned with a world in which nothing is certain, where no answers are given nor justice possible, where truth is arbitrary and action hopeless. The concept was first formulated by Albert Camus, the French novelist and philosopher, in his treatise *The Myth of Sisyphus*: 'A world that can be explained by reasoning, however faulty, is a familiar world. But in a universe that is suddenly deprived of illusions and of light, man feels a stranger . . . this divorce between man and his life, the actor and his setting, truly constitutes the feeling of Absurdity.'

This contention was to be proven dramatically in many plays written after the Second World War. The most famous of these is Beckett's *Waiting for Godot* (1947). Little happens in the play: two tramps, Vladimir and Estragon, meet, talk and squabble. A man, Pozzo, comes on stage, driving before him a miserable servant, Lucky. Pozzo talks with the tramps in a lordly fashion, then exits, to reappear at the end, blind. The tramps' ostensible reason for being is that they are waiting for a M. Godot, who has promised them aid; he never comes. They are forced to while away the time until the play ends. All kinds of meanings, symbolic and religious, have been ascribed to the play, but it remains elusive of definition, like so much of the best 'Absurd' drama. What emerges finally is Beckett's compassionate view of human hoplessness and desolation. Vladimir and Estragon converse, not to exchange ideas or information, but to cover the abyss of non-existence that constantly threatens to engulf them:

EST.: You'll help me.

VLA.: I will, of course.

EST.: We don't manage too badly, eh Didi, between the two of us?

VLA.: Yes yes. Come on, we'll try the left first.

EST.: We always find something, eh Didi, to give us the impression we exist?

VLA.: Yes yes, we're magicians.

Pozzo torments his helpless servant Lucky in Beckett's *Waiting for Godot,* perhaps this playwright's ultimate expression of his compassion for the human condition.

The tragic novel

The novelist has enormous scope to explore the intricacies of human existence, to probe motive and analyse error. These concerns have inspired some of the greatest works in literature.

TRAGEDY, in the classical sense – the fall of a man because of some deep fault in his character – is rare in the novel. The scope of this particular form has demanded that Man be seen in relation to other people in society, affected to a greater or lesser degree by that society itself. The hero of a 'tragic' novel does not usually bring about his own tragedy, though he may play a large part in doing so: it is the malignancy of others, or the force of the society of which he is a part, that plays a greater part in contributing to his fall.

Like the cinema, the novel is an art 'condemned' to reproduce a large part of observable reality and, for most novelists and their readers, this reality takes the form of cause and effect. A character does something for a reason, or because of a certain stimulus: this action in turn produces other effects, other actions.

Again, since Man is a social being, one of the primary influences upon him is society. Every society puts a certain amount of pressure upon its members to conform to its laws and customs: often, if the individual is at odds with these laws, the ensuing struggle results in tragedy, usually, of course, for himself. The novelist has enough space to explore such influences and reactions, and show how they interact upon each other.

In the view of some novelists, the forces acting upon Man are more often than not against the possibility of his full expression as a human being. In writing such a novel, the writer constructs a universe that is essentially malignant, destructive or restrictive. Very often, too, he creates a character of either extraordinary abilities or extraordinary purity, who comes to grief precisely because the universe is so constituted.

Many novels share an essentially tragic view of the world and of human nature, however differently that view may be expressed from novel to novel.

Take first two works, separated by a century and a half, in which tragedy predominates: Samuel Richardson's *Clarissa Harlowe* (1748) and Thomas Hardy's *Tess of the D'Urbervilles* (1891). Richardson wrote nothing else to compare with *Clarissa* – *Pamela* (1740), his first novel, was comic – while Hardy is often described as the only tragic novelist in English literature. It is not surprising that the treatments of the two novels differ greatly – yet the themes are surprisingly similar.

Both novels have a central heroine, innocent, beautiful and selfless; in both cases, the heroine loses her chastity – in Clarissa's case, by rape, in Tess's, through

reluctant submission. Both die as a direct result – Clarissa alone, spurning all help, Tess hung in punishment for the murder of her seducer.

Clarissa is a sexual tragedy; once she has been raped, even though her loss of chastity is a technicality and no fault of hers, Clarissa regards herself as lost. She is more unforgiving towards herself than society could ever be: she refuses to marry Lovelace, the man who has ruined her; she cuts herself off from family and friends. Clarissa is her own tragedy.

Tess, however, like all Hardy's characters, exists in an indifferent, even hostile, universe. Her submission to Alec D'Urberville is part fascination, part revulsion. She marries the man she loves, but he deserts her when he learns of her seduction. Cynically, her seducer takes her back, and finally, beyond endurance, Tess kills him. She is united to her husband in mutual love only when it is too late, when she is a hunted woman. Innocence, in Hardy's world, is doomed because it is innocence and can be manipulated. Hardy shows, in *Tess* and in his other novels – most notably *The Return of the Native* (1878), *The Mayor of Casterbridge* (1886) and *Jude the Obscure* (1895) – that it is in the nature of the weak to submit to the strong, that it is the nature of the offering

1 Raskolnikov visits the old pawnbroker in the film version of Dostoevsky's *Crime and Punishment*. He considers that she has forfeited the right to live and plans to exterminate her.
2 Richardson's novel *Clarissa Harlowe* was intended as a warning of 'the Distresses that may attend Misconduct both of Parents and Children in relation to Marriage'.

of true love to be misunderstood, ignored and humiliated.

Thus while Richardson presents what is really a middle-class tragedy – though there are deeper strains in the novel – Hardy presents a tragedy for all people at all times. His characters are less subtle psychological creations than forces of nature. The following passage is a description of the state into which Tess's husband Angel Clare falls when learning of her seduction:

'His air remained calm and cold, his small compressed mouth indexing his powers of self-control; his face wearing still that terribly sterile expression which had spread thereon since her disclosure. It was the face of a man who was no longer passion's slave, yet who found no advantage in his enfranchisement. He was simply regarding the harrowing contingencies of human experience, the unexpectedness of things.'

Hardy, more than any other English novelist, knew and wrote of 'the harrowing contingencies of human experience'.

Death-bed scene

Few novels show the harsh pessimism of Hardy's work, nor even the steady progression to ruin in *Clarissa*. Far more commonly, especially in the nineteenth century, the tragic elements of a novel were closer to pathos. Pathos might be described as tragedy weakened by sentimentality. Charles Dickens uses it a great deal, especially when describing a deathbed scene. Here is an excerpt from the death of Stephen Blackpool, the honest mill-hand of *Hard Times*:

'"Often as I coom to mysen, and found it shinin' on me down there in my trouble, I thowt it were the star as guided to Our Saviour's home. I awmost think it must be the very star!"

'They lifted him up, and he was overjoyed to find that they were about to take him in the direction whither the star seemed to lead.

'"Rachel, beloved lass! Don't let go my hand. We may walk together tonight, my dear!"

'"I will hold thy hand, and keep beside thee, Stephen, all the way."

'"Bless thee! Will someone please to cover my face?"

'They carried him very gently over the fields, and down the lanes and over the wide landscape; Rachel always holding the hand in hers. Very few whispers broke the mournful silence. It was soon a funeral procession. The star had shown him where to find the God of the poor; and through humility, sorrow and forgiveness, he had gone to his redeemer's rest.'

Nineteenth-century readers were particularly susceptible to pathos of this sort – indeed, a whole sub-class of literature

1 In *Dombey and Son* Dickens recounts the humiliation and subsequent repentance of Dombey, an arrogant husband and father who drives away wife and children by his cruelty.
2 Heathcliff, the sombre, violent hero of Emily Brontë's novel *Wuthering Heights,* devotes his life to revenging himself on those who once ill-treated him.

1 A scene from the film of Hardy's *Far from the Madding Crowd* where Gabriel Oak saves a farm from fire and in this way meets its mistress, Bathsheba Everdene.

2 George Eliot's novel *Middlemarch* explores the motives and errors of her main characters Dorothea Brooke and Dr Lydgate which lead to their respective and unwise marriages.

grew up at this time devoted to such subjects, treated in a much more mawkish fashion. The jarring feature of the passage quoted is the indulgence in the situation for its tearful qualities, and the inevitable falsification of death for a sentimental effect. Many of Dickens's child characters, especially those who die in their childhood, are subject to this treatment. Yet, though Dickens wrote no tragedy, he did create tragic figures – Lady Dedlock of *Bleak House,* for example, is one, a woman whose tragedy, like Clarissa's, resides in her proud nature.

There is one novel of the Victorian era (the period in which the novel form came most strongly into its own) which stands unique in a category of its own. The novel is *Wuthering Heights* (1847). The sole masterpiece of Emily Brontë, the most brilliant member of a brilliant family, its characters are elemental forces in a way similar to Hardy's (but without his over-riding pessimism) and to those of the later twentieth-century novelist D. H. Lawrence. Heathcliff, the hero, is perhaps the most powerful figure in English fiction, comparable to the best creations of the Russian and American novelists Dostoyevsky and Herman Melville. Indeed, like Captain Ahab in Melville's *Moby Dick,* he seems to be a natural force in human form.

This comparison with the great novelists of other countries suggests what seems to be specifically 'English' in the novel. Generally, it lacks characters of the power of Heathcliff – *Wuthering Heights* is without comparison in English literature. No English novelist has ever written a tragic novel of the stature of Dostoyevsky's *Crime and Punishment,* nor of the symbolic depth of *Moby Dick.* Again, Flaubert, the nineteenth-century French novelist, was not rivalled in his brilliantly analytic portrait of the discontented, aspiring Emma Bovary in *Madame Bovary* until James Joyce in the twentieth century. These novels, and others, have a strength which is generally lacking from the English 'tragic' or 'serious' novel – they are built round a main character of great force, to whom most of the events of the novel relate.

In most English novels, especially of the eighteenth and nineteenth centuries, the strength of the form is its social comprehensiveness. Dickens is an obvious case in point, but it was no less true of Thackeray, Trollope and George Eliot. George Eliot, whose real name was Mary Ann Evans, was the first to invest the English novel with high moral seriousness, mirroring the intellectual as well as the social life of her times.

Middlemarch, written in 1872, is her masterpiece, and contains her most subtly drawn heroine, Dorothea Brooke. Dorothea is invested with the passion to serve, to put her intellect, which is considerable, at the service of some great work. This ideal leads to self-deception; it makes her blind to other, less intellectual needs. Here is George Eliot's description of her temperament:

'All Dorothea's passion was transfused through a mind struggling towards an

ideal life; the radiance of her transfigured girlhood fell on the first object that came within its level. The impetus with which inclination became resolution was heightened by those little events of the day which had aroused her discontent with the actual conditions of her life.' This 'first object that came within its level' was Mr Casaubon, an elderly rector engaged in a long and cumbersome work of mythology: ignoring his dry, loveless nature, Dorothea marries him, inspired by what she imagines is the greatness of his intellect. But this unwise and immature choice does not lead to tragedy; though bitterly undeceived about her husband's character and intellect, Dorothea goes on to marry a much younger man whom she really loves. This is far from being a case of a happy ending for the sake of it. The novelist is illustrating a point, giving flesh to an idea: the idea that unselfish devotion to an ideal is unwise unless the person is fully mature and fully self-conscious, besides being certain that the ideal is worth while.

So tragedy is averted, in this case because it is subordinated to the moral and intellectual structure. George Eliot has been called the first 'modern' novelist for this very reason: where previous novelists wrote primarily for entertainment, she wrote her novels as an extension of her intellectual life.

The school of 'social realist' novels developed in America in the late nineteenth century; its most remarkable practitioners were Frank Norris, Theodore Dreiser, and the father of the school, William Dean Howells. These novelists, and other like them, were above all sensitive to the pressures of American life upon the individual. They wrote almost exclusively of characters who in one form or another were victims of American society, and though they did not escape from sentimentality on occasion, their novels were close enough to the truth to shock. Howells expressed the creed of the realist-novelist as an observer of Man who 'will not desire to look upon his heroic or occasional lapses, but will seek him in his habitual moods of vacancy and tiresomeness'.

In his most famous novel *The Rise of Silas Lapham* (1885), Howells portrays the attempt of a newly rich millionaire to break into exclusive Boston society; attendant on his social failure is his financial ruin. Lapham is not ground down by this misfortune. He revives enough to start a modest little business, having obviously learned much from his failures. But though Howells felt impelled to leave us with a happy ending, the indictment against society is strong. Here is Lapham, ruined, trying to make up his mind to sell his beautiful house, symbol of everything most precious to him:

'Now that it had come to the point, it did not seem to him that he could part with the house. So much of his hope for himself and his children had gone into it that the thought of selling it made him tremulous and sick . . . the long procession of lamps on the street was flaring in the clear red of the sunset towards which it marched, and Lapham, with a lump in his throat, stopped in front of his house, and looked at their multitude. They were not merely part of the landscape, they were part of his pride and glory, his success, his triumphant life's work, which was fading into failure in his helpless hands.'

The novelist's world

It is the potential tragedy, not just of Lapham, but of all society that it sees everything, every endeavour including love, in terms of money. It is this truth, most clearly revealed in the earliest days of America's prosperity, which gives *The Rise of Silas Lapham* and other novels of its genre their authority.

Several different conceptions of the tragedy that besets human life are apparent in the novel. Dickens believed that people suffer because society ignores their needs; Hardy that they struggle in vain to attain their ideals in the face of a hostile universe; Richardson that tragedy resides within the tragic hero or heroine. It is the novelist's skill in creating his world and the people in it that makes us accept the truth of his vision.

1 One of Dalziel's engravings to Dickens' *Hard Times,* a novel which describes the retribution falling on a father who has stunted and repressed his children.

2 Captain Ahab, hero of Melville's *Moby Dick,* has sworn vengeance on his personal enemy the white whale. The novel is an epic account of his search and the whale's final triumph.

3 The working of an indifferent fate is evoked in Hardy's *Tess of the D'Urbervilles,* the story of a victim of circumstances who is driven to an act which results in her death.

The comic novel

Tom Jones and Mr Pickwick, two well-loved characters separated by a century, are part of a tradition in the English novel which views the world and its inhabitants in a predominantly comic way.

'The battle royal in the churchyard', an illustration to Henry Fielding's novel *Tom Jones*, the plot of which is formed by the many comic exploits of the foundling Tom.

WHAT IS a novel? There have been various attempts to define it, but the organism eludes easy definition; indeed it is an elastic form that expands when each new major novel appears. What seems to be generally true is that a novel, by and large, tells a story, that it portrays a world created by the novelist, peopled by characters which are children of his imagination. Through the world he creates the writer is expressing his views about the nature of human life.

Knavish or rascally

Some novelists speak in their own person, commenting on their characters, telling the reader what to think of them, and so on. Others remain anonymous, letting the characters speak for themselves.

Life is a mixture of comedy and tragedy. Depending on his personal view, the novelist may create a universe which is predominately comic although the comedy may serve a serious purpose, such as satire. The original comic novel was the picaresque novel. 'Picaresque' is derived from a Spanish word, *picaresco*, meaning knavish or rascally, and the original meaning of the English word was that kind of literature which dealt with the adventures of a clever rascal. However, the application is now wider – it refers to the novel with a central hero (often something of a rogue, but usually with more than enough redeeming features) who goes travelling and has all sorts of adventures before settling down happily, usually with a wife. The plot is generally very thin – it depends entirely upon the movements of the main character for its

coherence, and is not much more than a collection of short stories with a single hero.

Many of the early English novels are wholly or partly picaresque in structure. Daniel Defoe wrote two: *Colonel Jack* and *Moll Flanders* (both 1722). Moll Flanders, the heroine of the second novel, is a young woman of easy virtue married to three or four husbands at once (one of whom turns out to be her brother). Of unquenchable good spirits, she moves through a series of adventures with endearing common sense and great vitality.

The most famous picaresque novel is the Spanish *Don Quixote*, written by Cervantes as a burlesque of the romance of chivalry common at that time and translated into English in 1612. More influential, though now less popular, was the French writer Le Sage's *Gil Blas*

Don Quixote, hero of the novel by Cervantes, imagines himself to be a knight and roams the world in search of adventure, accompanied by his faithful 'squire' Sancho Panza.

(1712). This work greatly influenced the Scots novelist Tobias Smollett (he translated *Gil Blas* into English), whose best novels, *Roderick Random* (1748) and *Humphrey Clinker* (1771) are examples of the picaresque form.

Roderick Random demonstrates both the attraction and the great weakness of this form. The hero, largely an autobiographical creation, is a young Scot who, deprived of his patrimony, wanders down to London, is press-ganged into the navy as a surgeon's mate and finally returns to Scotland and his rightful wealth. The incidents move quickly and are often exciting, and there are many

comic scenes. But, precisely because of the nature of the plot, the novelist does not leave himself time to draw his characters very fully or to explore their motivations.

Gradually the form was abandoned and the novel of character began to take its place. Although this second form may owe elements to the fast pace of the picaresque, it preferred to linger on character delineation and on the creation of a tighter plot structure. A modern novel showed that the mode may be successfully revived. This is John Barth's *The Sot-Weed Factor* (1960). It is significant, however, that Barth creates a hero, Ebeneezer Cooke, who is an early eighteenth-century Englishman, and adopts an eighteenth-century prose style.

The 'mainstream' tradition of the novel in general and the comic novel in particular was created in England largely by the work of two eighteenth-century novelists, Samuel Richardson and Henry Fielding. Richardson has the greatest claim to authorship of the first English novel – *Pamela*, published in 1740. It concerns a serving girl's efforts to retain her chastity against all the assaults of her employer, Mr B, who finally recognizes her worth and marries her. The story is maudlin and often silly; Pamela is vain and greedy, using her virtue to get what she wants, a rich match.

Battle of wits

Yet even within the middle-class society that is Richardson's world, there is excitement, tension and delicate characterization. The comedy lies in the constant battle of wits between Pamela and Mr B, and in Pamela's manner of recounting her escapades. The novel is written entirely in the form of letters (a device Richardson was to use again in his tragic novel, *Clarissa*).

This comedy is subtle and rarely overtly funny – Richardson lacks the vigour to create a truly comic world. His fellow novelist/pioneer, Henry Fielding, amply remedied the deficiency. Fielding was contemptuous of Richardson's moralizing tone and pettiness; he satirized *Pamela* in a parody *An Apology for the Life of Mrs Shamela Andrews* and in his first novel, *Joseph Andrews* (1742).

Joseph, the hero, is, like Pamela, fanatically concerned to preserve his chastity. Since he is male, however, this struggle takes on a large element of the ridiculous, and by implication makes Pamela ridiculous too. More important than the satire, however, is the comic creation of Parson Adams, the magnificently benevolent, utterly unworldly curate. His goodness is founded on his lack of worldly wisdom, a quality which he advises Joseph against possessing: 'I prefer a private school, where boys may be kept together in innocence and ignorance.'

Parson Adams is as satisfying a comic creation as there is to be found in the English novel. He can take his place with any of Dickens's best comic creations, and indeed resembles Dickens's Mr Pickwick. In Fielding's best-known novel, *Tom Jones*, there is no single figure so

rich, though there are a larger number of characters who are comic in their own ways – the tutors Thwackum and Square, the hard-drinking Squire Western and the fashionable and sensual Lady Bellaston.

Richardson and Fielding, these two antipathetic fathers of the English novel, were to point the way to successors far more distinguished than they. In the Richardson domestic-comic mode is Jane Austen: and in the Fielding epic-comic style is Charles Dickens.

Jane Austen (1775–1817) was the daughter of a country parson. She wrote only six novels – *Northanger Abbey, Sense and Sensibility, Pride and Prejudice,* *Mansfield Park, Emma* and *Persuasion.* Only one, *Mansfield Park*, was of any considerable length. But then, she never considered herself a writer: she would scribble at her books in intervals of conversation, or in a locked bedroom; they were published anonymously, and few knew of her until after her death. And the reasonableness and modesty which mark her approach to her writing are to be found everywhere in her work itself.

What makes these novels, especially *Pride and Prejudice* and *Emma* such great comic masterpieces is the ironic wit that informs them. Here is the famous

1–5 Jane Austen's novel *Emma* traces the growth to maturity of her self-satisfied heroine. Emma's world, and indeed the world of all this author's novels, is that of the English gentry, but within these self-imposed limits is ample scope for Jane Austen's subtle descriptions of human relationships and her delightful exposure of folly and humbug.

6 Jim Hawkins makes friends with the villainous Long John Silver and his buccaneers aboard Squire Trelawney's ship in Robert Louis Stevenson's romance *Treasure Island*.

7 Richardson's novel *Pamela* is told in the form of letters and concerns a young maidservant who protects her honour against the advances of her mistress's son Mr B.

was the beginning and end of Sir Walter Elliot's character; vanity of person and situation. He had been remarkably handsome in his youth; and at fifty-four, was still a very fine man. Few women could think more of their personal appearance than he did; nor could the valet of any new-made lord be more delighted with the place he held in society. He considered the blessing of beauty as inferior only to the blessing of a baronetcy; and the Sir Walter Elliot who united these gifts was the constant object of his warmest respect and devotion.'

Compare that description with this: 'My sister, Mrs Joe, with black hair and eyes, had such a prevailing redness of skin, that I sometimes used to wonder whether it was possible she washed herself with a nutmeg grater instead of soap. She was tall and bony, and almost always wore a coarse apron, fastened over her figure behind with two loops, and having a square impregnable bib in front, that was stuck full of pins and needles. She made it a powerful merit in herself, and strong reproach against Joe, that she wore this apron so much.'

This description is taken from Charles Dickens' *Great Expectations*; it reveals Dickens' comic style to be very different from Jane Austen's. Where the latter is

opening to *Pride and Prejudice*: 'It is a truth universally acknowledged, that a single man in possession of a good fortune must be in want of a wife.'

It is worth while looking at this sentence closely to see exactly where the comedy lies, for it contains in microcosm the key to Jane Austen's art. The sentence begins in grand style: 'It is a truth universally acknowledged . . .' the reader expects something equally grand to follow, but instead – a piece of domestic lore, the kind of thing a mother in Jane Austen's time (and even now) with four daughters on her hands would be expected to treasure as a maxim. Naturally, the anti-climax

here is intended; but in another sense, it is not an anti-climax, for the world of scheming mothers, eligible men and unmarried girls is Jane Austen's world, and she never once ventures outside it. No writer has been more conscious of marriage as a social contract; but it is part of her attractiveness as a writer that she demands a truly good marriage to be founded primarily on love.

Narrow as her world was, it contained ample room for satire and wit. Though she was subject to the unquestioned social prejudices of her time, she mocks pretension unmercifully. Sir Walter Elliot in *Persuasion* is her biggest snob: 'Vanity

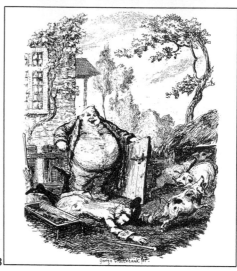

1 On a visit to Dingley Dell, home of the hospitable Mr Wardle, Mr Pickwick in Dickens's novel *The Pickwick Papers* indulges in an excursion on to the ice, with disastrous results.

2 Random and his old school friend Strap are terrified by what they take to be a sinister apparition – an enormous raven with its feet tied together – in Smollett's novel *Roderick Random*.

3 *Joseph Andrews* was Fielding's parody of Richardson's *Pamela*. Mr Trulliber, mistaking the identity of Parson Adams, shows him into a pigsty, where the parson is flattened by a hog.

restrained, Dickens is exaggerated – notice the grotesque image of a woman cleaning herself with a nutmeg grater. Jane Austen gives a fairly complete character in a few words – Dickens treats only a few salient features of Mrs Joe. Yet we still manage to form a vivid, perhaps a more vivid, picture of the Dickens creation. We assume, as we are meant to, that these few traits are indicative of the whole character of the woman described. She is in fact a nagging, domineering housewife, and though Dickens never says so in so many words we gather it very clearly from the paragraph quoted.

Again, where Jane Austen confines herself to one section of society, the country gentry, Dickens sweeps through all society, his purpose to expose the evils he saw there. No novelist in the world is so rich in inventiveness; above all, it is his comic creations that are best remembered and loved. One of his earliest works, *Pickwick Papers*, contains many of them – Mr Pickwick himself, Mr Tupman, Mr Snodgrass, Jingle and Sam Weller. Though the least accomplished of all his works in structure, it demonstrates that keen sense of the ridiculous which he was never to lose.

Dickens's novels are a mixture of tragedy and comedy, though with Dickens the tragic is more often melodrama. The

very eccentricity of his characters, the source of much of the humour, is indicative of an underlying tragedy. For their eccentricity often cuts them off from other human beings, isolates them within their self-created world. Although we smile at the almost grotesque figure of Mrs Joe, the grim loveless life she has forced herself to lead can evoke, too, a sympathetic understanding.

Good rewarded, evil punished

No other Victorian novelist has the comic inventiveness of Dickens. William Thackeray's *Vanity Fair* is a great work of satire, and though confused in its ending, reveals much of the pretensions of nineteenth-century England. But it is never comic; its tone is too serious for that. Seriousness is a constant factor in Victorian novels. Although many of them have a 'happy' ending, it is not the happy ending of comedy, with the final resolution of all the threads of the entangled plot, but rather the morally just ending, with the good getting their rewards and the evil punished.

One kind of novel, not really comic but closer to it than to any other mode, is the adventure romance novel. Two Scots novelists, Sir Walter Scott and Robert Louis Stevenson were the best practitioners of this kind of writing, the

first active in the early part of the nineteenth century, and the second in the latter. Neither writer has survived well, though Stevenson's *Kidnapped* is still widely read. Scott, who was the most popular novelist of his century, has survived largely for his comic or 'low-life' characters, like Mr Saddletree of *The Heart of Midlothian*. The humour of this figure and others like him is the folk humour of the Scots peasant, unaffected, quick to notice pretensions and a little ridiculous himself.

In the twentieth century, it becomes more and more difficult to speak of the 'comic novel' as a separate entity. The mode flourished in the eighteenth and nineteenth centuries, but in our century, the novel, like all forms of art, has undergone a profound change. The comic world of Jane Austen is complete. It is a creation of the novelist, who views her characters with detachment and manipulates their actions. By contrast, in this century the novel often seems to pass from the novelist's control to that of his characters; the writer 'knows' no more than his characters, or else he insists on the impossibility of knowing all about an event. For this reason many novels are neither 'comic' nor 'tragic' in the accepted sense but are concerned with the muddle and mixture of both that make up human life.

Once upon a time...

Children's stories are traditionally full of adventure, magic and make-believe. Since the last century, more and more books have been written and illustrated especially to appeal to a child.

CHILDREN WERE PUT ON EARTH, not to live happily but to prepare their souls for a joyful death. With this precept in mind it is hardly surprising that the literature for young people before the nineteenth century consisted almost entirely of moral tales and dire warnings. The only welcome exception was the *Orbis Sensualium* by Comenius, published in 1658. This was a Latin primer and, although educational, was simply written and illustrated with wood-engravings.

Fortunately for children of the time, the oral tradition of folklore and fairy stories was thriving. It is impossible to say how and where fairy stories originated. One of the oldest collections, *The Thousand and One Nights*, came from Arabia to Europe about the middle of the sixteenth century and later collections appeared in other countries. In Italy Giovan Francesco Straparola's *Piacevoli notti* was published in 1550 and *Das Erdkuhlein* appeared in Strasbourg about 1560. The same fairy stories appear over and over again in the literature of different countries; Cinderella, for example, appears in many languages, slightly changed in detail but substantially the same.

The one thing fairy stories have in common is the marvellous combination of magic, reality, good and evil. Good almost always triumphs over evil, and so the prince awakens Sleeping Beauty, and Snow White thwarts the attempts of her wicked stepmother to murder her. Yet none of these stories was intended primarily for children. They had to wait until Charles Perrault published his fairy stories in France in 1697. Although including many of the traditional tales, they were written in a simple, straightforward style so that children were more easily able to enjoy them. This was quite a new departure and remained a landmark until 1812. In this year the brothers Grimm published their *Kindermarchen* and in 1836 Hans Christian Andersen published his enchanting stories.

With the invention of printing in the fifteenth century many popular stories, such as Aesop's *Fables,* the legends of Robin Hood and Chaucer's *Canterbury Tales* had become available in book form. But they were far too precious for children, who had to be content with chapbooks. Crudely printed on inferior paper, chapbooks contained adventure stories, legends and the perennial fairy tales, and were bought from the pedlar on his rounds. They were the only books for children in English until 1767, when John Newbery published his *Little Pretty Pocketbook* and continued to produce small, attractively bound books especially for children.

Until the nineteenth century brought an increase of literacy, books were generally shared by adults and children. Many that have become children's classics were, in fact, written for adults; *Gulliver's Travels* by Jonathan Swift, *Pilgrim's Progress* by John Bunyan and, most famous of all, *Robinson Crusoe* by Daniel Defoe. This magnificent adventure story embodies everything dear to the heart of the eighteenth-century reader: adventure, mystery and, underneath, a strong moral attitude. It became popular immediately and engendered a whole collection of Robinson-type stories, the best of which is *The Swiss Family Robinson.*

1 *Gay-neck, the Story of a Pigeon* by Dhan Gopal Mukerji won an American award for children's literature. Illustrated with bold, lino-cut designs, it describes Gay-neck's adventures in India, the Himalayas and France.
2 Alice's adventure with the Duchess, the baby who turned into a pig and the celebrated Cheshire Cat was only a small part of her amazing travels in Wonderland.
3 *The Waterbabies* is a fairy story by Charles Kingsley about a little boy who escapes from his hard life as a chimney sweep when he falls into the river and becomes a waterbaby.

During the nineteenth century books were written with children in mind by people who thought it important that children should enjoy reading and like books. Moreover, they were written about subjects calculated to appeal to children. Naturally certain influences persisted. The emphasis on moral rectitude was still there and writers like Charlotte Yonge and Mrs Craik described the awful results of children's misbehaviour. But in the same century Maria Edgeworth wrote many stories for children embodying the liberalizing influence of the French philosopher Jean-Jacques Rousseau who, incidentally, considered *Robinson Crusoe* one of the best books ever written and based much of his teaching on the ideas it contains.

The social conditions of the nineteenth century induced many writers, notably Charles Dickens, to attack the exploitation of children in the mines and factories. *Oliver Twist* brings to the attention the

1 An illustration from 'The Red Shoes'. Many of Hans Andersen's fairy stories are based on old folk tales, written in a vigorous, concrete style about people, animals and birds.
2 Jack the Giant Killer is the hero of an English

fairy tale whose achievements are due as much to native wit and invention as to his magic sword, shoes and coat of invisibility.
3 'L is for lion' runs the legend for this imaginatively drawn animal in John Burningham's *ABC*.

4 Mole and Ratty in the Wild Wood, a 1969 illustration by E. H. Sheppard for *The Wind in the Willows*. The author Kenneth Grahame himself possessed that quality which he so prized in children — the sense of 'the wonder of the world'.
5 Beatrix Potter's stories, like *The Tailor of Gloucester* illustrated here, were a landmark in young children's literature. *Peter Rabbit,* the first, was born in a letter to a sick child.
6 'Beauty and the Beast' has appeared in many versions in many lands. Basically it tells the story of a girl who, by her fortitude, releases a prince from his imprisonment in beast form.

conditions prevailing in the slums and workhouses and the ease with which children could be tempted into crime. Dickens did not write for children but children read his books as eagerly as adults. One book of this type was written especially for children, however. *The Waterbabies* by Charles Kingsley exposed the terrible plight of the small boys who were sold into slavery as chimney sweeps. Written as a fairy tale in 1863, it informed children of the conditions suffered by the poor at that time. Also in this genre, in America, was Harriet Beecher Stowe's *Uncle Tom's Cabin,* with its plea for the liberation of slaves, and the various stories of the 'Wild West' written by Fenimore Cooper and Karl May, with their sympathy for the plight of the Indians.

Of far more lasting importance is a vein of pure nonsense and fantasy. Particularly typical of English literature for children, it produced one of the most popular books of all – Lewis Carroll's *Alice in Wonderland.*

Published in 1865 this delightful book developed from stories told by the Reverend Charles Dodgson (Lewis Carroll's real name) to the three small daughters of the Dean of Christ Church in Oxford. The adventure of Alice underground and her further adventure, *Through the Looking Glass,* have been translated into almost every language and have become part of every child's library. It is arguable that the book is not entirely suitable for children; it has an element of horror and of cruelty, but the sheer unreality of it all makes it less frightening. Since Lewis Carroll, numerous books have been published on the same lines although none has attained the popularity of *Alice.* One of the closest imitators was G.E. Farrow, who invented Wallypug Land ruled by the Wallypug. Rudyard Kipling's *Just-So*

Stories are also in the same vein, in that they are complete fantasy with a sharply realistic background. The Elephant Child's story of how he got his nose, or the story of how the camel got his hump are purely fantastic but at the same time, from a child's point of view, very possible. *The Chronicles of Narnia,* a series of books by C.S. Lewis are even more Alice-like. In the *Magician's Nephew* can be found the starting point of the series, the mysterious disappearance of the children, the meetings with extraordinary creatures both in human and in animal form, possessing a persistent chain of logic in conversation and event. Fantasy has always been one of the strongest elements in English children's literature.

Animals in fairy stories have been popular ever since the first book containing simplified versions of Aesop's Fables in English appeared in 1692. All of the animal characters so beloved today are really derived from the fascinating menagerie of Aesop. A child's mind is particularly ready to accept the possibility of animals using human speech and leading lives greatly resembling those led by children – indeed, to a child there is no reason why not.

In Beatrix Potter's well-loved stories for small children the animals lead a very similar life to that of human beings and it is possibly this which has made the books so popular. The first one to be published was *Peter Rabbit,* in 1901, who originally made his appearance in a letter to a sick child. From this developed a whole series of tales and characters. Each book was produced with great care and attention to detail, and it was thought particularly important that a new picture should appear every time the page was turned. Even after publication, alterations were made to the text and pictures if Miss Potter felt that either might cause a child

distress. There have been many imitations but none has remained so consistently popular and Beatrix Potter's books are now translated into most European languages.

Another 'animal' classic, this time for older children is *The Wind in the Willows* by Kenneth Grahame, which was published in 1908. Again, the animals in this story have human attributes but much more adult emotions and experiences than in the stories of Beatrix Potter. To begin with, the animals themselves are adult, and Mole's nostalgia for his home, Rat's keen enjoyment of the pleasures of good food and comfortable living, Toad's envy and jealous acquisition of a motor-car are all adult emotions. Nevertheless, the story itself is intended for children and much of it is child-like. Can one imagine a child who would not be delighted to live in Rat's neat little hole in the river-bank or visit Badger's vast underground palace with its cosy kitchen, or be terrified at night in the Wild Wood as was Mole? The popularity of *The Wind in the Willows* has probably only been equalled in this century by the Winnie-the-Pooh stories of A.A. Milne and the work of Enid Blyton.

Adventure stories

During this century many adventure stories have been written just for children. Particularly notable is Robert Louis Stevenson's *Treasure Island.* Stemming from the *Robinson Crusoe* tradition was Frederick Marryat's *Masterman Ready,* published in 1841 and, in a class of their own, are the books of Jules Verne with their mixture of science-fiction and fact.

Very popular with English children in the nineteenth century and in our own have been the stories of everyday life at school and at home. The school stories all proceeded along similar lines, with a school bully, a naughty boy with a good heart, a 'goody-goody', a 'swot' and so on.

1 John Bunyan wrote *The Pilgrim's Progress* for adult readers, but since its publication in 1678 it has been widely read by children, who appreciate its simple, vivid style.
2 *Treasure Island,* by R. L. Stevenson, appeared in book form in 1883. Its stirring account of buried treasure and wicked pirates has made it a favourite adventure story.

3 Puss in Boots, the magic cat who eventually marries his master to a king's daughter, is a well-loved folk character whose story was reinterpreted by the Brothers Grimm.
4 'The Adventures of Caliph Haroun Alras-chid' is one of the tales with which Scheherazade regales the sultan in *The Thousand and One Nights,* one of the oldest collections of stories.

The stories were usually about breaking bounds, or a mysterious stranger or someone caught cheating at exams, and always ended happily. The most famous of all is perhaps *Tom Brown's Schooldays* by Thomas Hughes or, for girls, the *Katie* series by Susan Coolidge, originally first published in America. The stories of home were considerably more imaginative and varied – since the children had greater freedom, there were many more opportunities for adventure. Louisa May Alcott's books are probably the most internationally known and loved of all. *Little Women,* based on the author's own childhood and family, is the story of four girls, their mother and the handsome young man next-door. Reading of their everyday trials and tribulations – Meg's vanity, Amy's nose, Jo's temper – children realize that people everywhere have the same problems, the same pleasures and the same temptations.

With the improved printing techniques evolved by the technological age children's books became more adventurous in their use of colour. The earliest picture books that a child has are A.B.C.s and nursery rhymes. From the rather faded charm of earlier book illustrators such as Kate Greenaway, with her delicate lines and pale shades, and Walter Crane, whose style was much heavier and brightly coloured, these illustrations have developed into the glorious masses of colour used by Brian Wildsmith and John Burningham, two of the most popular of contemporary book illustrators in Britain.

Young children are not especially gentle with books; to cope with this problem books for the very young used to be made of cloth, sewn at the spine and usually consisting of a single object printed on each page with its name in large, clear letters, the aim being to educate as well as amuse. Books were also printed on very thick cardboard, glued at the spine, having a large coloured picture on each page, often with a small simple text. For the slightly older child, books were printed in large, clear type with line drawings in two or three colours.

Photographs are limiting

The biggest change came in the 1930s with the improvement of photographic techniques. Now books could be illustrated with photographs of events and places, which was particularly useful in textbooks. Many of these photographic books were extremely beautiful. *The Red Balloon,* for example, published in 1956, told the story of a balloon's adventures in France. Although very useful to accompany a factual account, photographs tend to limit the child's use of his imagination. Lately there has been a swing away from books illustrated by photographs to the more rewarding coloured pictures.

Outstanding in twentieth-century literature of fantasy are Professor J. J. Tolkien's books about the Hobbits. Written origin-ally for his own children, *The Hobbit* has become popular with many people of all ages. Its sequel, *The Lord of the Rings,* is a more adult and more ambitious book. Professor Tolkien has invented whole races of beings each with its own language, history, legends and culture. Although possessing strong Nordic overtones, the stories and mythology are his own.

Animal stories continue in our century. Probably the best known are the *Dr Dolittle* stories by Hugh Lofting, but there are many others. The closest in spirit to *The Wind in the Willows* are the delightful stories by Will Nickless, who has invented a whole village full of animals living their lives as human beings and with an excellent sense of humour – an attribute which is rare in children's books.

Two new types of story have appeared in Britain. These are books which humanize mechanical objects, such as the Reverend Awdry's *Little Red Engine* books and Val Biro's adventure stories of the little car, Gumdrop. Books about adventure in space follow in the footsteps of H. G. Wells and Jules Verne but must now be as scientifically accurate as possible as well as imaginatively varied.

Children now have a much wider choice of reading matter, some of it good, some bad and much mediocre. All over the world, public libraries are busier than ever before; parents buy more books for their children and these, especially paperbacks, are so reasonably priced that children can build up libraries of their own. In this way they grow into adults for whom reading is an enjoyable and essential part of life.

Tales of fantasy and fright

Most people experience a thrill of terror when confronted with tales of the supernatural and bizarre. For a while they accept that beyond their own world exists another less easily explained.

MOST PEOPLE have woken with a start from a dream of such astonishing clarity that they feel that somehow they, or the world of reality, has changed. This strange feeling can persist in a subtle and disturbing manner for some hours, until dispelled by the ordinary routine of everyday life.

In spite of what we know now about the causes and mechanics of dreaming, a strong impression may remain that our dreams have come from outside ourselves, sent by a supernatural agency as a glimpse into a supernatural world.

Anyone who has dreamt fantastically, with the vivid realism of unreality, has had his own experience of that world of the mind that the writer of bizarre and imaginative fiction cultivates. Most writers of fiction build a world where their characters appear to take on realistic lives of their own; the imaginative and fantastic writer, too, builds his world in this way, but he goes further, for the scope of his subject is outside the normal world. He takes just one more step, but, having taken it, the possibilities of fantasy are boundless. And this creates problems, because the flow of imagination, like that of the dream, feeds upon itself and leads the writer on in such a way that unless he can provide himself with a disciplined framework he is led astray by his own imagination into confusion. Often a work of fantasy begins with a well built and original idea which gradually degenerates, often collapsing into a chaotic ending full of rapidly moving and hastily conceived incident.

Appalling tortures

The imaginative work has an origin in common with the myth and fairy tale, but an essential distinction must be made. The 'horror' tale has a self-consciousness which is lacking in folklore, but which is an essential part of the literary imagination. Dante in his *Inferno* gets close to the modern imagination when he attempts to describe the appalling tortures of souls in torment. Later Milton, in *Paradise Lost*, approaches still closer in his descriptions of Hell and Pandemonium, Satan's empire and its capital city. Here, by means of simile, implied and actual dimensions, he creates an idea of space and size with the precision of an explorer describing a new world in a manner never attempted before in fiction. What influenced Milton's dimensions was the discovery that the Earth and the moon are spheres in space, and that the planets and stars are not twinkling lights on concentric crystal spheres, but solid bodies in infinite space.

Like science fiction, its close cousin, fantastic literature is really born of scientific discovery. The voyages of exploration

1 Wild, rocky landscapes fill the canvases of Italian painter Salvator Rosa, whose liking for 'horrid' scenery was echoed in Mrs Radcliffe's novel *The Mysteries of Udolpho*.
2 Frederick March in a film version of R. L. Stevenson's *The Strange Case of Dr Jekyll and*

Mr Hyde, where a man possesses two personalities, gradually succumbing to the evil one.
3 The man who changes into a wolf when the full moon shines is a folk character who has gained renewed popularity in films: Lon Chaney Jr. plays the werewolf in *The Wolf Man*.

and accounts of strange lands, discoveries in astronomy and optics, the world of the microscope and telescope, early industrial machines, iron furnaces and blacksmiths' forges, the steam engine, fire and smoke and noise together, all fed the imagination of the novelist and poet. Some hint of this influence is given in accounts of mild schizophrenia, an abnormal condition where the victim is often under the illusion that he is being persecuted by sinister influences; the voices that he hears are in reality those of his unconscious mind. In the Middle Ages he would have described himself as bewitched. But in the seventeenth century there was an astonishing number of cases where people claimed that they were being influenced by mirrors or lenses. Dramatists made use of this device:

John Webster in *The White Devil* used a mirror which could show scenes at a distance – not by magic, but by science.

Later the voices from the unconscious mind were to be attributed to the newly electrical 'fluids', as they were thought to be. When telegraph wires were first put up people attributed the voices in their heads to these; then followed X-rays, then quite rapidly, wireless broadcasting, television and atomic power.

Men, normal as well as unbalanced, often want to believe in powers outside themselves. At one level it leads them to speculate on philosophy and religion; at another to a demand for tales of the supernatural.

Such tales followed quite soon on the invention of the novel itself. When Mrs

Industrial Revolution. Frankenstein possesses the world's greatest power, the ability to create life, but he only fashions a monster. And men, apparently given the ability to solve any problem by means of applied science and the machine, created instead a hell on earth, the nineteenth-century industrial town, where men became the slaves of machines, in turn giving birth to a violent proletarian monster.

Indeed, the terrors of the Gothick novel seemed tame by comparison with the industrial horrors portrayed by Mrs Gaskell, Disraeli and, above all, Charles Dickens. His underworld grotesques, epitomized by the monstrous dwarf Quilp, are portrayed with such insight and relish that in comparison his attempts to write of the conventional supernatural are pale ghosts indeed.

The growing interest in psychology revived the Gothick novel. Joseph Sheridan Le Fanu (1841–73), the Irish master of the mysterious and supernatural, never made the mistake of explaining his horrors, but by implication actually produced nervous sympathetic responses in his reader. In

Radcliffe (1764–1823) wrote her novel *The Mysteries of Udolpho* (1794), she was not spinning a fireside fairy story or folk-tale of ghosts and witchcraft, but writing for a new leisured and literate public which was beginning to demand romantic entertainment. Her work reflects the popular painting of the time, and she was described as the Salvator Rosa of British novelists. Like Rosa, she – and her readers, for she was extremely popular – adored to be frightened by 'horrid' scenery: mountains that dwarfed men who crawled in their valleys, wild and rugged rocky crags supporting twisted and blasted trees, vertiginous precipices and dark, gloomy ravines rushing with wild torrents of water. To this she added passion, suitably removed from realistic possibility into settings beyond the experience of her readers, so complying with the delicate standards of her day.

Matricide and incest

Matthew Gregory 'Monk' Lewis (1775–1818) wrote his novel *Ambrosis, or the Monk* (1795) in only ten weeks. This, too, is a story of the supernatural but, unlike Mrs Radcliffe, he was rather more explicit in his scenes of passion and found himself threatened with prosecution. He followed his success with *Tales of Terror* (1799) and *Tales of Wonder* (1801). *Crazy Jane* (1797) is a poetic transcription of an encounter with a maniac, with material gathered from visits to asylums. The plot of *The Monk* is complex, of tales within tales, complicated by matricide and incest. Lewis dwelt with relish on scenes of death, moral corruption and decay. The influence of the Marquis de Sade is strong; what is remarkable is that the novel was written by a boy of 20.

Mary Shelley's (1797–1851) *Frankenstein* has had perhaps more influence than any other 'horror' tale; the late Boris Karloff's name became synonymous with many successive portrayals of the man-made monster on film: in *Frankenstein*;

The Son of Frankenstein; *The Bride of Frankenstein*; *Frankenstein meets Dracula*; *Frankenstein meets the Wolf Man* and so on. Frankenstein is an aristocratic student of science who dabbles in magic and mystery. He builds a chemical laboratory, robs graves and dissecting rooms, and after incredible labours harnesses electricity to create a man, a gigantic monster eight feet high. The monster, a tragic figure, is shunned because of his ugliness and driven to crime. He murders Frankenstein's closest friend, and strangles his wife. The climax of the story is reached when Frankenstein pursues the monster into Arctic regions; Frankenstein perishes in the cold, but the monster vanishes, searching for death and release, but ready, we feel, to reappear.

The story is an allegory, born of the new

1 *Drawing the Retorts at the Great Gas Light Establishment, Brick Lane.* The terrors of the Gothick novel paled by comparison with the industrial horrors portrayed by Mrs Gaskell, Disraeli and Dickens.

2 One of the most popular subjects for films has always been the story of Frankenstein by Mary Shelley, a fable about a scientist who discovers the means of creating life.

3 Arthur Rackham's illustration to 'The Fall of the House of Usher' by Edgar Allan Poe, a morbid tale of sickness, unnatural attachment and premature burial.

4 Bizarre images in dreams can impress us with a sense of the supernatural. Delvaux's *Venus Asleep* juxtaposes female nudes with clothed figures in incongruous, dream-like settings.

5 Magritte's *Les Epaves de l'Ombre.* The surrealist imagination sees relationships which do not exist in the 'real' world.

3

4

5

this, and in his understanding and interpretation of dreams, he shows an intuitive understanding of psychology remarkable for a pre-Freudian amateur. *In a Glass Darkly* (1872) and *Uncle Silas* (1864) are examples of Le Fanu at his best, and his elaborate prose is worth the untangling.

Robert Louis Stevenson's *The Strange Case of Dr Jekyll and Mr Hyde* is another remarkable pre-Freudian work. Its theme is a man's possession of two separate personalities and his gradual succumbing to the evil one. The story's title became a synonym for cases of dual character. By contrast with Le Fanu, Stevenson's prose is simple and direct. He was a master at implying horror and violence by the use of the most unsensational language.

A double life

A real-life character and writer leading a double life was Lewis Carroll, whose real name was C. L. Dodgson. He lectured in mathematics at Oxford and wrote books for children. The 'Alice' books can hardly be classed as fairy tales; they are undoubtedly fantastic fiction, and have undertones of nightmare without horror. It is Carroll's application of logic under bizarre conditions that produces a unique quality, lifting his work out of the tales-for-children class. His lesser known work, *Sylvie and Bruno,* contains some of his finest parodies and some of the worst prose ever written, but what is most interesting to the modern reader is the constant slipping out of the scale and time of the everyday world into a mirror image that borders on that of mild insanity. Gradually the two elements become thoroughly confused.

It is worth noting in passing the suppressed violence, the bizarre and nightmare quality of Edward Lear's *Nonsense Poems*. In mild limerick form, and illustrated by Lear's own drawings, his victims of paranoia and weird physical deformities are the familiars of our own nightmares.

1 Bela Lugosi as the original film Dracula, the Transylvanian vampire whose popularity has never waned, although the novel by Bram Stoker is almost forgotten.

2 One of Piranesi's series of etchings and engravings entitled *Imaginary Prisons*. Such gloomy dungeons and horrific instruments of torture were paralleled in later tales of horror.

3 The Swiss-born painter and engraver Henry Fuseli excelled in strange, supernatural designs, best evidenced in *The Nightmare*.

For Edgar Allan Poe (1809–49) the nightmares were real. In an attempt to keep them at bay he took to alcohol and opium, and paradoxically increased their frequency and reality. His *Tales of Mystery and Imagination* vary from the personal experience of the nightmare in life – 'Buried Alive' expresses his own morbid fear – to the fantastic and Gothick in the 'Masque of the Red Death'. 'The Fall of the House of Usher' of the 1840s is a morbid story of sickness, unnatural attachment of brother and sister, of catalepsy and premature burial. Here the horror is implied rather than described, and is all the more effective.

The parallel with Oscar Wilde's *The Picture of Dorian Gray* is strong. Gray, a latter-day Dr Faustus, sells his soul to the Devil for eternal youth. While he gives himself up to pleasure his portrait ages and decays revealing his 'un-nameable debaucheries', while he remains forever young.

'Un-nameable debaucheries' are now out of fashion, and de Sade's mechanical catalogues of horror and torture have a new relevance, but whether the effect of Henry James's *The Turn of the Screw* (1898) would be increased by listing the schoolboy vices for which little Miles was expelled is debatable. The tension of the story lies in the fact that we are never certain whether the evil apparitions and their seduction of the children are real or figments of the governess's own imagination.

But probably the most famous, and least read, fantastic story of the turn of the century is Bram Stoker's *Dracula*. Stoker was secretary and business manager to the actor-manager Sir Henry Irving. He returned to folklore and witchcraft for his theme, but his novel of vampirism has an interesting combination of sadistic ingredients. The vampire imagery is bound up with bizarre eroticism, wealth, aristocratic power, the dream of the ability to fly, and physical immortality. Even when the evil Count is buried at a crossroads with a stake through his heart, we know instinctively that someone will remove the stake – and the horror will begin again. In fact, this vampiric resurrection has become another godsend to the twentieth-century cinema, rivalled only by the many appearances of Frankenstein's monster.

And in fact the *genre* of the Gothick novel and horror story has been transferred from print to film. For, since the turn of the century, the 'science' content of the fantastic story has understandably increased until it is the predominant theme. The stories of David Lindsay, a neglected writer of fantastic stories, are really early science fiction. His *Voyage to Arcturus*, an early novel of space travel, develops from the fantastic to the positively surrealist and, like so many good beginnings, collapses into wild confusion. H. G. Wells, too, balances between imaginative and pure science fiction. For a time he comes heavily down on the side of the latter, eventually to forsake both for realistic writing with a social message. Famous works in the field of science fiction are *The Time Machine* (1895), *The Invisible Man* (1897) and *The War of the Worlds* (1898).

Two stories by Wells are worth mentioning for their style and inventiveness in any commentary on fantastic fiction. One, 'The Island of Dr Moreau', is an adaptation of the Circe story from Homer's *Odyssey*. Circe, the beautiful witch, becomes the sinister, bespectacled scientist Dr Moreau. Circe turned men into wild beasts by enchantment. Moreau, by skilled plastic and brain surgery, creates half-human monsters out of wild beasts. The style, the setting, the consequence of the story, all revert to the Gothick horror tale.

Preserved alive

The second example is from 'The Sleeper Awakes'. The Sleeper, roused from a cataleptic trance which has preserved him alive and unchanged for a thousand years, finds himself in a museum of the future. From a gallery, he looks down upon a large, familiar yet strange sight. With a start he realizes that he is looking *down* upon the dome of St Paul's – the whole building is preserved as an exhibit.

The fantastic novel has become science fiction; other new forms and themes have overtaken the nightmare, which in the modern world sometimes seems feeble by comparison with reality. But vampires and werewolves, monsters and their creators, ghouls, mummies restored to life, and torture chambers in Gothick castles are as popular as ever with movie makers and their audiences. Producers, designers and actors have made this *genre* a speciality of their own; with their increasing attention to special effects, period costume and a strangely serious attitude, they have created the equivalent of the Gothick story in full flavour.

'Who dun it?'

A shot in the night. Criminals lurking round corners. Whether the reader pits his wits against a sleuth or simply lets his hair stand on end, novels of crime exert a powerful fascination.

1

2

1 Sidney Paget illustrated the Sherlock Holmes stories when they first appeared in the *Strand Magazine*; readers owe as much to him as to Conan Doyle for their picture of the hawk-eyed detective in his deerstalker and plaid coat.
2 Vidocq, the prototype of the detective, was a real-life French secret agent who began his career as a criminal and galley slave.

PROBABLY THE OLDEST detective story written down dates from the late Bronze Age: the story of Susannah and the Elders, part of the Apocryphal Old Testament. It is so modern in its theme that it is worth outlining the plot. Two respected and powerful members of the community, of which they are magistrates, attempt to seduce an innocent married woman. When the attempt fails they blackmail her by accusing her of adultery with a young man. She resists, and they take her to court. They claim to be eye-witnesses to the crime, and because of their power, the court convicts Susannah on circumstantial evidence. The crime carried the death penalty: death by stoning.

At the very last minute, however, in true Perry Mason style, a young lawyer persuades the gathering to retry the case. He, Daniel, later to be one of the most famous judges of his nation, cross-examines the two elders, separately. He asks each of them in turn where he saw Susannah with the young man. Each says under a tree. What sort of tree, asks Daniel. One says a holm tree, the other emphatically claims a mastic tree. The story concludes: 'And the assembly rose

against the two elders, for Daniel had convicted them of false witness by their own mouth.' So Susannah was saved, first by deduction on the part of a listener, and then by clever court-room cross-examination.

This story comes into the first of two general categories of crime story, the 'who-dun-it', which is primarily a puzzle story. The case is set out with all the suspects and the evidence paraded, and the reader tries to solve the mystery himself, pitting his wits against the compiler of the puzzle, the author. The climax takes place in court, or at a reconstruction of the scene of the crime, and the detective tries to justify his creator's solution. The way, needless to say, is strewn with false clues, false suspects, the author not stopping short of crimes against logic in order to baffle the reader.

The second category is the 'kick-down-the-door' school of writing. Here the reader enjoys reading about crime more than trying to solve it. Its antecedent is the picturesque novel, or adventure story. It depends upon one rule, continuous action. As the late Raymond Chandler wrote: 'When in doubt, have a man come

in at the door with a gun in his hand.'

To deal with the puzzle story first: in spite of the antiquity of the story of Susannah, it is a comparatively modern invention, like the crossword puzzle. It has roots in the 'horrid' Gothick novels of the late eighteenth and early nineteenth centuries, with their secret passages in old houses and clanks, bumps and groans in the middle of the night. The puzzle story has remained an essentially polite form of fiction in spite of its theme of murder and sudden death and still has its complement of lady writers and lady readers.

A master of disguise

The nineteenth century was the age of applied science, and the who-dun-it depends upon the application of logic and science to crime. The prototype of the detective, a master of disguise with his powers of super-detection and his knowledge of psychology, was the French secret agent Vidocq. An ex-criminal and galley slave, Vidocq could change his voice and appearance at will, being able to alter the shape of his face and vary his height by two inches without artificial aids. Vidocq was also a blackmailer, and not above arranging crimes of baffling insolubility in order to prove his own indispensability.

Vidocq was the real-life model of Honoré de Balzac's Vautrin, alias Collin, the anarchist, criminal and secret agent who was also a master spy for the police. He first appears in *Père Goriot,* published in 1834, as a comparatively minor but important character. He disappears at the end of the book in a blaze of fireworks to reappear again and again in Balzac's novels as a sinister master mind, who eventually had a whole melodrama to himself.

It was the work of Balzac that influenced English writers such as Thackeray and

Dickens, and particularly Tom Taylor and Wilkie Collins. Tom Taylor, in his play *The Ticket of Leave Man*, treats crime seriously though melodramatically, and his 'Hawkshaw, the detective' is another prototype figure whose name was once a byword.

Wilkie Collins may be said to have written the first serious detective novels. *The Woman in White*, a story of a strange abduction, is a romantic novel woven round a mystery, complete with a villain straight from Balzac. But *The Moonstone*, the story of a diamond theft, has as its hero a real policeman, the professional and unshakeable rose-loving Sergeant Cuff of the Detective Force. Cuff is definitely not an amateur gentleman, and the police methods are sensible and intelligent, and realistically described.

In the United States Edgar Allan Poe, a devotee of French literature, was fascinated by death and crime, and wrote 'mystery' as well as 'Gothick' stories. His long short-story 'The Murders in the Rue Morgue' was based upon newspaper accounts of the brutal murders of a mother and daughter in Paris. Poe, separated from the incident by the passage of time and the width of the Atlantic, produced an ingenious solution to the unsolved crime by pure deduction.

A trained eye

And pure deduction, of course, brings us to Sherlock Holmes and his creator, Arthur Conan Doyle. Doyle was a doctor, and got the idea for his master-detective by the application of the scientific methods of observation that he had learnt as a medical student. Holmes's eye is a trained eye; like that of a doctor or a laboratory worker it is trained to see what it has been taught to look for. This is why Holmes's observations can be so maddening to the ordinary reader and to his fictional representative, Dr Watson. Doyle always tried to play fair and never to stretch the long arm of coincidence too far. He was interested in cause and effect in the true spirit of nineteenth-century scientific materialism. The master-detective's superhuman concentration put some strain on his creator, too, who felt that he had created an incubus. He tried to kill off Holmes in a death grapple with the arch-villain Moriarty – a scientific criminal, by the way – but had to revive him under public pressure. Holmes was a brilliant amateur, and a drop-out as well. He took opium and cocaine to relieve his fits of depression and nervous debility and fired pistols into the wall of his room for amusement.

The scene of the who-dun-it is usually cosily domestic, involving disputes over wills rather than contracts, with jewel thefts from country houses rather than bank robberies, and heirs to private fortunes quietly eliminating each other. The corpse lies on the floor of an ancient college common-room or the gun room of a large country house. Skeletons peep out of family cupboards, while clumsy policemen tramp all over flowerbeds and flowered carpets. Servants are plentiful, from the scared tweeny maid to the tight-

lipped butler who goes on steadily polishing his silver in the pantry. We are provided with house plans, and elaborate railway timetables, and sometimes little lectures on bee-keeping or bell-ringing. The means of murder are elaborate, involving strange weapons from colonial possessions or rare and undetectable poisons. Coincidence is often stretched well beyond the bounds of credibility. But the lack of realism will never disturb the addict of the genre, and the formula, in contrast to its violent theme, is genteel and reassuring.

The formula strangely reflects the British statistics on crime. Murder is still predominantly a domestic affair, in spite of the increase in figures for crimes of violence. In the United States, American writers, too, reflect the local scene. They have lifted the crime story out of the country-house weekend party-game of murder and taken it into the streets and back alleys of the American city. The stories are adventure stories about crime, rather than crime puzzles to be solved. Their antecedents are in Robinson Crusoe's discovery of a footprint in the sand, and in the exploits of Jonathan Wild, fence and thief-taker, the prototype of John Gay's 'Peachum' in *The Beggar's Opera*; in the adventures of Dick Turpin and Jack Sheppard, and the 'gentlemen' highwaymen upon whom Gay modelled Captain Macheath; and in the gory accounts of the Newgate Calendar.

The gun-carrying frontier tradition of North America evolved a society where the responsibility for upholding the law

1 J. G. Reeder, clerk in the public prosecutor's office, is a master at solving crimes that baffle the police. This super-efficient detective is the hero of 'The Troupe' and many other stories by Edgar Wallace.
2 Georges Simenon's detective superintendent Maigret is one of the most famous crime investigators in modern fiction. He solves his crimes by psychological intuition rather than by logic.
3 Paul Temple, compulsive puzzle-solver in Francis Durbridge's television series, is himself a writer of mystery fiction who devotes his spare time to detective work.
4 A Flemish tapestry depicting the Apocryphal story of Susannah and the Elders. Through the timely intervention of the young lawyer Daniel, Susannah was cleared of the crime for which she was indicted.
5 The murder of Maria Marten in 1827 became the subject of a gory melodrama and has been reinterpreted several times since. William Corder, the murderer, is represented in front of the gaol a few days before his trial.

and for self-defence often devolved upon the individual, and not upon an abstract structure of law and order. The ruthless money-making methods of the early twentieth century, followed by economic depression, in a setting where prohibition made every other American a technical law-breaker, led the serious novelist to accept crime as part of the social scene. The name-character of Scott Fitzgerald's novel

of the early 1920s, the 'Great Gatsby' is a gangster and racketeer who throws big parties in a Long Island mansion and pathetically wants to be considered 'respectable'. One of his associates, Meyer Wolfsheim, who sports human molars as cuff links, is spoken of with awe as the man who fixed the 1919 World Series. This true-life incident, in which the Chicago Red Sox baseball team was bribed *en masse* by a gambling syndicate to lie down in the final, caused Ring Lardner, sports writer and friend of Hemingway and Fitzgerald, to abandon journalism in disgust and become a novelist of low-life stories. He was to have as great an influence as his friends on the American crime story. Fitzgerald's story is told in an involved, oblique style, as if his acknowledged master, Henry James, had taken to writing crime stories.

Equally involved in the telling is the tiny masterpiece by Ernest Hemingway, 'The Killers', the story of a man put on the spot by hired gunmen for a past betrayal. This short story unfolds with all the relentless inevitability of a Greek tragedy. The victim – who he was, and what he did we never know – is tired of running at last, and lets his fate catch up with him in a small town.

But the most involved crime story of all is *Sanctuary*. William Faulkner is one of the major novelists of the century. His use of a fractured time-scale, of oblique, never direct statement and of soliloquy and allusion tend to hide the raw plot – of bootlegging, kidnapping and rape – and

his study of a psychopathic criminal. He deliberately involves his reader in mental effort of such magnitude that an English writer, wartime Squadron Leader Raymond, relied upon being able to lift Faulkner's plot wholesale and re-write it as a sensational popular thriller. He took the pen-name James Hadley Chase, and called his story *No Orchids for Miss Blandish*. It was not only the plot that he adapted. His tough, slangy style was copied from the American crime magazines. These 'pulp' magazines, taking their name from the cheap wood-pulp paper upon which they were printed, carried stories written in language as luridly cliché-ridden as their bright, erotic covers. Nevertheless, some of the century's best short-story writing came from magazines such as *Black Mask*.

'The Simple Art of Murder'

Two names in particular stand out: those of Dashiell Hammett and Raymond Chandler. Hammett, whose style may be influenced by Lardner and Hemingway, or who may have influenced them, was first taken seriously by Robert Graves in an essay in *The Long Weekend* in which he reviews the detective story. Graves and his associate critic Alan Hodge decided that Hammett was the most original American writer in this field. In his essay, 'The Simple Art of Murder', the best on the subject ever written, Raymond Chandler designates Hammett's style 'as at its worst almost as formalized as a page of *Marius the Epicurean* [by Walter Pater]; at its best it could say almost anything.'

the character whom Conrad uses as a narrator in many of his novels, comments: 'He is one of us.' The guilt which dogs Jim's life is common to all humanity; Conrad's best characters are those who fight it best, like Captain McWhirr of his long story, *Typhoon*.

These writers are important to the development of the modern novel for many reasons, and for none so much as their insistence upon showing character from the inside. Although their novels are written mainly in the third person, the narrator assumes full knowledge of the complex workings of the mind which lie behind his characters' actions. This is a very basic change of direction in the novel. The great novelists of the past had endowed their characters with a specific set of characteristics, and then shown them in action; development of character was slight, and followed the demands of plot rather than psychological truth. Jane Austen's heroine Emma, for example, gains wisdom which is necessary to the novel's happy ending; it is desirable that she should become wise, but hardly likely outside the special world of the novel.

Illusions of dignity

The best writers in the twentieth century after James and Conrad were more concerned with truth in human terms than with plot. The work of the psychologist Sigmund Freud had demonstrated the complex and often amoral aspects of human behaviour; the First World War had dispelled illusions of Man's inherent dignity. Writers could not fail, if they wished to be 'true to life', to have a fundamentally altered viewpoint from that of their predecessors.

E. M. Forster can in many ways be seen as the heir of James and Conrad, although he is not usually so regarded. He wrote much of his work before 1914, except that his last (and best) novel, *A Passage to India,* was written after a long gap in 1924. An Englishman by birth, he builds his novels on a narrow, closely observed social spectrum, the educated middle class. The moral tests that his characters undergo are rarely extreme, as in Conrad's work: but they are very real all the same, and just as real is the knowledge of the abyss, the nothingness that lies beneath society's forms. We catch a glimpse of this void from time to time, as in *A Passage to India* when Mrs Moore visits the splendid and horrifying Malabar caves: 'Pathos, piety, courage – they exist, but are identical, and so is filth. Everything exists, nothing has value. If one had spoken vileness in that place, or quoted lofty poetry, the comment would have been the same – "ou-boum".'

As well as the deepening of the novel's tragic awareness, the twentieth century has seen extraordinary advances in the formal technique of the art. James, Conrad and Forster, for all their precision, were not great technical innovators. The work of James Joyce, an Irishman who lived most of his life in continental Europe, extended the novel greatly in this sphere; so much so indeed, that some consider Joyce extended the form as far as it could go. His three novels are *Portrait of the*

1 Norman Mailer is one of the leading writers in the United States. Among his works are *The Naked and the Dead,* about the Second World War, and *An American Dream.*

2 A scene from a television production of Galsworthy's *Forsyte Saga,* a series of novels which attempt to satirize middle-class society while retaining a good deal of affection for it.

3 An eighteenth-century plantation house in Mississippi. Such scenes in the Deep South inspired the invention of Yoknapatawpha County, mythical situation of William Faulkner's novels.

4 Although he spent most of his life abroad, the work of James Joyce is rooted in his native Dublin. *Portrait of the Artist as a Young Man* and *Ulysses* contain vivid evocations of the city.

Artist as a Young Man (1916), *Ulysses* (1922) and *Finnegans Wake* (1939).

In the *Portrait,* Joyce developed a technique which was later to be called 'the stream of consciousness' (the phrase had first been used by William James). Briefly, this may be defined as the reproduction in prose of the mental processes – thoughts, doubts, hopes, emotions – of the main character of the novel. In *Ulysses,* Joyce takes the form still further. He uses three characters – Bloom, his wife Molly and Stephen Dedalus (a self-portrait) – and switches from the stream of consciousness of one character to that of another. Through these three characters he builds a picture of a day in Dublin, of a whole society and of their creator's own universe. Perhaps the most famous passage, although not the most germane to the novel, is Molly's soliloquy at the end. Molly, for all her rag-bag mind and her casual unfaithfulness, is a true life-force, one of the most vital beings in the whole of twentieth-century fiction: '... When I put the rose in my hair like the Andalusian girls used or shall I wear a red yes and how he kissed me under the Moorish wall and I thought well as well him as another and then I asked him with my eyes to ask again yes and then he asked me would I yes to say yes my mountain flower and first I put my arms round him yes and drew him down to me so he could feel my breasts all perfume yes and his heart was going like mad and yes I said yes I will Yes.'

Virginia Woolf anticipated both *Ulysses* and her own major works – *Jacob's Room* (1922), *To the Lighthouse* (1927), *The Waves* (1931) – when she said: '... if a writer were a free man, and not a slave, if he could base his work upon his own feelings and not upon convention, there would be no plot, no comedy, no tragedy, no love interest or catastrophe in the accepted sense'. A large part of her work was concerned, too, with a reassessment of style: her characters are engaged upon a perpetual soliloquy, obsessed with questions and dilemmas. Her technique may be likened to Impressionist painting – the Impressionist school was first seen in London in 1910 – relationships are suggested by hints, oblique references, not directly stated as they are in the conventional novel.

Faulkner and Beckett

The problems of content and form are as vexed in the novel as in any form of art. Indeed, many critics have divided twentieth-century novelists into the stylists (like Joyce) and into those primarily interested in plot and character (like Conrad). Many writers since Joyce have chosen a prose style which is original in one way or another. Two of the most important are William Faulkner and Samuel Beckett.

Faulkner, an American, chose to write most of his novels about an imaginary area in the Deep South, Yoknapatawpha County. His prose owes much to Joyce's stream-of-consciousness technique, but it is perfectly adapted to suit Faulkner's themes. In one of his finest novels, *The Sound and the Fury* (1929), the theme is the degeneration of a Southern family, the Compsons, told by four narrators – Benjy, Quentin and Jason Compson, and the last part directly by Faulkner himself. Benjy is an idiot and the first part is therefore illogical and often nonsensical. But it is part of Faulkner's point that 'truth', or reality observed, is always subjective, and the observation of an idiot may count for as much as that of a sane man. The following is part of Benjy's narration: 'In the corner it was dark, but I could see the window. I squatted there, holding the slipper. I couldn't see it, but my hands saw it, and I couldn't hear it getting night, and my hands saw the slipper, but I couldn't see it myself, but my hands could see the

3

4

slipper, and I squatted there, hearing it getting dark.'

Beckett's career has a close resemblance superficially to Joyce's. Like him, he was born in Ireland, and went to France where he has since lived and worked. His novels have been perhaps the most influential works of fiction since the Second World War; his fame as a novelist (he is also a playwright, and has published poems) rests largely on *Murphy* (1938), *Watt* (1953) and the trilogy *Molloy, Malone Dies* and *The Unnamable* (1955–58). His work is bleak, and grows progressively bleaker. His characters have little to begin with, and end the novels with less; the one thing they possess is a mind constantly questioning, doubting, counting, never at peace. It is Beckett's achievement that he has fictionalized the very processes of the brain. He does it using the stream-of-consciousness technique, but makes no attempt at naturalism. Rather it is the style of a mind concerned above all else to be correct, even in the face of hopelessness: 'Gravely I struggled to be grave no more, to live, to invent, I know what I mean. But at each fresh attempt I lost my head, fled to my shadows as to sanctuary, to his lap who can neither live nor suffer the sight of others living. I say living without knowing what it is. I tried to live without knowing what I was trying.' (From *Malone Dies*.)

All these writers use the stream-of-consciousness technique: it has been the single most powerful form in the contemporary novel. Its greatest advantage is that it demands involvement from the reader; he must construct the novelist's world with the aid of clues given to him by the characters' thoughts – he is no longer a passive recipient of information.

But it cannot do everything; most important, it deprives the novelist of the possibility of commenting directly on his characters and situations. Certain novelists, indeed the majority of novelists writing in English, prefer to work at least partly from outside the character's mind. Though this is obviously the technique used by most 'commercial' authors – writers of thrillers, adventure stories, romances – it is also widely used in the serious novel. The greatest practitioner of the direct approach – though he does at times use an adaptation of the stream of consciousness – was D. H. Lawrence, who died in 1930. His two finest works, *The Rainbow* (1915) and *Women in Love* (1917) are explorations into the nature of emotion, the validity of action in a godless world, the meaning of life itself. Lawrence's enemy was anything which 'did the dirt' on life, and these forces could take many forms – over-sophistication, industrialization, intellectualism, apathy. By contrast there exist men like the Brangwen men in *The Rainbow*: 'So much warmth and generating and pain and death did they know in their blood, earth and sky and heat and green plant, so much exchange and interchange had they with these, that they lived full and surcharged, their senses full fed.'

No English author since has matched

1 The characters created by Canadian-born novelist Saul Bellow struggle to find themselves. In *Herzog* the hero retreats from the confusion of life into fantasy; letters are his main form of communication, some of them written to God.
2 James Joyce's *Ulysses* covers 24 hours in a Dublin day. It reproduces the mental processes of its characters in prose, conveying the very inmost texture of their minds and personalities.
3 In *Animal Farm*, George Orwell, English essayist and novelist, satirized the Communist régime in Russia, setting his work in a farm-yard, with pigs as his central characters.

Lawrence's passion; but more English fiction has been written in his tradition than in Joyce's. Aldous Huxley in *Crome Yellow* (1921), *Antic Hay* (1923) and *Point Counter-Point* (1928) exposed the fashionable and literary society of the 1920s. George Orwell recounted his own experiences in *Burmese Days* (1934), *Homage to Catalonia* (1938) and others, experiences which confirmed him in his socialist persuasions. Both writers give their own particular horror-vision of the future, Huxley in *Brave New World* (1932) and Orwell in *1984* (1949). The 1950s school of English novelists – John Wain, John Braine, Kingsley Amis, David Storey – continued the investigation into British social life, in their case usually working-class life, with varying success. Though widely publicized and praised at the time, when phrases like 'angry young men' and 'working-class novelists' were bandied about, it seems doubtful now if their work will continue to be regarded as of much worth.

Vitality

Since the war, fiction written in English has been largely dominated by American authors: Norman Mailer, James Baldwin, Jack Kerouac, William Burroughs, Saul Bellow, Bernard Malamud and others. The differences between these authors are immense, but all share the vitality of American writing, together with a large sense, in most cases, of the novelist's responsibility to hold on to the true values, the values of life itself. Many deal with the problems of the individual in relating to a society which is growing more confused and uncaring. Some characters take refuge in fantasy, some in drugs, some in sex, and some, finally, in death.

These human values, emerging from the social picture that each writer creates, have always been the main concern of the best novelists. When, as in our century, the risk of these values being defeated, forgotten or 'done the dirt on' is greater than ever before, the novelist's concern, and his responsibility, increases in consequence.

In the footsteps of Homer

Battles between mighty forces, the intervention of the gods to save a favoured mortal are themes of epic poetry, a form which originated in ancient societies and developed in later centuries.

THE EXPLOITS OF HEROES, of warriors and chiefs are the subject of a large body of poetry which has its beginnings in ancient times. Such 'heroic' poems were later called *epics*, a word which came to mean any work conceived and written on a grand scale. The earliest poems were never written down by their authors, but formed part of an oral tradition transmitted by bards and reciters who enthralled their audiences with tales of heroes and monsters and the deeds of the gods. Western culture is influenced by both the Greek and the Germanic legends which were written down by scribes long after the events concerned had passed into folk-lore.

Though based very often on fact, the epic never pretends to be 'true' to the facts, but rather to the spirit of the times. Aristotle in his *Poetics* drew this distinction between historian and the epic poet: '... They [the historian and the poet] differ in this, that the one speaks of things which have happened, and the other of things that might have happened. For poetry speaks more of universals, but history of particulars.'

Glorifying heroes

In other words, when Vergil wrote in the *Aeneid* about the fall of the great city of Troy (which, it seems certain, was an actual event) it was not meant to be a document of the proceedings of the war but rather a glorification of heroic deeds, both those of men and of the gods.

The authors of the early poems are usually unknown; it is possible, for instance, that Homer is a convenient and reverential name for a collection of poets. It is only in comparatively later centuries, in a literate culture, that poetry is ascribed to a particular author. The early heroic epics were composed by bard-poets and sung or recited for the enjoyment of everyone – they were an early form of popular entertainment.

The works of these anonymous poets inspired authors of later centuries to follow their example and copy the form they gave their works. The later epics, like Milton's *Paradise Lost*, were conceived as pieces of literature, more often than not aimed at literate, educated readers who would buy a copy and read it privately or in the company of friends. These 'literary' epics were written in an ornamental style, whereas the earlier heroic poems tended to be more direct.

Heroic poetry has been composed practically everywhere; hundreds of examples still exist, although many more hundreds have been lost for ever. They were either transcribed because of their popularity, as with Homer's works, or are still remembered and repeated to this day. Heroic poems were handed down the

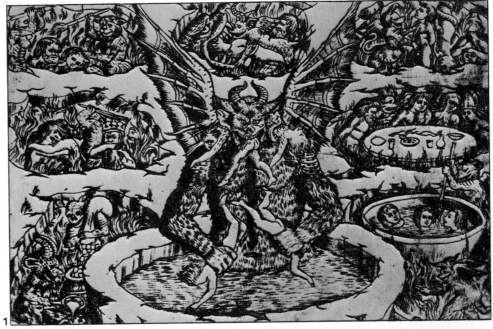

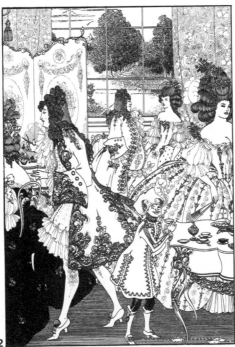

1 During his journey through the Underworld, Dante saw many horrifying sights, none more terrible than the punishment of the damned. It is depicted here in one of the drawings made by Botticelli for the *Divine Comedy*.
2 Aubrey Beardsley cleverly evokes the atmo-

sphere of eighteenth-century society, one of several illustrations for Pope's mock-heroic poem *The Rape of the Lock*.
3 In ancient Greece, poets and bards known as *rhapsodes* recited epic poems. This one figures on an Attic vase, dated 480 B C.

generations from father to son, from master to pupil. The bard's function was to entertain: often his audience was composed of aristocrats and in any primitive society these aristocrats would wish to hear of the deeds of heroes, of skill in war and of honour between friend and enemy. Homer's *Iliad* is full of detailed descriptions of skill in the use of weapons, and so

are the Anglo-Saxon *Beowulf* and the medieval Spanish *Poema de mio Cid*. Men accustomed to war would take great pleasure in this description from the *Iliad*: 'Deiphobus . . . came up close to Idomeneus and let fly a shining lance. But Idomeneus was looking out and avoided the bronze spear by sheltering behind the rounded shield he always carried. It was

built of concentric rings of oxhide and of glittering bronze, and was fitted with a couple of crossbars. He crouched under cover of this, and the bronze spear flew over him, drawing a deep note from the shield as it grazed the edge.'

Heroic poems are of course concerned with the deeds of heroes: Achilles, Hector, Patroclus and others in the *Iliad*, Odysseus in the *Odyssey*, Beowulf in *Beowulf*, Roland in *The Song of Roland* and so on. These heroes are all primarily fighting men, though there are more ways of winning glory than in battle. Odysseus, for example, shows his heroism by his endurance, his patience and his intelligence as well as by his courage. One of the hero's main concerns is to preserve and extend his honour; much of the heroic poem is concerned with descriptions of how the hero proved his honour in different dangerous situations.

The deeds of the hero in pursuit of

honour often appear to us to be exceptionally brutal; but this brutality is often the reaction to a grievous personal loss which the hero can only exorcize by violence towards his enemies. When the Norse hero, Volund, escapes from his tormentor Nithuth he savagely kills the latter's children and sends their mutilated bodies back to their parents:

> Their skulls, once hid by their hair, he took,
> Set them in silver, and sent them to Nithuth;
> Gems full fair from their eyes he fashioned
> To Nithuth's wife so wise he gave them.

Volund finds his way from Germanic legend into Anglo-Saxon mythology as Wayland the Smith. Again, Achilles, stricken with grief by the death of his friend Patroclus, slaughters scores of

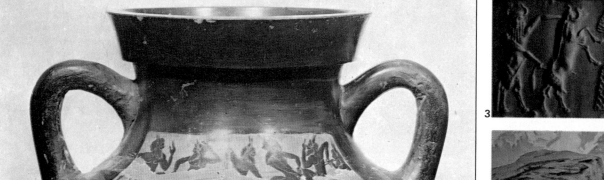

Trojan chieftains with no thought of mercy.

The other side of the epic hero's honour is one more readily calculated to win sympathy from modern readers: it was contained in the unwritten code of battle which forbad extremes of brutality, even to deadliest enemies: Achilles the Greek treats Priam, king of Troy, with great honour when the latter comes to him to beg for the return of the body of his son Hector. Roland, the Christian knight, while hating his heathen foe, does not deprive them of their rights as human beings once he has captured them.

One of the most warlike of all peoples

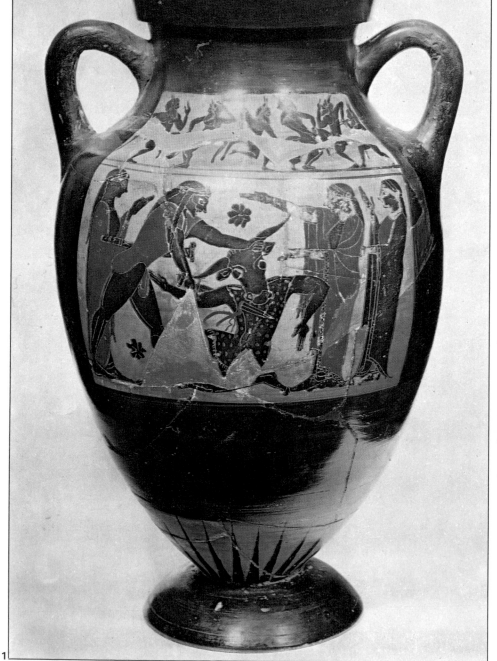

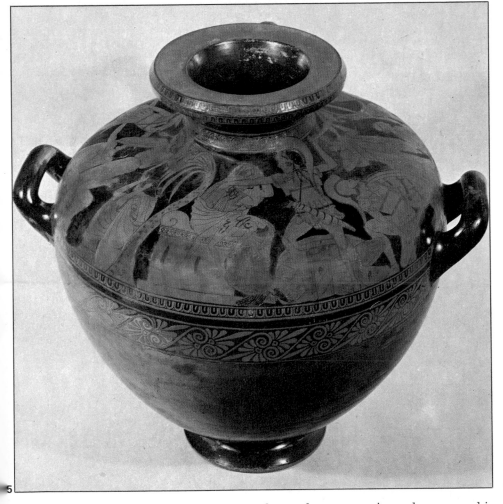

1 The legendary Minotaur, half bull, half man, was kept in the Labyrinth by King Minos. The slaying of the monster by Theseus is a popular subject in Greek art and literature.
2 *The Rape of Helen,* by Liberale da Verona. The subsequent siege of Troy by the Greeks and the quarrel between Achilles and Agamemnon forms the theme of Homer's *Iliad.*
3 On a 'cylinder seal' from Mesopotamia, dated 2200 B C are Gilgamesh *(right)* and the bull-man Enkidu, heroes of the Sumerian poem *Gilgamesh.*
4 Volund (between his two brothers), one of the heroes of the *Poetic Edda,* was famous as a craftsman in Germanic legends. He is known in Anglo-Saxon mythology as Wayland the Smith.
5 The fall of Troy to the Greeks, depicted here on a Greek vase, is described in Book 2 of Vergil's poem the *Aeneid.* Aeneas, leader of the survivors, travels to Italy and defeats the Italians; his descendants eventually founded Rome.

draw their own conclusions. In some poetry, notably in the Norse poems of the *Elder Edda,* these speeches constitute poems in their own right: in other examples, the form of the poetry is almost entirely dramatic, rather like a primitive verse play with a few narrative interpolations to help the story along.

Heroic epic poetry is still practised in some parts of the world. Examples can be found in Russia, where the Ryabinin family keeps the tradition alive, in Yugoslavia, Greece and in many parts of Asia and some parts of Africa. It continues in the form it has always taken, depending for its existence on the passing down of the bardic skills from father to son. It functions best in societies which have remained for the most part illiterate and tribal. It can hardly be written in a modern society, since it assumes a code of honour in action which has ceased to be the society's dominant interest for many centuries. The only heroic poems composed in Britain were *Beowulf, The Battle of Maldon* and *Brunanburh* in the Anglo-Saxon period.

The literary or artificial epic lasted longer in the West. Though based upon the form of the heroic epic, it is not so much concerned with the deeds of heroes as with endowing its events with the grandeur of

were the Norsemen, whose raids into Britain in the early Middle Ages caused the priests to create a special prayer: 'From the fury of the Norsemen, good Lord deliver us.' Many of their legends are recorded in the Sagas, which belong to the twelfth and thirteenth centuries. The *Eddas* of Iceland deal with the same material – these legends find an echo in the first British heroic poetry which is based on tales brought in by Saxon invaders in the fifth and sixth centuries.

Epic heroes, whether Greek, Norse or Anglo-Saxon, pagan or Christian, share many qualities: one of the most notable traditions in epic poetry is that the hero has a close companion, a hero second in courage only to himself. Achilles has Patroclus in the *Iliad*; Roland, Oliver in *The Song of Roland*; Gilgamesh, Enkidu in the Sumerian poem *Gilgamesh,* and so on. This friend is often killed in the course of the story, causing grief to the hero and often stirring him to his finest action.

The virtue that epic poetry must maintain above all others is that of a strong narrative. With a few exceptions, such as *Beowulf,* which contains many elements of lament, the heroic epics contain no moralizing. This is achieved in large part by giving speeches to the main characters of the poem, allowing the audiences to

epic status. A good example is also one of the earliest – the *Aeneid*, written by Vergil in the first century B C. The *Aeneid* was a highly conscious imitation of Homer's work: its hero, Aeneas, was a Trojan prince who plays a minor part in the *Iliad*. Vergil, an intensely patriotic Roman, wanted to give his countrymen a mythology as respectable as that of ancient Greece. And so Aeneas makes a voyage from Troy to Italy lasting seven years, a voyage very similar to Odysseus' journey home in the *Odyssey*. Finally he lands on the banks of the Tiber and defeats the Italians. Aeneas was the son of Anchises, a mortal, but his mother was Aphrodite, a goddess. Consequently the father of Rome could claim divine parentage, and was a fitting progenitor of a race of heroes.

Though containing much heroic material, the *Aeneid* is written in a cultivated, literary style: its appeal was primarily to an educated class and it lacks the simplicity as well as the strength of Homer's narration. Yet for the very reason that he was a *literary* poet, Vergil set the style of literary epic: it is significant that the Italian poet Dante, in his greatest work, the *Divine Comedy*, chose Vergil as his guide through the Underworld.

The *Divine Comedy* is epic in length. Its intention, too, is epic. It comprises three books, one each on Heaven, Hell and Purgatory. In allegorical terms it affirms Dante's ethical and political conception of the world and the duties of Man. It is also an exciting adventure story, for the poet, in his descent into Hell, meets terrible monsters and ghosts of men punished eternally for their earthly crimes.

There are some grounds for comparing the *Divine Comedy* with Milton's *Paradise Lost*. Both poets set out to write a poem of epic dimensions – Milton's poem was to achieve 'Things unattempted yet in prose or rime', and both poems have a sense of adventure about them. The battle between the forces of God and the forces of Satan, ending in Satan's fall to Hell is forcefully described in the following lines:

And now thir mightiest quell'd, the battel swerved,
With many an inrode gor'd; deformed rout
Enter'd and foul disorder: all the ground
With shivered armour strew'n, and on a heap
Chariot and Charioteer lay overturned
And fierce foaming Steeds.

Milton replaced the old warrior heroes by heroes whose functions were more carefully defined. Though he makes a show of maintaining a well-balanced struggle between God and Satan, the issue is predetermined. Again, though Satan is not an entirely unsympathetic portrait, there is none of the old objectivity in Milton's treatment of his protagonists. This is not a human conflict, undertaken

1 'Awake, arise, or be for ever fallen.' With these stirring words Satan marshals his flagging forces for the struggle with God in Milton's epic *Paradise Lost*.
2 Descriptions of mighty battles are important elements in heroic poetry, for here the hero displays his valour and skill in combat.
3 The Cid, famous hero of the medieval Spanish *Poema de mio Cid*. The poem tells of the fall and restoration to royal favour of a Castilian noble known by the Arabic title of *sidi* ('lord').

for the glory of it, but a deeply serious struggle over the soul of mortal Man.

Dante and Milton did not aim primarily to tell a story, as the ancient bards did. Dante felt that only through poetry could he express his vision of a spiritual renewal of the whole of humanity. Milton, more sternly, wished to 'justifie the wayes of God to men': both were preoccupied with a vision of Man's spiritual needs and their poems are calculated, by use of character and style, to achieve an allegory of the human condition.

Of course, allegory had no place in the heroic epic and the spiritual example set by the bards was confined to advice on the wisdom of propitiating the capricious gods. Again, the literary epic differs from its heroic model by choosing idealized heroes: though Homer's heroes perform almost supernatural feats of courage and strength, they are very human; they boast, sulk, cheat and run away when occasion demands it. Spenser, the only other English poet whose work *The Faerie Queene*, can be called epic, set out to create an idealized representation of Queen Elizabeth and 'to fashion a gentleman or noble person in virtuous and gentle discipline'. To achieve his end, he used tales of medieval chivalry for complex symbolic purposes.

The mock-heroic poem

Spenser had a vision of the good society, and his poem is a model to all who would learn how to live in such a society. Its narrative, far from being taut and fast-moving, flows along at a very leisurely pace. The language is modelled on the gentle cadences of Italian poetry of the time, and is pleasant to read even now.

Later examples of epic are hard to find. The 'Augustan Age', the eighteenth century, produced no more than mock-heroic poems like Pope's *The Rape of the Lock*, which applied the elevated language of Greek heroic poetry to a trivial subject. The poem depends for its considerable wit on the description of the capture of a lock of a beauty's hair by an amorous beau in grandiose language. Pope, the most brilliant poet of his generation, knew that the epic form could exist only in this way for his time.

While Byron and Browning both wrote long poems in the nineteenth century, none of their work was 'epic' in the original sense of the word. Longfellow's *Hiawatha* has more of the epic mood than any other: it deals with a warrior-hero and with the original race of the American continent, and it was, at least in part, epic in intention. But its treatment is more lyrical than heroic.

Though epic, whether heroic or literary, is no longer written outside a few societies, the epics of the past have never been so popular. New translations of Homer appear every few years in Britain alone, and much research is being done on the legends of tribes and races now almost forgotten. This popularity is more than a cult: a society in which great deeds are becoming increasingly rare is likely to gain more and more pleasure from reading of the prowess of the heroes of antiquity.

'Pop' poetry of the past

A thriving ballad tradition existed all over Europe into the nineteenth century. Anonymous poets sang and wrote of popular events in life and legend, using established metres and rhyme schemes.

WHEN WE TALK ABOUT POPULAR CULTURE – or pop culture – we mean that often highly sophisticated body of songs which are composed for a mass audience. But although these songs are certainly popular in this sense, they are not written by the people who listen to them, and are sung only by professional musicians.

The true popular poetry is folk song and ballad – songs composed by anonymous poets and remembered and sung throughout the centuries. The art of the folk song according to this definition is practically extinct – it is part of the oral tradition which can live only in simple and illiterate societies. The modern folk singer, although he may compose his own songs, writes a personal, not a communal work. Like any other artist, he cannot assume that his audience will share his experience, since with the disintegration of small communities and communal living, each person's experience of the world is unique and separate.

To say that ballad can no longer exist as a living force in Western society is not to deny the beauty of the form as it once existed; it is part of the true folk poetry and its popularity is still strong, as the recent 'folk revival' testifies.

A constant rhythm

The beginnings of ballad in Britain are difficult to trace precisely. The earliest ballards are related in form to the courtly medieval Romances of France and Italy, and especially to Breton *Lais,* or lays: these lays were concerned with traditional folklore and were short narrative poems dealing with a single incident. Again, the word ballad itself is probably derived from the Latin *ballare,* meaning 'to dance'. The earliest Danish ballads, composed in the thirteenth century, were certainly meant to accompany a form of dancing known as the ring dance: they all have refrains which suggest the need for a constant rhythm. Over half the ballads recorded in Britain also have refrains; that is, the same lines repeated from verse to verse, as are the second and fourth lines in *The Wife Wrapt in Wether's Skin* (sheep's skin):

> I married me a wife, I got her home,
> For gentle for Jenny, my Rosemaree,
> But I've oftentime wished I'd let her
> alone
> As the dew falls over the green valley.

Ballads were not only a comparatively late form of expression in Western cultural history – the earliest recorded ballad is the fourteenth-century *Judas* – but have literary ancestors, the Romances. Yet even if it borrowed its form from courtly verse, the themes and the method of treatment are distinctive: the balladeers sang of

popular themes and they told their story in a simple and dramatic fashion.

The subjects of the traditional ballads were simple – the tale of murder, or love, or of the loss of a baby to the fairies. It is not the ballad's business to teach, or to show the just reaping their just rewards: indeed the just and the unjust are usually treated exactly alike, according to fate. This is at least partly explicable by the lack of Christian morality in the ballads: although the form began well after Christianity was entrenched throughout

1 Coleridge's symbolic story of sin and redemption is unfolded in *The Rime of the Ancient Mariner* using the ballad form. Here the pallid figure Death-in-Life beats Death at dice; her name implies the narrator's own tragic predicament, for his guilt prevents him from dying.
2 'I sat her on my pacing steed, / And nothing else saw all day long, / For sideways she would bend, and sing / A faëry song.' These lines are from Keats's ballad, *La Belle Dame Sans Merci,* where a wandering knight is waylaid by a fairy lady. She entices him into a sleep from which he wakes to wait for ever on the cold hill-side.

Europe, the subjects refer back to pagan beliefs and ritual, kept alive by the peasants beneath the superstructure of Christianity.

Old superstitions, like the magic qualities which accrue on the drinking of a dead man's blood, appear in *The Braes of Yarrow*:

> She kissed his cheek, she kissed his hair,
> As oft she did before, O
> She drank the red blood frae him ran,
> On the dowie houms of Yarrow.

Ghosts and fairies occur commonly, as well as spirits who can assume human shape to lure people and children away to their dark kingdom. Animals are granted the power of speech and comment on human affairs.

Scots lords drowned

The ballad is the easiest of folk-song types to date, since it often tells the story of some famous event. However, there is no guarantee that the ballad was written at the time of the event or that it bears much relation to the historical truth. *Sir Patrick Spens* is one well-known example.

This ballad, first appearing in the eighteenth century, is certainly Scots in origin, for it appears nowhere else. It probably refers to the drowning of a number of Scots lords on the way home from escorting Margaret, the daughter of the Scots King Alexander III, to her new husband, the king of Norway. It must be admitted, however, that the name of Sir Patrick Spens is not recorded in connection with that event.

But whether truth, or fictionalized fact, or pure fantasy, the ballad is rightly considered one of the classics of its kind. It is direct, wastes no time, and is extremely dramatic in its presentation.

> The King sits in Dunferling toune,
> Drinking the blude-reid wine:
> 'O whaur will I get skeely skipper
> To sail this schip of mine?'
>
> Up and spak an eldern knicht,
> Sat at the king's richt kne:
> 'Sir Patrick Spens is the best sailor
> That sails upon the se.'
>
> The King has written a braid letter,
> And signd it wi' his hand,
> And sent it to Sir Patrick Spens,
> Was walking on the strand.

In the first three verses, a dramatic situation is presented and associations evoked. The king must have a sailor – Sir Patrick Spens is the one to go. The reference to wine suggests that the king was in a hasty and intemperate mood, possibly drunk, and 'blude-reid' hints at impending tra-

1 Robert Burns was brought up to learn the traditional Scottish songs and ballads. His work is informed by the native tradition and by his own liveliness, intelligence and taste.

gedy. Spens is loath to go out in the stormy season, but the king's orders must be obeyed. And so he orders his men:

> 'Mak hast, mak hast, my mirry men all,
> Our guid schip sails the morn:'
> 'O say na sae, my master deir,
> For I fear a dedlie storme.
>
> 'Late late yestreen I saw the new moone,
> Wi' the auld moone in her arme,

2 'A new love song, only ha'penny a piece' was a familiar cry in London's streets in the eighteenth century. The practice of selling ballad sheets continued well into the nineteenth.

3 Bob Dylan, American folk singer of the 1960s, writes and sings of the social problems which beset the modern world.

172

4 The Calypso singer in the West Indies composes his songs impromptu, their themes the tragi-comic incidents of daily life. His art has much in common with the ballad tradition.

5 Handsom Patie is the subject of this English ballad, a love song by his mistress containing an admonition against yielding too easily.

And I feir, I feir, my deir master
That we will come to harme.'

The second speaker is not introduced – presumably since he addresses Spens as 'my master deir' he is a servant, possibly his mate – but this information is not necessary to the narrative. His purpose is to predict the doom to come, for he is a man who can read the signs correctly.

The end of Spens and the Scots lords is not described – that would be something of an anti-climax, since by this stage in the ballad it is felt to be inevitable. Instead, the anonymous poet takes us back to those who are left to mourn their death:

O lang lang may their ladies sit
Wi' their fans into their hands
Or ere they se Sir Patrick Spens
Cum sailing to the land.

O lang lang may the ladies stand
Wi' the gold kaims in their hair,
Waiting for their ain deir lords,
For they'll se thame na mair.

Then, once the wreck of the ship is established in this oblique and effective manner, the fact of it is told in plain terms:

Half owre, half owre to Aberdour,
It's fiftie fadom deep,
And thair lies guid Sir Patrick Spens
Wi' the Scots lords at his feit.

Like myth, ballads are to be found in varying forms in many languages. The ballad *Edward*, best known in Britain in the Scots form:

'Why does your brand (sword) sae drop
wi' blude
Edward, Edward?
Why does your brand sae drop wi' blude
And why sae sad gang ye, O?'

is found throughout Europe. It is a question and answer between mother and son, the mother questioning until the son reveals he has killed his father (in other versions, it is his brother).

This ballad differs from those like *Sir Patrick Spens* and the Robin Hood ballads in that it does not tell of a real event: yet it does tell a story, and a very powerful one. Such ballads deal with elemental situations, often tragic, and tell them in a dramatized form. The treatment of the theme is brilliantly accomplished: many ballads are not of this class, but many others are, and they deny the notion that folk poetry is by its nature crude and badly composed.

This misconception has arisen from the simplicity and unpretentious nature of the ballad form. It uses the basic speech rhythms of the language, familiar tunes (several different ballads will often use the same tune) and a repetitive or simple rhyme scheme to aid memory. For the same purpose, the verses are frequently 'interlocked' by rhyme or meaning: for example a question is asked in one verse, answered in another, and the answer repeated in a different form in another and so on. *The Daemon Lover* is one of the finest English ballads:

They hadn't been on sail but about two
weeks
I'm sure it was not three,
Till she began to weep and she began to
mourn
She wept most bitterly.

O are you weeping for gold, my love,
Or are you weeping for fee,
Or are you weeping for your house
carpenter
That you love much better than me?

I neither weep for gold, my love,
I neither weep for fee,
But I weep to return back again
My sweet little babe to see.

You need not weep for gold, my love,
You need not weep for store,
You need not weep for your sweet little
babe;
You'll see it never no more.

Balladeers at fairs

Ballad literature has survived to this day rather better than most oral poetry because it was one of the most popular forms in a largely illiterate society, and continued as a living tradition into the nineteenth century. Ballads were often printed and sold by the balladeers themselves at fairs and markets: a man might buy several to read or recite to friends.

These sheets were what came to be known as 'broadside ballads', so called because of their often satirical nature. These broadsides dealt with what is now the subject-matter of sensational journalism – scandal, rumour, crises and the like. Other broadsides took their subject from the Bible and contemporary literature.

Not surprisingly, these broadsides were generally inferior to traditional ballads: they were the equivalent of hack journalism, written in haste and for a fee. Many of them lack the tightness of construction

How sweetly bloom'd the gay green birk,
 How rich the hawthorn's blossom!
As underneath their fragrant shade,
 I clasp'd her to my bosom!
The golden hours, on angel wings,
 Flew o'er me and my dearie;
For dear to me as light and life,
 Was my sweet Highland Mary.

O pale, pale now those rosy lips,
 I aft ha'e kiss'd sae fondly!
And clos'd for aye the sparkling glance
 That dwelt on me sae kindly!
And mouldering now in silent dust,
 That heart that lo'ed me dearly!
But still within my bosom's core,
 Shall live my Highland Mary.

An engraving for Burns's ballad *Highland Mary*. The first stanza affirms the life-giving forces of nature; the second suggests its coldness and hostility when the loved one lies dead.

seen in *Sir Patrick Spens*. However, there were exceptions, like *Loving Mad Tom*:

> The moon's my constant mistress
> And the lovely owl my marrow
> The flaming drake
> And the night crow make
> Me music to my sorrow.

There are many collections of ballads available – most of these collections give several different versions of what is essentially the same song. There is no such thing as the 'correct' version of any ballad, though different regions may claim their version as the original one. Scotland is one of the richest areas for the folk-song collector, and many of the original ballads may well have been first composed in Scots. The main reason is that Scotland retained a predominately rural society later than England, and folk song played a vital role in community life for much longer.

Excitement in Europe

Collections of ballads were first made in the eighteenth century; the most influential of these was Bishop Thomas Percy's collection, *Reliques of Ancient English Poetry,* in 1765. This found its way to Germany, where it was eagerly studied by the young German poets of the day. These poets then consciously imitated the form: Goethe's famous poem *Erlkönig* (1782) shows the influence of the ballad style.

The excitement felt in Europe over this book and others like it found its way back to Britain, where Sir Walter Scott was

The Braes of Yarrow is a traditional Scots ballad that occurs in different forms throughout the British Isles. Its theme is a country girl's lament over her lost love.

encouraged to publish his collection of border ballads, *Minstrelsy of the Scottish Border*. His fellow countryman, Robert Burns, wrote and edited a number of ballads. By the beginning of the nineteenth century the ballad, previously despised by 'literary' authors, had become one of the most popular poetic forms, imitated by almost all the Romantic poets. Indeed, it is to ballad and to the oral tradition generally that Romantic poetry owes much of its subject-matter.

Generally these ballad imitations were poor because they were too contrived, but there are notable exceptions: Coleridge's *The Rime of the Ancient Mariner*

Tam O'Shanter's trusty steed, Maggie, hurtles through the air pursued by a 'hellish legion' of monsters: an illustration to Burns's rollicking narrative poem *Tam O'Shanter*.

remains one of the finest narrative poems in the language, imbued with a supernatural, nightmarish atmosphere, and Keats's *La Belle Dame Sans Merci* imitates the ballad of lament with great beauty and austerity. George Crabbe before them, who lived in the late eighteenth and early nineteenth centuries, used the narrative ballad form extensively, especially in his poems *The Village* and *The Borough* (upon which Benjamin Britten's opera *Peter Grimes* was based).

The literary ballad is often considered a rather inferior form of poetry: tied to the necessity of telling a story, the poet has little time to indulge in lyricism or sensitive observation. It is true, certainly, that there are few literary ballads of the first rank – *The Ancient Mariner* remains the supreme example, a fine fusion of content and style. Here the Mariner describes water-snakes swimming around the ship in the phosphorescent sea:

> Within the shadow of the ship,
> I watched their rich attire:
> Blue, glossy green and velvet black,
> They coiled and swam; and every track
> Was a flash of golden fire.

There is no doubt that the skill of balladry has largely been lost: it is no longer a popular literary form, and there are few good original ballads composed by singers. Yet, thanks to the work of scholars and researchers, enthusiasts can enjoy on records and in books the best of the ballads sung by men and women who have inherited their art from their fathers and mothers, in the time-honoured fashion.

Scanning God

'Know then thyself; presume not God to scan', advised Alexander Pope. But, some of the most compelling poetry ever written has concerned the nature of God and Man's relationship with him.

'They hand in hand, with wandering steps and slow/Through Eden took their solitary way.' Two lines from 'Paradise Lost' show Milton in an unusually tender mood.

An engraving of the *Eurydice* about to capsize after a squall. Gerard Manley Hopkins wrote one of his most passionate poems about the incident, entitled 'The Loss of the *Eurydice*'.

WHAT IS religious poetry? Is all poetry religious because, as W. H. Auden has said, the very act of writing a poem constitutes a religious act? Can religious poetry only be written by a believer in a religious faith? The answer to both these questions is 'yes'. But, more narrowly defined, religious poetry deals directly with the nature of belief or with God in some form.

The quality of religious poetry has differed greatly through the centuries and, within any generation of poets, there is as wide a difference in their approach to religion as there are varieties of religious faith. Yet there is a definable watershed in religious verse, which can be placed about 1500. On the one side there is Old- and Middle-English poetry, on the other what is called 'modern' poetry. This was a turning point in literature for several reasons, many of which are directly related to the causes of change in religious verse. The specific outcome of the change was that religious poetry became more personal, more questioning and relied less on an assumed background of common faith.

Anglo-Saxon verse was a vitally alive tradition when it first received the impact of Christianity and, while it owed much to the new religion, the traditional themes were not ousted. 'Beowulf' and 'The Battle of Maldon' were written down long after the advent of the gospel teaching. Although they did show some Christian elements, they had an ancestry reaching back several centuries BC, and were concerned with the ancient conception of the hero and with honour in battle.

But Christianity was celebrated fully in several Anglo-Saxon poems, notably 'The Dream of the Rood', 'The Fall of the Angels' and 'The Ascension'. What distinguishes them is their literal quality, as this passage from 'The Dream of the Rood' shows:

When the Hero clasped me, I trembled in terror,
But I dared not bend me nor bow to earth,
. . . I was wet with blood
From the Hero's side when he sent forth his spirit.

Middle-English poetry is never so direct – Man's relationship with God through the medium of a poem becomes more troubled and complex. Chaucer never takes religious faith as his main theme, though it inevitably plays a large part in his work. He often mocks the excesses of established religion – as the Abbot and the Pardoner are mocked for their greed and worldliness in 'The Canterbury Tales' – but never Christianity itself. The Abbot and the Pardoner have transgressed what was to Chaucer a deeply held moral code – his sympathetic portrait of the poor parish priest in the 'Tales' shows what he thinks a true churchman should be like.

Severe and puritanical

The greatest religious work written in England at this time was William Langland's 'Piers Plowman', a long allegorical poem which examined the nature of Christian existence, of the possibility of leading the good life in Christian terms. The poem is sometimes severe and puritanical in tone, for it mirrors the religious attitude of the times, which was unbending and often cruel in its rigorous application of the laws of the faith.

But it was Italy which produced the greatest religious poem of that or any other period – Dante's 'The Divine Comedy'. Born in Florence in 1265, Dante is hailed by some as the forerunner of the Renaissance, because he broke with the medieval tradition and wrote 'The Divine Comedy' in Italian, not in Latin. In fact, the themes with which he deals are the

medieval concept of humankind as crawling flies in the eye of a mighty God. When Spenser endowed his knight with charity, justice and holiness, he did so in the belief of Man's goodness and importance.

It was this drastic change in poetic temper that was to pave the way for some of the greatest of all religious poets in the English language – John Donne (one-time dean of St Paul's Cathedral), George Herbert, Richard Crashaw, Henry Vaughan and Thomas Traherne. These poets were called the 'Metaphysicals' because of their use of philosophical terms and methods in the structure of their verse. This same questioning pervaded their religious poems, making them stronger, more doubting and also more fervent than religious poetry had ever been before. There are vast differences in their style and in their approach to God : Donne is the fiercest and most intellectually rigorous; Herbert the most direct and lyrical; Vaughan is often mystical; Traherne often preoccupied with problems of sin; Crashaw is elaborate and sometimes remote. But they are generally characterized by the personal force of their poetry, the desire for an intimate dialogue with God on their own terms. One example must suffice, 'The Pulley' by George Herbert:

When God at first made man,
Having a glass of blessings standing by;
Let us (said he) poure on him all we can;
Let the world's riches, which dispersed
lie,
Contract into a span.

So strength first made a way;
Then beautie flow'd, then wisdom,
honour, pleasure:
When almost all was out, God made a
stay,

Perceiving that alone of all his treasure
Rest in the bottome lay.

For if I should (said he)
Bestow this jewell also on my creature,
He would adore my gifts instead of me,
And rest in Nature, not the God of
Nature:
So both should losers be.

Yet let him keep the rest,
But keep with them repining restless-
nesse:
Let him be rich and wearie, that at least,
If goodnesse leade him not, yet weari-
nesse
May tosse him to my breast.

Title is a puzzle

Herbert is the most direct of these poets, yet still he uses quaint and even difficult images in his poem. The idea that God endows Man with all things except the ability to rest, so that he will finally come to him in weariness, is not difficult to grasp, but Herbert embellishes the idea to make it richer than itself. In the first place, the title 'The Pulley' is a puzzle, since there is no reference to a pulley in the rest of the poem. The pulley is, of course, a strange and effective image for the rest that God will not bestow on Man, and which will in the end 'wind him up' to God.

In the first verse, the image of God having a 'glass of blessings' conveys overtones of a chemist mixing various substances to form a potion; this image is continued in the second verse. The last two verses depict God arguing out a point with himself. Such a depiction would have seemed almost blasphemous to earlier (and later) poets, but to Herbert and the Metaphysicals it was quite natural that they

1 The Anglo-Saxon poem 'The Battle of Maldon' was written well within the Christian era, but celebrates an ancient code of heroic conduct. Brihtnoth, its hero, stands in a niche in the wall of All Saints Church, Maldon, England.
2 Wordsworth found God in Nature: his poem 'Lines Written Above Tintern Abbey' is imbued with a sense of harmony and joy.

glories of medieval Christianity. There are three books – 'Heaven', 'Hell' and 'Purgatory'. Through each of these states, the poet is guided by the Latin poet Vergil, and in each he is shown the reward of sin or virtue. The poem is an expression of medieval Man's belief in heaven and hell; in allegorical terms it is a demonstration of Man's need for spiritual illumination and guidance.

The signs of change in religious verse are apparent in Edmund Spenser's allegorical poem, 'The Faerie Queene', written in the latter half of the sixteenth century. Spenser is a greater poet than he is an allegorizer or moralizer – he paints beautiful word-pictures which often obscure his purpose – but in the poem are the beginnings of humanism. Spenser was a man of the Renaissance, although his poetry looks back to the Middle Ages. The distinguishing feature of the Renaissance was its conception of Man as the centre of the Universe, a notion that dispelled the

The poetry and paintings of William Blake are the work of a visionary. *Satan Smiting Job with Sore Boils* is a compelling portrayal of spiritual evil.

The seventeenth-century poet John Donne is the best known of the Metaphysicals. One-time dean of St Paul's Cathedral, his 'Divine Poems' belong to a period of religious crisis.

should endow their creator with the same astuteness and logical nature they prided in themselves.

Milton's preoccupations were different. His epic poem 'Paradise Lost' is an attempt to 'justifie the wayes of God to men', by demonstrating God's goodness and concern for human kind. Though often moving

– as in lines describing the eviction of Adam and Eve from Paradise:

> They hand in hand, with wandering steps and slow,
> Through Eden took their solitary way.

it is generally much less concrete than the Metaphysicals' verse.

It is something of a generalization, but one which contains some truth, to say that the finest English religious poetry was written before the eighteenth century. There were two important and many lesser exceptions to this, but it is true that religious poetry flourishes where there is powerful religious debate, and even strife. Once an established state of affairs exists between Church and State, there is less need for each man to examine his conscience.

The eighteenth-century poets rarely showed more than conventional piety in their poems; their subject was the foibles of mankind, and they considered it almost improper to meddle with things divine. Pope's lines from the 'Essay on Man' were taken as a general rule:

> Know then thyself; presume not God to scan,

The proper study of Mankind is Man.

It is difficult to know whether or not to characterize much of the nineteenth-century Romantic verse as 'religious', for though there is little overt reference to God or to religious subjects, many of the poems deal with experiences of a spiritual nature:

> Nor less, I trust,
> To them I have owed another gift,
> Of suspect more sublime; that blessed mood,
> In which the burthen of the mystery,
> In which the heavy and the weary weight
> Of all this unintelligible world,
> Is lightened: that serene and blessed mood,
> In which the affections gently lead us on,
> Until, the breath of this corporeal frame
> And even the motion of our human blood
> Almost suspended, we are laid asleep
> In body, and become a living soul:
> While with an eye made quiet with the power
> Of harmony, and the deep power of joy,
> We see into the life of things.

The religious feeling obvious in every line from Wordsworth's 'Lines written Above Tintern Abbey' is directed not towards a supernatural being but towards

177

1 George Herbert, a churchman in seventeenth-century England, wrote some of the best devotional poetry in English. 'The Collar' and 'The Pulley' are among his finest.

2 Although not an overtly religious poem, Chaucer's 'Canterbury Tales' mocks the excesses of the religious establishment in the shape of the worldly Pardoner who sells false reliques.

Nature itself. What has caused the poet's almost mystical trance is the trees, the fields, the sky. This has led to the designation of Wordsworth and the other Romantic poets as 'pantheists', those who believe that Nature is God and God Nature. Wordsworth, Keats and Coleridge were Christians, but they found their inspiration in natural things rather than in any abstract contemplation of God.

There is one figure of the nineteenth century whose Christian faith was expressed in magnificent poetry – Gerard Manley Hopkins. Hopkins was a Jesuit priest. He became a Roman Catholic soon after his graduation from Oxford and, like many converts to faith, he is at once more fervent and more questioning than one who has been accustomed to a faith from birth. He, like the Metaphysicals, conducts a personal dialogue with God, experimenting with language and rhythm, but his dialogue is still more passionate, even

desperate, than theirs. This can be seen in the first verse of his poem 'The Loss of the *Eurydice*', with its abrupt, almost indignant opening:

> The *Eurydice* – it concerned thee, O Lord:
> Three hundred souls, O alas! on board,
> Some asleep unawakened, all un-
> Warned, eleven fathoms fallen
> Where she foundered! One stroke
> Felled and furled them, the hearts of oak!
> And flockbells off the aeriel
> Downs' forefalls beat to the burial.

One giant among religious poets belongs to no movement or century. He is William Blake, whose work appeared and was largely ignored, in the latter half of the eighteenth century. His prophetic poems, like 'The Four Zoas' and 'The Book of Los' are extraordinarily complex, full of strange symbolism and self-created cosmologies. The minor poems are, in a sense, a key to

the larger works: here is the first verse of his best known work, 'The Tyger':

> Tyger! Tyger! Burning bright
> In the forests of the night,
> What immortal hand or eye
> Could frame thy fearful symmetry.

This first verse is characteristic: its immense power comes from suggestion, not from literal statement. 'Burning bright', for example, is a metaphor for the power of the tiger, a 'burning' quality. The poem is an attempt to examine how such a powerful beast could be created and, through his creations, to approach the nature of God himself.

The poetry might be called mystic because it transcends all rationality, and uses words to express an inner truth, explicable only through metaphor. Many scholars claim that no Western poetry can be called mystic. Yet certain poets do show, to a greater or lesser degree, insights into 'the nature of things', their 'inscape' as Hopkins called it, which can be called mystic or transcendental. The metaphysical poet Henry Vaughan displays this same quality in his poetry:

> I saw Eternity the other night,
> Like a great ring of pure and endless light,
> All calm, as it was bright,
> And round beneath it, Time in hours, days, years,
> Driv'n by the spheres
> Like a vast shadow moved . . .
> (from 'The World').

The distinguishing feature of all the poets and poems discussed is their sincerity: it would seem that religious poetry, to succeed as poetry, must be the product of some deeply felt faith or a sincere expression of doubt. While no amount of faith can make a bad poet a good one, no amount of skill in versifying can conceal a lack of conviction or a shallowness of faith.

Dante with his poem 'The Divine Comedy' and, on the right, his beloved city of Florence. The poem represents Dante's spiritual development and the quest of the soul for regeneration.

Poetry from the heart

Out of the songs of anonymous minstrels grew the lyrical poem, a personal expression of the poet's thoughts and feelings, which was to have its fullest flowering in the Romantic age.

MOST PEOPLE have experienced the transporting quality of love, the fear of death, the emotions of joy, grief, awe in the face of Nature or art. But only a few have the facility to express their feelings, to set down the significance of the experience in a poem. However deeply felt, the sentiment must be ordered and disciplined before it can achieve its affect. The most powerful emotive works are almost invariably those in which the poet has imposed the greatest measure of control over his material. Poems of this kind, which explore a single idea or emotion in language appropriate to the subject, are known as *lyrics*.

The word 'lyric' is derived from the 'lyre', a musical instrument once used to accompany songs, and it is from songs that the lyric first developed. Not from songs of battle, but from love songs in the courtly tradition. The Elizabethan poet Sir Thomas Wyatt first made the lyric a vehicle for personal expression, and for more than simply the expression of love. He also gave it a definite literary status; before this time the lyric had been composed and sung by anonymous minstrels, and handed down or forgotten according to its merit. Wyatt made it into a writer's medium, an intimate and often dramatic statement. Yet the influence of music is still to be seen in many of his lyrics:

My lute awake! perform the last
Labour that thou and I shall waste,
The end that I have now begun;
For when my song is sung and past,
My lute be still, for I have done.

Poem with a single theme

The poem from which this verse is taken – 'My Lute Awake' – may have been composed to be sung as a song – it certainly calls itself a song – but may equally well have been meant to be simply recited or read in private. The practice of private reading influenced writing, and forms that had been taken over from the oral tradition were changed radically. The content in a lyrical poem, as compared with a song, could be much more complex: though the poem still dealt with a single theme, usually an aspect of love, it relied less upon repetition and simple lines and more upon subtleties of thought and expression for its effect.

The richest period in English literature for the impassioned lyric, the poetry of emotion, is the nineteenth century. In reaction to the rational, social poetry of the preceding century, the Romantic poets explored again the themes that had moved the Elizabethan lyricists. They wrote of love, of Nature's beauty, of death, of mystery. The choice of subject was dictated by their feeling that poetry must pierce deep into the more exalted states of Man's mental and emotional life. Wordsworth in fact defined poetry as 'the spontaneous overflow of powerful feelings'. Here are two verses from Keats's 'Ode on a Grecian Urn', a poem celebrating the enduring nature of art:

Ah, happy, happy boughs! that cannot
shed
Your leaves, nor ever bid the Spring
adieu;
And, happy melodist, unwearied,

1 Tennyson's Lady of Shalott is doomed to die when she turns from the shadows in her mirror to gaze upon the real world. Floating down the river, she gradually expires in her boat.
2 The Elizabethan poet Sir Thomas Wyatt introduced the sonnet into England from Italy and

For ever piping songs for ever new;
More happy love! More happy, happy
love!
For ever warm and still to be enjoy'd,
For ever panting, and forever young;
All breathing human passion far above,
That leaves a heart high sorrowful and
cloy'd,
A burning forehead and a parching
tongue.

Who are these coming to the sacrifice?

wrote some of the first lyrical poems in English.
3 An illustration to lines from Gray's 'Elegy'. 'There at the foot of yonder nodding beech, That wreathes its old fantastic roots so high, His listless length at noontide would he stretch; And pore upon the brook that babbles by.'

1

2

3

179

To what green altar, O mysterious priest,
Lead'st thou that heifer lowing at the
skies,
And all her silken flanks with garlands
drest?
What little town by river or sea shore,
Or mountain-built with peaceful citadel,
Is emptied of its folk, this pious morn?
And, little town, thy streets for ever-
more
Will silent be; and not a soul to tell
Why thou art desolate, can e'er return.

The sensuous and evocative nature of the images is characteristic of the Romantic lyrics, while the permanence of art contrasted with the mutability of life is a favourite Romantic theme.

Wordsworth was the first great Romantic poet, and in his preface to a collection of poems entitled *Lyrical Ballads,* he sets forth the first creed of the lyrical-Romantic poet: 'The principal object, then, proposed in these poems, was to choose incidents and situations from common life, and to relate or describe them, throughout, as far as possible in a selection of language really used by men and, at the same time, to throw over them a certain colouring of imagination, whereby ordinary things should be presented to the mind in an unusual aspect; and . . . to make these incidents and situations interesting by

Shelley was drowned at the age of 30 while sailing off the Gulf of Spezia in Italy. His body was burned according to the ancient Greek tradition and his ashes buried in Rome.

tracing in them . . . the primary laws of our nature.'

This piece of theory gave the Romantic poets the starting point for all their best work, which was an investigation into 'ordinary things . . . presented in an unusual aspect'. Though Byron was more interested in the extraordinary, the importance the Romantics placed upon the imagination and the senses remained common to them all, right up to Tennyson, the last of them. Some of Tennyson's lyrics are among the most beautiful of that

school – here are the opening lines of 'The Lotus Eaters':

There is sweet music here that softer
falls,
Than petals from blown roses on the
grass,
Or night-dews on still waters between
walls,

'Full on the casement shone the wintry moon, And threw warm gules on Madeleine's fair breast': Millais's painting evokes the sensuous quality of Keats's poem 'The Eve of St Agnes'.

The quest for the Holy Grail — the vessel used by Christ at the Last Supper — occupied many of King Arthur's knights and is recounted in Tennyson's poem 'The Idylls of the King'. Because of his purity, Sir Galahad was at last successful.

The Romantic spirit all over Europe was imbued with a love of the mysterious and the macabre. Ghosts and other supernatural beings figure in much Romantic literature.

Of shadowy granite, in a gleaming pass.

The distinguishing feature of this type of poetry is the concentration on the thing itself for its natural qualities, the appreciation of objects and events for their purely sensuous qualities.

It is not easy to imagine, in this century which has seen a revolt in poetry and the arts against the Romantic movement, how widely the Romantic poets were accepted as spokesmen for their times. Most popular of all was Lord Byron, who embodied certain elements of the Romantic world in his very life. He was not the best of that talented group — there is much that is sentimental and much that is false in his work — but he caught the imagination of his age, and embodied many of its aspirations. Matthew Arnold, who saw Byron from the perspective of some years, wrote of him:

He taught us little, but our soul
Had *felt* him like the thunder's roll.

The strength of poems like 'The Corsair', 'Childe Harold's Pilgrimage' and 'Don Juan' lay in their communication of excitement, of youthful fervour, of emotion that could not be contained. Nobility, honour, pure love — all these feelings have been to some extent discredited since Byron's day, but it must be remembered that for his audience they were very real, and very admirable.

If Byron was in many ways a symbol of the Romantics, Shelley was their finest singer. He lived much of his short life in Italy, where he met Byron and where he wrote his best work. Though he wrote two long dramatic poems – 'Prometheus Un-

bound' and 'The Cenci' – his best work is contained in his songs and short lyrics, poems like 'Adonais' (written on the death of Keats in 1821), 'Ozymandias', and 'To a Skylark'. It has been said that Shelley has two styles, the gorgeous and the simple: it is the simple which appeals more to modern ears. Here are the last lines of 'Ozymandias':

And on the pedestal these words appear:
'My name is Ozymandias, king of kings:
Look on my works, ye mighty, and
despair!'
Nothing beside remains. Round the
decay
Of that colossal wreck, boundless and
bare
The lone and level sands stretch far
away.

The Romantic movement was a brief flowering between the rationalism of the eighteenth century and the more solemn works of the later Victorian age. Where the Augustan poets of the previous century had exalted the reason, the Romantics exalted the heart and the heart's emotions. That this led to excesses was inevitable: it also gave expression to poems like Coleridge's remarkable ballad 'The Ancient Mariner' and his inspired dream-poem, 'Kubla Khan':

In Xanadu did Kubla Khan
A stately pleasure dome decree:
Where Alph, the sacred river ran
Through caverns measureless to man
Down to a sunless sea.

A form of lyric poetry that is very

A scene from 'Childe Harold's Pilgrimage' in which Byron (thinly disguised as Childe Harold) visits foreign lands to seek distraction from a life of revelry and luxury.

specialized and stands in contrast to much of the Romantics' work (though they used the form from time to time) is the sonnet. Like the lyric, it was introduced to England by Wyatt in the sixteenth century. Petrarch, the great Italian sonneteer of the fourteenth century, was an important influence, and has remained so to this day: he was one of the first to record the personal anguish and joy of the poet himself.

Sir Philip Sidney (1554–86) created in his 'Astrophel and Stella' the first of the sonnet sequences written in English, relating the melancholy progress of his love. Ostensibly addressed to Penelope Devereux, daughter of the earl of Essex, on one level the sonnets are personal, but on another they are symbolic and explore the nature of love in general. Though over-coloured and lacking the simplicity of the best sonnets of Shakespeare, who wrote some years after him, they are at times beautifully tender and always give the impression of sincerity, of coming from the heart. Indeed, he held the heart as the true source of his inspiration.

A Shakespearean sonnet

The following sonnet by Shakespeare is one of the most famous in the English language:

Shall I compare thee to a summer's day?
Thou art more lovely and more tem-
perate:
Rough winds do shake the darling buds
of May,
And summer's lease hath all too short a
date:
Sometime too hot the eye of heaven
shines,
And often is his gold complexion dimm'd;
And every fair from fair sometime
declines,
By chance or nature's changing course
untrimm'd;
But thy eternal summer shall not fade
Nor lose possession of that fair thou
ow'st;

Handsome and famous though he was, Byron suffered from a morbid sense of isolation. The gloomy yet flamboyant Byronic hero was imitated throughout Europe, in life as well as literature.

Nor shall Death brag, thou wander'st in
his shade,
When in eternal lines to time thou
grow'st:
So long as men can breathe or eyes can
see,
So long lives this, and this gives life to
thee.

The poet is not so much praising the beauty of the woman addressed, as the immortality she will achieve in his poem. He speaks of the irreversible course of time, the changes it effects on physical beauty, and contrasts this decay with the immortality of a poem, which will continue 'So long as men can breathe or eyes can see'. This is a simple enough contrast; indeed, it could be said that many of the best sonnets turn on a simple idea, and depend for their effectiveness on the originality with which it is treated by the poet.

Originality of presentation is a prerequisite of every good poem: the sonnet form demands another element: compression. The idea must be expressed in 14 lines and in a tightly organized rhyme-scheme. This restriction on length offered a chal-

lenge to the poet: most sonnets take a universal theme, say, the fear of old age, and produce a variation upon it, rather in the way a musician composes a variation on a well-known musical theme. It is also a good medium for originality and wit – Shakespeare's sonnet is witty in the sense that it proves a simple point (that a poem lasts longer than a human being) in a cunningly fresh manner.

Lyric poetry is the prevalent mode in contemporary verse, for it is the only classification that covers the bulk of modern poetry. Poets no longer write 'satires' or 'odes' or 'elegies', though their poems may contain elements from these earlier types. Even when this division of poems into categories was common, the content was often lyrical as, for example, the first verse of Thomas Gray's 'Elegy Written in a Country Churchyard':

The curfew tolls the knell of parting day,
The lowing herd winds slowly o'er the
lea,
The ploughman homewards plods his
weary way,
And leaves the world to darkness and to
me.

Thus, even in a poet supposedly so 'difficult' or 'intellectual' as T.S. Eliot, there are lyrical passages within his poems:

The yellow fog that rubs its back upon
the window panes,
The yellow smoke that rubs its muzzle
on the window panes,
Licked its tongue into the corners of the
evening,
Lingered upon the pools that stand in
drains.
('The Love song of J. Alfred Prufrock')

This is lyric verse in a descriptive mood, evoking not a romantic scene certainly, but very effectively creating a mood of gentle melancholy. With the inevitable shift of temper that comes from a passing of time, the modern poetic mode rejected the fervid lyrics of the Romantics in favour of something more subtle, less passionate. A modern love lyric is apt to contain a large amount of bitterness, or reservation; it is hardly likely to be, as the Romantics' were, a paean of undiluted praise for the loved one. Here is the first verse of *Lullaby,* a poem by W.H. Auden, who reached prominence in the 1930s:

Lay your sleeping head, my love,
Human on my faithless arm;
Time and fevers burn away
Individual beauty from
Thoughtful children, and the grave
Proves the child ephemeral:
But in my arms till break of day
Let the living creature lie,
Mortal, guilty, but to me
The entirely beautiful.

The lyric, after all, is fundamentally the poet's celebration of an existing state of affairs, whether it be love, or a natural scene, or an event. Though it is an expression of his personal feelings, it is a very deliberate act: it is emotion given form through a poem.

Poetry for our time

In the early part of our century three poets — Pound, Yeats and Eliot — changed the course of poetry written in English. What was so special about them, and how have they affected later poets?

The devastation of the First World War had a profound effect on the poets of the time. Among them, Edmund Blunden and Wilfred Owen wrote of their war experiences.

ONE NIGHT, just after the century's turn, two spinster sisters found a dancing girl in the rooms of a lecturer who lodged in their boarding house. Duly reported to the authorities of Wabash College, Indiana, young Ezra Pound lost his first academic job, missed his likely destiny as an American professor, and roved in 1908 to Europe. There he met Uncle William (as he called him), the Irish poet William Butler Yeats, and T.S. Eliot, another American. Between the three of them, two Americans and one Irishman, they changed the face of poetry written in the English language. What they did, and what has happened since, still bears the name of Modern Poetry.

That these three giants can still be described as 'modern' in such a fast-moving century is no small feat. For English is a rich, world-wide language, and more poetry is published in it today than ever before. Yet behind the sound of poetry read, say, by the American poet Robert Frost at President Kennedy's inauguration, or listened to by a packed Albert Hall in London, or even written and sung by the Beatles, lies the effect of Pound, Yeats and Eliot. What special thing happened to poetry at their hands to give them their definitive status?

Their poems, and their lives, were not alike. Pound, the wandering expatriate, made his major achievement — the very

long and very difficult 'Cantos' – a melting pot of his vast reading and quirky ideas. In the Second World War he found a perch in Mussolini's Italy and broadcast his odd economic theories and his dislike of the American establishment. This was embarrassing enough for the American authorities to persuade them to tidy him away into a lunatic asylum at the end of the war. Eliot, on the other hand, became the most honoured man of letters of his time. He worked in publishing and became a High Anglican. It took him five years, from 1910 to 1915, to find an editor daring enough to print in 'The Love Song of J. Alfred Prufrock') lines like:

I grow old . . . I grow old . . .
I shall wear the bottoms of my trousers rolled.

And he survived to see his major works 'The Waste Land', 'The Four Quartets' and others become part of the texture of every educated mind.

Poetry of passion

Yeats, finally, had perhaps the widest reach of them all. He founded the Irish National Theatre, was an Irish Senator, won a Nobel Prize. He probed deep into Irish myth and legend, further still into psychic investigation and vision. He believed that 'the natural and supernatural are knit together', that the poet is an oracle. Poems like 'The Second Coming', and 'Sailing to Byzantium' are examples of the oracular Yeats, and among the very greatest in English literature. But he also wrote poetry of passion and suffering.

Robert Graves lives in seclusion on the island of Majorca. He has said 'the traditional theme of all good poetry is the love and fear of the poet for a beautiful woman'.

Eliot called Yeats's middle and later work 'a great and permanent example of a kind of moral as well as intellectual excellence'.

Take three fragments from their work: the first, a complete poem, is by Ezra Pound, called, 'In a Station of the Metro'.

The apparition of these faces in the crowd
Petals on a wet, black bough.

Next, from 'The Waste Land' by Eliot:

Madame Sosostris, famous clairvoyante,
Had a bad cold, nevertheless
Is known to be the wisest woman in Europe
With a wicked pack of cards. . . .

And third, from 'The Second Coming', by Yeats:

Turning and turning in the widening gyre
The falcon cannot hear the falconer;
Things fall apart; the centre cannot hold;
Mere anarchy is loosed upon the world,
The blood-dimmed tide is loosed, and everywhere
The ceremony of innocence is drowned;
The best lack all conviction, while the worst
Are full of passionate intensity.

Pound's poem is a single image. Given the experience of seeing beautiful, haunt-

ing girls' faces in a crowd, he worked on it until he had caught it in 14 words. This concentration on the importance of the image – Pound and his friends developed it into a theory called Imagism – is something that especially marks modern poetry.

Of course, poets had used images before. And Pound and his associates eagerly rediscovered those poets to whom imagery had been most vivid and essential, such as John Donne, one of the 'Metaphysical' poets of England. Pound's major discovery was the huge world of Oriental writing and its ideograms. All three poets were dauntingly well read. In fact it is this aspect of the three giants' work that frightens people away from modern poetry.

But the poets were not being consciously clever in drawing in this way on the richness of their reading. They simply wanted to put English poetry back into the mainstream of European poetry, and back on to a proper level of seriousness fitting to the complex century in which they lived. They were receptive not only to the wide world of other literature, but to the world of very ordinary, everyday human experience as well. Perhaps it is this extraordinary mix of culture and experience that most gives their work its character. Said Eliot: 'the ordinary man falls in love, or reads Spinoza, and these two experiences have nothing to do with each other, or with the noise of the typewriter or the smell of cooking; in the mind of the poet these experiences are always forming new wholes.'

The musical phrase

A great part of their modernity lies, too, in the rhythms they used. In the same spirit that he had said 'use no superfluous word, no adjective which does not reveal something' Pound sought for a way to use rhythms that fitted more closely with the sense of his words than traditional metre pedantically used would do. This is what he meant by saying that the poet must 'compose in the sequence of the musical phrase, not in the sequence of the metronome'. One of the first things that must be said about the new poetry is that it has nothing to do with rejection of rhythm. By 1918, Pound had stern things to say about the sloppiness of poets who indulged in 'free verse' (*vers libre*) as if this were the answer to all their problems. 'Vers libre', he said, 'has become as prolix and as verbose as any of the flaccid varieties that preceded it.' Pound simply claimed that there could be a much tighter interweaving of sense and rhythm than the traditional measure, the *iamb*, allowed. 'Don't chop your stuff into separate *iambs*', he begged other poets. 'Don't make each line stop dead at the end, and then begin every next line with a heave. Let the beginning of the next line catch the rise of the rhythm wave, unless you want a definite longish pause.'

New interest in rhythms awoke new interest in an extraordinary Victorian poet, Gerard Manley Hopkins, who had already adopted the exciting and difficult measures of much earlier English poets, such as Langland. And in Eliot – often at his most seemingly conversational – can

1

be found the measures of ancient Greece.

Finally, the factor that marks the poetry of the three giants very specially is a tremendous social sense about the general plight of their times. They worked, of course, amid the ruins of the world's bloodiest war, and the beginnings of those times in which the individual's life often seems hollow and waste. The lines quoted from Yeats are among the most sublime expression of this pessimism and despondency in these poets' work. Pound's greatest early poem 'Hugh Selwyn

1 In Yeats's poetry, images of age contrast with those of dancing and blossoming, while a gold enamelled nightingale, symbol of permanence, sings 'to lords and ladies of Byzantium/Of what is past or passing or to come'.
2 W. H. Auden was a stretcher-bearer during the Spanish Civil War, an experience which shaped his attitudes and found a voice in some of his best poetry.
3 T. S. Eliot's poetry is a shifting landscape of symbol and allusion; his foremost concern was to create new wholes from separate fragments of experience.

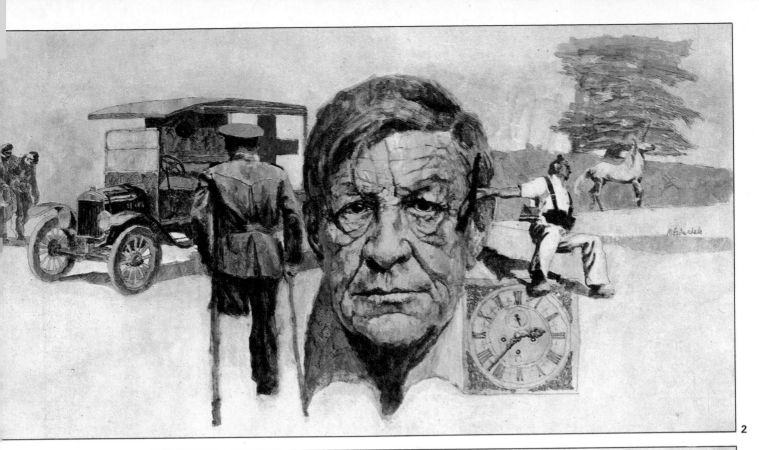

Mauberley', and Eliot's 'The Waste Land' and 'The Hollow Men' are of the same order. By 1918, Pound had this to hazard about the future of poetry: 'As to twentieth-century poetry, and the poetry which I expect to see written during the next decade or so, it will, I think, move against poppycock, it will be harder and saner . . . nearer the bone.' Fifty odd years later, it seems not a bad assessment. Things have worked out differently in Britain and America, of course, and the really important poets in either country are too big to

bundle into tidy groups and movements.

W. H. Auden, for example, is far too important to be slotted as the poet of the 1930s, and to be spoken of in the same breath as Stephen Spender and Louis MacNeice and Cecil Day Lewis. Nevertheless, in a brief summary, it is round these names that the poetry of the 1930s in Britain hangs. Auden, born in 1907 is undoubtedly the major poet of this era born in England. He is a wide traveller – born in York, emigrating to America, settling in Austria; and voyaging on the

way from Marx to Christ. The gloom of the 1930s and the Spanish Civil War shaped his work and that of the others named. Twenty-one years after Pound's piece of prophecy, Auden was writing a poem called '1st September 1939':

> I sit in one of the dives
> On Fifty-second Street
> Uncertain and afraid
> As the clever hopes expire
> Of a low dishonest decade.

Auden eludes easy definitions of his worth.

He wrote no one poem with the obvious stature of a masterwork. The sound of his poetry can be masculine, almost rough and ready rhythmically – yet conceal great technical expertise, awareness of Anglo-Saxon poetic forms as well as of ballads and blues. He is a public poet in his concern with truth and the state of Man as a political animal. But he is also a private poet of some of the best lyrics. ('Lay your sleeping head, my love,/Human on my faithless arm' is one of his best.) He has commented on this double task of his poetry himself: 'Art arises out of our desire for beauty and truth and our knowledge that they are not identical.'

It is arguable that almost everything else in the British part of modern poetry's story is in some way an evasion of the double task of dealing with both beauty and truth, of making a *whole* experience from Spinoza and the smell of cooking. Perhaps we live in an age too fragmented, too difficult, for anybody to make a synthesis honestly any more.

There are several ways to batten down the hatches, while the storm rises outside. The Georgian poets were a group who loved the countryside. Their work began before the First World War, and continued after it, marshalled into a series of anthologies called *Georgian Poetry*. Rupert Brooke, Robert Graves, Edward Thomas and D. H. Lawrence published in these collections. Most of them had as their master Thomas Hardy. Theirs was the hard fate to see a green world smashed by war – a war which killed some of them and broke the spirit of others. As a place to put their faith, the countryside failed – the hatches blew off. Here is something from a poem by Edmund Blunden:

I saw the sunlit vale, and the pastoral
 fairy-tale;
The sweet and bitter scent of the may
 drifted by;
And never have I seen such a bright
 bewildering green,
But it looked like a lie,
Like a kindly meant lie.

When Eliot called one of his 'Four Quartets' after a place in the countryside, Little Gidding, he was doing something very different. The difference is this: Georgian poetry, at its best, wonderfully takes the mood and meaning of its subjects – but there is not much beyond the edges of their poems except a sweet nostalgia to give that sunlit vale the strength to survive. Eliot sees a particular place just as vividly – the names of the quartets, 'Little Gidding', 'East Coker' and the rest are not just identity tags – but the place is also part of a much vaster landscape of the soul.

There is, of course, a place for poetry about the smaller parts of life – odd corners of landscape and odd people. The Georgian tradition did not utterly die with the First World War: John Betjeman has kept it hauntingly alive with his cameos of suburban summer afternoons, the sounds of tennis balls and teacups and the gentle eccentricities of the upper middle class at church and play. Nor did all the original Georgian poets fade away – Robert Graves, self-exiled to Majorca, has found his own

true voice, poems largely based on his claim that 'the true traditional theme of all good poetry is the love and fear of the poet for a beautiful woman'.

In the 1940s, with another war upon the world, the general mood in poetry was once again for something more vital than teacups – or even the dry realism of Auden. The times were apocalyptic, and poetry swung towards the grand, bardic manner. The major figure of the time was the Welshman Dylan Thomas. For him, language was something of an end in itself. He became drunk with it. The Welsh have always delighted in the sound of words, and Dylan Thomas at his best (in his early poems, and in his poetic drama 'Under Milk Wood') makes magic out of them. But in the end he very often used sound for the sake of it, with very little meaning.

Just dull

Since the Second World War, poetry has become limited in quite another way. Reacting against the sound and fury of the poets of the 1940s a number of people began to work together under the name of 'The Movement'. They were followed by another number who became known as 'The Group'. If Pound has ever noticed them, he must have been surprised by the interpretation now put upon the 'move against poppycock'. Kingsley Amis, a Movement writer, wrote in the 1950s 'Nobody wants any more poems about philosophers or paintings or novelists or art galleries or mythology or foreign cities or other poems. At least I hope nobody wants them.' At its best, this attitude (which fits in well with a traditional tenor in British philosophy, careful, empirical and common sense) did create poems of honesty – particularly in the work of Philip Larkin. At its worst, it led to

poems that sounded honest but were really just dull.

In their daily jobs, the Movement people were quite academic. The Group, a reaction against them, stressed the importance of daily toil. Much to the pleasure of the critic and poet Alfred Alvarez, who was more aware than most of the spirits that were moving American poetry at this period, the Group poets began to take as their themes aspects of the violence of our times. But sometimes, just as honesty can be diminished to dullness, the subject-matter of the Group poets often seems little more than nasty (Hobsbaum wrote a poem about his teeth falling out).

However, in the late 1960s in Britain more and more younger poets seem to be showing an openness to the real roughness of the world as it is that can be the breeding ground of the best poetry. Revolution, noise, poems presented as manifestos and posters began to appear – many of them, admittedly, superficial or downright bogus. But at least they showed the art was still alive, 'closer to the bone'.

And at the same time, awareness has been growing of the sort of poetry now being written in America, and the special heritage behind it. The association seems likely to be fruitful, and not merely imitative. At the same time, many of the best poets of this century in Britain have been those who have carved out their work from a close association with their own special part of the country – Edwin Muir of the Orkneys, Jack Clemo of Cornwall, Hugh MacDiarmid of Scotland. This is a special kind of vocation. For the state of the game as a whole, a blood transfusion from American poetry seems very likely indeed to be what is needed to strengthen British poets to lift the hatches of their craft and face the storm again.

The American expatriate Ezra Pound has exerted a strong influence on modern poetry, notably that of T. S. Eliot and W. B. Yeats. His major life-work is the 'Cantos'.

Adrian Henri, one of the Liverpool poets of the 1960s, became interested in poetry and jazz in 1961. In 1968 he published a book of poems entitled *Tonight at Noon*.

Poetry of the New World

The achievement of American poets is that, forced to write in a language with a rich tradition of lyric verse, they have forged a tool to express what is genuinely and uniquely their own.

'. . . ON APRIL 16, 1862, I took from the post-office the following letter: "Mr. Higginson, – Are you too deeply occupied to say if my verse is alive? The mind is so near itself it cannot see distinctly, and I have none to ask. Should you think it breathed, and had you the leisure to tell me, I should feel quick gratitude. . . ." The letter was post-marked "Amherst", and it was in a handwriting so peculiar that it seemed as if the writer might have taken her first lessons by studying the famous fossil bird-tracks in the museum of that college town. . . .'

So Mr Higginson, a worthy Unitarian clergyman, describes his encounter with Emily Dickinson, an utterly extraordinary poet.

Higginson had written a piece of encouraging journalism to America's young authors. It was this that inspired shy Emily to write to him – though she did not bring herself to sign the letter, but enclosed with it a card lightly pencilled with her name. They corresponded for years, she sending him her poems, he sending her advice of which, fortunately, she only pretended to take notice. They met for the first time eight years later. 'It was at her father's house,' recalls Higginson. 'It was one of those large, square, brick mansions so familiar in our older New England towns, surrounded by trees and blossoming shrubs without, and within exquisitely neat, cool, spacious and fragrant with flowers. After a little delay, I heard an extremely faint and pattering footstep like that of a child, in the hall, and in glided, almost noiselessly, a plain, shy little person . . . with eyes as she herself said, "like the sherry the guest leaves in the glass".'

Emily lived her whole life, cool and fragrant with flowers, in her father's house. She wrote close to 2,000 poems. Seven were printed in her lifetime and it was not until 1958 that editors gave up trying to 'improve' her punctuation (all dashes and capital letters). Yet in this seclusion she reached what Henry James has called 'the landscape of the soul'. Her poems, all brief, all in short words and short lines, catch vast terrors of life and death into the space of a brilliant snatch of language. They add up to a 'letter to the world' – the way she defined it herself.

She wrote of things closely, disquietingly observed:

A bird came down the walk:
He did not know I saw;
He bit an angle worm in halves
And ate the fellow, raw.

She catches the nature of despair in two words:

And that White Sustenance –
Despair –

Allen Ginsberg, one of the 'beat' poets who became widely known in the 1950s. Often operating as 'drop-outs', they reject the conventions of ordinary society in their search for new values.

Robert Lowell's verse is packed with vivid images which convey a strong sense of the thing described but which lead the reader on further into a visionary world.

And she wrote:

Because I could not stop for Death,
He kindly stopped for me;
The carriage held but just ourselves
And immortality.

Emily Dickinson, born in 1830, is completely a modern poet. She is typical of nobody but herself, yet she is typically an American poet. For American poets seem very often driven to find some kind of privacy to conduct their business in. They become hermits, like Emily; or they emigrate, like Pound and Eliot; or they go mad, either for good or periodically, like Hart Crane or Theodore Roethke; or they live oddly double lives, like Wallace Stevens, who was the vice-president of an insurance company for most of his life; or they turn their backs on the 'American Dream', like the 'beat' poets seeking Buddha.

Perhaps the explanation is that the American Dream is not a poetic one: the heart of the vast country lies not in its literary activities but in its huge struggle to master its resources – the Wild West, the Ford assembly line, the melting pot of immigrant races. Certainly America has no poets, as most other nations have, who act as national bards. Isolation has had the effect of driving poets into their own very personal search for that landscape of the soul. They have had to write in a language already made by Shakespeare, Chaucer and Milton in another place, and they have remade that language. The

result has been that even the earliest American poetry that is not simply an imitation of English forms seems vitally modern to European ears. It has the boldness of experiment, the brightness as of fragments chipped from flint by a new discoverer of stone axes, working out the problem of sharpness for himself.

Here, for example, is an American born about 1645, Edward Taylor, writing about a spider catching a fly. First, the spider lands a wasp in his web, and is wary of it:

But as afraid, remote,
Didst stand hereat,
And with thy little fingers stroke
And gently tap
His back.

It goes differently with the fly:

Whereas the silly Fly,
Caught by its leg,
Thou by the throate took'st hastily,
And hinde the head
Bite Dead.

There is the same tightness of language, the same closeness to the event that Emily achieves. American poets may stand slightly to one side of daily life in their daily lives, but they do not dodge or evade the central issues of poetry – they have that 'closeness to the bone' that Ezra Pound recommended.

'Closeness to the heart' might be the better description: many American poets, like Emily, have written what has come to be termed 'confessional' poetry. It is the

job of opening windows into the poet's own soul, and because great human hopes, fears, emotions are common to the rest of us, opening windows into the reader's soul, too. In the late 1960s, one of the poets doing it was William Wantling, five years in San Quentin gaol for drug addiction. Here, in *Heroin*, he recalls 'what I remember of the good times . . .'

and once, high . . .
so high I never reached that peak
again, happy my wife & I
lie coasting beside a small pond
in an impossibly green park
under a godblue sky.

Mental agony

The major confessional poet of the age has been Robert Lowell, born one year from the end of the First World War, and imprisoned in the second for pacifism. Lowell is a member of one of Boston's most famous families. His two most important books are *Life Studies* and *For the Union Dead*. Here, in 'Skunk Hour' he used words of one syllable to state mental agony:

One dark night,
my Tudor Ford climbed the hill's skull,
I watched for love-cars. Lights turned
down,
they lay together, hull to hull,
where the graveyard shelves on the
town . . .
My mind's not right.

The hill is like a skull; the courting couples lie close to the graveyard. Only the skunks are out and about:

a mother skunk with her column of
kittens swills
the garbage pail.
She jabs her wedge-head in a cup
of sour cream, drops her ostrich tail
and will not scare.

It is, like Taylor's seventeenth-century spider stroking a wasp, a way of looking quite straightforwardly at things, yet through them into a visionary world as well.

Mr Higginson asked Emily if she had read Walt Whitman. 'I never read his book, but was told that it was disgraceful,' she replied, and for once was well in line with the opinions of her countryfolk. Whitman's book was *Leaves of Grass,* published for the first time in 1855. Everything about it was expansive, novel, extraordinary, against the pattern of verse writing of the age. His age thought Whitman obscene and left him largely unread. He is the major American poet – almost a 'national' poet, though the America he talks of in his wide, flowing free verse is a dream America. Certainly he is a 'universal' poet, in the sense that his 'Song of Myself' is the song of Everyman.

While Emily caught a place within the frame of her little lines, Whitman takes a deal more space for the same task, but in this lies perhaps the second special talent of American poetry next to (but of course related to) its closeness to heart and bone. In the lines that follow, Whitman displays a lilac-bush, in a poem called 'When Lilacs Last in the Dooryard Bloom'd'. As

1

a whole, the poem concerns the death of Lincoln. But the lilacs are there for their own sake, too, and the words and shape of the lines are there to do the job of telling about the lilacs. Traditional poetic forms are abandoned, lest they stand in the way of the job in hand:

In the dooryard of an old farmhouse
near the white-wash'd palings,
Stands the lilac-bush tall growing with
heart-shaped leaves of rich green,

1 In his long, rolling lines Walt Whitman speaks as the voice of America. In poems like 'Song of Myself' he urges the reader to think as he thinks, feel as he feels, to sense the inner life of America through its outward forms.
2 Living her whole life in her father's secluded mansion, Emily Dickinson experienced an intense and passionate inner life which is revealed in some 2,000 poems. Cool, serene, surrounded by flowers and books, she explored in her short lines and vivid images her conception of life and her concern with death.

3 Robert Frost wrote personal poems, many of them deeply pessimistic, which are closely related to the spirit and texture of the New England countryside that was his home.

With many a pointed blossom rising
delicate, with the perfume strong I love,
With every leaf a miracle – and from this
bush in the dooryard,
With delicate-color'd blossoms and
heart-shaped leaves of rich green,
A sprig with a flower I break.

What Whitman was doing explains another major poet of our own age. William Carlos Williams (1883–1963) was to break 'through the deadness of copied forms which keep shouting above everything that wants to get said today, drowning out one man with the accumulated weight of a thousand voices in the past. . . .' Williams also was a pathfinder to new verse forms: 'I was early in life sick to my very pit with order that cuts off the crab's feelers to make it fit into the box.' He believed that poetry should be counted not by its syllables but by the musical beat of its lines.

Today my son told me
that in the meadows
at the edge of the heavy woods
in the distance, he saw
trees of white flowers.
I feel that I would like
to go there
and fall into those flowers
and sink into the marsh near them.

Thus Williams writes in 'The Widow's Lament in Springtime'. You notice how carefully, in what a painterly way the trees are placed – in the meadows, at the edge, in the distance, just as Whitman places his lilac-bush, Emily her bird.

The freedom of form available to American poetry lifted a number of poets from smallness to greatness. Edgar Lee Masters, a Chicago lawyer, found his voice in 1915 after publishing a number of undistinguished things. His new work was *The Spoon River Anthology*. Here, in 'The Hill', he talks of the local dead:

Where are Elmer, Herman, Bert, Tom
 and Charley,
The weak of will, the strong of arm, the
 clown, the boozer, the fighter?
All, all, are sleeping on the hill.

Rugged appearance is not the only face of American poetry. The complexity of word and form in Ezra Pound and T.S. Eliot show that. In post-war America, a number of the better writers have been polished and academic – Richard Wilbur is a fine example – and excellent translators of foreign classics and poetry. But there has always been a kind of dualism in American verse, just as American life mixes urbanity and violence freely. Beating a path away from the university campus and its resident poet is a whole flock of barefoot 'drop-out' poets, searching, as Pound did in the far East, for a better meaning to it all. The wildest and most lasting declaration of this school remains Ginsberg's *Howl*. Others have found a voice in song – the lyrics of Simon and Garfunkel are examples of this.

In a way, too, one can see this dualism in action in two poets very different both from each other and certainly very different indeed from the beat poets: Robert Frost and Wallace Stevens. Frost quite deliberately played up the 'rough-hewn' element which is certainly in his work. Reading it aloud in his superb, gravelly voice, he seemed to sum up New England,

farming, stoical good sense. But much of Frost's poetry is dark and pessimistic. In fact he was no simple countryman but a sophisticated man of letters. That he was more complex than he liked to convey is worth knowing because it yields greater rewards from reading his poetry, which is on all counts some of the century's best. President Kennedy was particularly fond of one called 'Stopping by Woods on a Snowy Evening', which includes these lines:

The woods are lovely, dark and deep,
But I have promises to keep,
And miles to go before I sleep,
And miles to go before I sleep.

Frost made a definition of poetry and its creation that could hardly be put more simply, or better. He said of 'the figure a poem makes' that 'It begins in delight and ends in wisdom.' And he said of the job of creating a poem, 'The figure is the same as for love. Like a piece of ice on a hot stove the poem must ride on its own melting.'

If Frost's solution to that apparently peculiarly American problem of how to present oneself to the world as a poet lay in acting up the role of the honest countryman, Wallace Stevens's mannerism was to act up the role of the honest businessman. He was quite genuinely vice-president of the Hartford Insurance Company, but the myth built round this fact neglects the other fact that as a young man he was as busily engaged in writing for small magazines in the Greenwich Village world as any other poet of the time. Nevertheless, his double life, which he enjoyed in both its parts, is extraordinary, like his poetry. It sounds very different from Frost, or from the kind of reality that marks American poetry. But in fact, like Frost, Stevens's poems ride on their own melting, are a new reality in themselves. 'The poem is a nature created by the poet,' he said once. Stevens, in other words, just like Emily, believes 'one may find intimations of immortality in an object on the mantelpiece.' And like her he finds those intimations all the more fresh for being freed from the shackles of old truths and old forms into that wider and wilder air which is America – and the human condition. In such freedom 'the ultimate value is reality': a freedom without God, or any system of salvation, in which 'there is nothing beautiful in life except life', in which there is no longer a grand 'Truth' to refer to but:

It was when I said,
'There is no such thing as the truth',
That the grapes seemed fatter,
The fox ran out of his hole.

Musical revolutions

The even tenor of musical development may be shattered by a sudden burst of experimental activity. Sometimes the change happens logically; often it is triggered by the genius of one man.

WHAT THE WORDS MEAN

Chord – any combination of notes played together.
Scale – progression of notes upwards or downwards by steps from a given note. Different types of scales (major, minor and chromatic) use different sequences of steps.
Octave – an interval covering eight notes of a musical scale.
Key – a piece in the key of D major or D minor, for example, uses only the notes in the scale of D.
Chromaticism – music which uses notes regardless of their key. (A chromatic scale progresses through all the black and white notes on the piano.)
Harmony – a progression of chords having some musical shape.
Melody – a progression of different notes with a musical shape – a tune.
Counterpoint – two or more melodies combined simultaneously, one 'in counterpoint' to the other(s). Adjective: contrapuntal.
Sonata form – movements whose structure is derived from the contrast between two keys. Usually the first movement of a sonata or a symphony is in this form.
Sonata – stabilized by Mozart's time into a type of instrumental work in three or four movements. Now it means a work for one or two players only.
Symphony – sonata for orchestra.
Concerto – a work contrasting solo instrument and orchestra.
Concerto grosso – a work contrasting a small and large group of instruments; prevalent in seventeenth and eighteenth centuries.

THE HISTORY of Western music is one of continuous change and development. But from time to time the changes have been swift and dramatic enough to justify the description of 'revolutions'; within a brief period a new development has been universally adopted to alter the general course of musical thought. The nature of the revolutions varies, incorporating the development of new instruments and new ideas of composition.

From around 900 A D up to 1600, music developed fairly steadily. Important changes did take place, but they were gradual and well spread over the centuries. One of the earliest began to take effect in the years after 900. Plainsong, the only form of church music up to this time, began to take second place to early forms of polyphony, where more than one line of melody was sung simultaneously.

New art

Such early polyphony could either be *strict* (when both voices sang the same melody four or five notes apart) or *free* (when other intervals were allowed, and the voices could be rhythmically more independent). By the twelfth and early thirteenth centuries composers such as Léonin and Pérotin were writing highly elaborate four-part pieces.

An important change was brought about by the development of notation around the beginning of the fourteenth century. The French composer Philippe de Vitry (1291–1361) describes it as *Ars Nova* (new art) in a complex theoretical treatise. The old art had tended to use a waltz-like rhythm all the time, and it allowed only the *long* (the longest note) and *breve* (half a *long*) as standard note lengths. By introducing the *semibreve* (half a *breve*) and smaller units,

1 A grotesque cartoon of the day depicts the German composer Richard Wagner splitting an eardrum with a crochet. His bold musical experiments offended many conventional listeners.

2 Present-day experiments with musical notation are of great complexity, incorporating many dimensions of musical performance, such as the movement, direction and quality of sound.

Vitry opened the door to music of much greater rhythmic subtlety and complexity. It was possible for melodic and rhythmic patterns to become separated, and for each to travel independently through a piece. Thus four repetitions of a melody, for example, might be sung to five repetitions of a rhythmic pattern. This almost supermathematical complexity was called *Isorhythm*.

When the noted English composer John Dunstable (*c.* 1370–1453) moved to Paris,

he took with him the typically English harmonic style, which was widely admired and copied on the Continent. Dunstable's main concern was with smooth-flowing melody parts which were easy to sing, and with sweet and agreeable harmonies. People became more aware of the different effect of various notes played together, of harmony and dissonance (discord) as factors in a composition. Earlier they had been merely the chance results of two melodies performed together. Many

magnificent pieces of church music, especially masses, were produced in the next two centuries by composers like Josquin Després (*c.* 1450–1521) and Giovanni Pierluigi da Palestrina (*c.* 1525–94).

By 1600, the growing awareness of harmony and dissonance led to the firm establishment of the tonal system, with every piece rooted solidly in a key (for example C major, D minor). The form which was probably most important in the tonal revolution was the *madrigal,* a short piece of music with one voice (or instrument) performing each part.

During the early years of the sixteenth century, many Flemish composers made their homes in northern Italy. There they found a form of popular song in four parts, called the *frottola.* They brought to this established form their own polyphonic skills and sense of harmony to create the madrigal, which strove to reflect a particular piece of verse in musical terms. Jacob Arcadelt, Adriaan Willaert, Philippe Verdelot and later Cipriano de Rore began a search for more and more expressive techniques to illustrate sharply and clearly the emotion of the text and even the meanings of important words.

The rise of opera

This constant seeking for expressiveness led to some of the wild experiments in chromaticism and word-painting encountered later in the century. Luca Marenzio (1553–99) was a master of word-painting. He depicted Roman pillars by massive chords, and arches by ascending and descending scales. His contemporary, Count Gesualdo (1560–1613), excelled in placing extreme and unrelated harmonies next to each other. He gave his singers awkward intervals to deliver, yet created very impressive sounds. In the madrigals of the sixteenth century, passages of block chords were freely interspersed with more contrapuntal sections – always strictly according to the demands of the text – allowing the composer to jump quickly from one mood to another and back again.

The stage was set in this way for the revolution which changed the course of music about 1600 – the rise of opera. Again, the system of notation played a major part. The small group of Florentines who created the opera were trying to revive the glories of Greek music. They decided that the 'decadence' of the music of their time was caused by polyphony. The only successful union of music and poetry, they thought, would use a single voice with accompaniment. Thus the words would be clearly heard and the singer could appeal to the intellect (through the words) and to the emotions (through the music). Being aware of the intensely expressive power of harmony as exemplified in the madrigals of their time, they were unwilling to sacrifice it altogether. Therefore they sought a notation which would enable an accompanist to fill in the appropriate chords, but would at the same time make the accompaniment quite clearly subordinate.

The notation which was eventually formulated was known as *basso continuo.* The singer's melody line would be written

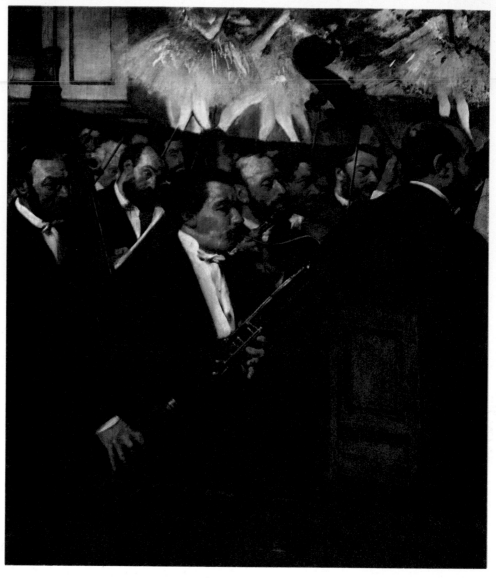

The nineteenth-century orchestra, used in symphonies, opera and the ballet, was the main achievement of the classical revolution of Haydn, Mozart and their contemporaries.

out in full, together with a bass line for the accompaniment. Figures above each bass note served to indicate which chord was to be played at that point; for example, the figures 6 3 would indicate the chord formed of the bass note, the note 3 steps above and the note 6 steps above it in that key. Sometimes there were no figures, and the continuo player at his harpsichord had a certain amount of freedom in choosing appropriate chords (providing always that they fitted with the main melody). Although this technique had been developed for other purposes by the organist of Mantua Cathedral, it was quickly adopted by opera composers, and it caused a startling change in the madrigal, too.

Claudio Monteverdi (1567–1643) was already an acknowledged success by this time. He had made a reputation as a composer of intense and powerful madrigal sets (a group of madrigals linked by a common theme), and his Third and Fourth books of Madrigals (1592 and 1603) were both reprinted twice. In his Fifth book (1605) he finally took the plunge and wrote, as many of his more adventurous fellow composers had already written, madrigals with basso continuo. The very first of these

shows his mastery; he uses not one melody line but two rich and florid tenor voices, interweaving over the bass with its brief figures to indicate the harmony.

In 1607 Monteverdi produced *Orfeo,* the first great opera. The traditional story of Orpheus and his search for his wife Eurydice in the Underworld presented composers with many moments of extreme crisis in which the characters, especially Orpheus, could express great emotion. The powerful musical language of the madrigal, transformed by the use of basso continuo to give great prominence to the solo voice, provided them with the means of expressing this emotion. In *Orfeo,* there are great set pieces for the soloists which exploit the tension between the strophic (continually repeated) base line and a free-roving top line.

A popular lament

The score of *Arianna* (1608), Monteverdi's second opera, is lost, but one of its set pieces, a lament by the heroine, has survived. In the opera it was a solo piece with basso continuo, but Monteverdi later arranged it as a five-voice madrigal in the old manner, because it had become so popular. The influence of these dramatic set pieces on the madrigal became more pronounced, however, in later books by Monteverdi.

In 1624 he staged a battle piece. Here

1 The close unity between instruments and voices in medieval music is shown clearly here. It was not until the opera prompted a new cohesion of instrumental sound that they divided.
2 Palestrina continued the tradition of polyphonic music for the Church at a time when secular music was changing radically. His masses are still played as part of the basic repertoire.
3 The medieval ensemble was composed of instruments each playing its own melody independently of the others. By contrast, music for the modern orchestra is written for massed instruments.

musical instruments were used to represent the trotting of horses, and the clashing of swords, and rapid repetitions of violin notes – the *stile concitato* – show great agitation. These effects, together with the use of the trombone to represent the Underworld spirits, were pioneered in *Orfeo*. They later became the stock-in-trade of every opera composer.

The sudden rise of this new music led to a search for new instrumental colours in the orchestra, and sparked off the process of evolution which was to produce most of the instruments in the modern orchestra in the following 150 years.

During the 150-year period which we now call the Baroque, music once again resumed the steady process of consolidation and development following the period of violent change just described. The opera, and later the concerto grosso, were the main vehicles for musical thought, and the new basso continuo was the most important technical device. Composers thus built up a well-established tradition which served its purpose until the mid-eighteenth century.

In the years after 1750, once again a great many changes took place in a short period. What we now call sonata form arrived on the scene; the symphony and the string quartet became the principal modes of expression; the basso continuo, for so long an indispensable element,

193

1 The madrigal, a piece of music sung or played in parts, was an important vehicle for musical experiment. Claudio Monteverdi extended its range and produced the first great opera – *Orfeo*.
2 The frontispiece for Monteverdi's funeral music contrasts the old stringed instruments of the viol family with the modern violin. Both were in use by 1600.

disappeared; and counterpoint lost all its potential as an agent for holding together large musical structures. All these changes stemmed from one fundamental alteration in outlook: composers had discovered that the dramatic tension set up between music in one key and music in another key could be used as the driving force behind their music.

A baroque piece in the key of F major will run steadily from harmony to harmony, the basso continuo filling in the appropriate chords, whilst the other instruments disport themselves in contrapuntal weavings. From time to time it may alight on chords which are normally outside the key of F, but these will only be touched upon in passing, and will still be closely related to the main key.

Tension leads to drama

The new element in a piece by one of the *classical* composers of the time (for this is what the new style is now called) is that after opening clearly in F, it will completely uproot itself, and move all the music bodily into another key, probably the key of C major. (C is five steps up the scale from F – a key five notes up the scale from the original key is called the *dominant*; for example D is the dominant of G.) Thus an element of tension is introduced, and tension leads to drama. The move from an area of sound based on one note to a similar area based on another note is the basis of the continuous drama of classical symphonies and string quartets.

Counterpoint was dropped because it slowed down the action and provided a rival centre of interest to the crucial tonal conflicts contained in contrasting different keys. It was replaced by block harmony – chordal accompaniments – which rendered the basso continuo obsolete. The need for this block harmony caused orchestral writing to change. Instruments were used to fill in the harmony, creating the nucleus of the modern symphony orchestra.

As the orchestra became more stable and fixed, so the distinction between orchestral music and chamber music (where a single instrument instead of a group plays each part) became more clear. In the first string quartets of Franz Joseph Haydn (1732–1809) there is evidence that they may have been played by a string orchestra, but

later ones are quite definitely intended for solo players. Melody, which had been the basis of counterpoint, was replaced by themes – short phrases usually emphasizing the outlines of a chord, in order to distinguish it from another chord.

During the next 50 years, Haydn and Mozart (1756–91) were the principal figures who made the string quartet and symphony into acceptable musical forms. They were the men who took the essence of this tonal revolution and turned something which was still almost experimental into the foundation of a new era in music, much as Monteverdi had done 150 years earlier.

The freedom to rove from one key to another was established by the classical composers. This was stretched to the limit in what may be described as the atonal revolution of the late nineteenth century. Among the principal leaders of this revolution were the German opera composer Richard Wagner (1813–83) and his father-in-law the Hungarian pianist Franz Liszt (1811–86). Wagner in his later music, such as *Parsifal* (1882), ranged so freely from one key to another that *tonality* (the anchorage of a piece in one 'home' key) had virtually ceased to exist. The later works of Liszt in fact reach the frontiers of *atonality* – that is, the lack of a definite key.

Musical democracy

The disappearance of the rules of tonality left the pioneers of music with no real anchors or charts to keep them safe in the sea of musical exploration. It was left to Arnold Schönberg (1874–1951), a Viennese-born disciple of Wagner, to take the new freedom and impose upon it a straightjacket of his own devising. This was the *note-row*, sometimes called the *tone-row*. In Schönberg's system, all the 12 notes of the octave are employed in a piece, each piece being based on a theme in which each of the notes is used once only. This theme is the note-row. The note-row can be played backwards, or upside down, or both, in any rhythm and at any pitch.

Though Schönberg's idea has its followers, it is not so much a revolution as a declaration of musical democracy on the part of a section of the musical world – all 12 notes are equal.

It is too soon to say which of the many experiments now enlivening music all over the world will lead to a true change of course. The present situation is more one of rioting and anarchy than revolution. The search for something different has led to many strange paths. For example, music by chance has been the subject of experiment by the American composer John Cage (1912–), who has used *I-Ching*, an old Chinese form of divination, for deciding the order of events in some of his compositions.

By way of contrast, other musicians have used computers for composition, because, they argue, music is a logical form, and computers are built to handle anything with a logical structure. Such experiments show that the forces of musical change are still working strongly. The revolution itself may well have taken place already, but this we shall not know for some years yet.

Plainsong and polyphony

Plainsong has developed over the centuries from the simple chants of worshippers into a body of music with its own techniques and style. There is now a revival of interest in this music.

1 Notre Dame in Paris, and the church which preceded it on the same site, was an important centre for the development of music.
2 In the Middle Ages, pilgrims from all over Europe flocked to Santiago de Compostela in Corunna, an important centre of Christianity.
3 The monks of the Abbey of Solesmes in France undertook the enormous task of photographing and assessing all the available plainsong texts.

AMONG THE UNISON MELODIES sung by worshippers throughout the world are some that are known to have been composed more than a thousand years ago. The style and tradition of chants such as the *psalm tones* (the notes on which the Psalms are recited) are even older, and may well have started at the time of the great Temple of Solomon in Jerusalem, at the same time as the words of many of the Psalms.

Apart from the desire common to men everywhere to use music in their worship, this chanting had a very practical origin: in large buildings, such as Solomon's Temple probably was and present-day cathedrals undoubtedly are, priests have found that their words carry better if they are sung on one note than if they are spoken. This way of singing on one note, or *tone,* is called *intoning*.

Because just one tone could sound monotonous, a new custom grew up. Priests began the intoning with two or three other notes, having a cadence, or close, called the *mediation,* half-way through, where the sense of the words indicated a pause, finishing with another cadence called the *ending*. From these simple beginnings has grown the great body of church music which is known as *plainsong*. Over hundreds of years a great repertoire has evolved to cover the various parts of the Church's services.

The earliest Christians were Jews. In their worship of Christ they naturally followed at first the *liturgies* (forms of service) of the Jewish religion, especially the singing of psalms. When new converts from Greece and Rome joined the Christian Church, they imported aspects of their own music to embellish the celebration of the Mass. As the Christian Church spread, the diversity in its music and liturgy increased, until reform became necessary in the interests of unity. The early Western

By 1450, plainsong was becoming more and more elaborate, as this manuscript from the Abbey of St Denis in France shows. In the illumination appears Dagobert I, who founded the abbey on the spot where St Denis was buried. Scholars believe the music was written to celebrate this act.

Church, centred on Rome, used the Greek language until about 300 A D. By then the Scriptures had been translated into the early *Vetus Latina,* or *Itala,* Latin version, and this replaced the Greek in general use. A vigorous development of plainsong began at this time. Some of this 'Old Latin' plainsong has survived to the present day.

During the reign of Pope Gregory the Great (590–604), a major reorganization of plainsong took place. The so-called *Vulgate* translation of the Scriptures, made by the theologian St Jerome (*c.* 340–420), had completely replaced the older *Itala* version. Under Gregory's leadership the chants were organized into a complete cycle, known as *Gregorian Chant.* Many new chants may well have been composed at this time.

One great feature of plainsong is the wider variety of scales, called *modes,* which are used, as compared with later music's use of only two scales, major and minor. The particular quality of each mode is determined by three things: the *final* (finishing note) in relation to the other notes of the scale; the *dominant,* the note round which the melody tends to hang (the reciting note in the psalm tones); and certain characteristic melodic phrases peculiar to each mode.

Modes and rites

The modes can all be played on the white keys of a piano. Each has a normal compass of eight notes. Originally there were four modes, later known as the *authentic* modes. Gregory's reforms included the addition of four more, known as *plagal* modes, each of which was a variant of one of the authentic modes. Four others were added by a Swiss monk, Henricus Glareanus, in the sixteenth century, but these were never used for plainsong. Glareanus gave these the names of ancient Greek modes, but later scholars have found that there is no connection between them. Modern scholars prefer to use Gregory's system of numbering the modes for identification. The numbers, and the names that go with them, are as follows:

i	Dorian	v Lydian
ii	Hypodorian	vi Hypolydian
iii	Phrygian	vii Mixolydian
iv	Hypophrygian	viii Hypomixolydian

Four different *rites* (liturgies and music) existed in various regions of Western Europe in the early Middle Ages: the Roman (Gregorian) Rite, and the Ambrosian, Gallican, and Mozarabic Rites. The Ambrosian Rite, named after St Ambrose, Bishop of Milan in 374–397, originated in Milan, and is still used there. The music shows strong oriental influence. The Gallican Rite, which took its name from Gaul (France), flourished in that country roughly between 400 and 800 A D. It was superseded by the Roman Rite during the reign of the Emperor Charlemagne (768–814). As a consequence of this change, most of the music was lost.

The Mozarabic Rite flourished in Spain. It is the earliest Latin liturgy, and goes back to the third or perhaps even the second century. The music of this rite dates largely from the period 550–660 A D, and survived the Arab invasion of Spain in 711. From this invasion came the name *Mozarabic* (living under Arab rule). An earlier name for the rite was *Visigothic,* from one of the barbarian tribes which overran the Roman Empire from northern Europe and settled in Spain. The Roman Rite replaced the Mozarabic Rite in the eleventh century, except in Toledo, where the old rite was allowed to continue.

There are two other important forms of plainsong: the Byzantine and Russian Rites of the Eastern Orthodox Churches. The Byzantine Rite evolved during the sixth century, and was based on the rites of Antioch and Alexandria, two early Christian cities. Its text differs from the Roman Rite, and it has its own music. Over the centuries there has been an exchange of liturgy and music between the two Churches, the Roman Church being the principal gainer. The Russian Rite is based on the Byzantine Rite and dates from the tenth century.

In 597, Gregory sent St Augustine of Canterbury with 40 monks to England to convert the inhabitants to Christianity. During their journey from Rome they passed through France, and were influenced by the Gallican Rite. Gregory authorized Augustine to introduce elements of the Gallican or any other rite into England if he thought fit, and so the earliest plainsong in England was probably Gregorian, but with French influences.

When the Normans invaded England in

1 Salisbury Cathedral was the centre of the Sarum Rite, which superseded the other English rites centred on York, Hereford and Bangor (Wales).
2 This simple plainsong notation on an English manuscript dates from 1200. Each syllable has its corresponding note or notes.

1066 they brought with them their own plainsong. This was also Gregorian, with some Gallican elements. But despite this common background, the two forms of plainsong were sufficiently different for the Normans to have to use force to get their own version accepted. The *Anglo-Saxon Chronicle* records that in 1083 Abbot Thurston of Glastonbury stationed Norman archers in the clerestory of the abbey church during the service. When the English monks persisted in singing in the way to which they were accustomed, the archers showed no mercy and shot them down.

After these early troubles, English plainsong settled down into four local rites, centred on Sarum (Salisbury), York, Hereford and Bangor. The Sarum Rite was the most important, and towards the end of the fifteenth century it had superseded all the others throughout the country.

During the Reformation in the sixteenth century there was a reaction against the more florid and elaborate plainsong melodies which had come into general use by that time, and also against the use of a dead language (Latin) rather than the everyday speech of the people in the services of the Church. In England, Archbishop Cranmer, one of the leaders of the Reformation, published the Litany in English in 1544. It was set to simple plainsong, with one note to each syllable in contrast to the habit that had grown up of singing many notes to some syllables. The Litany of 1544 is still sung in the Church of England to this day. The setting may well have been the work of John Merbecke, organist of St George's Chapel, Windsor, who certainly set the prayer book of 1549 to music in his *The Booke of Common Praier Noted,* published in 1550.

Plainsong revised

Merbecke's setting did not remain in use, probably because slight changes in the new prayer book which was issued in 1552 made revision necessary, and before this could be done the Roman Catholic Queen Mary I came to the throne. During her reign (1553–58), the Protestant reformers were repressed and persecuted. When the Reformation resumed its course in England, a different kind of church music rapidly eclipsed plainsong – the works in many parts produced by Thomas Tallis (*c.* 1505–85) and William Byrd (1542–1623) and their contemporaries and followers.

The over-elaboration of plainsong had also led to a desire for reform in the Roman Catholic Church, and in 1577 Pope Gregory XIII commissioned one of the greatest Italian composers of the day, Giovanni Pierluigi da Palestrina, to revise portions of the old Gregorian chant. But Palestrina gave up the task when he had nearly finished it. A revision which may have been based on his work was published

in 1614, ten years after his death, by the Medicean Press, a private business. It was a simplified version and received general approval for a while, but gradually fell out of use. In France, various composers produced a series of similarly simplified and modernized forms, known in that country as *plainchant* to distinguish them from the older Gregorian plainsong.

From the sixteenth century onwards, plainsong passed through a very decadent phase. The beginnings of this decadence can be traced back to the thirteenth century, or possibly to the beginnings of a precise musical notation. The reason is fashion. When all music was in unison, like folk song, plainsong was 'up to date' and developed to its highest artistic point. However, musicians started experimenting. When a large group of people sing a melody together it frequently happens that some sing below the correct *pitch* (level), usually at a *fourth* (four notes in the scale) below. This can produce an attractive sound – a sort of primitive harmony. Medieval musicians liked this effect, and codified it into a standard practice, calling it *organum,* a name derived from the organ, on which it could be easily played.

The next step was for both voice parts to start on the same note, the lower one waiting until the melody had moved a fourth apart. Both voices then moved in parallel, ending by coming together again on the same note. This practice developed further into the art of adding a new melody to fit with an existing one, note against note. The Latin phrase for note against note, *punctum contra punctum,* gave rise to our modern word for multiple melodies, counterpoint. During the twelfth century, composers next tried making the added melody much more florid and ornate than the first melody, and combining three or more melodies. This was the birth of what is known as *polyphony* which means many voices.

Gothic revival

With these exciting new developments it is understandable that interest in the simpler plainsong began to wane. But such developments would not have been possible without the help of a positive system of notation. Composition and performance of music in more than one part was difficult until it could be written down accurately. Once this became possible, early in the fourteenth century, polyphony grew rapidly.

The practice of performing music of former times and regarding it as just as enjoyable as current music is a comparatively modern idea. Its earliest appearance was in England in the early part of the eighteenth century, when the music of Tallis and other Elizabethan composers was sung, as well as contemporary church music. Following this tradition, a new interest in plainsong came about at the beginning of the nineteenth century, at the height of the Gothic revival. Musicians began to take an interest in the music which was written at the time the great Gothic cathedrals and churches were being built.

By about 1841, plainsong was again

In the fourth century Ambrose, Bishop of Milan, imposed order on the confused state of church music, giving his name to the Ambrosian Rite.

being sung in England, in Lichfield Cathedral and at St Peter in the East, in Oxford. In 1843 William Dyce published the *Order of Daily Service,* which was an adaptation of the neglected Merbecke.

In Germany a group of scholars issued a new revision of plainsong for the Roman Catholic Church in the mid-1800s, which received papal authority in 1870. Unfortunately it was based on the sixteenth-century Medicean Edition, and not on the old manuscripts. The major work of revival, however, was done by the monks of the Benedictine Abbey of Solesmes, near Le Mans, in France. They undertook the enormous task of photographing all the available old plainsong manuscripts in Europe, collating them, and producing

The Mozarabic Rite flourished all over Spain up to the eleventh century. It was then replaced by the Roman Rite – except in Toledo.

During Pope Gregory's reign (590–604), the music was again reorganized. Gregorian Chant is the name given to this type of plainsong.

musical texts based on the results of this scholarly investigation. They published their first revisions in 1883, and their work has been going on ever since. The most important of the Solesmes publications is the *Liber Usualis* of 1904, which was adopted as the official revision of plainsong for Roman Catholics by order of Pope Pius X.

One of the problems in the revival of plainsong is that of notation. As we have seen, musical notation did not become precise until after the greatest period of plainsong was over. Early medieval manuscripts were merely marked with *neumes* – marks indicating a rise or fall in the melody, but not how large a rise or fall. To reconstruct the plainsong of the Dark Ages – the period from the 400s to the 1000s – scholars have to try to correlate the neumes of early manuscripts with the melodies in more readable notation.

Modern plainsong notation follows fairly closely that used in the later Middle Ages. The notes are solid black, square or diamond shaped, the different shapes having no rhythmic significance. The notes are written on a four-line stave, as compared with the five-line stave of ordinary music. The notes for each syllable are joined together to form what is called a ligature, if possible, or grouped closely together. If two notes are joined vertically one above the other the lower is sung first, followed by the upper.

Scholars in the Roman Catholic, Anglican, and American Episcopal Churches are continuing to work on plainsong, producing not only reproductions of the ancient texts, but also practical performing editions. Through their efforts, plainsong, with its formative years in the Middle Ages and its roots in the Jewish music of Old Testament times, is still flourishing as a living medium for Man's musical worship of God.

Musical masters of form and technique

Musical composition and performance are today entirely separate disciplines. But the great classical composers were masters of many instruments as well as the techniques of composition.

THE EARLIEST COMPOSERS of music were performers, who wrote music for themselves and their friends. Church singers wrote the new settings of religious services, troubadours and minstrels wrote the songs and dances with which they entertained others, a tradition spanning many centuries. Such musicians were essentially practical men.

Many composers were in fact best known as performers. Even those holding official positions which required them to compose, such as Monteverdi or Palestrina, were expected to train and lead a choir and play the organ. This practical aspect of their lives meant that they really understood the instruments of their day and the technique of playing them. Thus a long line of player-composers sprang up, who were not only masters of their instruments, but explored and extended their possibilities and techniques. Often the complex nature of the music they composed and played inspired the designers and makers of instruments to develop them further, to accommodate the new brilliance of composition and technique.

Bach's musical versatility

Only in the past hundred years or so has the increased specialization which marks every walk of life so affected music that one man can no longer be, as was Johann Sebastian Bach (1685–1750), professional singer, violinist, conductor and trainer of

Franz Liszt (1811–86) was a virtuoso pianist of great brilliance. He introduced new processes in composition, and was responsible for launching Brahms and Grieg on their careers.

Although Niccolò Paganini (1784–1840) is remembered for his compositions, his main contribution to music was the extension of playing technique on stringed instruments.

soloists, choir and orchestra, and the greatest composer and organ virtuoso of his time.

As a boy, Bach learned the harpsichord and violin, but he began his musical career as a choirboy at Lüneberg, in northern Germany. When his voice broke, he turned to the violin and then to the organ, holding a succession of church and court appointments. While he was organist at Arnstadt, in central Germany, he obtained a few weeks' leave in order to

hear the great virtuoso organist Dietrich Buxtehude (1637–1707). Buxtehude was organist at St Mary's Church at Lübeck, some 200 miles from Arnstadt. Bach walked the whole 200 miles, such was his desire to hear him.

Buxtehude was nearing retirement and Bach may have had some notion of succeeding him. But a condition of the succession was the hand of the retiring organist's daughter. As she was ten years older than Bach, the prospect evidently did not appeal. Bach returned to his duties, and received a tremendous scolding for overstaying his leave.

He soon married and settled down, and thereafter his life was one of domesticity and hard work, conducting, composing and teaching. ('Hard work' was Bach's own recipe for success.) Though he wrote an enormous amount of music, his main fame in his lifetime was as a keyboard player. It was this reputation that secured him an invitation to visit Frederick the Great of Prussia, in Potsdam.

Bach, then 63, arrived at court just as the king (a keen flautist) was about to take part in some chamber music. Frederick broke off, saying eagerly, 'Gentlemen, old Bach is here!' and called him in to play. Bach had to try first the royal harpsichords, then some new pianofortes which Frederick had just bought, and finally all the organs at Potsdam.

Mastery of musical technique

Bach composed his music at a time when the *contrapuntal* form of composition (in which a number of tunes were woven into a complex strand) was giving way to a form where melody was used more simply with a harmonic accompaniment. Bach, however, despite his genius was no innovator; he took the contrapuntal style and polished it to perfection.

He was, in particular, a master of the art of writing *fugues,* a special form of counterpoint in which a melody appears in turn in each part. Bach's writing for organ, harpsichord and violin displays a masterly knowledge of the technique of each instrument. Until Beethoven's day, Bach's *Goldberg Variations* for harpsichord remained the supreme example of technical display for any stringed keyboard instrument. Bach also wrote six suites for unaccompanied violin, of great technical difficulty, which have never been surpassed as solo music for the instrument.

Bach's reputation was gained largely through his own efforts and he was to a great extent self-taught. It was far otherwise with Wolfgang Amadeus Mozart (1756–91). Mozart was the son of a talented violinist, Leopold Mozart, who won a lasting fame for writing a textbook on

violin technique. Leopold was quick to recognize a musical genius in his young son and was also enough of a businessman to make the most of the opportunity offered.

He trained the boy carefully on the harpsichord and violin. Then, when Wolfgang was seven years old, Leopold took him and his 11-year-old sister Maria Anna (Nännerl), who was also a talented performer, on a tour of Europe. The astonishing talent of the young Mozart caused a considerable sensation. He could play difficult works at an early age, memorize music, transpose it to a different key and compose pieces of his own.

After four years of touring, the Mozarts returned to their home town of Salzburg, in Austria. There young Mozart applied himself to studying playing and composition. By the time he was 12, he had written five symphonies and an opera, besides many other works. Though these early pieces are obviously those of an immature talent, that talent was developing rapidly.

At the age of 20, Mozart had already completed his five violin concertos (still in the concert repertory) and was on the way to becoming, in his critical father's

1 Wolfgang Amadeus Mozart (1756–91) was a prolific composer as well as a brilliant performer. By the age of 11, when this portrait was painted, he was an experienced concert pianist.
2 During his lifetime Johann Sebastian Bach (1685–1750) was renowned as a master organist. But his compositions were virtually ignored during the hundred years after his death.
3 Frédéric Chopin (1810–49) concentrated his playing and composing talents mainly on the piano. In compositions which include other instruments, the piano is always dominant.

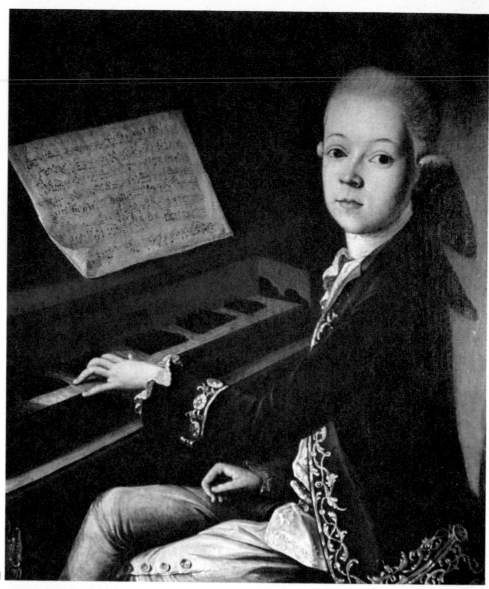

1

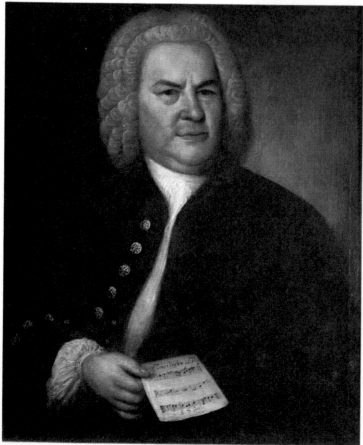

2

3

estimation, the finest violinist in Europe. The concertos were all written for his own performance. But Mozart did not care for the violin as an instrument – he much preferred the piano. Once free from his father's influence (when he left Salzburg to try his fortunes elsewhere), Mozart devoted his attention to the piano and wrote a number of concertos for that instrument.

But after he had ceased to be a child prodigy, Mozart had difficulty in earning a living, a difficulty that persisted to the end of his short life – despite a talent generally agreed to be among the greatest any musician has ever possessed.

Mozart's playing was the essence of the 'gallant' style, a light and elegant approach to music characteristic of the end of the eighteenth century. This style is reflected in much of his composition. Even his most passionate music has a courtly grace. He once told a pupil, 'Melody is the essence of music', and melodies in profusion came pouring from his pen. Although it brought him little income, his music did give him the satisfaction of unstinted applause from his audiences, including the most critical of his fellow musicians.

If Mozart's playing and his music delighted audiences, that of Ludwig van Beethoven (1770–1827) shocked and astonished them. Like Mozart, Beethoven was trained as a pianist, violinist and viola player. Like Mozart, too, he was the son of a musician who kept him working hard at his music.

But there the similarity ended. The elder Beethoven was a lazy drunkard. From the age of 17, when his mother died, Ludwig had to shoulder all the responsibilities of the head of the house, his shiftless father being by then incapable of doing so.

It was as a pianist that the young Beethoven acquired his early reputation. When, at the age of 22, he burst upon the outside world, playing at concerts in Vienna, he startled that music-loving city. One man who heard him about that time wrote: 'His playing is so utterly different from the usual methods of the pianist that he seems to be striking out an entirely new way of his own.'

The comparative isolation in which Beethoven lived and studied in his early years was probably responsible for this independent attitude to music, which was most strikingly evident in his piano compositions. From the first, his style was bold and forthright, with none of the tender, refined graces of the 'gallant' style. He demanded from the piano a great range of tone and a rounder, richer sound than any of the instruments of his day could produce.

He tried many makes of piano and rejected them. Finally, he persuaded his friend Andreas Streicher, a pianoforte maker in Vienna, to experiment and produce something nearer his ideal. In 1809 Streicher made a piano with an improved touch, over which the performer had much greater control. Even this did not satisfy Beethoven, and to the end of his life he demanded more and more responsive pianos. He once said sadly, 'It is, and always will be, a disappointing instrument.'

The art of improvisation

Many of Beethoven's performances, until deafness in his early forties ended his playing career, were improvisations, when musical ideas cascaded from him in an apparently endless stream. Much of this music has been preserved; Beethoven was careful to retain in his memory all that he thought worth preserving, and used it in his published works. He once repeated an improvisation to an astonished listener who had expressed sorrow that he could never hear it again.

Improvisation requires a free flow of thought; the strict form of the sonata, in which Beethoven excelled, required just the opposite. Beethoven contrived to unite both fantasy and formalism in his music, particularly in his *fantasia-sonatas* (Opus 27, numbers one and two), which were his own creation. Characteristic of his music are his use of rolling, sometimes crashing chords contrasted with sustained, flowing melodies.

So far from shocking his audiences, Niccolò Paganini (1784–1840) exhilarated them. Of all the virtuoso composers of the past 300 years, probably none has created quite such a sensation as he did. Paganini was born at Genoa in northern Italy, and

1 So great was Chopin's fame as a keyboard performer that Clesinger made a cast of his left hand. Throughout his life, however, Chopin disliked performing in public.

2 Beethoven's funeral was marked by the attendance of vast crowds of Viennese. Eight prominent orchestra conductors acted as his pallbearers, and all schools were closed for the day.

was a child prodigy of the violin. Before he was 17, he was developing his extraordinary technique by writing studies so difficult that he himself had to practise them for hours at a stretch in order to master them.

About this time he left home and wandered about Italy, creating a sensation wherever he played and leading a dissolute life in between concerts. Women and gambling were his principal recreations. On one occasion he even gambled away his violin and had to borrow another in order to give his next concert. So beautifully did he play that the man who lent him the violin – a fine Joseph Guarneri – insisted that he should keep it. Paganini played on the instrument for the rest of his life.

For many years Paganini toured Italy, and his concerts were sell-outs wherever he went. Not until he was 44 did he play anywhere else. Then his performances took audiences in Austria, Germany, France and England by storm. Mostly he played his own compositions, for only they were difficult enough to display his extraordinary talent.

His concerts earned him a fortune and other people were quick to cash in on his success. Restaurants served steaks *à la Paganini,* shopkeepers sold Paganini gloves, neckties and other articles. His extraordinary appearance, tall and gaunt, with dark, expressive eyes, helped to enhance the Paganini legend.

Paganini's violin technique

Paganini invented many new tricks and devices in violin playing, such as plucking the strings with his left hand (the fingering hand), and developed many others. All the battery of his vast technique, scales in chords, harmonics, fancy bowings, was employed in his music. But with it all, the musical thought shone through, and he drew unstinted praise not only from the uncritical, but from his fellow musicians.

Schumann described his playing as a 'delight', while Liszt wrote, 'What a man, what a violin, what an artist!' Schumann, Liszt and Brahms all took music by Paganini as the basis for piano compositions of their own.

Paganini's tricks and general method of performance were deliberately sensational. Of the pianist Frédéric Chopin (1810–49) a contemporary critic wrote, 'Chopin in his life never wrote a vulgar note.' Chopin was born in Poland, the son of a French father and a Polish mother. In spirit and in patriotic feelings he was entirely Polish, but he spent most of his adult life in France, where he found congenial company and an audience for his music.

His health was poor, and for the last few years of his life he suffered with tuberculosis. He spent ten years in the constant company of the eccentric writer George Sand (Baroness Dudevant), who looked after him more like a mother than a mistress.

Chopin did not possess the versatility of Mozart or the rugged mastery of Beethoven. Away from the piano, his

genius was unhappy. But his technique had a purity of style that none of his contemporaries could match. His supple hands made technical difficulties seem easy, and for this reason his playing invariably seemed more languid than in fact it was. He excelled in *cantabile* (singing) playing, each note blending smoothly into the next.

Schumann described one of his performances as 'dreamy and soft . . . as if a child were singing in its sleep'. He could also draw from the piano an immense tone, full of strength, yet still refined. These attributes of his playing are mirrored in his music. Possibly his studies and preludes are the most typical, lyrical in style but embellished with harmonies that were, for his day, considered daring. In gayer mood were the mazurkas, polonaises and waltzes that he wrote, gay dances full of fire and melody.

Chopin was not at his best when playing the works of others, especially composers such as Beethoven, whose style was so different from his own. The reverse is true of the Hungarian Franz Liszt (1811–86), the giant of nineteenth-century pianists, and the supreme performer of other men's music as well as his own. He too was a child prodigy, making his first public appearance at the early age of nine, and touring Europe during his teens.

At the age of 20 he first heard Paganini, and from his example learnt the art of showmanship, which dominated his public life thereafter.

Liszt's double life

Liszt was a strange mixture, one part of his nature inclining towards a religious life, the other to a life of sensual pleasure. In his early years he had a prolonged love affair with Countess Marie d'Agoult, who bore him three children. Later he had a long liaison with a Polish princess, Carolyne von Sayn-Wittgenstein. When he was 52, he went into semi-retirement at a monastery and took minor religious orders, which brought him the unofficial title of *Abbé*. His career as a travelling virtuoso lasted some twelve years, beginning when he was 26. He created much the same sensation as Paganini, and like him made a fortune. He was always ready to help and encourage his fellow musicians, and Wagner was among those who readily acknowledged his aid.

Liszt's music reflects his technique. Like that of Paganini, much of it was written to show off his own powers, and it is this 'firework' music which has remained consistently popular. In the last 15 years of his life, when he was performing less in public, he experimented in new ways of composition. In particular, his music strayed from the paths of tonality (that is, association with a particular key) into the borders of *atonality* (absence of fixed key), in which he anticipated much of the work of twentieth-century composers.

Many of Liszt's later compositions were religious works, including oratorios and a setting of the Mass. But it is his piano music that has survived over the years, and qualifies Liszt to be considered as the last of the great virtuoso composers.

1 Francesco Landini (1325–97) played and composed primarily for the organ. He was also an expert performer on the flute and the lute. He was known as 'Francesco of the organs'.
2 Ludwig van Beethoven (1770–1827) deserves to be called the 'Shakespeare of music'. He possessed a unique combination of deep feeling and expressive composing technique.

The keyboard in music

The development of the keyboard as a means of striking or plucking strings or sounding pipes put an entirely new range of instruments in the hands of performers and composers.

THE INVENTION of the keyboard conferred one of the greatest benefits on the solo musician: it enabled him to play a piece of music, complete with all its harmonies, more easily than on the harp, lute, or other similar instruments. The keyboard itself is as old as the organ, the senior of the keyboard instruments, which was developed in ancient Greece, and it has changed very little since about 1450.

The earliest organ

There are two main varieties of keyboard instruments: wind and strings. The wind instruments are the organ and its cousins, the harmonium and American organ. The stringed instruments are of two basic types: those in which the strings are plucked – harpsichord, spinet and virginals; and those in which they are struck – clavichord and piano.

The earliest known organ was made by a Greek engineer, Ktesibios of Alexandria, in the third century BC. It was called a *hydraulos,* because the air reservoir was sealed by water to smooth out the individual blasts of air from the bellows. We have little knowledge of the music played on the organ in the first 800 years or so of its existence. But an instrument capable of playing more than one note at once, and possessing considerable power (one early organ could be heard more than a mile off), was bound to attract the attention of the biggest musical centre of the Middle Ages – the Church. According to tradition, Pope Vitalian introduced the organ into services in Rome in the middle of the seventh century. From that day to this, the story of the organ has been closely associated with the music of the Christian Church.

Up to the sixteenth century, organ music was largely an integral part of the service, and had the same forms as the vocal parts of the plainsong. Then gradually independent organ music developed, first as improvisation, then into the form that became known as the *toccata* – literally, a touch-piece, in which the notes were played rapidly and not dwelt on. Later toccatas contained slow sections.

After the Reformation in Germany, the services of the Protestant Church contained hymns for the congregation to sing, which became known as *chorales.* It became the custom to provide an organ prelude to a chorale, and the fine hymn tunes of the chorales provided a source of inspiration for the organ composers of the sixteenth century onwards. Among the early composers of such chorale preludes

1 The organ is one of the oldest instruments: legend ascribes its invention to the god Pan. In medieval times, small portable organs were used for music at home.
2 The virginals are related to the harpsichord, since the strings are plucked mechanically, but they are smaller and differently shaped.
3 To sound the notes of an organ, wind is pumped through the pipes by bellows. This was originally done by hand, but the bellows are activated by electricity in later instruments.

were the Dutch organist Jan Pieterszoon Sweelinck (1562–1621) and Dietrich Buxtehude (1637–1707), of Denmark.

The greatest organ composer, however, was Johann Sebastian Bach (1685–1750). Bach was the master of the style of writing known as counterpoint, which has a number of parallel melodies going on at once. Such music is the kind that suits the organ best. Bach's chorale preludes were the finest examples of their kind ever produced. He treated the hymn tunes which formed the basis of his chorales in a variety of ways, often relating his musical thought to the words of the hymns, as exemplified in the vigorous, dramatic style of the prelude on *Ein' feste Burg ist unser Gott* (A mighty fortress is our God).

In these works, and in others – such as toccatas, preludes and fugues – Bach

showed a complete control over the instru- **1**
ment and its possibilities. He contrasted
the power and majesty of rolling chord
sequences with passages of fast notes. He
also knew to the full the tone value of
the various *stops* (sets of pipes) of the
organs of his day. Every organ has many
stops, each with a distinctive tone, like a
different musical instrument. By com-
bining stops, or playing one part on one
stop and another on a second (by means of
a different keyboard) a musician can give
an otherwise straightforward passage a
great deal of colour and life.

After Bach died, organ composition fell
into decline. His great contemporary,
George Frederic Handel (1685–1759), left
a number of fine organ concertos, and a
number of lesser composers wrote music
in the old contrapuntal style. But the
new music of the second half of the eigh-
teenth century, in which melody sup-
ported by harmony was the principal
feature, was less suited to the capacities of
the organ.

Organs, dulcimers, clavichords

Apart from some isolated examples, such
as the fine chorale preludes of Johannes
Brahms (1833–97), the great organ music
of the nineteenth century came from
France and the school of playing and com-
position founded by César Franck (1822–
90). Like Bach, Franck spent his life in
quiet, patient toil. For more than 30
years he was organist of a church in Paris,
and taught at the Paris Conservatoire.
Much of his work is contrapuntal in style.
Charles Widor (1844–1937), who succeeded
Franck as organ professor at the Con-
servatoire, introduced a new kind of
organ composition, which he called *sym-
phonies*. These are more like suites than
orchestral symphonies, having a number
of movements of various styles.

The existence side by side of multi-
stringed instruments called dulcimers –
where the player strikes the strings with
sticks – and harps and psalteries – where
the strings are plucked – and the organ
keyboard prompted inventive musicians
to try to combine keyboard and strings.
The earliest attempt was based on the
struck-string principle of the dulcimer. It
was an instrument in which a single string
was struck by key-operated metal plates
called *tangents*. These tangents changed
the effective, vibrating length of the
string, thus altering the pitch of note,
and sounded the string as they struck it.
The clavichord, which has a number of
strings played in this way, evolved during
the fourteenth and fifteenth centuries.
It was a popular chamber instrument until
the beginning of the nineteenth century.
Because of its quiet, delicate tone, it
could not readily be combined with other
instruments. It is a very expressive instru-
ment, on which the player can play louder
or softer according to how hard he strikes
the keys. He can also introduce an expres-
sive vibrato or shake (known by its German
name of *Bebung*) by rocking his finger up
and down on the keys.

The harpsichord was evolved in the
fourteenth century from the psaltery. It
was very popular from about 1500 to

about 1800, when it was supplanted by the
piano. Interest in the harpsichord and the
music written for it revived in the 1890s,
and harpsichords are again being made
and used. When a harpsichord is played,
the action of the key causes a piece of
quill to pluck the string, producing a
resonant sound. One nineteenth-century
writer contemptuously likened the sound
to that made by a bird-cage played with a
toasting-fork. The larger harpsichords
possess two keyboards and three complete
sets of strings, with a small range of tone
colours, comparable to the stops of an
organ. Smaller harpsichords, and their
close relatives the spinet and the virginals,
have only one set of strings.

Experimental instruments of the piano

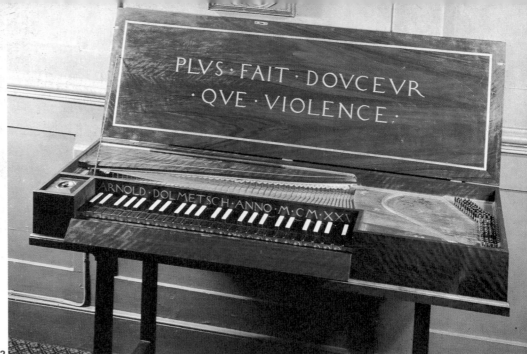

1 A portrait of the eighteenth-century Italian composer Domenico Cimarosa at the spinet, a wing-shaped instrument of the same family as the harpsichord and virginals.

2 A fine clavichord manufactured in 1925 by Arnold Dolmetsch is evidence of the revival of interest in ancient keyboard instruments and the music written for them.

3 A satire on Handel, the 'charming brute', published in 1754, stresses the composer's portliness. Nevertheless, he was an esteemed exponent of the harpsichord and organ.

4 Two keyboards are commonly found in the harpsichord, perhaps the best-known of old keyboard instruments. Today it enjoys renewed popularity and many are manufactured.

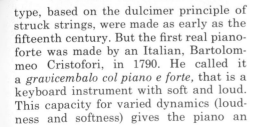

type, based on the dulcimer principle of struck strings, were made as early as the fifteenth century. But the first real pianoforte was made by an Italian, Bartolommeo Cristofori, in 1790. He called it a *gravicembalo col piano e forte,* that is a keyboard instrument with soft and loud. This capacity for varied dynamics (loudness and softness) gives the piano an advantage over the harpsichord, whose dynamic range is fairly limited.

In the seventeenth and eighteenth centuries, composers tended not to specify which stringed keyboard instrument they were writing for. The evidence of style is the only real clue to their intentions.

The tonal limitations of the harpsichord led composers to use a number of devices to compensate for the instrument's deficiencies. These shortcomings include a rather rapid dying away of each note, as well as a limited dynamic range. Examples of many of the devices occur in the 300 keyboard pieces collected about 1621 in a manuscript of English works known now as the *Fitzwilliam Virginal Book*. They include rapidly repeated notes and chords, to give an effect of continual tone, and the decoration of a passage with extraneous notes and flourishes.

One of the greatest exponents of these special techniques was Domenico Scarlatti (1685–1757), writing for the harpsichord in Italy more than a century later. Scarlatti made extensive use of what are called *terrace dynamics*. In this device, a phrase is played on one keyboard of a two-manual harpsichord, and immediately echoed on the second keyboard, which has been arranged to give a quieter tone. Scarlatti also echoed phrases from one end of the keyboard to the other, making up in change of pitch for lack of dynamic variety.

A double problem facing all keyboard players of the seventeenth and eighteenth centuries was that of key and tuning. If you tune a keyboard instrument so that all

1 The piano was invented shortly after 1700. Its name comes from the Italian *piano-forte*.
2 A hurdy-gurdy dating from 1770–80. The handle at the base operates a wooden wheel which passes across the strings. To the right is the keyboard.
3 Domenico Scarlatti was a harpsichord virtuoso and composer who wrote a great number of works which extended the capacities of the instrument.

the notes of one scale are perfectly in tune, when you play in another scale some of the intervals between the notes will be very slightly out of tune. If you move to a remote key – that is, one that has few notes in common with the original key – this tendency becomes very obvious. The answer to the problem is what is called *equal temperament,* in which every semitone (the smallest interval in Western music) is made equal. In this way no key is completely in tune, but the discrepancy is so slight as to be virtually unnoticeable. Such a tuning opens up at once enormous musical possibilities; a composer can let his music wander readily from one key to another and back again, a device known as *modulation.*

The Well-Tempered Clavier

The principle of equal temperament was known in the fifteenth century. But its great champion was Bach, who tuned his own instruments this way. Bach further demonstrated his support of equal temperament by publishing two books of preludes and fugues in all 12 major and 12 minor keys, to which he gave the title *The Well-Tempered Clavier.*

The Well-Tempered Clavier was written as an instructional book, but its musical content is of the very highest. Bach specified no particular instrument, but some of the preludes and fugues have an expressive, lyrical quality that seems to suit the clavichord, and others contain characteristic harpsichord or organ writing.

The earliest great composers for the piano were Bach's son, Carl Philip Emmanual Bach (1714–88), Joseph Haydn (1732–1809) and Wolfgang Mozart (1756–91). During their time, a great change took place in musical form with the development of the keyboard sonata.

The sonata of the eighteenth century contained three *movements* (sections), fast, slow and fast. Sometimes a fourth movement, usually a minuet, was inserted after the slow movement. The construction of the first movement of a sonata is the most complex and important. It begins with an *exposition,* in which the themes or tunes are stated. Then follows a *development* section, in which the composer's imagination is allowed free rein to elaborate on

4 The powerful sound emitted by the organ makes it an ideal instrument for church music. Fine organs were made and placed in settings of tremendous grandeur, like this one in Rome.

the themes; sometimes he introduces others. Finally, there is a *recapitulation,* in which the themes are stated once again.

The pianos used by Haydn, Mozart and their contemporaries were light in touch and fairly small in tone, and these were important factors in the development of the *gallant* style, a clean-cut, refined manner of playing and composition of which Mozart was the supreme exponent. With Ludwig van Beethoven (1770–1827) the sonata assumed a bolder, more majestic character, and the piano itself was improved at Beethoven's insistence to match the demands of his new music. Bach's *Well-Tempered Clavier* and Beethoven's 32 piano sonatas have been called the 'Old and New Testaments' of keyboard music. Beethoven's music is rugged and powerful; he was inspired by moods of sadness and passion, and these are echoed in his music. He transformed the sonata, and with it the piano, into vehicles for expressing emotion, which paved the way for the Romantic composers of the nineteenth century.

Beethoven's sonatas are virtuoso works, requiring great technical and musical ability. Those of Franz Schubert (1797–1828) are essentially melodic and lyrical, as might be expected from one of the greatest of all song-writers. He also wrote

a number of smaller works which resemble songs even more closely, such as his *Moments Musical* or *Impromptus.* This idea was taken a stage further by Felix Mendelssohn (1809–47), whose best-known contributions to piano literature are his *Songs without Words.* The essence of these pieces is melody, with accompanying material of a purely pianistic character.

The piano works of Frederick Chopin (1810–49) and Franz Liszt (1811–86), two immensely talented virtuoso players, display strong contrast. Chopin's are intimate, precise and often delicate, but with some bursts of fire. Those of Liszt are more flamboyant, expressing a more extrovert nature. Both composers are in the stream of Romanticism; but the true line of Beethoven and Schumann was continued by Johannes Brahms (1833–97). He brought to the piano much of the lushness associated with the Romantic movement, coupled with a superb craftsmanship, and a grasp of form and style that echoes the eighteenth century. His works have the majesty of Beethoven, yet contain contrapuntal writing directly comparable with that of Bach. He was a master of varied rhythms, which often make his works difficult to play.

Present-day idioms

In the twentieth century, the use of the piano as one of the basic instruments of jazz has influenced composers, especially in the United States. George Gershwin (1898–1937) produced work with a strong jazz flavour, and jazz influences are also to be found in the work of Aaron Copland (b. 1900). One of the most important of twentieth-century composers for the piano, however, was the Hungarian Bela Bartok (1881–1945). His *Mikrokosmos,* 153 pieces ranging in difficulty, are a magnificent introduction to the complexities of present-day idioms.

The keyboard instruments, offering as they do a power and range unsurpassed by any other instrument, have long been favourites with composers as concerto instruments. They can stand up against a full orchestra in a way that few other instruments can. The popularity of keyboard concertos has persisted from the days of Bach to the present time.

The devil's own instrument

Paganini's playing was so brilliant that a man swore he saw the devil guiding the bow. What sort of instrument is it that has made such virtuosity possible, and how did it develop?

OF ALL the instruments of the orchestra, the violin is the most romantic and also one of the oldest. Most wind players use new or nearly new instruments, few more than 50 years old. Although the harp has been played since Old Testament times, the modern concert harp was evolved at the beginning of the last century. But in the string section of any orchestra there are instruments with bodies 200 years old and more. Violin music and playing traditions stretch back for nearly four centuries.

Instruments with strings have been in use for many thousands of years, but the earliest bowed stringed instruments appeared sometime shortly before 900 AD. These fiddles had various names according to their country of origin, such as the almost universal *rebab* or *rabab,* which became known in European countries as the *rebec.* Two forms of fiddle were evolved in Europe during the 1400s. One kind was played upright, resting on the knee. These instruments had gut *frets* (bars) on their fingerboards, rather like the frets of a modern guitar. They were called *viols.* They remained popular for some 300 years, eventually declining about the beginning of the eighteenth century.

The other kind of fiddle was held on the arm or under the chin for playing, and

generally had no frets. These instruments were the violins, and they reached their present form sometime during the early part of the sixteenth century. The earliest versions had three or five strings, but four strings were standard by about the middle of the 1500s. The violins of this period, and until about 1800, had necks slightly shorter, and fingerboards considerably shorter, than present-day instruments.

Beautiful musical instruments

One of the earliest violins known is in the Ashmolean Museum at Oxford. It was made by the Italian Andrea Amati (*c.* 1505– *c.* 1580), and is dated 1564. Amati was the founder of a distinguished family of violin-makers who lived in the little town of Cremona, in northern Italy. Nearly all the early development of the violin, and of its music, took place in Italy. The early days of the violin were those of the High Renaissance, when artists such as Michelangelo, Titian and Benvenuto Cellini were producing their masterpieces. This was just the artistic climate in which beautiful musical instruments could be created. The Amatis continued to practise their craft until the eighteenth century.

The Renaissance was a revival of interest in the art and scholarship of ancient Greece and Rome. It was not possible,

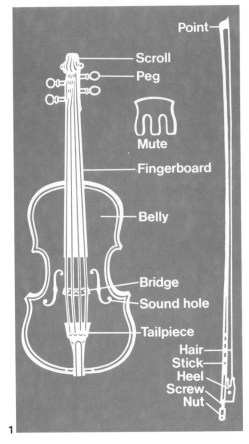

1 A diagrammatic view of the modern violin and bow. Old instruments are valuable and are modified to suit modern requirements.

2 The two bowed instruments in the middle of the engraving are members of the violin family and date back to 1600.

3 One of the greatest living exponents of the violin, Yehudi Menuhin rehearses for his 50th birthday concert with conductor Sir Adrian Boult.

however, to revive the Greek and Roman musical traditions, for these had largely been lost. The Renaissance produced the violin, but players and composers were left to break new ground in providing music for it.

At first, the violin was used largely for playing dance music, as its ancestor, the rebec, had been. Up to the beginning of the seventeenth century, the viol was the 'classical' bowed instrument, but the violin gained ground rapidly. Charles IX of France (1560–74) had an orchestra of which all the violins (according to tradition) were made by Andrea Amati. Louis XIII (1610–43) established a band known as *The 24 violins of the King,* which Charles II of England copied on his restoration to the throne in 1660. The popularity of the violin was established, and Italian makers were busy supplying the demand for their instruments. It was an Italian musician who really set the violin on its course as a serious instrument.

Masterly playing

Archangelo Corelli (1653–1713) was concert-master to Cardinal Pietro Ottoboni, an important patron of the arts in Rome. Corelli was no fiery technician or virtuoso in the modern sense. His playing was regarded by his contemporaries as masterly, however, codifying and refining as it did the techniques of his day. In his compositions for the violin, particularly his 12 sonatas, he demonstrated that great music could be written to exploit the techniques and possibilities of the instrument. The various *movements* (sections) of Corelli's sonatas preserved the names and some of the character of the dances with which the violin had been associated, such as the sarabande, the gavotte and the jig.

In an age of *polyphonic* (many parts) music, it was natural that composers should try to play several parts at once on the violin. It is, in fact, not possible to play more than two strings simultaneously, but by the use of rapidly played broken chords and quick crossing of the strings Corelli and his contemporaries managed to convey the impression of three and sometimes four parts going on at once. They interspersed such complex movements with light, running jigs and courantes using a succession of fast single notes.

We owe much of our knowledge of how violin music of that time was performed to Corelli's pupil, Francesco Geminiani (1687–1762), who wrote an important textbook on violin technique. A slow, sustained melody, in which a violinist of today would allow the tone of his instrument to sing in long, throbbing notes, was generally decorated with a succession of trills, runs and other ornaments. The decoration was largely left to the discretion of the player. Most of the bows in use at that time were shorter than the modern bow, and therefore not so suited to sustained tone.

The range of the violin and the music written for it was much less than it is now. Two things were chiefly responsible for this. The first was the length of the finger-board, often as much as 2½ inches shorter than a modern one. To play high

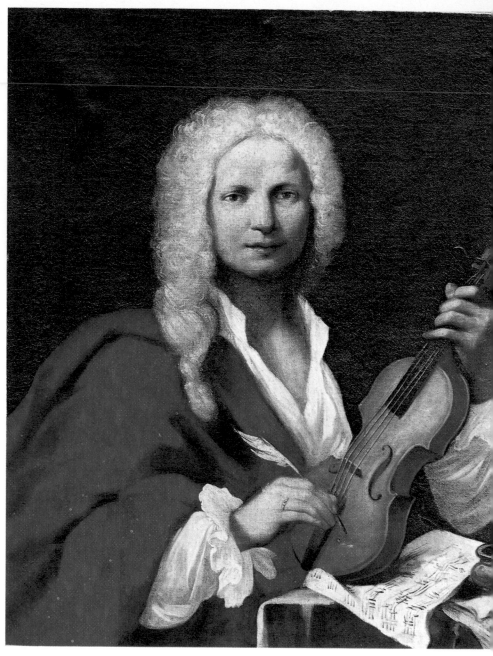

notes, the violinist presses his fingers on the strings closer to the bridge, in this way shortening the effective length. With a short finger-board, there was a limit to how close to the bridge he could go. The other factor was the way in which the violin was held. Early violinists, up to about 1700, held the violin against the chest, with the weight of the instrument taken by the left hand. Any attempt to move the hand in order to change the positions of the fingers on the strings was difficult.

Soon the demands of composers and the experiments of players changed the technique of the violin. By the time of Leopold Mozart (1719–87), father of W. A. Mozart, the modern technique of gripping the violin between the chin and the collarbone was in vogue. Leopold Mozart published his *Violinschule,* a complete instruction course, in 1756.

From its use in dance bands (as in *The 24 violins of the King*) the violin came to be the backbone of the orchestra, whether playing for opera or ballet, or on its own. Among the earliest orchestral works was the kind known as the *concerto grosso,* in

Antonio Vivaldi (*c.* 1685–1741), the Italian violinist and composer, is an important figure in the development of the concerto. He was much admired by Bach, who transcribed some of his works for other instruments.

which a small group of instruments play more or less alternately with the rest of the orchestra. From the concerto grosso the Italian violin composers evolved the concept of the solo concerto, for one violin with orchestra, in the first years of the eighteenth century. The greatest influence in the early days of the concerto was that of Antonio Vivaldi (*c.* 1677–1741), who spent much of his life as violin professor at a foundling hospital for girls in Venice. One of the conditions of his employment was that he should write two concertos (some for orchestra, some for a solo instrument with orchestra) every month. Vivaldi reacted brilliantly to this challenge. His development of the concerto was inspired by opera, and his concertos form a dramatic conflict between the solo instrument and the orchestra. He uses repeated notes and pounding rhythms to give an impression of force and drive, interspersed with bold

1

2

3

4

1 One of the violins manufactured by Antonio Stradivari, the most famous of all violin-makers. In 1704 he produced a violin which combined sweetness of tone with great power and sonority.
2 There is a legend that the devil appeared in a dream to Giuseppe Tartini, the Italian violinist and composer, and played a tune on the violin. On waking, the musician is said to have written it down under the title *The Devil's Trill*.
3 A beautiful example of a bass viol, painted (under the bridge) with the Somerset arms. The bass viol is commonly known as the viola da gamba.
4 Paganini's violin, on which he played music of such brilliance that many people thought he was inspired by the devil.

solo passages for the violin. His slow movements are pure song for the soloist, like the arias of opera.

Vivaldi's concertos served as a model to future composers, in particular Johann Sebastian Bach (1685–1750). Bach transcribed a number of Vivaldi's violin concertos for harpsichord, and modelled his own concertos closely on them, though with a greater attention to the melodies of the orchestral parts.

By now the demands of its music were beginning to overtake the capacity of the violin. In particular, greater power was needed for the solo instruments in the new concertos. The need produced the man – Antonio Stradivari (1644–1737), the greatest of the Italian violin-makers. Stradivari was not only a superb craftsman, but also a tireless experimenter. The bodies of the early violins, such as those of the Amati family, had high-arched backs and bellies,

producing generally a sweet tone. Stradivari gradually flattened the arching, and made various other adjustments in the proportions of the various parts of his violins.

Model violins

In 1704 he produced a violin that combined sweetness of tone with great power and sonority. Having found this perfect formula he kept to it, and the instruments that he made in the last 30 years of his life (he continued making up to the year of his death) have been taken as models by violin-makers ever since.

During the eighteenth century, the main developments of the violin were in orchestral playing, in its growing use in chamber music, and in the sonata. The earliest form of the sonata was the *trio sonata,* in three parts, the two upper parts being taken by two solo instruments, such

as two violins, and the lower part by a continuo – that is, a keyboard instrument supported by a bass stringed instrument, a cello or viola da gamba. Bach's sonatas for violin and keyboard were really trio sonatas, one of the two upper parts being taken by the right hand of the keyboard player. The form of the sonata changed gradually over the years, but in essence remained the same – three or four movements of contrasted rhythms and speeds. Towards the end of the century, the development of the keyboard sonata gave rise to a curious hybrid, the keyboard sonata with violin accompaniment, though this form had been anticipated by the French composer Jean-Joseph Cassanea de Mondonville (1711–72) earlier in the century.

Changes in musical demands on the violin led to further modifications of the instrument around the first years of

François Tourte (1747–1835), a Parisian bowmaker. According to tradition, he was advised in his work by the violinist Jean Baptiste Viotti (1753–1824), who is generally regarded as the father of modern violin playing. Tourte standardized the dimensions of the bow, made the stick curve inwards towards the hair, and gave the bow more weight and a different but fixed point of balance. With these new bows, players could sustain long notes with ease, and play runs and cascades of notes with one bow-stroke. Viotti was one of the first players and composers to exploit the possibilities of the new bow, which was ideally suited to the music of the Romantic movement of the nineteenth century.

The nineteenth century was a rich period for the violin repertoire, and most of the great concertos were composed during that time. Curiously enough, many of them were written by composers who were not themselves violinists. The first of the 'romantic' concertos was that of Ludwig van Beethoven (1770–1827), who did play the violin in his youth. He established a grand pattern for the concerto, which was followed by his successors.

Mendelssohn the revolutionary

Like earlier composers, however, Beethoven began his concerto with a long introduction for orchestra before the soloist made his entry. A considerable innovation was made by Felix Mendelssohn (1809–47). He abolished the long introduction; almost from the first note the soloist is playing, in a long, lyrical phrase soaring high in the violin's register and exploiting to the full the new bow and modified violin so recently developed. Mendelssohn also revolutionized the *cadenza,* traditionally a solo spot in which the player could improvise, much as a jazz player does today. Mendelssohn kept the cadenza, but wrote it out himself, so that it became an integral part of the whole work and not just an interpolation of virtuoso skill. To help him make the solo part technically sound and playable Mendelssohn sought the help of Ferdinand David, a leading player of the day, a practice adopted by many composers for the instrument since.

Despite the musical innovations of the twentieth century, the violin has held its own as the mainstay of ensemble playing, and as a favourite solo instrument. Its wide range of expression and its versatility have helped it to adapt to all demands. The traditions of the old craftsmen who made the first violins are being carried on in Europe and America, and its career, already four centuries old, seems likely to go on for a long time.

the nineteenth century. Three main factors led to these alterations. They were: changes in pitch (the general height of notes); a desire to play even higher notes; and a desire for a greater brilliance of tone. The pitch of notes was raised steadily after the time of Bach and Handel. This meant that the strings had to be stretched more tightly to tune them to the new level. Strings sound more brilliant the tighter they are stretched, and so the strings were lengthened as well, by about half an inch. Higher bridges were fitted, because they too helped the 'brightness' of tone.

Modified violins

To effect all these changes meant fitting a longer neck to the violin and setting it at an angle in order to keep the strings the same distance from the fingerboard. The changes in pitch rendered all existing wind instruments obsolete, because it is virtually impossible to change the pitch of a wind instrument once it is made. With the stringed instruments, however, modifications were made to existing instruments. Few violins made before the early 1800s now exist unaltered.

Altering instruments was considered worth while, because then, as now, players greatly prized old fiddles. There is a good scientific reason why this should be so, for there is an actual physical change in the wood of violins that only age can bring.

The wood of a new instrument, however well seasoned, still retains a certain amount of moisture and sap. Over many years this moisture dries out, leaving a wood that is dry and has within it minute dry resonant cavities. Such wood has better acoustic properties than new wood. It is also more sensitive to damp. An old violin can lose much of its beauty of tone in a cold, damp atmosphere, recovering its tone when it becomes warm and dry again.

At the same time, even more dramatic changes in the bow were taking place. The early bows were made of springy wood, curving outwards like an archer's bow, and with only crude devices for altering the tension of the hairs (up to 200 of them) with which the bow is strung. The length of bows varied, and so did the weight and the point of balance. By the mid-1700s, the arrangements for hair-tensioning were similar to those now used, but bows were generally shorter and lighter. Their effect was rather different from that of a modern bow, and they were more suited to short strokes than to long ones. As a result, players tended to play one note, or at the most only a few notes, to each bow stroke. This suited the strongly rhythmic allegro or lively movements of the Bach period.

Many experiments had been made with the form of the bow during the eighteenth century. The man who codified them was

Scored for orchestra

Blending and contrasting the tones of string, woodwind and brass instruments into a woven fabric of sound led to the development of an entirely new musical form — the orchestra.

THE ORCHESTRA as a band of instruments of varying tone-qualities and kinds is a comparatively modern development. Throughout the Middle Ages, instrumental music generally was at a low ebb. Voices, supported later by the organ, were the principal source of music for the Church. The main instrumental players were the wandering minstrels, and their instruments were more suited for solo work than for combining. The tone of the strings was comparatively weak and delicate, while that of the brass instruments was strong and strident.

Playing in harmony

For this reason, the earliest groups, up to the sixteenth century, tended to be of similar instruments – brass bands or string bands, for example, but they rarely joined forces. Such groups were called *consorts* and the rare groups of mixed instruments *broken consorts*. Composers still tended to think of music in terms of the voice, and wrote their instrumental music rather as a blending of tones than as a contrast. One of the earliest large mixed bands of instruments was assembled by Claudio Monteverdi for his opera *Orfeo* in 1607. It contained bowed and plucked strings, woodwind and brass, together with harpsichords and organs. Even in this work, the various groups play mainly on their own, although, at the beginning and end, the whole band plays together.

One of the most important features of Monteverdi's orchestra was the use he made of a considerable body of bowed strings to form the backbone of his orchestra. The development of the violin, and its rapid increase in popularity during the seventeenth century, took Monteverdi's practice a stage further. The use of string bands to provide music for dancing – such as the French King Louis XIII's

24 violins – helped in this direction. Court composers, with such a band available to them, tended to write music to make use of it. A typical Venetian orchestra of the mid-seventeenth century had 34 instruments, of which 24 were members of the violin family – violins, violas and cellos. By the end of the century, Alessandro Scarlatti (1660–1725) was asking for an orchestra consisting almost entirely of strings for his operas and church music.

The Bach-Handel period, often called the Baroque period, had as its typical orchestra a string band – violins, violas, cellos and double basses – with pairs of

other instruments such as flutes, oboes and trumpets, supported by drums and a harpsichord. The harpsichord was the conductor's instrument. From its keyboard he directed the players, and filled in harmonies or missing parts. In those days the difference between orchestral music and chamber music (in which each part is played by one instrument only) was rather tenuous. The same music was often played by both groups. For example, a trio sonata, normally played by two solo violins with keyboard accompaniment, plus a cello to reinforce the bass line, could be played equally well by a small orchestra.

The earliest purely orchestral works were *suites,* consisting of several movements (sections) based on dance rhythms. Towards the end of the seventeenth century composers in Italy developed the *concerto* as an orchestral form. The invention of the concerto is attributed to Giuseppe Torelli (1658–1709), a violinist and composer who spent much of his working life at Bologna, in northern Italy. He and his contemporaries evolved three main types of concerto. One was simply a work for orchestra, in several movements, similar to a suite. The *concerto grosso* and the *solo concerto* were each written for solo instruments whose

tone was contrasted with that of the full orchestra. In the concerto grosso there was a group of solo players, called the *concertino* (little group). In the solo concerto there was only one solo instrument. The bands available to the composers of the day – who mostly worked for the Church or at the courts of princes or rich noblemen – lent themselves to this type of work. Their regular players were few but highly skilled; the players brought in to augment the orchestra for special performances were usually less competent. Composers, therefore, wrote pieces in which their best players could display their skill and virtuosity, with simpler sections for the full orchestra.

Polyphony and oratorio

In the orchestras of the Baroque period the solo tone of each player counted for more than it does in today's large orchestras. This also suited the *polyphonic* style of writing, in which a number of melodies weave in and out. J.S. Bach's Third Brandenburg Concerto is a familiar example of this style. Though a large string orchestra is often employed in modern performances, the concerto can equally well be played by 11 instruments

The instrumental sections of an orchestra are always arranged in the same position relative to the conductor. Strings are to the front so that their tone will not be drowned.

– one to each of the solo parts, plus a continuo of harpsichord and double bass.

Much of the work of the Baroque orchestra was in opera and oratorio. In addition to accompanying the voices, the orchestra had interludes of its own, such as the Pastoral Symphony in George Frederic Handel's oratorio *Messiah,* or the introductory music to Italian operas, which soon received the name of overture – literally opening music. These overtures, being complete pieces of music themselves, soon found their way into the concert hall, and similar pieces were written for concert performance only. Orchestral works went under a bewildering variety of names, but were in fact of two main types: the suite and the sonata. The suite form, as we have seen, consisted of dance-like movements. The sonata form was generally of three or four movements, alternately slow and fast, in each of which the composer worked out ideas on a theme or themes. From this came the symphony. Much of the development of the symphony, and of the orchestras that played it, took place at Mannheim, in southwest Germany.

In the middle of the eighteenth century the court orchestra of the Elector of Mannheim was under the direction of Johann Stamitz (1717–57) and later his two sons, Karl and Anton. The Mannheim orchestra became famous throughout Europe for its polished performance. In particular, the Stamitzs introduced grada-

tions of loudness and softness, a revolution when musicians were accustomed to playing either loud *or* soft. The orchestra also made regular use of horns and clarinets, which were only occasionally used in other orchestras. Stamitz's own works also provided more interesting parts for the violas to play. Except in the music of Bach, the violas had been for many years the Cinderellas of the orchestra. They had dull, simple parts to play, and inferior violinists tended to take up the viola because the parts were so much easier.

Mozart and Haydn

Among the contributions made by the Stamitz family to the symphony was the regular use of a fourth movement. Hitherto composers had generally written three movements – a quick first movement, a slow second movement, and a minuet and trio to close. Johann Stamitz added a final allegro.

In the earliest symphonies, as with other orchestral pieces, composers tended to make little distinction between the kind of music the instruments of the various sections of the orchestra played. Usually, the wind instruments doubled the string parts to add additional tone colour, or played identical phrases instead of the strings. By the end of the eighteenth century the wind players were given truly independent parts, differing

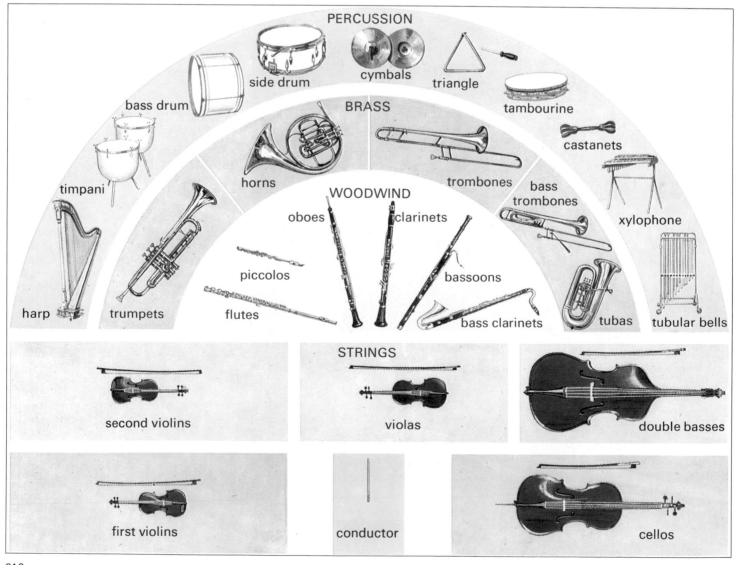

in character as well as being separate.

The biggest step forward in the emergence of the symphony as we know it today was taken by two composers, friends whose work influenced each other's: Joseph Haydn (1732–1809) and Wolfgang Mozart (1756–91). Haydn wrote the prodigious total of 104 symphonies. Of these, by far the greater number are charming works, little different in character from those of his contemporaries. The same might be said of many of Mozart's 41 symphonies. But the younger composer found in the symphonic form more than

just a way of writing pleasant orchestral pieces. His last three symphonies, completed within eight weeks during the summer of 1788, are works on a grand scale, both in depth of musical thought and in quality of workmanship.

Already Mozart's example had led Haydn to produce a series of magnificent symphonies for performance in Paris – the so-called *Paris symphonies* of 1785–6. But after 1788, Haydn produced what are undoubtedly his finest works for orchestra, the twelve symphonies written for performance in London. In their late works

1 The Royal Festival Hall, London, ranks as one of the world's leading concert halls, and consequently attracts many internationally famous orchestras and conductors.
2 California's Hollywood Bowl is a famous open-air concert arena with acoustics which are good enough for symphony concerts.
3 Many amateur orchestras flourish in the United States and Europe, despite the difficulty of finding a place large enough to accommodate all the players.
4 Johannes Brahms (1833–97) wrote symphonies which are reminiscent of Beethoven's. He also avoided mammoth orchestras.

both he and Mozart broke new ground in orchestration, and are considered founders of modern orchestral tone-colouring. They made more frequent use of muted strings, used the various sections – strings, woodwind and brass – to provide 'blocks' of contrasting tone, and explored new effects made possible by combining various instruments.

This consideration of the various sections as providing contrasting sounds, rather than just adding to the total tone effect, led inevitably to the more precise writing of orchestral parts and an insistence that such parts were properly played. This development made the harpsichord, up to that time considered the continuity keystone of the orchestra, redundant. Its dry, percussive tone could not be allowed to intrude when special tonal effects were the order of the day. Around the turn of the century the harpsichord gradually fell out of use. The leadership of the orchestra was at first given to the principal violin, and then to a new member of the orchestra: the conductor.

The conductor filled the position formerly held by the keyboard player, especially when that player was a composer such as Haydn directing one of his own works. The earliest conductors beat time with a roll of music or a violin bow. Soon they adopted a baton, at first the size and shape of a field-marshal's baton. The present-day slim white stick was introduced by Felix Mendelssohn (1809–47) at a concert in London in 1829. The growing complexity of orchestral music and the need for more control to ensure complete co-ordination made the development of the conductor inevitable.

With the development of the conductor, the role of the leader, or *concertmaster,* as he is called in America, changed too. Conductors come and go, often for just one concert. The leader is always there, to provide the vital link between conductor and players. He is responsible for the orchestra's playing, discipline and tuning, and for conducting some rehearsals.

Beethoven's change of emphasis

Conducting was firmly established in most countries (England being an exception) by the time the giant figure of Ludwig van Beethoven (1770–1827) arrived on the orchestral scene. His first symphony, produced five years after the last of Haydn's, was scored for a similar orchestra. But the sounds he obtained from the orchestra were different. He massed his wind instruments together to form almost a wind band within the orchestra. In his third and later symphonies he gave more strongly independent parts to the violas and double-basses, and demanded a steadily increasing virtuosity for all his players. Gradually he increased the size and scope of the orchestra. By the time he produced his ninth and last symphony in 1824 he demanded four horns (instead of the pair typical of eighteenth-century orchestras), three trombones, a piccolo and a double

Oratorio was a musical form much favoured by eighteenth-century composers. This contemporary engraving shows Handel watching a rehearsal of one of his works.

bassoon, in addition to the normal pairs of flutes, clarinets, oboes and trumpets. To balance these extra wind instruments he employed more strings and a wider range of percussion instruments, including bass drum, cymbals and triangle.

The use of varied orchestral tone-colour was carried a stage further by Franz Schubert (1797–1828). Like Beethoven, he paid special attention to the *dynamics* (loudness and softness) of his orchestral parts. Where Beethoven was the master of the grand mood, Schubert was the master of the quiet effect.

Beethoven extended the size of the orchestra. Some of the nineteenth-century composers of the Romantic school extended it a great deal further. By the mid-nineteenth century the biggest orchestras had nearly 80 players – about the size of a modern symphony orchestra – and bigger concert halls were being built to accommodate them. But some composers demanded larger forces still. Among them was the French composer Hector Berlioz (1803–69). He scored his *Requiem Mass* of 1837 for an orchestra of more than 150 players, plus 200 singers and four brass bands. Two years later his vast symphony *Romeo and Juliet* was scored for an orchestra of 160 players, with, for the vocal sections, three soloists and a chorus of 98. In 1840 he wrote a *Funeral and Triumphal Symphony,* intended for a national ceremony, which was played by an orchestra 130-strong, supported by a military band of 120 players. This aroused the admiration of Richard Wagner (1813–83), himself a lover of large forces. For Wagner, the orchestra was an adjunct of his mighty operas and he generally employed over 100 players. His orchestration was masterly, and he was also responsible for the invention of a new set of brass instruments, the so-called Wagner tubas.

Twenty years younger than Wagner, Johannes Brahms (1833–97) was musically a throwback to the days of Beethoven. In an age of enormous orchestras, he employed one no larger than Beethoven had used, and his four symphonies have been compared with those of the older master. They have a power and vitality similar to that of Beethoven, in contrast to the more spacious, leisurely work of Brahms's contemporary Anton Bruckner (1824–96).

The economics of huge orchestras have tended to work against the composers who use them. The symphonies of such composers as Gustav Mahler (1860–1911), whose eighth symphony is often called the 'Symphony of a Thousand' because of the number of performers required, and Havergal Brian (1876–) get fewer performances than they might because of the huge cost of putting them on.

In the twentieth century composers have veered the other way. For example, Igor Stravinsky (1882–) used an 'orchestra' of only seven players for his *Soldier's Tale,* and similar small combinations are not uncommon. With the wide range of music now in the repertoire, today's orchestral players need to be versatile; Sir Adrian Boult said that in his lifetime the greatest change in the orchestra had been a general increase in skill.

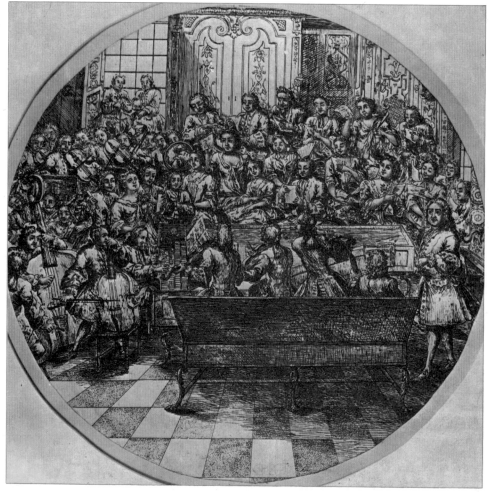

Music among friends

Four or five friends playing together for enjoyment was the essence of chamber music. Today it has become more complex and professional, but still retains an intimate quality all of its own.

CHAMBER MUSIC might well be described as 'musicians' music'. It has also been called the 'music of friends'. Though a great deal of chamber music is in fact performed in public, most of it is played, as the name implies, in ordinary rooms in the players' homes. Chamber music provides the great common bond between the amateur and the professional: both play it for fun and relaxation, and many musicians regard its performance as one of the highest forms of musical experience.

One of the first requisites for the proper enjoyment and performance of chamber music is that the players shall enjoy one another's company and work well together. Compatibility is more important than great technical ability, given a reasonable degree of competence all round. A maximum of nine players is generally taken to be the limit of a chamber music group.

The great difference between orchestral music and chamber music is that of texture. In an orchestra there are many dominating instruments, such as trumpets and trombones and drums; massed against them are solid phalanxes of strings whose unison playing produces a rich sonority. In chamber music, the clear, individual timbre of each instrument is heard. This clarity imposes greater demands on the players, particularly on string players. In orchestral playing an occasional roughness or imprecision may escape undetected in the general blending of tone, but in chamber music the slightest imperfection is all too painfully obvious.

Intimate atmosphere

The position of the amateur in chamber music is important. For the amateur, chamber music provides the most important outlet for his skill and musical desires. Amateurs make considerable contributions to music by their playing and by their support of professional music-making. Besides going to concerts, they are among the principal purchasers of printed music and recordings. They also contribute to the revival of much lesser, but excellent, music which might otherwise be forgotten. An extreme example of the importance of amateurs is provided by Walter Willson Cobbett (1847–1937). He was an English industrialist who commissioned much new music, founded competitions for chamber music composition, and also compiled an exhaustive *Cyclopedia of Chamber Music*, now a standard reference work.

Listening to chamber music imposes a special discipline upon the audience. Because of the small numbers of players involved, chamber music sounds best in a room or a small hall rather than a large hall. Audiences in such circumstances

1 As well as his famous symphonies, Beethoven wrote 17 string quartets, which form a basic part of the chamber music repertoire. Three of them were written after he became deaf.
2 Haydn was largely responsible for developing the string quartet into a strong musical form, giving each of the instruments its own individual part to play.
3 In the Netherlands, as in Elizabethan England, accompanied airs were very popular with the bourgeois class. Replacing the voice part by another instrument transformed these into chamber music.

tend to be small and to be on more intimate terms with the players; the impersonal atmosphere associated with an orchestra is absent. Even in a larger hall, the sense of intimacy is retained, because the small volume of sound produced means that a bigger audience must listen more attentively to catch all the nuances and beauty of the music and the playing.

Scholars differ about what exactly comprises chamber music. Generally, however, music for a solo instrument such as a piano or violin is excluded, and so are the majority of duets for keyboard and one other instrument, such as piano and violin together.

Stringed instruments have always been the most generally suitable for chamber music, because their individual tone is not dominating and they can be played in a wide variety of styles. Although the string quartet has been the most typical medium for chamber music for 200 years, other forms have also been popular. These include the string trio (violin, viola, cello), and the string quintet (a quartet with a second viola or cello), and combinations of strings with piano – trios, quartets and quintets. In addition, there are a number of combinations in which a wind instrument – usually flute, oboe or clarinet – is substituted for one of the strings. Composers in the twentieth century have been noticeably more adventurous in their use of unusual combinations of instruments. An example is Hanns Jelinek's divertimento for three clarinets and basset horn.

The most intense emotion

Despite all this variety, the string quartet remains the favourite combination. This ensemble, the tone of whose members balances and blends and yet affords a measure of contrast, has been found to be as effective for the austerities of modern compositions as for the gay classicism of Mozart. Of the string quartet, the French composer Darius Milhaud has written: 'It is a form . . . that conduces to meditation, to the expression of what is deepest within oneself . . . at once an intellectual discipline and the crucible of the most intense emotion.'

The origins of chamber music have been traced back as far as the beginning of the fourteenth century. Its ancestor, and for a long time its co-partner, was the vocal music of motets and madrigals. These were pieces for a number of solo voices, as chamber music is for solo instruments. In the fourteenth and fifteenth centuries it was common for one or more of these vocal parts to be taken by stringed or wind instruments.

By the sixteenth century, the writing of instrumental chamber music was well under way. Soon a musical education became a regular part of the education of a gentleman. It became the custom to have in his home a consort or chest of viols – usually six instruments, two trebles, two tenors and two basses. The development of this form of chamber music in England had a magnificent swan-song in 1680 in the three-, four- and five-part fantasias of Henry Purcell.

The next stage in the development of **2**

chamber music came with the adoption of the violin family as the main bowed stringed instruments, to the virtual exclusion of the viols. The violins, with their louder and more brilliant tone, lent themselves to a more bravura style of music and playing. The violin first became popular in Italy during the late sixteenth and early seventeenth centuries. The earliest violin music was of two main kinds. The *suite* consisted of dance movements of various rhythms, such as the allemande, bourrée, courante, chaconne, gavotte and minuet. The *canzona sonata* (played song) was instrumental music in imitation of the French *chanson*.

Both the suite and the canzona sonata had a number of movements of varying

speeds and rhythms. The canzona sonata was gradually standardized at four movements, from which evolved a form known as the *sonata da chiesa* (church sonata), so-called because it was in a style often used in church music. Its more serious character contrasted with the gayer form of sonata that developed from the suite, known as the *sonata da camera* (chamber sonata). The sonata da camera was a purely secular form of music intended primarily for performance in halls and *salons* . . . in short, chamber music.

Both kinds of sonatas were composed for one or more solo instruments with a *continuo* part. The continuo consisted of a bass line played on a cello or similar instrument, with a more or less freely

1 A child prodigy on the harpsichord, Mozart continued to play in later life. Here he is seated at the instrument with his sister Nännerl, Leopold, his violinist father, standing on the right.

2 Schubert took part in many a fashionable soirée in private houses in Vienna. Although people delighted in his playing, he gained little recognition as a composer until after his death.

known string quartets. But chamber music with continuo parts continued to be the rule rather than the exception during the first half of the eighteenth century.

The earliest known regular production of string quartets was in the Rhine Valley of Germany, where the Czech composer Johann Stamitz (1717–57) was director of chamber music to the Elector of Mannheim. But the real development of the string quartet was undoubtedly due to the Austrian genius Joseph Haydn (1732–1809), who was for 30 years resident musician to the wealthy Hungarian family of Esterházy, and spent most of his time on their estates some miles to the southwest of Vienna. His earliest quartets date from 1755 to 1756, and were originally known as *divertimenti*. These still had much of the character of the trio sonatas from which they evolved. The two violins had the lion's share of the work – indeed in the six quartets of Opus 17, written in 1771, the

1 In the sixteenth century, music was often composed for voices with instrumental background, as a detail from Brueghel's picture *The Audition* shows. Performers sometimes transposed one or more of the voice parts for instruments, which eventually led to compositions for these alone.
2 The English composer Henry Purcell wrote three-, four- and five-part fantasias for viols.
3 Amateurs have always delighted in playing chamber music together. The picture shows a music party given by Frederick, Prince of Wales and his sisters in 1733.

improvised harmonic accompaniment for an organ or harpsichord. The usual combination was the *trio sonata* for two violins and continuo.

The string quartet was derived directly from the trio sonata, with the improvised keyboard part replaced by a viola part. The Italian master violinists made use of this form in the early eighteenth century, if not before. Alessandro Scarlatti (1659–1725) has been credited by some authorities with the authorship of the earliest

1 Candles burn lower and lower as this dedicated group of musicians practise late into the night, while one member of the party nods wearily in his chair by the fire.

2 Before public concerts, chamber music was performed in the halls of royalty and the aristocracy. Often such occasions provided the excuse for a different kind of activity.

his finest works in this vein was the trio for piano, viola and clarinet, the sombre tones of the viola and clarinet providing rich patterns of sound. Mozart was also a pioneer of the modern piano quartet in which, as in his piano trios, all four instruments have individual roles.

The development of chamber music and its emotional possibilities was carried much further by Ludwig van Beethoven (1770–1827). His 17 string quartets are the keystone of the chamber music repertoire, and his 30 other chamber music works include a number for wind instruments or for wind and strings combined. His late quartets (written 1824–6) were regarded for many years as difficult to understand, but are generally revered today as supreme examples of their kind.

Schubert and Mendelssohn

With Franz Schubert (1797–1828), as with Beethoven, chamber music moved from the classical period of music to the Romantic. Like a number of chamber music composers, Schubert was himself a viola player. His intimate knowledge of the medium shows in his skill in blending lyricism with clever writing for strings. His last nine chamber works, less than a third of his total production, are among the finest in the chamber music repertoire. They include, besides string quartets, two piano trios, of which the first, in B flat, Op. 99, is a joyful and highly tuneful work; and two quintets, one with two cellos and the other for the rare combination of violin, viola, cello, double bass and piano. This quintet, called 'The Trout' because one of its melodies is taken from Schubert's song of that name, is one of the few chamber works for double bass.

Felix Mendelssohn (1809–47) brought to chamber music all the sweetness of melody and harmony that characterizes his work. But his writing tends to be rather dense and 'busy', with a lot going on at once. Most of the chamber music of Robert Schumann (1810–56) includes the piano, his own instrument. Far more important was the chamber music of his friend Johannes Brahms (1833–97). Brahms's reputation for never having published chamber work that was not a masterpiece may well have been acquired because he destroyed more music than he published. His works are notable for the exciting rhythmic variation between the different parts. After Brahms, the great names in chamber music are many. They include Antonin Dvořák, Alexander Glazounov, César Franck, Claude Debussy and a host of contemporary composers.

The outstanding twentieth-century chamber music composer is Béla Bartók (1881–1945). Perhaps because he was an avid collector, Bartók was greatly influenced by folk-music, and this influence is apparent in his quartets. It is sad that, like most twentieth-century music, Bartók's quartets call for a high degree of technical skill, placing them outside the scope of most amateur players. Unhappily, this reduces the part that amateurs are able to play in the furtherance of chamber music, and many of the old traditions are disappearing.

first violin part is almost as difficult as the solo part of a violin concerto. But from 1772 onwards Haydn suddenly brought the string quartet to its full fruition, giving each instrument a strong, individual part to play, and one moreover suited to the tonal qualities of the different instruments – the brilliance of the violins at the top, the rich sonority of the cello in the base, and in between the haunting, mysterious tone of the viola.

During the brief period of Wolfgang Amadeus Mozart's life (1756–91), he and Haydn influenced each other, and the quality of their chamber music increased accordingly. An interesting development came as a result of a commission to Mozart to write some quartets for Frederick William II of Prussia. Frederick William was himself a good cellist, and Mozart was careful to provide an especially brilliant part for the cello to please his patron. To do this without unbalancing the quartet

meant writing more brilliant parts for the other instruments too, thus producing an altogether richer effect. Mozart and Luigi Boccherini (1743–1805) were largely responsible for exploring the musical possibilities of the string quintet, and Mozart also wrote quintets with one wind instrument – clarinet or horn.

The disappearance of the trio sonata and the continuo left the keyboard instruments with no real chamber music part to play. Haydn and Mozart and their contemporaries evolved a form that was a complete reversal of the continuo. Instead of playing a fill-in part, the keyboard instrument, now the newly popular piano, played the main part, with an accompaniment provided by violin and/or cello. In fact, in Haydn's trios for piano, violin and cello the string parts are unimportant.

Mozart took the piano trio and revitalized it, with all three instruments playing equally important parts. One of

Music for the millions

Music satisfies a deep-seated human need. This is as true today as it was in the distant past of minstrels and troubadours. How has the form and character of popular music changed?

THE MODERN POPULAR SONG is the end-product of a huge industry. Music for entertainment is manufactured, marketed and consumed just like any other product in present-day society. Just as other industries have developed from small-scale local production and consumption to modern mass-production, so has the popular music industry developed.

In medieval times, the ordinary people entertained themselves with music. The village would provide its own music for a festival, or just for an evening's pleasure – music we now call folk-music. The only music specially written for entertaining medieval Man (in the way that pop music is now produced specially for this purpose) was provided by wandering minstrels.

In praise of woman

These men were often all-round entertainers (they were called *jongleurs,* or jesters, which gives some idea of the range of their activities). The minstrels would perform wherever there was enough prosperity to keep them alive. Obviously their most remunerative engagements would be at Court. In the Provence district of France the troubadours were the highest class of jongleurs, producing passionate lyric poetry to rhapsodic tunes, mostly in praise of woman.

In Germany the counterpart of the troubadours were the *Minnesingers,* aristocratic, and equally concerned with the virtues of the female. By the fourteenth century the merchant classes were becoming an important source of revenue for jongleurs and minstrels, and, as with many other trades, guilds were set up. The Mastersingers were one such guild

(used as the subject of an opera by Wagner). They were very highly organized and membership was by examination, with an elaborate series of grades culminating in 'Master'.

In the early 1500s some Italian composers took a form of light-hearted street song, the *frottola,* and began making it into a musical entertainment more suitable for their rich and cultured patrons. These

1 During the eighteenth century, penny ballads, forerunners of modern sheet music, were sold in the streets, often with the words only.
2 Madrigals, which gained popularity in England in the sixteenth century, were sung at home, usually by five voices.
3 A night at the music hall was an entertainment of not only songs and music but turns by jugglers, acrobats, comedians and magicians. This later developed into the modern variety show.

were banking families, who required a form of music in which they could participate, yet which expressed rather higher sentiments than coarse street songs. Thus the madrigal was born. This was a piece of music, usually for five voices, which could be sung in the home. By 1600 it was immensely popular in Italy, and several books of madrigals published by Claudio Monteverdi had to be reprinted – a great achievement considering that music printing had only been invented twenty years before.

The vogue spread to England and enjoyed a similar success in the years before the Puritan Revolution in 1640. Thomas Morley's famous song 'It was a lover and his lass' is still very popular today, and John Dowland's *Firste Booke of Ayres of Four Partes*, 1597, went through four editions before 1613.

The spectacular success achieved by Italian opera in the seventeenth century gave popular music a tremendous fillip. For the first time, music became known amongst a wide range of people in many countries instead of just locally as had been the case in the Middle Ages. By the end of the century aristocratic and bourgeois audiences throughout Europe would be humming tunes from the latest Italian hit. And on the streets of every city, performers would sing half-remembered arias to the crowds. Dr Charles Burney, a famous English musician and historian, visited Italy in 1770 and found street music flourishing everywhere. He found the Venetian gondoliers the most pleasing, and put this down to the fact that they had free admission to the opera-houses.

Scandalous street-music

The success of John Gay's *Beggar's Opera* in England, first produced in London in 1728, indicates the flourishing state of street music at the time. Penny ballads were on sale everywhere, dealing openly and scurrilously with all the gossip and scandal of the day. These were in part the ancestors of the sheet music of modern times, though they often printed only the words, accompanied by the instruction 'To the tune of . . .'.

The French Revolution made military marching songs popular overnight. The Revolutionary armies swept across Europe to the tune of the 'Marseillaise', and ten years later, when the Napoleonic forces were being rolled back, Beethoven wrote one of his most popular pieces, and one of the most curious – 'The Battle Symphony'. This symphony opens with the entry of the British forces at the Battle of Leipzig to the tune of 'Rule Britannia'. Then the French enter to one of their national march tunes. The battle follows and the British victory is celebrated by variations on 'God Save The Queen'. All this was written first for a primitive sort of jukebox, but later Beethoven arranged it for orchestra.

Later in the nineteenth century, the piano became the essential instrument for home entertainment in every middle-class household. Many composers, realizing this, tried to popularize serious music by arranging it for the piano. In the 1850s and

1 When sound came to the cinema in the 1920s the spectacular Hollywood 'musicals' became a major industry. Later colour added a new reality to the screen. This is the 'Ascot Scene' from the lavishly costumed *My Fair Lady*.
2 Julie Andrews, the star of many musical films, played the heroine of *The Sound of Music* against a background of impressive mountain scenery.

60s, when Richard Wagner's operas were hardly ever performed, enthusiasts got to know them through the arrangements of Franz Liszt, the virtuoso pianist. Other, less able, composers were content to turn out countless 'Maiden's Prayers' and 'Nightingale's Songs' all with sentimental melodies and simple harmonies. The career of Sir Henry Bishop, one of the most successful composers of early Victorian times, is typical of many. At 23 his opera *The Circassian Bride* was very successful and he was engaged by the Royal Opera House, Covent Garden to write and direct musical productions. *Clari,* one of his greatest hits, contained the tune 'Home Sweet Home', which has been popular ever since. He received the Freedom of the City of Dublin, professorships at Edinburgh and Oxford, a knighthood, and after his death an expensive memorial was erected over his grave. Such was the way the Victorians treated the success of a man of enterprise.

The two traditions of popular music – music for the stage and sheet music for the home – continued to make great strides in the later nineteenth century. Both became increasingly commercial; sales of music were pushed up higher and higher by the effective use of advertising and prices were lowered by large-scale mass-production.

Many of the dance crazes are well known. The Can-Can, and the Viennese Waltz are still heard, mainly because of the marvellous music written by Offenbach and Johann Strauss. Innumerable others waxed and waned, much as they were to do right through the 'naughty nineties',

into the twenties and thirties (with the Charleston, the Fox-trot, and the host of South American dances) and up to the present day (with rock'n'roll and its numerous fellows).

At the same time, the theatre had in many cases abandoned all pretence of presenting a coherent dramatic show and developed the music hall, which is the ancestor of modern 'variety shows'. At all the different levels of society, a rousing evening's entertainment was provided by jugglers, acrobats, comedians, magicians and singers of all types. The songs were the same as those sold over the counter and

when wax recordings first appeared, it was natural to record music-hall singers, since these were the most popular throughout England and would sell most copies.

The wax recording, and later the familiar black disc, were created at the same period as the other great agents of modern mass society – the large-circulation newspaper and the movie film. All of these developments, although very important in Europe, had maximum impact in the United States. There a huge and rapidly expanding population existed in a highly advanced industrial society; a perfect market for the professional profit-hunters of the entertainment industry.

Films and pop records grew up side by side, and in many ways they developed similarly. Early on in the career of movies the star 'system' was established. This put films at the top of a hierarchy of acting; the ultimate ambition of every young actor was to be a film star. The same conditions arose in the music industry, where millions of young musicians aspired to making recordings which would make them a fortune. The films, being silent, created a new musical need. Musicians

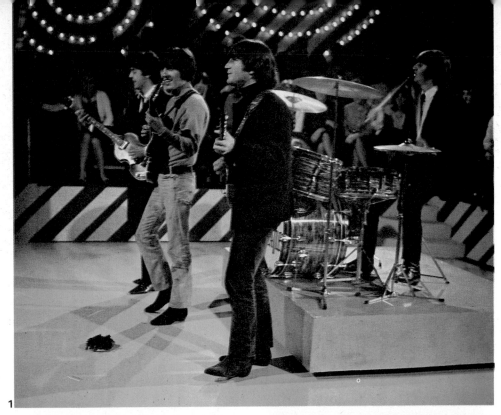

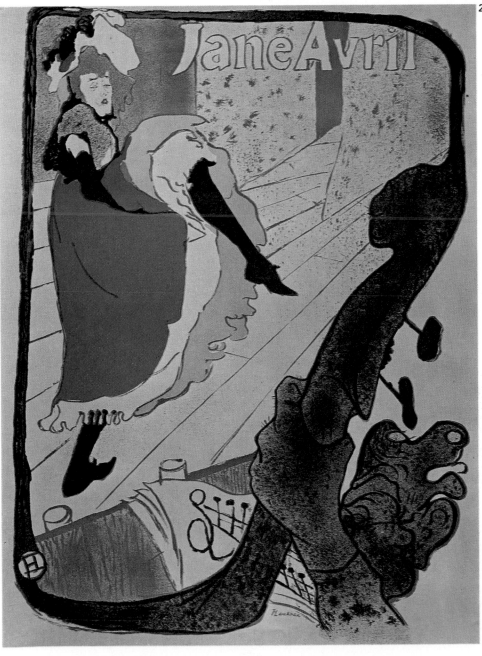

1 The world-famous group, the Beatles, started a revolution in 'pop' music when they composed their own music and songs instead of using those churned out by professional song-writers. Their success is backed by a highly commercialized and profitable record-making industry.
2 This poster by Toulouse-Lautrec advertises the Can-Can, with music by Offenbach, which was very popular in Paris in the 1890s.
3 Elvis Presley, a leading singer of rock'n'roll in the 1950s, proved that the tastes of youth influenced the trends of popular music.

were hired to play suitable music to each part of the film. Sometimes it was just a pianist, in other cinemas a small chamber group would play, and in the biggest and most elaborate, the organ came into its own. Highly elaborate organs were constructed on a massive scale in cinemas throughout America and Europe.

When sound finally came to the screen in the late twenties, Hollywood quickly developed the idea of the 'musical'. A plot was contrived which gave the hero and heroine the maximum number of opportunities to burst into song. Plots with show business as a background were preferred, since these were the excuse for spectacular scenes involving hundreds of lavishly

dressed showgirls and dancers. This type of film continued throughout the Depression of the thirties. It stressed the virtues of money, and the good life that money could buy, an escapist formula which proved extremely popular with the poverty-stricken masses (when they could afford to attend the cinema). But massive audiences led to large advertising revenues for the cinema circuits, and thus to lower seat prices.

The world of recording had its own stars too. The earliest recordings of Bing Crosby date from the twenties. In those days he was the singer with a big band – an 'orchestra' composed largely of wind instruments which played swing music, influenced by jazz. Crosby's style of singing – a soft, warm, relaxing and reassuring tone – is typical of the most popular music of the thirties. People wished to withdraw from the troubles of life – depression, inflation, continuing political troubles in Europe – into a make-believe world of carefree happiness. The industry was poised to reap the benefits of this mood, and songs such as 'White Christmas', and 'Underneath the Arches' with their sentimental, half-nostalgic mood, had tremendous success.

Radio and records

The development of commercial radio expanded the market for such music as dramatically as records had in the early years of the century. People could buy a radio set and have free entertainment piped into their homes. The programmes were all paid for by advertising. Advertisers, enraptured with the opportunity to enter people's homes, speedily subscribed to the new medium. Amongst the most popular shows were the record-request programmes. These have remained an integral part of the radio repertoire right up to the present day. The request show gave a record manufacturer a ready-made guide to the popularity of his recordings. If they were broadcast regularly then all was well. But if they were conspicuous by their absence then something had to be done about it. The manufacturer would send copies of all his records to the disc jockeys to make sure that they were well informed about his products. And then some of the more unscrupulous record 'promoters' devised many other means of persuading disc jockeys to play their records. Sometimes this took the form of cash bribes – this was called 'payola', and has been largely stamped out now by the United States government.

As this vast capitalist entertainment industry is constantly searching for something new in order to increase its turnover, its successes reflect to a great degree the changes within society. During the Second World War, songs like Vera Lynn's 'We'll Meet Again' were successful because they reflected the sentiments of men and women separated by thousands of miles. In the mid-fifties the emergence of rock'n'roll and its hero, Elvis Presley, gave vigorous expression to the feelings of a new generation of youth, who were too young to remember war and lived in comparatively prosperous times. Rock'n'roll showed

Bing Crosby's nostalgic crooning, and the big-band sound, suited the mood of the 1930s. His records became best-sellers.

record-makers that a fortune could be earned simply by appealing to youth. This they have done ever since, and the composition of the 'top ten' record charts is increasingly determined by the tastes of 13- and 14-year olds. The Beatles, for example, owed most of their early success to the very young. But since the Beatles appeared things have become very different.

Many groups now compose their own songs – as the Beatles did – and the result

The record-making industry mass produces millions of discs a year, following and moulding the rapidly changing tastes in 'pop' music.

is a great increase in originality. The fresh approach of such songs is in complete contrast with the simple harmonies of songs churned out as standard material by many of the older generation of composers. A new emphasis is laid on the 'noise' produced on a record. Many such 'noises' are unperformable on stage and derive from complex manipulation of electronic and acoustic effects.

Here popular music seems to be aiming in the same direction as many composers of 'serious' music. They are both trying to expand the area of sound that we recognize as 'music'. Some composers do this by including all sorts of seemingly non-musical 'instruments', such as buckets of glass, sirens and radios; 'pop' musicians do it by including in their records electronic sounds (often obtained by maltreating their guitar amplifiers) and other strange noises.

Yet side by side with this new, *avant-garde* pop world there exists the more traditional world of musical show and film. Since the war there have been many huge successes in this field – for example the long-running film version of the *Sound of Music*. The television variety show is still very popular, though in many respects its format has had to change.

All the widely known forms of musical entertainment today are related to a system in which large amounts of capital are invested by cool-headed businessmen. Anything which fails to provide a sufficient return on capital invested stands little chance of surviving. Yet modern 'pop' music is truly popular in a sense that music never was before. It depends for its success on the support of millions of people, although that support can be controlled and directed (by successful promotion) to a large degree. If music were free of the constant obligation to make a profit it is possible that entirely different types of music might be called 'popular'.

'Pictures that move'

The first cameramen filmed crowds, trains, horses — anything that moved. But in the early years of the twentieth century, film changed from being a delightful toy to international big business.

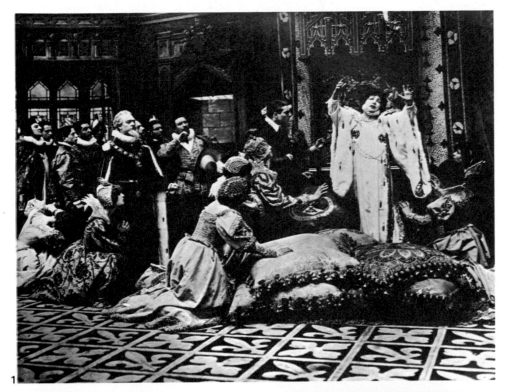

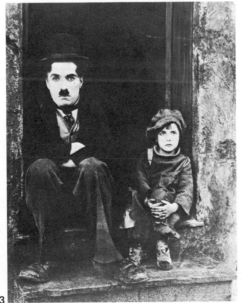

1 The *film d'art* movement in France returned to the theatre for themes and actors. *Queen Elizabeth,* starring Sarah Bernhardt, was one of many films made in this mode.

2 Thomas Edison, the American inventor who began it all. In 1889 he produced the first moving picture; inventors in other countries were quick to follow him.

3 Charles Chaplin's 'little fellow' is the cinema's most famous character. His own best director, Chaplin developed the tramp figure in a series of films, including *The Kid* (1921).

THE CINEMA – 'the eighth art' – has been in existence only since the 1890s. There are still people alive who remember the first films ever made, shown perhaps in the local town hall or in a booth run by a travelling showman. In their advertisements these showmen told the public of excitement, marvels and spectacle in the new moving pictures, and they were not far wrong: to our grandparents, to see images move on a screen must have been one of the most exciting things they had ever experienced.

The years from the birth of the motion picture to the present day have seen its scope and technique advance swiftly. The design of cameras and projectors has been refined; sound (introduced in the late 1920s) has been perfected; colour film has largely superseded black and white; and cinemas are specially designed for the maximum comfort and enjoyment of the cinema-going public.

Yet the modern cinema industry, with its million-dollar productions, its chains of cinemas and its internationally known stars depends for its existence on a curious trick of the human eye – its ability to retain the image of something seen for a second. The discovery of this 'trick', known as 'the persistence of vision', in 1824, began a series of experiments which culminated in the motion picture film very much as we know it today.

Experiments in photography went on throughout the nineteenth century, especially in France, where Louis-Jacques-Mandé Daguerre and Joseph Niepce demonstrated their photographic process in 1839. Of course, these early experimenters did not solve the problem of reproducing motion. It was not until 1889 that the first motion picture film was produced. Thomas Edison, an American inventor, had been working for years on the problem of recording and playing back sound, and was interested in the attempts of others to produce the illusion of motion by means of revolving drums and mirrors. His assistant, William Dickson, constructed a camera which took pictures in a continuous strip of film fed through a gate in front of the camera aperture. Because of the principle of the persistence of vision, the film gave the illusion of motion. The problem had been solved.

The 'moving picture machine'

Inventors in other countries were quick to copy Edison's and Dickson's invention, and to improve on it. Robert Paul in England produced a portable, hand-cranked camera; Louis Lumière in France made the cinematographe, a camera which could print and project the film it took. This work, which owed its inspiration largely to Edison, would nevertheless have been impossible without the work of the early still photographers, and those men in other countries who improved immediately on his discovery had long been working on the same problems.

It was not long before the new 'moving picture machine' found a commercial outlet. Edison gave the first public showing of the kinetoscope in 1894; in a year's time, Americans were seeing crude little films in improvised cinemas from coast to coast. In Europe, Lumière, Charles Pathé and Léon Gaumont found an audience just as willing to queue up and pay for their first sight of people, horses and trains moving miraculously, if somewhat jerkily,

across a lighted screen. An uproar took place in a Paris cinema when Lumière presented a film about a train pulling into a station: shot with the camera in front of the train, it appeared to the audience that it was coming through the wall straight at them, and they fled.

The early photographers found themselves with a whole world to photograph and a whole world awaiting their results. Anyone who had the money and inclination could buy a camera (which could easily be adapted for projection) and shoot anything that moved; for these first, exuberant years, motion was by far the most important element. But soon the audience wanted more than motion; and the narrative film began.

The American public had always shown a marked preference for the theatrical rather than the actual – the first American films often showed part of a vaudeville act. But when the audience began to turn away from one-minute movies, the film-makers realized that the film like the theatre, would have to tell a story. Since the theatrical tradition was ready to hand, it is not surprising that the first great innovator in the field of narrative film was a man of the theatre the French producer Georges Méliès.

Fantasy and reality

Before Méliès, cameramen had been too fascinated by the ability of the movie camera to record motion to explore the other possibilities of the medium. Méliès first discovered how to create 'magical' effects on the screen – he remains one of the screen's most delightful magicians to this day. By using models, trick effects and superimposition, he created fantasies like *Journey to the Moon* (1902) especially for the camera. He found, for example, that if he filmed a person, stopped the camera, removed the person then filmed again, the effect on the screen was as though the person had suddenly disappeared. Méliès's films became widely popular in Europe and America, but with the spread of the naturalistic cinema, his style went out of vogue and he died in poverty in 1938.

Although Méliès was the first to realize that film could produce extraordinary effects, he was too much ahead of his time, and also behind it: his work still largely dealt with *theatrical,* rather than *cinematic* effects. It was an American, Edward Porter, who was the unwitting originator of future trends, and his unpretentious Western, *The Great Train Robbery,* showed the way to all film-makers of the time.

The story of *The Great Train Robbery* has a simple theme but is technically extremely inventive. Within eight minutes of film, Porter incorporated the first *panning* shot (where the camera swivels round to follow the bandits riding away from the train), the first example of parallel editing (where two different sets of action, happening simultaneously are presented in sequence in the film) and the first extended use of outdoor sequences, in strong contrast to Méliès's staged, studio-made films.

This film had an enormous commercial success, recouping its minute production

cost many hundreds of times over. It was imitated by film-makers all over the world, notably by the English cameraman Cecil Hepworth, whose *Rescue by Rover* shared with Porter's film a strong story line, a moving camera and extensive outdoor sequences. The French were inspired to make hundreds of farcical chase films, predecessors of the famous Keystone Cops, entirely out of doors.

It was in France, too, that the *film d'art* movement began, a movement which, while it did nothing to further the technique of the cinema (it returned consciously to the theatre for its subjects and actors), did much to raise the social status of film. Using such internationally famous players as Sarah Bernhardt and plays by Shakespeare and Goethe, the *film d'art* showed excerpts or potted versions of the greatest world literature.

In this way the cinema, which till then had drawn its audience from the working

classes, began to appeal to the middle classes, who presumably thought it quite proper to attend a ten-minute version of *Hamlet.* As the film gained prestige, it also gained length. The rule had been that each picture was one reel long, running about eight minutes. But in 1912, the first version of *Quo Vadis* was made in Italy in eight reels, almost two hours of cinema. It proved a success, and was copied internationally.

By 1911, film had become a world-wide business, and each of the major film-producing countries contributed their own style. America and Britain usually made films on simple themes, with a strong story and a lot of action. France tended towards the theatrical and the farcical, while Italy made spectacular historical pageants. Germany and Denmark had the beginnings of film industries which were later to grow and flourish in their own ways: the rest of the world watched, with

1 Although colour was not used widely until the 1950s, the early films were often painted by hand, frame by frame. Only fragments of these beautiful films survive.

2 Before the first moving film was made, the Victorians devised fascinating toys which delighted children by forming moving patterns at the turn of a handle.

1

2

Experienced in the ways of the theatre, Griffith realized that film had to differ radically in its treatment of themes. In his use of new camera and editing techniques, his films came alive, in startling contrast to those of previous directors. He used close-up to great effect, cutting from long shot to a close shot of, for example, the hero's face in a moment of tension. He realized that audiences did not have to see an actor move from one place to another – cutting quickly from point to point was more economical and dramatic. Working with a stock company of actors, Mary Pickford, Lionel Barrymore, Lillian and Dorothy Gish and others, he changed the old posturing theatrical style into a quieter more expressive style suited to a camera which could isolate a face or a pair of hands in close-up.

The climax of his film career was two superb films – *Birth of a Nation* (1915) and *Intolerance* (1916), both three hours long, released with their own specially composed musical scores. *Birth of a Nation*, though it upset many because of its racialist implications (it was sympathetic to the Ku Klux Klan) was an immense

1, 2 Sometimes frames were given monochrome tints, but often each figure was painted separately, each garment in different colours.
3 Herbert Ponting accompanied Scott of the Antarctic on his last expedition in 1910–12. Besides many superb still photographs, Ponting shot a moving film which was later tinted by hand. One of the first documentaries, the film was shown in cinemas under the title *Ninety Degrees South*.

increasing avidity.

The First World War changed the face of the rapidly developing film industries of the world; the countries of Europe produced little but newsreels for five years, while America jumped into the unchallenged lead as the biggest film-making country in the world, a lead it has never really lost. Thomas Ince, an ex-actor, became producer and script-writer of hundreds of films. Most of these were Westerns, a popular form which showed the American cowboy hero to an instantly admiring world. Mack Sennett originated the Keystone Cops, directed and scripted countless one-reel slapstick comedies and then, like Ince, moved into production, closely supervising his teams of actors, directors and technicians. The period is best remembered, however, by the first two real geniuses of the cinema, who worked at the same time and (for a short period) for the same studio – David Wark Griffith and Charles Chaplin.

Griffith first entered motion pictures from the front of the camera: he was employed by Biograph, then the largest studio in Hollywood, as an actor for five dollars a day. It was not long before Biograph and Griffith realized that his talents lay behind the camera, and from 1908 to 1912 he directed many films of varying length, all the while experimenting and discovering. For the first time, the innovations of Méliès, Porter, and the *film d'art* were brought together in the creative energy of one man, and moulded into cinematic art.

D. W. Griffith (left) was one of the great innovators in the cinema, breaking its links with the theatre by developing the close-up and other cinematic techniques.

The towering Babylon set for *Intolerance* was the most spectacular in an extremely lavish production. Four themes run parallel in the film, all culminating in one grand climax.

financial and artistic success.

Intolerance, on the other hand, was a comparative failure financially. By far the most expensive picture produced up to that time, it told four parallel stories, illustrating the theme of Man's intolerance to Man. The stories were not told in sequence, but were intercut, with the fall of Babylon, the assassination of the Huguenots, the life of Christ and the race to save an innocent man from the scaffold all reaching their climaxes together. Unfortunately, the film was released just when America entered the war. Its theme ran counter to the country's mood at the time, and it was largely ignored. Griffith made nothing of the same stature again, and was later relegated to being a stock director in a large studio.

Chaplin's rise to fame was much more explosive – indeed, he created his immortal tramp figure in a rainy afternoon. An English orphan, who had played in vaudeville since childhood, he went to America on tour as a moderately successful stage comedian. He was spotted by

Sennett in 1912, and, with some reluctance, went to Hollywood at Sennett's insistence in 1914, at the age of 24. He appeared as a variety of comic figures in the early one-reel farces, but it was only when, one afternoon, he put on a pair of baggy trousers, a tight coat, outsize shoes and stuck a false moustache on his lip that the 'little fellow' (as he later called himself) appeared.

He worked for Sennett at Biograph for some time, until a rival studio, Essanay offered him a larger salary and, more importantly, a longer time to develop his tramp figure. *The Tramp* itself appeared in 1915 and in the films that followed – *East Street* (1917), *Shoulder Arms* (1918), *The Kid* (1921) and *The Gold Rush* (1925) – the character did not change, except to become richer and more comic. Chaplin was his own best director. From 1914, he was allowed to make his own films as he wanted, and his touch was unerring. The figure he portrays is always shabby, always in danger of being knocked over, beaten up or put down once and for all.

A cleverly constructed set for *Journey to the Moon* (1902), a fantasy made by the one-time magician Georges Méliès, who became fascinated by the potential of the motion picture camera.

But always he revives and, with dignity unshaken, totters off down the road.

Chaplin was not only the first great comedian; he was also the first great star. In the early days the studios, accustomed to using different actors for each new film, never advertised the names of their players – only the theme of the film itself. But when it became clear that the public liked one face or personal style more than another, the studios began to 'build' the favourites into stars by judicious publicity and increased salaries. Chaplin and Mary Pickford – 'America's sweetheart' – were the first superstars, both earning up to a million dollars a year. So the screen found its own immortals, quite distinct from the theatre – indeed the most successful stars were those who could put the theatre behind them, and adapt completely to the cinema.

A household name

By 1920, America was in control of the world film market, exporting films to the countries of Europe exhausted by war and only beginning to revive their own shattered industries. Cinemas were built in every town and village in the country, replacing the old halls and their hard benches. Film companies, harassed by excessive New York taxes and looking for sun all the year round, moved to California, to a quiet suburb of Los Angeles called Hollywood, and soon that name became as well known to people throughout the world as their own birthplace.

Films were longer – usually about five reels – and cost many thousands of dollars, much of which went to the star. Distributing companies acquired rights for films, and charged exhibitors large rentals: exhibitors were forced to form cinema chains, and the independent houses were gradually forced out of business. In 20 crowded years, the cinema had become at once an industry and an art. Its big-business aspect was to develop to an astronomical degree in America; in Europe it found its freest artistic expression.

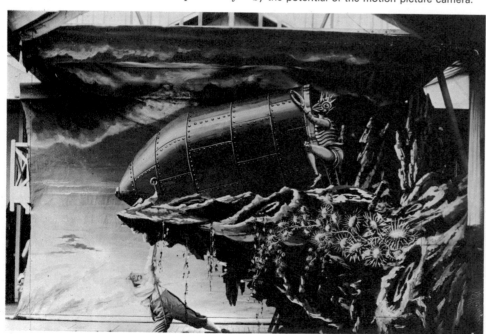

Film for art's sake

Between the two world wars, the European cinema came into its own. Directors of talent extended film's range of expression, shooting original themes using inspired new camera techniques.

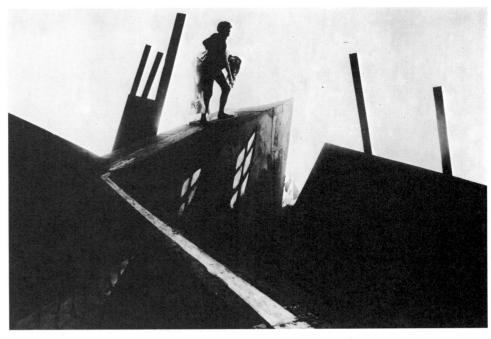

THE END of the First World War found America in effective control of the film industry of the world; for movie-goers of the time, film was American. Charlie Chaplin, Mary Pickford, William S. Hart (the first cowboy star) and Douglas Fairbanks were the first actors to achieve truly international fame, and their beauty, comedy or heroism became part of the national consciousness of nearly every nation.

Although the war had killed the film industries of Europe at a stroke, they rapidly came to life again. Surprisingly, it was the defeated and impoverished Germany which first showed it had not forgotten the art of film. In 1919 production began again, almost totally under the aegis of the government-sponsored Universum Film Aktiengesellschaft (UFA) studio, founded in 1917, mainly for propaganda purposes. And 1919 saw the making of one of the most famous films ever – Robert Wiene's *The Cabinet of Dr Caligari.*

The film is about a madman's hallucination, his fantasy about Dr Caligari, a fairground hypnotist, and Caligari's slave, Cesare, whom he keeps in a constant sleepwalking trance, directing him secretly to murder innocent victims. The film was very successful and caused a profound effect; it was completely original in its detailed handling of the theme of insanity, and also in the sets which suggested the disturbed mind of the narrator – crazy, towering buildings, a huge stool for a petty official,

Row after row of Cossacks march inplacably down the steps at Odessa, firing on men, women and children in the Russian classic, *Battleship Potemkin,* made by Sergei Eisenstein in 1925.

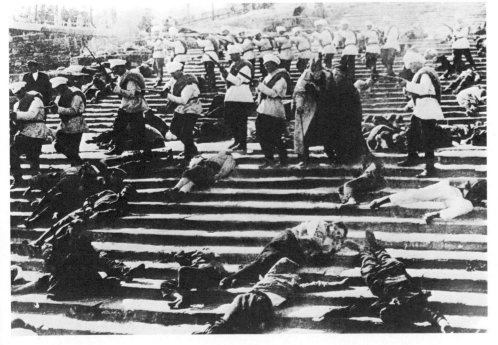

to emphasize his vested authority, the white skull-like face of Cesare. Strongly influenced by surrealist and expressionist art, the director and the designers were concerned to show, not the real world, but the vision of the world as it might look to an insane man.

Caligari was never imitated, but it was the forerunner of a number of exceptionally distinguished films which were to come from the UFA studios in the 1920s. All were centred in one way or another on the individual's struggle against hostile forces, a kind of cinematic representation of the harshness of life in Germany after the war.

The slave Cesare bears a victim across a crazy set to his master Caligari. Made in 1919, by Robert Wiene, *The Cabinet of Dr Caligari* deals with the fantasies of a disturbed mind.

The Germans proved themselves mighty innovators with the camera, setting a style in the 1920s which was copied internationally. Wishing to present as accurate a picture as possible of the poverty and unemployment of the time, directors like Friedrich Murnau, Ewald-André Dupont and Georg Pabst took their cameras into the street, and made the city their studio.

The best and most influential of these 'street' films was Murnau's *The Last Laugh* (1924), starring Emil Jannings. The theme was simple – Jannings played the part of a doorman of a large hotel, proud of his ability to carry huge trunks and of his splendid uniform. What impressed audiences most was the mobility of the camerawork and the effect motion could have. In one scene when Jannings gets drunk, the camera becomes his eyes, and whirls about, showing the experience of drunkenness, not only its effects.

The Last Laugh, more than any other film, deeply impressed American producers with the fact that the Germans had talent. When Dupont's *Variety* had a similar success using Murnau's techniques, Hollywood reached for its chequebook and bought director, cameraman and stars, trying then and subsequently to re-create the magic in California. Very few of these 'transplanted' artists did anything like their best work in Hollywood; with notable exceptions. Most of them found the control of the big studios too constricting for their personal art, especially after the freer, if poorer,

atmosphere of Europe. They either returned or wasted their talents in America.

Probably the greatest of the early German directors was Georg Pabst, an Austrian by birth. His first film, *The Treasure,* was made in 1924, but he first showed his preoccupation with social reality in *The Joyless Street* (1925), which featured Greta Garbo for the first time. The film is about the ruin of a bourgeois family, told with absolute cinema realism. His camera photographed the German depression as it was, and he weaved the story of the family into it.

Actuality as it was – that was the principle which animated Pabst's films at their best, and in the later ones – *The Love of Jeanne Ney* (1927), *Pandora's Box* (1929), *Threepenny Opera* (1930) and *Kameradschaft* (1931) – it is the realism of the settings that conveys the film's social implications. *Threepenny Opera* and *Kameradschaft* were 'talkies', among the first produced in Germany.

Sound films were introduced in the United States in 1927; the new technique spread instantly to Europe. By the early 1930s, the German company Tobis Klangfilm had established a European monopoly on sound. The huge German UFA studio could afford the high cost of sound conversion: other European countries found it almost prohibitive. Here was another graphic illustration of the universal power of Hollywood: since every European country was dependent on America for the bulk of its exhibited films, either the money for sound conversion was found or the cinemas went out of business. And so it was found.

The Berlin Olympics

Once Hitler attained power in 1933, with Goebbels as Minister of Propaganda, film, now fully converted to sound, was harnessed to the aims and methods of the Nazi Party, directly in the form of propaganda film, indirectly in sentimental romances and trivial, nationalistic comedies. One film remains outstanding from this period – Leni Riefenstahl's *Olympiad,* a brilliant record of the 1936 Berlin Olympics. Riefenstahl worked independently of Goebbels (she was a close friend of Hitler), and thus, though there are many shots of Hitler taken from a low angle to emphasize his divine status, the propaganda element does not conceal the finely shot events of the track.

The Russian cinema has laboured for its entire existence under a censorship which has eliminated all elements which might be in the least subversive to the interests of the State. The result has been that few films of artistic interest have emerged, though there is evidence that the cinema has freed itself to some degree in recent years. The Russian cinema was very great and very original for a few years only: from its nationalization in 1919 till the early 1930s when Stalin, like Hitler in Germany, found it necessary to muzzle free expression entirely.

These early years were years of triumph for the Russian people, freed from the Tsar's oppression; and so it is not surprising that the great Russian directors,

Vsevolod Pudovkin, Sergei Eisenstein and Alexander Dovzhenko should, in their own very distinct ways, make their films about the Revolution.

Pudovkin was a student of Lev Kuleshov, one of the few pre-revolutionary film-makers to remain in Russia after 1917. Kuleshov refined the editing technique and discovered the value of careful juxtaposition of shots. Pudovkin's technique grew out of his teacher's studies. He insisted on showing every nuance of his characters' moods on film, rather than relying on subtitles. In each of his films – *Mother* (1925), *End of St Petersburg* (1927), *Storm over Asia* (1928) and *Deserter* (1933) the hero represents the masses – he is an idealized picture of what was in itself an ideal.

Sergei Eisenstein is the most famous of Russian directors, and his *Battleship Potemkin* is possibly the best-known Russian film in the world. It follows an act of

In 1926 the Gaumont-British studio produced *Mademoiselle from Armentières,* a story about the Great War in which the heroine uses her influence with the enemy in favour of the British.

mutiny in 1905 by sailors on a ship of the Russian Imperial Navy. The film made use of Eisenstein's 'montage' theory of editing, one of the most influential of all cinema techniques, and widely used ever since. A superb illustration of this technique is the Odessa steps sequence from *Potemkin,* where Cossacks advance down the steps, shooting at the townspeople who are cheering the mutineers. Shots of the Cossacks are intercut with shots of a pram bouncing down the steps, of an old woman shot in the eye, of a horrified student and so on, to give the sense, impressionistic rather than realistic, of the horror of the scene.

Stalin came to power during the making of *Ten Days that Shook the World* and Eisenstein found himself up against Party opposition for the first time. This was to grow progressively more severe, and indeed he made only four more films – *Old and New* (1929), *Alexander Nevsky* (1934), and Parts I and II of *Ivan the Terrible* (1947). He died in 1947, with most of his later films cut or not distributed, his plans for future films discarded.

The last of the 'big three', Alexander

A. C. & R. C. BROMHEAD present

"MADEMOISELLE from ARMENTIERES"

A GAUMONT BRITISH FILM

The intimate drama and comedy of the War, told with skill and convincing realism. An exceptional combination of great popular entertainment values and the most magnetic of all British box-office titles.

Produced by MAURICE ELVEY.

Sole Distributors · THE GAUMONT COMPANY LIMITED. [1898-1926]

Dovzhenko, stands between Pudovkin and Eisenstein in style and technique. He deals with huge themes, like Eisenstein; and he made his characters and images bear the weight of symbolism and allegory, like Pudovkin. His greatest films – *Arsenal* (1929), *Earth* (1930) and *Frontier* (1935) – show a concern for human values and aspirations in the midst of revolutionary turmoil.

France, the only other European country whose film production underwent a renaissance in the 1920s and 1930s, was unique in that it had no system of government aid: films were produced by people interested in the quality of the work itself. The man who did most for the revival of French cinema after the war was Louis Delluc, who pleaded for films which would be 'truly cinematic' and 'truly French'. While his own films tended towards self-consciousness, his inspiration was behind the great directors of the time – René Clair, Jacques Feyder, Jean Renoir and others.

It was Clair who showed the most exceptional talent. His first film, *The Crazy Ray* (1923) showed where his genius lay – in closely observed fantastic comedy. Fantasy and comedy were the mainsprings of all his subsequent work. His most successful film, the one in which his favourite elements were most cunningly embodied, was *The Italian Straw Hat* (1926). Based on a nineteenth-century farce, the film tells of a bridegroom caught up in an affair between a married lady and an officer because his horse ate the lady's hat. The plot is slight but Clair's comic invention keeps it moving at a great pace.

In Feyder's films – *Crainquebille* (1923), *Thérèse Raquin* (1928) and *Les Nouveaux Messieurs* (1928) – comedy is still the mode, but it is a more ironic comedy, seen especially in *Les Nouveaux Messieurs,* which was banned from the screen because of its political satire. Feyder's strength is in his humanism, his insistence on understanding the characters he filmed. It was this

human concern which made him one of the most popular directors of his day.

Jean Renoir, son of Auguste Renoir, the famous impressionist painter, is one of the most respected directors in the French cinema. In the 1920s, however, his only great success was *Nana* (1926), a film adaptation of Émile Zola's novel. The film showed Renoir's admiration for the German cinema and his assimilation of its techniques, while at the same time fulfilling Delluc's maxim that French cinema should be 'truly French'. After *Nana,* however, Renoir found himself with no more money, the distributors having taken all the profits, and he was forced to turn out standard commercial films.

But there was another side to French cinema in the 1920s when the surrealist cinema came into its own. The movement began in Germany, with the camerawork of Viking Eggeling and Walter Ruttmann, but it was the films of Clair, Fernand Léger, Luis Buñuel and Salvador Dali in France which first reached a wider audience than the artists' immediate circle. Clair's *Entr'acte* was unlike his previous

1 A poster advertises the release in 1927 of *The Circus of Life*, a German-produced film about a young Russian officer who secretly weds a girl of the people and is sent to Siberia.

2 Leni Riefenstahl directing the shooting of *Olympiad*, a record of the 1936 Berlin Olympics. A friend of Hitler, she managed to avoid the crude propaganda of most German films of this time.

or subsequent films in that it used the technique of Surrealism to achieve its comic successes: the events are absurd, unexpected and apparently unrelated.

For Léger and Clair, film experiments of this kind were only part of their artistic preoccupation; for one film-maker, it was a starting-point. Buñuel, an aspiring film-maker worked with Dali, already an artist of some reputation, to make *Un Chien Andalou* (1929), which has become a symbol for *avant-garde* film. Working with images of shock, horror or absurdity, the film attempted to simulate the logic of the dream which, the Surrealists claimed, was 'more real than reality'. This was Buñuel's first film, and it marked the start of one of the most brilliant careers of the cinema.

Finally, in France in 1928 a film was made which both showed the art of film at its highest peak and emphasized its worst fault. This was Carl Dreyer's *The Passion of Joan of Arc*. Its astounding power came from the beauty and expressiveness of the central character and the ability of the camera to reveal the significant look, gesture or object at each stage of Joan's trial. The weakness of the film was that it was silent – it was overloaded with titles, necessary for the development of the theme, but inevitably distracting from the beauty of the images.

France's cinema industry was hit harder than most when sound came. Since there were no big studios, nor any system of

1 John Grierson was the formative influence behind the British documentary movement. He directed only one film, a long documentary called *Drifters* in 1929.
2 *Un Chien Andalou,* made by Luis Buñuel and Salvador Dali, combines images of shock and horror (this woman's eye is about to be slit open) in an attempt to simulate 'the logic of dreams'.
3 René Clair's most successful film was *The Italian Straw Hat* (1926). The plot is slight, but Clair's elegant and witty style made it one of the finest examples of comedy in silent films.

government aid, the film companies were forced into the hands of bankers and financiers and turned to safe commercial films to pay the bills.

Only one great talent emerged at this time, and that was a brief one – Jean Vigo, who made only two feature films, *Zéro de Conduite* (1933) and *L'Atalante* (1934). Both films were shot on very little money; both (especially the latter) show superb craftsmanship and a developing genius. But Vigo died, in poverty, at the age of 29.

The other countries of Europe produced little of note between the wars. The film industry was still dominated by the American giant, especially the British industry. The exceptional British talent of the time, Alfred Hitchcock, soon left for America, where his best films were made. It was not until the mid 1930s that John Grierson and the documentary film movement put Britain in the forefront of film production. Although by the beginning of the Second World War America was still indisputably the biggest producer of films in the world, its position had been shaken by the European experiments.

Hollywood's first boom

In 1911 the calm of a respectable Los Angeles suburb was rudely shattered by the influx of a bizarre group of people — the movie magnates. Hollywood's traffic in dreams was under way.

THE FILM INDUSTRY as we know it today is very much a creation of the American 1920s. Though methods of producing and directing films have changed greatly since these days, it was in that period that films became an industry. Hollywood changed the attitudes of film-makers and audiences, created huge stars and million-dollar productions and sent a certain image of America round the world.

Money was the keystone of the film industry in Hollywood from the beginning; flamboyancy and adventure, independent film-making on a shoestring, all that was past. Companies like Metro-Goldwyn-Mayer became enormous, with vast studios, world-famous stars and millions of dollars in the bank. Naturally such huge spending had to be recouped with huge profit: the Hollywood 'formula' had begun.

This formula is hard to define, since it changed continually to suit public taste and social conditions. But its basis was simply success. Nothing was done by halves. Those stars who were successful appeared in film after film, cast in the roles in which they were most loved. Books which became best-sellers were almost automatically made into films (which still happens today), and the authors were paid big fees for the rights; directors who pleased the public taste with one film directed sequels along the same lines. When German and French cinema began to find a market for their films, Hollywood bought the best-known directors, stars and technicians.

Dream factory

It had taken ten years to transform Hollywood from a respectable Los Angeles suburb into a fully operational dream factory. It became the most publicized and discussed area in the world, a place where reputations were made (or lost) in a day or a night, where the transformation of waitress to millionairess was not unknown.

The films produced by Hollywood in its first boom tended to mirror the type of society it fostered. The years immediately after the First World War saw a great relaxing of pre-war morals, and one of the first of the Hollywood formulae was the sex-comedy. Sophisticated and elegant, it inevitably featured seductive and beautiful women usually undressing for the bath or the bed, and handsome, unscrupulous men. Drink, sex and luxury were the ingredients of hundreds of films in this mould.

The best-known director of this time, the man whose name has become almost synonymous with that of Hollywood, was Cecil B. De Mille. No one could gauge public taste more accurately than he. During the war he made patriotic films with a strongly nationalist flavour: after-

1 Greta Garbo, the actress who became a legend, left her native Sweden in 1926 for Hollywood. She starred in many films, among them *Anna Karenina,* before retiring in 1942.
2 *The Jazz Singer* (1927), starring Al Jolson, was the first talking-singing feature to come out of

Hollywood. Sound killed the silent film but boosted box-office takings.
3 Douglas Fairbanks Sen. captures a galleon single-handed, overcoming the swashbuckling pirate crew in *The Black Pirate* (1926), which he wrote, produced and directed.

wards, observing the revolution in moral attitudes, he made sex-comedies like *Male and Female* (1919), *Why Change Your Wife?* (1920) and *Adam's Rib* (1923).

Society, however, could scarcely allow this anarchy to continue unchecked for long: in 1922, the Hollywood producers, acting together for once, formed a society called the Motion Pictures Producers and Distributors of America. This was essentially an organization which censored the films produced by members of the association before they were released, and the head of it was a church elder named

William P. Hays.

The establishment of the Hays Office, as it became known, had been necessary in the face of increasing protest from religious, temperance and other groups in American society. The protest was directed at the picture of vice and depravity Hollywood productions conveyed. This pressure was not that of a few religious cranks: it became a national movement, adversely affecting box-office returns. Hit where it hurt most – in the pocket – the industry rapidly changed.

But it did not change too radically. Sex and debauchery had been successful before and it was obvious that they would be again: all that was needed were concessions to common morality. Again, it was De Mille, with his special knowledge of how far to go in the right direction, who led the way in the new style. His *The Ten Commandments*, made in 1923, contained more orgiastic scenes, more half-undressed women, more immorality than ever before (indeed, it has seldom been rivalled since); however, it was all contained within a biblical framework, and since in the same picture Moses condemned it from Mount Sinai, the Hays Office allowed it to be shown – De Mille had found another formula.

A safe investment

The new formula, one which has existed in various forms up to the present day, was that you could present as much sin and sex as you liked, providing it was condemned in the last reel. De Mille's other epic of this time, *King of Kings* (1927), repeated the success of *The Ten Commandments*. From that day on the epic has represented one of the safest investments of film capital, though later examples (*Ben Hur, Spartacus* and others) have shown a good deal more taste and intelligence than

De Mille's blockbusters. The sin-meets-retribution-in-the-end formula was used for all kinds of films at this time, especially a rash of nineteenth-century set melodramas where the villain, after a good deal of salacious by-play with the heroine, came to a gruesome end at the hands of the handsome hero.

Such films represent Hollywood at its worst. Yet another blind alley into which the producers were betrayed by too much cash was their indiscriminate buying of foreign, especially German, talent. Germany's newly revived industry was ex-

periencing its most vigorous phase, and films like Friedrich Murnau's *The Last Laugh* or Ewald Dupont's *Variety* had great popular and critical acclaim. So directors, stars – notably Emil Jannings – and technicians were offered huge salaries to go to Hollywood.

In most cases, European artists responded badly to Hollywood. The big studios paid well, certainly, but they exacted from artists the highest price of all – the loss of their own talent. The businessman's policy of repeating one success by another resembling it in every

1

2

232

3

1 During the 1920s, experiments in colour processing were forging ahead. This test film, using the Kodachrome technique, has green on one side of the celluloid and red on the other.

2, 3 The biblical epic was Cecil B. De Mille's gift to posterity. With the establishment of the Hays Office, the first censoring committee, a formula was needed which bypassed the new moral codes. De Mille made *The Ten Commandments* in 1923. Its combination of sex and moralizing proved so successful that he repeated the theme in a colour production in 1956.

important detail was at odds with the artist's desire to find something new each time he created a film, and many of the directors and artists left again for Europe. Jannings, for example, created nothing of importance in America, but had to return to Germany to make *Blue Angel* with Marlene Dietrich.

The exception to the rule was Ernst Lubitsch, a German director already famous in Germany for his costume fantasies; he developed a sophisticated light-comedy style tailored, like De Mille's, for the Hays Office, but, unlike De Mille's, constructed with art and wit. Such films as *Kiss Me Again* (1925) and *So This Is Paris* (1926) are full of understated comedy, and he worked in sets which were free of the usual clutter of furniture. Soon, the 'Lubitsch touch' became a thing to be imitated by other directors and other studios.

Lubitsch was the director whose talents were happily contained within the big studio framework: most directors could hardly be said to be 'contained', since they displayed no noticeable reaction to the system. The system was that, if a director had proved himself as a good comedy director, comedies he directed until he retired. A few directors hung on until the bonds were loosed after the Second World War – among them William Wyler and Raoul Walsh: however, the majority directed films that looked very much like other people's films, and faded out.

Ten hours long

There were a few individuals whom the system could not contain, yet who worked in it for a short time. The most notorious of these was Erich von Stroheim, an Austrian actor who appeared in D. W. Griffith's *Intolerance,* and directed his first feature *Blind Husbands,* in 1919. This was a success, and he was employed by Universal International to make more films. *The Devil's Pass-key* (1920) and *Foolish Wives* (1921) repeated the success, and more or less the plot, of his first film. MGM, newly formed and anxious to attract talent, offered Stroheim an unlimited budget and his own choice of subject. His choice was a novel by Frank Norris called *McTeague,* from which he made *Greed* (1924), possibly the greatest of all American silent films.

The novel is a painfully minute account of the degradation and ruin of a naïve young dentist who achieves temporary security and happiness only to have it snatched away from him. It was filmed so carefully by Stroheim that the finished film lasted ten hours. He suggested to MGM, who had already been driven to despair by the enormous cost of the film, that they release it in two parts. Finally, it was taken from him and cut to two hours. Though so much of it has been removed that the film is hard to follow in parts, *Greed* remains a classic. Unfortunately, it almost finished Stroheim's career. He directed three more films, and each time shooting was stopped so that another director could finish it off quickly and cheaply.

Robert Flaherty attracted Hollywood's notice by an independently produced film *Nanook of the North* (1922), a record of Eskimo life. Paramount signed up Flaherty and sent him to Samoa to do the same for the Samoans as he had for the Eskimos. It took Flaherty two years to get to know the

epic Western, *The Covered Wagon,* shot in the wild country of Nevada. The famous John Ford made his first Western in 1924, *The Iron Horse,* on the same scale. Thereafter, it was the custom to produce the 'big' Western, a custom which continues to this day. It is only recently, with the Italian-made Westerns, that the basic elements of the form have changed. The Italian films, starring Clint Eastwood as an all-but-silent hero, emphasize the brutality of the time; the traditional Western emphasizes the moral order.

The greatest 'little fellow', of course, was Chaplin, who continued to make his slapstick, sentimental comedies throughout the 1920s. Buster Keaton was the straight-faced comic, who was continually caught up in events beyond his control: Harold Lloyd was earnest, eager, knowledgeable and utterly unable to do anything; Harry Langdon was simple and innocent. Each in their own way – Keaton in *The General* (1926), Lloyd in *The Freshman* (1925), Langdon in *The Strong Man* (1926) – confronted a world full of wiseguys, high buildings and speeding cars, impossibly complicated social events or machinery and muddled their way through them all. What they were doing was re-enacting in a comic way the more poignant struggle thousands of Americans were having to make, coming to terms with a new society as best they could. When these characters were entangled with the Establishment in some form, the Establishment is invariably represented as remote, super-efficient and fast: there lies one of the principal differences between them and English comics: to the latter the Establishment is more often than not stuffy and slow.

The first talkie

The introduction of sound caused the almost instant demise of the silent film, in America and later throughout the world. Warner Brothers, on the verge of bankruptcy and desperate to raise attendances, introduced the Vitaphone, the first sound system, and in 1927 released the first talking-singing feature, *The Jazz Singer* with Al Jolson. Within two years, 9,000 cinemas in the United States were equipped for sound, and most of the others were either closing down or in the process of converting. Box-office returns leapt from 60 million dollars a week to 110 million a week.

So ended Hollywood's first great era: for some years it also destroyed the fluent camerawork which had grown up in the studios. The new sound stages meant that the noisy cameras had to be enclosed in clumsy soundproof booths, and the cinema went back 20 years or more to use static camera positions.

Sound not only temporarily killed the moving camera: it also signalled the end of many careers, especially those of the European actors, whose heavy accents for the most part were unacceptable. For some years, the mere fact of having people talk was enough, just as in the earliest days, movement itself sufficed. But Hollywood was to revive, and the 1930s were to see its finest expression.

1 The cowboy is one of Hollywood's immortal characters. The first large-scale Western, *Covered Wagon,* directed by James Cruze, was shot on location in Nevada, instead of in the studio.
2 Hollywood imported the talented Austrian-born director Erich von Stroheim from Europe. He was allowed to make his early films much as he liked, but *Greed* (1925) was heavily cut.
3 Robert Flaherty spent months among the Eskimos. In 1922 he made a beautifully photographed documentary drama *Nanook of the North* on the daily life of an Eskimo woman.

islanders well enough to film them, and then he did it slowly and beautifully, with perfect knowledge of every gesture and scene he photographed. The result was *Moana* (1926), which Paramount understood so little that they released it as a South Seas romance and brought hula-hula girls on stage to introduce it. Flaherty was given another chance with *Tabu* (1931) but when he insisted that he must have time in which to work, Murnau was sent to finish it. Flaherty then went to Britain, and worked with John Grierson and his documentary movement, and continued to make documentaries until his death in 1951.

Austrian-born Josef von Sternberg, like Flaherty, made an independently produced film, *Salvation Hunters* (1925), which recommended itself to the studios because of its low budget and success. After a false start with MGM, he made *Underworld* (1927) for Paramount, a fine gangster thriller, which made a good deal of money and Sternberg's reputation as well. This success was repeated with *Dragnet* (1928). His next film, however, *Docks of New York*

(1928), was a flop because it was an attempt to break out of the thriller success-formula. He directed Jannings in *Blue Angel* in Germany in 1930, and returned to Hollywood with Dietrich. He made a number of films with her, beautifully photographed but lacking in content. Von Stroheim was fired, Flaherty left, but Sternberg's artistry was compromised by unsuccessful attempts to repeat his earlier successes.

Hollywood created two immortal characters: the cowboy and the 'little fellow'. Between them, they captured the myth of America: the fight for decency and moral values in simple terms; the laughable predicament of Man against society or the machine. William S. Hart was the first screen cowboy – hard-drinking, hard-riding and fast-drawing, but he was soon replaced by the 'goodie' – Tom Mix, Buck Jones and others – who only shot when they had to and never went to the saloon except to have a showdown with the big badman. Hundreds of these simple morality tales were turned out.

In 1923, James Cruze directed the first

Hollywood's heyday

The 1930s and 1940s were the grand days of Hollywood, the days of the Marx brothers and John Ford. Sound was established, and with it one of the best-loved spectacles of the screen — the musical.

BY THE LATE 1920s, sound was established in the motion-picture industry, first in Hollywood and rapidly throughout the world. Sound gravely limited freedom of expression in two ways. Camerawork was as static as the earliest days of silent pictures, because of the need to enclose the camera in a sound-proof booth; and the companies had to call in the financiers of Wall Street to lend them money for the expensive equipment needed for studios and cinemas. Boards of directors were created who, even more than before, were concerned solely with profit.

In time, however, these initial drawbacks were overcome. The cinema has always veered uneasily between art and business, and inevitably a very 'commercial' period was followed by a much freer, 'artistic' one. Of course, in the Hollywood set-up these terms are relative: profit was never lost sight of for long, and temperamental and expensive artists like the Austrian-born director Erich von Stroheim were a rare exception. Yet, though an industry, it depended upon artists to create its best films; and a few directors who achieved success in the studio system were also considerable innovators in style and technique. It was these men who liberated the cumbersome sound camera, and made Hollywood

1 *The Barkleys of Broadway* was one of many films woven around the famous dance partnership of Fred Astaire and Ginger Rogers in the 1930s.
2 Groucho Marx (second from the left) in a scene from *Duck Soup* (1933), a send-up of the middle-European musical. The three Marx Brothers made 12 fast-moving comedy classics once sound had become established.
3 The gangster film became as popular as the Western or the screen comedy. *Scarface* (1932) was based on the life of Al Capone (Paul Muni, centre), with George Raft (right).

movies fluid, graceful and expressive once more.

Before discussing the pioneer work done in the early days of sound, it is worth noting that colour films became a practical possibility on the cinema screen at about the same time as sound came in. Herbert Kalmus, who began his technicolour researches in 1918, marketed a two-colour process in 1923. Producers were encouraged to try it, and several films were made in technicolour towards the end of the 1920s, especially the new musicals.

The technicolour laboratories, unprepared for the sudden rush of orders, were completely unable to print the film in time for the producers: the results, produced too hastily, were bad and very expensive, at a time when huge sums of money were being spent on sound conversion. So colour was dropped, until the competition of television sent the producers in search of something new once more.

It was Ernst Lubitsch, already established at Paramount with many successful silent films to his credit, who first realized that a 'talkie' need not be all talk. Directing Maurice Chevalier in *The Love Parade* in 1929, he allowed the camera to pan away from Chevalier as he was telling jokes, to show the effect they had on his audience, while still keeping the joke on the soundtrack. In other words, he discovered the effective use of *non-synchronous sound* – sound which is recorded over action, and which does not necessarily come from people or objects on the screen. Again, in *The Smiling Lieutenant* (1931), he timed the actors' movements to fit a musical score which was recorded later.

King Vidor, in *Hallelujah!* (1929) and Lewis Milestone in *All Quiet on the Western Front* (1930) also used *post-synchronized* sound: both these films were made on location, and the noises of the forest or of war were added later. The technique of post-synchronization was thus an early development of sound, and was the greatest aid to freeing the film from its static, stagey set-ups. This technique is still used widely, indeed much more widely now than then: whole films are often entirely post-synchronized, the actors dubbing their lines in a sound studio after shooting the scene on location.

The tyranny of the sound booth could not last long: Hollywood's technicians were always inventive. The booth came to be replaced with a *blimp*, a soundproof cover which fitted over the camera body. Microphones became *directional*, that is, they recorded only the sounds coming from the direction in which their head was pointing. Later, these microphones were suspended on a *boom*, which was manipulated to follow the actors.

It was in France that non-synchronous

1, 2 *Gone With the Wind,* made in 1939, has proved to be the world's biggest screen success. Based on a novel by Margaret Mitchell, it portrays, through the relationships of a small group of people, the changes in Southern society at the time of the American Civil War. Vivien Leigh and Clark Gable seen here in the leading roles still attract large audiences all over the world. The film has often been revived.

3 *Cleopatra,* starring Elizabeth Taylor and Richard Burton, was made in 1961–63 but it was still in the lavish Hollywood tradition of the 1930s.

sound was first used to best effect, in the comedies of René Clair. While Hollywood's directors were limited by the realism demanded in their scripts, Clair's almost surrealistic treatments could use sound effects which did not match the screen images. In *Le Million* (1931) he shows a clock on the mantelpiece; instead of ticking, the soundtrack carries the blast of trumpets. Clair was at an advantage in his attitude towards the new talkies – he considered the image much more important, and was not afraid of sparse dialogue.

In Hollywood, his example was imitated best by Rouben Mamoulian, ironically enough a stage director brought to Hollywood to produce the 'canned theatre' films which characterized most of the early talkies. But he instinctively knew the difference between stage and screen: in one of his first films, *City Streets* (1931), a filmed montage of china figures is matched with a montage of voices from the heroine's past – the first purely sound flashback, which has been in common use ever since. In *Dr Jekyll and Mr Hyde* (1932), his use of sound had matured into artistry. In a scene with the wicked Mr Hyde and one of his victims, the murderer bends over the girl as she lies on the bed singing. Hyde bends down until he is out of the frame. While he is out of sight, the singing stops abruptly, and he rises back into the picture, triumphant.

The third film genre which Hollywood made its own at this time, besides cowboys and clowns, was the gangster film. A few stars, still treasured by film audiences today, became inevitably typed with the gangster image: Edward G. Robinson, James Cagney, Paul Muni, George Ban-

croft. The scripts for such films as *Little Caesar* (1930) and *Scarface* (1932) were based on events and characters alive while the film was shot. *Scarface* was based on the exploits of the gangster Al Capone, who was at the height of his career in 1932. The dialogue of these films was terse and colloquial: phrases like 'We're goin' for a ride' became part of the national myth. Toughness in both men and women, shoot-outs and shoot-ups, car chases, daring and even more fantastic exploits – this was the content of the new formula which Hollywood found to be another 'world beater'.

The musical film was a sound 'natural' – indeed, the film which first established sound irrevocably was a musical, *The Jazz Singer* (1927), which featured Al Jolson. At first, these musicals followed the pat-

tern of most early sound films, being filmed Broadway musicals. It took an original director to transform them into cinematic art – Busby Berkeley. Like Mamoulian, Berkeley was originally a stage director. He devised spectacular dance sequences for films like *Whoopee* (1930) and *Gold Diggers of 1933,* which used camera angles from above, below and the side, breaking away from the head-on 'full-view' format with which the musicals had previously been typed. His dances became almost abstract in their patterned beauty: but their popularity declined when Fred Astaire with his intimate style began to draw his audience into the dance, rather than keep them at a distance.

Sound affected the comics of Hollywood more than any other branch of the movies: the popularity of Chaplin, Keaton and

(1935) he displays the perfect timing he learned from years of vaudeville. Fields and the Marx Brothers were perfect examples of talent which Hollywood needed too much to discipline. Their comedy was uniquely their own in each case, often ridiculing the system itself to the wrath of the producers.

It was in the 1930s and early 1940s when sound-film had become an art rather than a novelty, that three of the finest directors in the history of film made their best films: John Ford, Alfred Hitchcock and Orson Welles.

Ford had already achieved some fame in the 1920s with *The Iron Horse* (1924), one of the first 'big' Westerns. In the 1930s he teamed up with scriptwriter Dudley Nichols, and together they produced such films as *The Lost Patrol* (1934), *The Informer* (1935), *The Plough and the Stars* (1936) and, of course, *Stagecoach* (1939), which contained everything – Indians, cavalry, a stagecoach, a beautiful woman and John Wayne.

American morality play

Ford films tend to follow a formula, but it is more the Ford formula than the Hollywood one. The Western has been and still largely is an American morality play, with easily recognizable good and evil men – a drama where good wins in the end, played out against magnificent scenery and dusty cattle towns. The skill of the Western director has traditionally been measured not by originality of plot, but by his individual style in manipulating elements.

Ford has always been among the most successful directors: *My Darling Clementine* (1946), *She Wore a Yellow Ribbon* (1949) and *The Horse Soldiers* (1959) are distinctive because of their clear-cut story (matched by perfect camerawork) and first-rate acting. The federal colonel in *The Horse Soldiers* (played by John Wayne) is a typical Ford hero: a natural leader, brave, impatient of red tape, awkward with women but courteous, sure of his beliefs.

Hitchcock has his set elements, too: but unlike Ford's, his are uncertainty,

Lloyd declined: the Marx Brothers, W.C. Fields and (a little later) Bob Hope took their place. Chaplin especially knew instinctively that sound was not for him: he made *City Lights* in 1931, long after sound had become established, as a silent film. But the Marx Brothers, schooled in vaudeville, in the art of repartee, were completely at home with words and sound effects. (Though it is interesting that Harpo, who was dumb, played the part of a silent screen comic with elaborate gestures and miming.)

What the brothers, especially Groucho, did was to turn the system of Hollywood upside down. Their plots were absurd parodies of the well-made Hollywood stories. *Duck Soup* (1933) was a prolonged joke at the expense of the middle-European musical, with Groucho playing the part of Rufus T. Firefly, President of Fredonia, while Chico and Harpo were utterly inefficient spies.

Fields was the complete comic act in himself, bragging and shouting his way through situations which conspired to put him down: in his best films, *You're Telling Me* (1934), *It's a Gift* (1934), and *Mississippi*

4 The star system was established in the early days of Hollywood; today a big name like Julie Andrews (shown here in *Star*) still ensures huge takings at the box office.

5 One of the few technicolour films made in the 1930s was *The Adventures of Tom Sawyer* (1937), directed by Norman Taurog and based on the novel by Mark Twain.

probably the most popular in the world, which might be taken as a symbol of the Hollywood system. The film is *Gone With The Wind*. Directed without noticeable strain by Victor Fleming, it featured Clark Gable, a war scene, a fiery heroine, a saintly second female lead, a noble second male lead, impoverished southern families and Negroes who acted reassuringly like Uncle Toms. Adapted from a monolithic novel by Margaret Mitchell the film ran almost four hours, and has made several fortunes in its still-healthy life.

A second world war was to cause another great revolution in world cinema. The first established America's primacy, the second knocked it down, at least for a few years. The Hollywood system of the huge studio was replaced by a number of rich distribution companies, still bearing the same names, but now confining themselves to financing the films made by 'independent' producers. Of course, this means that the 'independent' producer is still as tied financially as ever, but the more meretricious products of the big studios have tended to disappear, and a good deal of socially committed and courageous films have been made.

Hollywood during its heyday was many things: rich beyond measure, a world of dreams and dreamers, a jungle of cut-throat ambition – but it rarely produced anything of worth of its own will. Those outstanding and memorable directors and stars were in conflict with the system for most of their careers, or else too exceptional to be dropped. Though many now look back on Hollywood with nostalgia, if the system had not arisen, if producers and directors had not been treated like sausage machines, there would have been a great deal more to remember.

mystery, shock. He began his film career in England, but left for the more lucrative (and freer) American studios, from which his films began to flow about 1935.

His horror stems from the sinister undercurrents hidden in the most banal situations. There are no monsters, no supernatural curses; everything is logically explicable at the end, but only in the end. Hitchcock, like Ford, is not interested in breaking the bounds of the commercial system: he can get on very well inside them.

Orson Welles did wish to break the bounds of Hollywood, and in a way he did, with *Citizen Kane* (1941). Welles was only 25 when RKO gave him a free hand to make his first film, but already he had produced plays and radio shows, and had established himself as a considerable actor in the Mercury Theatre company in San Francisco. Completely untrained in film technique, he prepared himself for the making of *Kane* by watching the old classics in the New York Museum of Modern Art for three months.

Kane is a thinly disguised biography of William Randolph Hearst Jr., the gutter-press tycoon, then still alive. The film begins with Kane's death, switches to a preview theatre where film-makers are

watching the first run of a newsreel they have made on Kane's (Hearst's) life. The rest of the film is flashback, the reminiscences of wives, friends and enemies of Kane.

The camerawork was no less revolutionary than the form – Welles used deep-focus photography, which meant that he could concentrate attention on a figure in the background as well as one in the foreground. The use of wide-angle lenses created the illusion of vast spaces, and dramatic camera angles made his characters appear huge or tiny while still occupying the same amount of screen.

His next film, *The Magnificent Ambersons* (1942), was less showy than *Kane*, and more conventional; in fact, the film was taken away from Welles during editing, and cut by RKO editors for the story content only. However, enough remains to show that it is a masterpiece: Welles developed the technique of a montage of speech to convey a certain impression. In *The Magnificent Ambersons* he photographed in close-up a number of people talking with a montage of voices on the soundtrack, giving an impression of the whole town talking.

There is one film, not the best but

Life on the screen

The Italian films of the 1940s were cheaply made using ordinary people and settings. Yet they were to have an effect far beyond Italy, launching the neo-realist movement across the world.

WHEN THE HOLLYWOOD big studio system ended after the Second World War, there ended too a certain attitude to films. The giant companies had given the world dreams and fables, often over-sentimentalized, occasionally beautiful; these films continued to be made, but the best and most important of those made after the war, the films which make up what we call the contemporary cinema, were often concerned less with wish-fulfilment, more with social reality.

Though this concern was soon to manifest itself in America, it was from Europe that the new direction came. It did not spring up suddenly after the war: the movement towards social themes had begun, in a very conscious way, in Britain as far back as 1929, with what is now known as the British documentary movement. This movement was largely the work of one man, John Grierson, whose vision of film was that it should enlighten and inform every person about the community of which he was a member. Films like Grierson's *Drifters* (1929), Basil Wright's *Song of Ceylon* (1934) and *Night Mail* (1936) were never government propaganda, not even in the war years. They were unemphatic, under-stated rather

than overstated, provocative; their aim was to do justice to their subject. They were to serve as a model for later artists who wished to paint on a larger canvas.

The directors of the neo-realist school of Italy were such artists. Like Britain, Italy could not look back with any pride on its early film production – it was known mainly for its grandiose spectaculars in the silent era and for its sugary musicals in the early days of sound. A system of state patronage secured the studios to Mussolini's cause during the war. But one film was made in this period, in 1942, which contained the seeds of the realist movement. This was Luchino Vis-

1 Sir Laurence Olivier in *The Entertainer* (1958). Directed by Tony Richardson, the film version of John Osborne's play about a third-rate comedian incorporates criticism of British society.
2 *On the Waterfront* (1954), directed by Elia Kazan, made Marlon Brando a star. Set on a New York dock-side, it deals uncompromisingly with corrupt trade unionists.
3 Luchino Visconti's *Obsession* was made in 1942 and heralded the neo-realist movement in Italy. His use of ordinary faces and landscapes had a profound effect on other Italian directors.

conti's *Obsession*, a sombre drama set in a small village in the Po marshes. For the first time, everyday faces and landscapes were the theme of a film, and the effect on other Italian directors was profound.

The work usually credited with marking the beginning of the neo-realist movement was Roberto Rossellini's *Open City,* begun in 1944 while the Germans were occupying Rome. None of the cast, apart from the principal actors, was a professional – they were the people of Rome and the German troops, photographed with hidden cameras. What emerged was a film which used the documentary technique to create a study of heroism in the face of Nazi oppression. Rossellini's next film, *Paisa* (1946) used the same technique, but this time the subject was the liberation of Rome by the Allied soldiers.

Suffering and despair

Vittorio de Sica's first film, *Shoeshine* (1946) revealed a director of the realist school whose talent explored the minute, the particular, the little tragedy. *Shoeshine* took its subject from the cynical, amoral, war-wise children of southern Italy. De Sica's best-known film was *Bicycle Thieves,* made in 1949: a simple story (a poor labourer has his bicycle stolen, and spends a day looking for it, accompanied by his son) is used to reveal suffering and despair seldom seen in films working on a grander scale. Two later films – *Miracle in Milan* and *Umberto D* – revealed the same compassion for the 'losers' of life.

Visconti, whose *Obsession* had made such an impression, made *La Terra Trema* (*The Earth Trembles*) in 1948 without any professional actors or studio settings; it was shot entirely in Sicily, in a small,

poor, fishing village. Other directors followed the lead of Visconti, Rossellini and De Sica, and a number of fine films was made in the realist style, among them Luigi Zampa's *To Live in Peace* (1946), a plea for human friendship, irrespective of race; and Alberto Lattuada's *Without Pity* (1947), about Negro deserters from the American army.

It was inevitable that neo-realism should become stylish and forced. With the return of economic stability in Italy, the building of Cinecitta, the best equipped studios in Europe, and the influx of American capital, the Italian cinema became 'box office orientated', and the true spirit of social realism was lost. Yet while it lasted, its influence was wide and deep, especially on the American cinema, where it is said that millions of dollars were spent trying to give movies the 'rough, cheap look' of the Italian films. There has been no comparable movement in Italy since – the history of the best of its cinema has been that of individual artists like Michelangelo Antonioni, Frederico Fellini and, more recently, Pier Pasolini.

British cinema first attracted international attention for its documentaries, and the best post-war features preserved this documentary quality of sharp observation. Indeed, it is arguable that the most successful British style, right down to the present day, has been that of social realism. For example, David Lean's film *Brief Encounter* (1945) was set against a middleclass, utterly English background of railway stations, teashops and front parlours. It also had excellent performances from Trevor Howard and Celia Johnson. Lean went on to make *Great Expectations* (1946), based on the novel by Dickens, perhaps the best film adaptation ever made. More recently, he has specialized in big-budget films, like *The Bridge on the River Kwai* and *Lawrence of Arabia,* made for American companies.

Hunted and in danger

Carol Reed is the greatest stylist of the post-war British cinema. His unique touch is seen at its best in his three 'man' films – *The Odd Man Out* (1947), *The Third Man* (1949) and *The Man Between* (1953). All three deal with men on the edge, hunted and in danger, preserving dignity and even wit in the face of shadowy and nameless forces.

The most successful kind of British film in this period was what came to be known as the 'Ealing comedies', made at the Ealing studios, of which the best two were *Man in a White Suit* (1951) and *Kind Hearts and Coronets* (1948/49) (starring Alec Guinness). These, and others like them, were comparatively cheaply made films for the home market but the disastrous big-budget films made by the same British companies chewed up all their profits. The studio system collapsed and, as had happened earlier in America, they were replaced by independent companies.

The first of the films to signal the new direction in British cinema was Jack Clayton's *Room at the Top* (1958), with Laurence Harvey. The film followed the hero's rise from clerk to tycoon in a real-

1 Albert Finney (left) directed and starred in *Charlie Bubbles,* a British film about a workingclass writer made good. Here, hero and friend indulge in slapstick in a smart restaurant.

2 Many of Otto Preminger's films deal overtly with social problems. *Hurry Sundown,* set in a small town in the deep South of America, revealed racial hatred deeply entrenched.

istic, unsentimental manner. It had the traditional strength of the British cinema – fine characterization – and avoided many of the old weaknesses – clichéd story, overglamourized cast and sugary sentiment. *Saturday Night and Sunday Morning* (1960), directed by Karel Reisz, was in the same mode: Albert Finney, then unknown, played the hard-drinking factory hand who lives from day to day, has little thought for morality and is always ready to stand up

for his rights.

The most successful independent company was Woodfall, founded by Tony Richardson, John Osborne and the American producer Harry Saltzman. In their productions of two of Osborne's stage successes, *Look Back in Anger* (1959) and *The Entertainer* (1960), both directed by Richardson, they revealed that a strong script and unpretentious direction could make a film that spoke to its audience with

a directness and a clarity unknown in previous British films. This upsurge of talent was not confined to directors and writers. New stars were 'born': Finney was one, others included Rita Tushingham and Tom Courtenay. They were not only exceptionally fine actors (Albert Finney, with *Charlie Bubbles* [1968], has proved a fine director, too), but they spoke with their own, strong regional accents, accents which previously had been used by the 'lower classes' or by clowns.

More recently, the contemporary British cinema has lost something of this impetus. The 'new wave' directors like Richardson and Brian Forbes have, like their predecessors, put their talents at the service of the big American film – Richardson's *The Charge of the Light Brigade* (1968) is a good example – since this is often the only way they can get money to make films at all.

That this is hardly the fault of the directors can be seen in the career of

1 When one of his many girl-friends finds true love with the milkman played by Graham Stark, Alfie, in the film of the same name, realizes the futility of a life of casual love affairs.
2 At the same time as realism crept into the cinema, the epic gained a new lease of life in America to compete with the growing popularity of television. *Ben Hur* was one of the finest.

The themes of many of Vittorio de Sica's films are the problems of ordinary people. *Bicycle Thieves* (1949) is a moving account of a poor labourer's search for his stolen bicycle.

Open City (1944), starring Anna Magnani and directed by Roberto Rossellini, was shot in natural settings using sparse resources. It achieved a passion and vigour not equalled since.

Lindsay Anderson. He made several documentaries in England in the 1950s of varying quality, the best of which, *Thursday's Children,* was a marvellously sensitive study of blind children learning the nature of the world about them. His first feature, *This Sporting Life* (1963), was in fact sponsored by a British production company – Gaumont-British – and was concerned with the rise and fall of a professional rugby player. The hero, played by Richard Harris, is portrayed as a boor with a few good instincts; the harshness of his life and circumstances wreck the only thing that matters to him, his love for his landlady, played by Rachel Roberts. In his second feature film, *If* . . . (1968) Anderson surveyed the English public school with a mixture of detachment and passion. Anderson had long wanted to make a film on this theme, and tried every means possible of raising the money in Britain, without success. *If* . . . was eventually financed by Paramount, an American company.

Films to a formula

America holds something of an equivocal position in the contemporary film scene. With the decline of the studios and the success of European films, America reversed its traditional policy. Realizing that it could no longer get the best in the world to go to Hollywood, it went out to meet them, and financed films made by native directors in their own countries. The habit of making films to a formula still remains in almost any European-American production: still, as has been seen in the case of *If* . . . , the American producers are often more adventurous than the native financiers.

Domestic film production in America was also profoundly affected: with the financial control of the film more often in the hands of the artists (directors and stars often took a percentage of the profits), the themes became concerned more directly with social problems. Before examining

Billy Wilder has been called Hollywood's most cynical director. *Some Like It Hot* is a farcical treatment of a 1920s gangster theme, where Jack Lemmon and Tony Curtis (left) pose as girls.

the work of these directors, one post-war phenomenon should be mentioned: the 'blockbuster', or 'it takes five million dollars to catch ten million' picture.

With a nation which was rapidly turning into television addicts, the producers experimented with a new attraction, the wide screen. This came in various forms: CinemaScope, VistaVision, Todd-AO and Cinerama: what was needed were themes big enough to fill them. So the epics came back: *The Robe* (1953), the first Cinema-Scope film, was a huge success. De Mille quickly followed with *The Ten Commandments* (1956), based on his old formula of sex and religion. But it was *Ben Hur* (1959), starring Charlton Heston, that changed the epic from mere spectacle into something approaching art. *Ben Hur* was made by William Wyler, a distinguished and sensitive director. Others were made in the same style by equally fine directors.

But it was in the new, personal style of cinema that the greatest triumphs were achieved. Elia Kazan in New York de-

veloped 'the method' – a style of acting based on the teaching of Stanislavsky which forced the actor to live the part he was playing. If, for example, he had to play a teenage hoodlum, he had to observe and appreciate the mentality of such a person, and then the actions would follow naturally. Marlon Brando is the most famous exponent of this method; the late James Dean was another. Kazan made *A Streetcar Named Desire* (1950), *Baby Doll* (1956) and *On the Waterfront* (1954). The last film made Brando a star: his portrayal of an illiterate and often brutal hero awakening to a sense of his own and others' dignity was a brilliant vindication of the method style.

Billy Wilder, whose best films include *Double Indemnity* (1945), *Sunset Boulevard* (1950), *Some Like It Hot* (1959) and *The Apartment* (1960), is a sardonic realist whose films are occasionally works of near genius; *Some Like It Hot* was one. Starring Tony Curtis and Jack Lemmon as two musicians on the run from a Chicago gang and forced to dress as girls in an all-female band, the film was pure farce played realistically – one of the funniest films ever made.

More obviously a 'committed' director is Otto Preminger: many of his films deal with a specific problem. In *The Man with the Golden Arm* (1953), Frank Sinatra plays a drug addict, the first time drug addiction was ever shown overtly on American screens. *Hurry Sundown* (1966) was set in a town in the American South, and revealed bigotry and racialism lying deep in the fibres of such a society.

In general, the direction that American cinema took after the war was towards increased realism. Sentimentality and kowtowing to public taste were still there to a certain extent, even in the best films. But many were made – and were successful – that revealed their directors' anger and compassion. These films did much to bring issues of public concern into the open, making them much more difficult to ignore.

Cinema comes of age

In its short life the cinema has been a wonder of science, a maker of dreams and dollars, an expression of personal vision. Now its diversity earns it a place alongside the older 'seven arts'.

THE CONTEMPORARY CINEMA presents a scene more interesting and diverse than at any other time in its history. On one hand the monolithic American companies still produce lavish musicals and super-epics; on the other a growing number of film-makers experiment with cheap materials and intensely personal themes, making films which can have only a limited circulation. Between these poles lies the main body of modern film.

A public following

The fact that film is no longer the property of a handful of production companies has meant a great change in film style. A new cinema-going public has grown up since the war, one whose film expectations are not to be satisfied by factory-made fantasies, but who regard film as an artistic expression as valid as literature or painting. This public is large enough to ensure that the work of the greatest post-war directors – Luis Buñuel, Ingmar Bergman, Federico Fellini, Michelangelo Antonioni and Akira Kurosawa – are widely seen. And so what before the war would have been regarded as 'box-office poison' has become a sure success.

This trend may be summarized by saying that cinema has become more 'personal'; more and more films deal directly with the director's or the scriptwriter's preoccupations with social, moral or political questions. This is not an entirely new departure, of course; Sergei Eisenstein, Georg Pabst, René Clair and others did their best work in the 1920s and 1930s, while the factory-made film was in its heyday. What *is* new is that the contemporary director

The work of Alain Resnais, a professional film-maker, deals largely with time. In *Hiroshima Mon Amour,* the two lovers are linked by memories which bind them to their different pasts.

Akira Kurosawa is the only Japanese director who is well known in the West. *The Seven Samurai,* his most famous film, owes much to American Westerns.

can remain within the commercial framework and produce films very much as his own vision dictates.

Much has been written about the work of these directors; each new film they make is something of an event, and is immediately discussed and compared with that director's previous work. There are, of course, great differences between their styles and themes; nevertheless they can be seen in relation to each other as well.

Each one examines the nature of the society in which he lives, and the effect the society has upon people's actions. The two Italian directors Fellini and Antonioni invariably deal with contemporary society. In Antonioni's *The Eclipse* (1962) the modern architecture of Rome, harsh and functional, underscores the emotions of the distant lovers. Kurosawa, a Japanese, and Bergman, a Swede, often set their films in some period in their country's

Symbolism dominates much of Ingmar Bergman's work. In *The Seventh Seal* the knight (right) plays chess with Death and, by a stalling move, manages to prolong his life.

past: Kurosawa's *Seven Samurai* (1954) presents, rather in the manner of a Western, man faced with the moral problem of how to deal with danger, and shows the meaning of comradeship and maturity in hazardous situations.

Another common factor is the pessimistic, uncompromising nature of these artists' visions. They portray Man perverted by his religion (as in Buñuel), compromised by his selfishness and materialism (as in Antonioni), destroyed by his own personal demons and terrors (Bergman). The social order is seen either as a threat or as an illusion, an all-too-thin veneer over chaos. In Buñuel's films, beggars and social outcasts appear again and again as representatives of anarchy and disorder. In *Viridiana* (1962) the beggars take over the home of their benefactress and in a travesty of a feast their behaviour grows more and more violent, culminating in the rape of Viridiana herself. Kurosawa alone makes films whose message, if not optimistic, often points tentatively to hope in the future.

On the fringes of film

These directors are all in the forefront of contemporary cinema. Their reputations were built in the post-war years and the financial success usually attendant on their films allows them to work freely with themes which interest them most. All had to serve an apprenticeship, some longer than others, before graduating to make their own films. Buñuel, for example, spent 20 years on the fringes of the film industry before making his first feature. But all have benefited since the 1950s from the changed climate of public taste.

If Japan is known in the West mainly through the work of Kurosawa, Indian cinema *is* one man – Satyajit Ray. His three most famous films, known as the Apu trilogy *(Pather Panchali, Aparajito* and *The World of Apu),* were made between 1954 and 1959. They study the development of one man, Apu, from childhood to maturity, and present a sensitive study in microcosm of life in modern India.

With a few exceptions, French cinema

1

2

1 Federico Fellini directing *Satyricon,* the film he wanted to make since his career began. Set in the degenerate days of declining Rome, *Satyricon* is based on fragments of a novel by Petronius, who died in 66 A D.
2 The hero of *Herostratus,* an experimental film made by Don Levy, decides to sell his death (by suicide) to a public relations firm.

languished after the pre-war period when Jean Renoir made *La Grande Illusion (The Great Illusion)* in 1937 and *La Règle du Jeu (The Rules of the Game)* in 1939, and Jean Vigo made *Zéro de Conduite (No Marks for Conduct)* (1934) and *L'Atalante* (1935). The industry itself was stagnant, so it is not surprising that the new directors came from outside, several from the critical magazine *Cahiers du Cinéma,* still the most respected film magazine in the world.

These film-makers – Jean-Luc Godard, François Truffaut, Claude Chabrol and Alain Resnais, to mention only the best known – were for the most part untrained.

The style they developed was free from the clichés of the commercial cinema as far as technique goes. But more than that, they believed that the cinema had no bounds: what was previously thought to be 'un-cinematic' was filmed, and often found to work. The cinema had to be concerned with *now*. The soundtracks of their films often contained news broadcasts about the Vietnam War or General de Gaulle, while contemporary events and figures were

1 *The Graduate,* directed by Mike Nichols, was a great box-office success, yet within the commercial framework it used techniques usually associated with 'new wave' directors.

2 A scene inside a space station in Stanley Kubrick's *2001 – a Space Odyssey,* which exploited to the full advanced techniques in cinematography and stereophonic sound.

discussed at length. Because the first films were made with very little money, they took the cameras out into the streets and filmed Paris and the Parisians.

These young directors of the 'new wave', as this new cinema was called, had their common origins. Especially important was the influence of two film critics of the previous generation, Alexandre Astruc and André Bazin. In a series of articles, these two virtually set up a new aesthetic of the cinema in France. They looked at what to them were the most important aspects – technique, style, the director's use of camera, actors and cutting.

Of course the new wave produced utterly dissimilar films: Truffaut's best, *Les Quatre Cent Coups (Four Hundred Blows)*, is an autobiographical study, a film about the institutionalized childhood

of an orphan – detailed, funny and sad. His most famous film is *Jules et Jim*, the eternal triangle subtly and often movingly refreshed. *The Bride Wore Black* (1968) is a suspense thriller very consciously in the Hitchcock mode, with Jeanne Moreau (who starred in *Jules et Jim*) playing the vengeful wife who tracks down and kills the men who shot her husband on their wedding day.

Alain Resnais is distinguished from his new-wave colleagues largely by the fact that he is a professional film-maker. He made many short films before starting on his first full-length feature, *Hiroshima Mon Amour* in 1959. Another of Resnais's distinctive features is that he does not write his own scripts: unlike Godard, Truffaut and the others, he does not subscribe to the idea that the film must be the

director's conception from beginning to end. *Hiroshima Mon Amour* was written by Margueritte Duras on Resnais's request; *Last Year in Marienbad* (1961) is a novel by Alain Robbe-Grillet. Yet his films, seen as a whole, have a certain unity: they deal with the theme of time, with memory, of the connections between present and past events. In *Hiroshima,* the two lovers, one French, one Japanese, have a bond of memory as well as attraction: the woman remembers the shame she suffered after the war for having had a German lover during the occupation; the man remembers the atom bomb on his home town of Hiroshima, and the horror he suffered. The title of *Muriel* (1963) is derived from the name of a girl who never appears in the film. She exists in the hero's memory, an Algerian girl whose death he subscribed to while serving in the army.

Jean-Luc Godard's name is certainly the most widely known of all the new-wave directors, though it is questionable if his films, especially his most recent work, are as famous. Far and away the most *avant-garde* of the group, his films are full of social references, of 'quotations' from other films or other styles. A Godard film is rarely easily defined: it is never simply a love story, or a thriller, or a comedy, or a musical. In *Pierrot le Fou (Crazy Pierrot),* for example, there are two songs, a number of murders treated in a light or comic fashion, a single comedy act which seems to bear little relation to the rest of the film, and a love story in which one of the couple murders the other. In *Weekend,* the characters of the French revolutionary leader Saint Juste and the novelist Emily Brontë appear on the contemporary scene amid a countryside littered with wrecked cars and injured drivers, and a group of hippy-bandits feast on human flesh. Godard's cinema cannot be adequately summarized in a few words, but it is among the richest and most rewarding body of work in the contemporary cinema.

The effect of the new wave has been profound. Not only have its different styles begun a new era for the cinema, but the films have also achieved great commercial success as well, especially in the 'art' cinemas of America. They proved that the new cinema-going public, though much depleted when compared with pre-war figures, can accept the films of artists who make few if any concessions to 'popular taste' – a far cry from the Hollywood formulae of the 1930s. Although the commercial cinema is still much more successful financially than the 'art' or *avant-garde* cinema, the latter has ensured a place for itself which enables it to continue with sufficient funds. In turn, its influence is felt in the commercial world. Although *The Sound of Music* and others like it achieve fortunes without even nodding in the direction of the new wave, the American film *The Graduate* (1968), directed by Mike Nichols, earned large sums of money, while using unusual and exciting camera-work and embodying a good deal of social criticism.

Cinema underground

While artists like Antonioni, Bergman and Godard can work more or less within a commercially viable structure, there has grown up, again in post-war years, a large body of films which are resolutely on the outside. This movement, if it can be called such, is known as the Underground Cinema, and has been most active in America. The work of men like Andy Warhol, Stan Brakhage, Harry Smith, Gregory Markopoulis (in America), Wim Verstappen (in Holland) and Don Levy (in Britain) is not generally known, but is beginning to attract wider notice.

These film-makers have nothing more in common than a desire to make films in exactly the way they wish, to try new techniques and modes of expression which in most cases break away entirely from the traditional film form. Of course this means that their films tend to be short and seen by few: but like all true artists, these men consider that the success or failure of the film is secondary to the need to create it.

To forecast any development in film is always dangerous, but it does seem now that the pessimists who predicted that the cinema would die in the face of competition from television are proved wrong. The cinema and television are two different media, two different experiences, and it is unlikely that one can supersede the other. The wide screen, first introduced in a panic in the mid 1950s when the challenge of television was felt at its strongest, is still developing: so is stereophonic sound. They have both been used to best effect in Stanley Kubrick's *2001: A Space Odyssey,* where the most advanced techniques in cinematography and special effects were combined with sensitive film-making to create the first space epic.

What is also clear is that cinema has won its battle to be recognized as an art form, perhaps the most relevant art form of our times. Like any other art, it requires an original artist and an aware audience: as long as it continues to have both, there seems little chance that it will die out.

1 In Luis Buñuel's *Nazarin* the main character is a priest who visits a plague-stricken village (shown here). The film explores the quality of Christian charity.

2 A quiet interlude for Apu and his wife in *The World of Apu,* the third of a trilogy made by the Indian director Satyajit Ray, a study of one man and the society in which he lives.

Art for art's sake?

The aesthetic movement of the 1880s held that art is justified by beauty alone. While aestheticians argue the point, the critic faces the task of applying principles to the judgement of individual works of art.

EVERYBODY is constantly subjected, through newspapers, television and radio, to 'talk' about books, paintings, plays, music, sculpture and other 'works of art'. Two types of people are primarily occupied with trying to analyse the works of art – the critic and the aesthetician. Aesthetics, in its widest sense, is the philosophy of art and concerned with 'art in general' – with the nature, significance and symbology of the work, rather than with its assessment as 'good or bad', successful or unsuccessful.

The term 'aesthetics' was coined by the eighteenth-century German philosopher Baumgarten, who defined it as 'the science of sensuous knowledge'. In its austere form, aesthetics involves the discussion of concepts related to art, such as imagination and fancy, form and idea, often dealt with in the abstract, and with no relation to any particular work of art. Little criticism is involved and there is no appeal to fact or instance.

In the latter half of the nineteenth century, there was a move to base aesthetics on a practical study of works of art. This involved complex psychological experiments which revealed a great deal about the physical nature of objects commonly believed to be beautiful, and about the reactions of people to such objects. The movement was also a protest against the idea that art must serve some ulterior purpose – and against the 'philistine' taste of the period.

Why is art important?

This approach to aesthetics became increasingly popular. It examined the nature, for instance, of aesthetic pleasure – why one shape, phrase, form or movement is more pleasing than another – and looked at the sympathetic relationship established between the spectator and the work of art. This 'sympathy' is thought by many to be the result of an immediate intuitive understanding of the form or meaning of the object, a kind of identification with the work, an understanding which creates a new experience in itself.

But why is art thought to be so important, and what is it about art that merits so much time and trouble, talk and criticism? Reading a novel or looking at a painting does not further the cause of science or clothe children, yet many people think all education should be based on art. What does it add to our lives, and what has the artist to say?

Many aestheticians speak of the artist as one who has a 'vision', his own unique angle on experience combined with the ability, and the need, to express it in some way. A good artist understands what he sees or feels, how he sees it and the way he has chosen to express it – his medium. He is not aiming at a straightforward imitation of nature, but at an interpretation of some aspect of life.

Other aestheticians have denied that the artist has a vision which is something greater or beyond what the 'man in the street' sees. They look on the artist's talent as the gift of being able to pass immediately from perception to an intuitive expression of that perception. Herbert Read, the author of many books on art and the philosophy of art, says: 'The artist speaks in stone, in wood, in bronze, in colour, just as the poet speaks in words; the artist makes thought visible without the intermediary of verbal concepts.'

Henri Bergson, the French philosopher, says of artists: 'They induce us to make the same effort ourselves; they continue to make us see something of what they have seen.' But why, if the aim of the work of art is to clear the path of our perceptions and to enable us to have some immediate understanding of it, should so much effort be necessary? Could it just be that the artist has failed in whatever he set out to do? But art is an *interpretation* of reality, and therefore not everything in it may be immediately apparent.

Herbert Read observes that what is easily and clearly seen in primitive art may be difficult to perceive in 'the complex products of highly cultured civilizations'. So the spectator may have to work as hard to understand art as the artist did to create it.

The work of art does not exist in a vacuum; it must be experienced and it is the business of the watcher, reader or listener to get the greatest value he can

1 The Merce Cunningham Dance Group rehearses a new production in New York. The critic must be able to judge whether or not dance, music and scenery have produced a unified performance.

2 These hand-made wine glasses were designed with contemporary tastes in mind for simplicity of line. Commercial firms follow trends of taste so that their products are attractive and functional.

out of such an experience. Nor is the work of art created in a vacuum – many factors contribute to its creation: the people whose work influenced the artist; the way his 'eye' has developed as a result of his own experience in life; his increasing familiarity with his work and his medium. His outlook on life, or the style of his work may change drastically, and then his work must be looked at from a new point of view. The spectator must learn the extent to which such factors should be taken into account in his judgements.

With many art forms there is an additional factor, the performance, as in a play, concert, opera or ballet. The spectator must learn to distinguish for instance, whether the playwright's message or idea was not clear, or whether it was badly interpreted by the director or badly performed by the actors.

Most of the performed arts are highly complex. There may be technical factors involved. Of a drama, the critic must decide if the set is apt, the actors well grouped or positioned, the timing of the dialogue and its articulation good or bad. When watching a television play or film he must be conscious of the location of the camera in relation to the action, the use of space, colour, 'atmosphere' and the use of lighting and photographic effects – whether they lend anything to the performance, or whether they are distracting. Ballet is a combination of dancing, music, costume, drama and scenery. The composer, the choreographer, the art-director and the artists must all bring the conception of the work into line to make a harmonious whole.

In the case of music, some like to make themselves familiar with the themes of the work before attending a concert in order to leave more of their concentration free for examining the use the composer makes of these themes, and the sensitivity with which they are handled by the conductor. In every case the most important consideration will be: is perception extended through the artist's work; have we benefited by looking through his eyes?

Having asked these questions, are there, in fact, any 'right' answers? And if so, who is in a position to give them? Understandably, many would say the artist himself was the best qualified to comment upon his work. But this may not necessarily be the case, for the talents of criticism and creation are not the same, though of course some have an aptitude for both. While the artist may, on occasion, be able to describe his creation, there is no guarantee that he can do it better than anyone else, let alone assess it critically. Many artists are extremely wary of talking about their work, feeling that they have already said all they wish to say in the way that they know best.

The language of critics

But what of the ordinary man who understandably may not be able to comprehend the workings of an extraordinary mind? This is where the function of the critic is fulfilled. A critic may not be able to paint or compose a symphony, but he uses language, as we all do, to express ideas and feelings. He must also, through his education and experience be equipped to express a well-reasoned opinion – to be not just an opinionated man, but a man of informed opinion.

A critic should be able to perform three functions. Firstly, he must be able to describe a work of art such as a painting in a practical sense, distinguishing the sun from the moon, the stone from the mountain, the man from the woman. Next he must be able to elaborate his description – why is it the sun and not the moon, the man and not the woman? What are the inter-relationships between the separate and distinguishable parts of the work? Does the placing of the sun, the man and the mountain merely produce a pleasing composition, or does it mean something more than this? Is it a strict representation of reality, or is it symbolic in any sense? Is there only something for the eye to see, or is there something for the mind to fasten on and explore? What in other words, is the artist here trying to do?

Finally, and perhaps most important of the critic's tasks, he must be able to evaluate what he has explained. Is the work of art as a whole good, bad or neither, and why? He must have sufficient experience to know where the particular work stands in relation to historical tradition, and how relevant it is to the present; how much it takes from the past and how much it adds to the future – for as one critic has observed: 'the study of art is not concerned with isolated manifestations, however brilliant, but with a series of inter-linked developments'.

Creating 'public taste'

The modern critic who has access to the public through any of the mass media is obviously in a position of considerable power. For even the most sensitive and intelligent person can be overwhelmed by the idea of what he is 'supposed' to like. In the same way that they assume that a painting is not hung in the Louvre unless it is 'great', they also tend to assume that a critic is not given space in a daily paper to write about a film, book or play unless it is important. So if the critic does not actually create 'public taste', he can certainly influence it, and because of this the critic must exercise judgement, responsibility and integrity. He must maintain some objective distance from what he is writing about, for if he is prone to being subjective, the reader will find out much more about his personality than about the particular work under scrutiny. There are critics who tend to create a cult of opinion through their witty or sarcastic views, and while they may make interesting reading for a time, the information imparted may be negligible.

While good critical writing is an art in itself, too often it is sacrificed to promoting the wrong things for the wrong reasons. There is more than a subtle difference between personal preference and critical opinion. The former may be mere self-indulgence, while the latter is the result of careful and well-reasoned deliberation.

But although the critic is powerful and, in the case of the Broadway critics of New York who are notorious for closing plays after the first night, often all-powerful, public taste can and will take a stand against them. In 1967 *Time* magazine reviewed Arthur Penn's film *Bonnie and Clyde*, and disposed of it in no uncertain terms. Shortly afterwards it had to apologize for its error in judgement, because public response was so greatly in favour of the film, and furthermore it received great critical acclaim from other sources. In its reassessment the magazine took an almost completely opposing stance to its original view.

But of course critics are not infallible. The lot of even the most honest is not a happy one for there are really no rules for him to follow, no practical criteria that remain the same from case to case to serve as guidelines for what Wordsworth once termed that 'inglorious employment' of criticism. It should also be remembered that the critic may have been badly overexposed to many works, and the fact that it now takes an exceptional performance to arouse him may be reflected in an unenthusiastic piece of criticism.

Considering all these difficulties, should not the public be left to make up its own mind? If all these barriers present themselves and serve only to get in the way between the work of art and the audience, why not dispense with the critic entirely? Although the processes of analysis and discovery are not the exclusive rights of the critic, we should not be too quick to deny that with a little more knowledge at his disposal, and perhaps with a little more deference, the critic does tend to establish an order of ideas, and to make apparent the best of them to a less well-informed audience.

Criticize and understand

If criticism is not at all times strictly accurate or true, it is better than the ambiguous vacuum of 'I like it, but I don't know why'. For although the 'impact' (the first 'I like it') of any work of art on any man is a unique and important experience, he will, if he is keenly interested, be aiming at the greatest response which he can achieve from that work. Repeated mindless lookings or listenings will not increase that experience, for mere repetition only brings boredom. For appreciation and enjoyment to be increased, he must criticize and understand.

Each person's response to a work of art too is based on his individual experience. Books which present and discuss a variety of art form are valuable to him because they bring other versions of experience to his attention.

Art critics, like artists, are products of the age in which they live. The art they criticize, as well as their criticism itself, provides a rich backcloth for the historian when he views the cultural context of a particular time and evaluates the events of that age.